Garments of Paradise

Garments of Paradise

Wearable Discourse in the Digital Age

Susan Elizabeth Ryan

The MIT Press
Cambridge, Massachusetts
London, England

MIT Press books may be purchased at special quantity discounts for business or sales promotional use. For information, please email special_sales@mitpress.mit.edu.

This book was set in StoneSerifStd and StoneSansStd by Toppan Best-set Premedia Limited. Printed and bound in the United States of America.

Library of Congress Cataloging-in-Publication Data
Ryan, Susan Elizabeth.
Garments of paradise : wearable discourse in the digital age / by Susan Elizabeth Ryan.
 pages cm
Includes bibliographical references and index.
ISBN 978-0-262-02744-1 (hardcover : alk. paper) 1. Wearable computers. 2. Wearable art. 3. Miniature electronic equipment. 4. Ubiquitous computing. 5. New media art. I. Title.
QA76.592.R93 2014
004.16—dc23

 2013037225

10 9 8 7 6 5 4 3 2 1

For Paul

Contents

Acknowledgments

My focus on wearable technology began with my desire to overhaul my contemporary art courses at Louisiana State University in light of the increasing prominence of new-media art forms, specifically digital technology, and above all in relation to the human body. In 2004 I saw my first wearable technology fashion show at the SIGGRAPH conference, and Isa Gordon's performance onstage caught my attention. Perhaps nothing further would have happened, but in 2005 my life was changed by Hurricane Katrina, which demolished my home, computer, archives, and library. It seemed appropriate at that time to refocus my research and consider something that allowed me to indulge my interests in technology and art, and my lifelong curiosity about dress.

In 2006 I won a competition from the Leonardo Education and Art Forum (LEAF, a branch of Leonardo/ISAST) to curate an exhibition entitled *Social Fabrics*. It focused on wearable technology's social-networking capacity and ability to merge online and offline participation. That exhibition was held in Dallas in 2008 at the College Art Association Annual Conference, and was supported by funds from LEAF, the University of Texas at Dallas, and the LSU College of Art and Design. The exhibition allowed a large audience to view wearable works in action, worn by models as they walked a runway. Participating artists came from all over the United States and from Canada, Australia, Austria, Scotland, and South Korea. In addition, I created a *Social Fabrics* catalog, published by the new-media journal *Intelligent Agent*, and wrote an article for *Leonardo*, the oldest and preeminent peer-reviewed journal on art and science. My essays in that catalog and papers delivered at several SIGGRAPH panels and at the International Symposium on Electronic Art (ISEA) since 2004 formed the basis for this book.

My accomplishment of the initial manuscript is entirely due to the support of a grant from the Louisiana Board of Regents through their Awards to Louisiana Artists and Scholars (ATLAS) program. There is no question of completing such an undertaking during a regular academic year; the kind of uninterrupted time that allowed disparate ideas to resolve themselves would not have been possible without that grant. I am also grateful for the generous travel and research support from the LSU School of Art and the LSU Center for Computation and Technology.

I have benefited from the ideas of many people who have discussed the work with me: Laura Beloff, Joanna Berzowska, Leah Buechley, Elise Co, Diana Eng, Ying Gao, Ryan Genz, Isa Gordon, Deanna Little, Jane McCann, Dimitri Negroponte, Alex Pentland, Mary Redin Poor, Rehmi Post, Ricardo O'Nascimento, Francesca Rosella, Thad Starner, Brygg Ulmer, and Anouk Wippricht. Special thanks to Maggie Orth for sharing her thoughts and her archives with me.

I wish to thank my students at LSU who assisted with research: Jeane Cooper, Randy Damico, Lydia Dorsey, Caitlin Lennon, Nick Lopes, Dorian Mister, and Rae Jung Wilburn; and my colleagues Matthew Savage and especially the late Mark Zucker. Special appreciation to Rod Parker for his support and assistance with illustrations. Thanks also to LSU Middleton Library Research Specialist Hillary Veeder; to Neil Parkinson, Archives and Collections Manager at the Royal College of Art; and to James Long, who helped me prepare the manuscript. At the MIT Press, I owe thanks to Doug Sery for his faith and patience. I also wish to thank Katie Helke Dokshina and Susan Buckley, my production editor Matthew Abbate, and my copy editor Thomas Frick.

Introduction: Wearing Technologies

"Clothing and other kinds of ornamentation make the human body culturally visible. As Eugénie Lemoine-Luccioni suggests, clothing draws the body so that it can be culturally seen, and articulates it as a meaningful form."[1] Kaja Silverman wrote this in the late 1980s, citing Lemoine-Luccioni's *La Robe*, published a few years previously. Neither author was talking about wearable computers or electronic devices, but within ten years' time researchers began to develop them, and designers began to imagine garments that, in style and visual references, represented a futuristic digital age. Another fifteen years forward, mobile devices, phones, music players, and digital pads—rather than the desktop screens we have already begun to move on from—fill our lives and reflect our basic need not only for clothing, but for systems of embodiment shared together and supporting mobility and the embodied dimension of social life. Mobile technologies have virtualized our perceptions of reality, but still we feel drawn to the street, to physical spaces and places of mutual looking and interacting, and we still dress to feel culturally visible in the way Silverman and Lemoine-Luccioni describe.

This is a study of wearable technology as an evolving set of ideas and their contexts, chief among which are actual wearables, that is, clothing, dress, and fashion, and the histories and social relations they represent. Wearing technology, say, in the form of a Walkman in the 1970s, augmented-reality headsets in the 1990s, or an electronically illuminated gown in the 2000s, does not bring forth a condition of suspended time, nor is it immune to cultural entanglement. These items engage with the complex language of dress, which has in fact always involved technology at some level. To wear technological enhancements or devices is to advance the language of dress in specific ways that converge with the cultural dimensions of technology, and, as a result, to become "culturally seen" within a technologically literate environment.

Dress as cultural visibility within technologically transformed circumstances is an idea that also appears in the work of Walter Benjamin, who wrote in the mid-twentieth century about, among other things, the end of the nineteenth, in his Arcades project. For Benjamin, the paradigmatic social spaces of interaction were these predecessors of

our now-endangered shopping malls, and in the Parisian shopping arcades that he wrote about the ebb and flow of social types reflected modern ideas of media and fashion. One dressed in the arcades in whatever manner was available to one's status in life, and through dress one participated in the fluctuating tastes and frivolous aspirations of the moment. French social philosopher Gilles Lipovetsky, in *The Empire of Fashion*, agrees but goes further: he places dress at the level of civic behavior. In the modern era it is specifically fashion that is the essential form for democratic societies. He argues that mass-produced fashion offers nuances of choice and symbolism, which in turn enables consumers to behave as complex individuals within a consolidated, democratically educated society: "Fashion is one of the faces of modern artifice, of the effort of human beings to make themselves masters of the conditions of their own existence." This is "a modern social logic instituting a new legitimate temporality—the social present."[2] The twentieth century was an era of "consummate fashion"—a term Lipovetsky relates to a society's "ideal type" in Max Weber's work. Moreover, Lipovetsky writes that modern democracies are structured by fashion, meaning that taste in dress (among other things) is a manifestation of media and information and comprises an essential skill set for individuals.[3] In fact, the entire concept of modernism is paradoxical for Lipovetsky: representing rationality, technology, and production, on the one hand, but characterized by frivolity and desire on the other. He writes:

Consummate fashion celebrates the marriage of seduction and productive, instrumental, operational reason. What is at stake is not at all a vision of modernity that would affirm the progress of rational universality through the dialectical play of individual tendencies, but the autonomy of a society structured by fashion, where rationality functions by way of evanescence and superficiality, where objectivity is instituted as spectacle, where the dominion of technology is reconciled with play and the realm of politics is reconciled with seduction.[4]

Unlikely as it may seem, these are the very paradoxes that have been at work in the evolution of what we today call wearable technologies.

In the early 1990s, when the English version of *The Empire of Fashion* appeared, Lipovetsky added that the "logic of appearances" had begun to move from dress to the body, and the prestige involved in distinctions of dress was ebbing in favor of skin-based systems of meaning involving tattoos, bodybuilding regimens, and plastic surgery. At the same time, virtual environments began to develop, allowing users to create screen personas or avatars with customized "skins." Online or off, fashion at the level of the skin ran parallel with a trend toward "intuitive" wearable technology in that decade, and disembodiment and invisibility became common themes.

But in the everyday world of our physical embodiment, what would it mean to do without dress—is that even possible in any but the most extreme science fiction fantasy? On the other hand, if dress is central to our experience as humans, as I think it is, how wearable might our smart technologies become? Wearable computers,

e-textiles, and garments and accessories engineered with microcontrollers that perform various functions have been around only a short time yet have evolved considerably. This study undertakes a combined historical and critical view of wearable technologies—which I will refer to throughout the book (in both singular and plural form) by the shorthand WT—over more than two decades, in order to frame a perspective on what they are, where they might be going, and what is at stake. What is the real potential for wearables as performative acts of embodied sociality—dress acts—in a world where our communal spaces, the traditional context for dress, are increasingly fictionalized, virtualized, and dematerialized?

My objective is not to create a comprehensive history of all types of WT. Rather, I hope to begin a discussion about WT as a cultural phenomenon, one embedded in social behavior, communication, and display. As a result, I will focus on particular broad trends that emerge from the ocean of inventions, applications, and innovations, as well as on how these have been discussed, promoted, shown, and, to various degrees, worn. That last caveat is necessary, because wearable technology, although envisioning itself within everyday social contexts, is not at the time of this writing something that many of us have actually experienced. In fact, at the end of the 2000s, as mobile phone technologies advanced, many wondered whether or not WT was really viable, or if its promise had passed by. But the story was far from over.

Though WT's growth has been subject to fits and starts, the idea of WT has lured us on at some intuitive level, and its economic potential always seems just around the corner. Smart fabrics and interactive textiles (SFIT, in industry rubric) represented, in 2008, a global market of some $600 million, with an exponential annual growth rate.[5] In 2012 Global Industry Analysts, Inc., projected a $2.6 billion market share by 2017. These projections deal with the whole range of industrial textile applications, of which a small but growing portion are wearable. According to the GIA report:

Noteworthy innovations . . . include illuminated fashion for the consumer market [comprising] textiles containing hundreds of LEDs embroidered onto the fabric. Other innovations include smart bandages, based on stretchable circuit technology, to detect the presence of specific proteins in the wound, thereby monitoring the healing process. Smart shoe insoles detect pressure marks in diabetic patients for preventing ulcers and wounds. Respiratory sensors incorporated in baby clothes . . . help prevent crib death.[6]

It is interesting that the report lumps together medical applications for therapy and physical enhancement with technologies for personal expression and display (the so-called "consumer market"). Indeed, beyond medical and military applications, recent years have seen the unprecedented use of LED garments on red carpets and in music performances, harbingers of a broader popular dissemination of smart clothes expected to come on the heels of decades of skyrocketing innovations in smart phones and other handheld devices. With the publicity surrounding Google Glass (or Project

Glass), new expectations for a wearables revolution are once again being proclaimed.[7] This book is not about technical innovations, which amount to a moving stream of ephemeral marvels, but rather how these are historically framed and how, to use Silverman's term, they make the body culturally visible—or not. Stepping back, it is clear that digital and Internet media have transformed culture, industry, and scholarship over the last twenty-five years. However, despite the field's expanding literature, many specific areas have yet to be scrutinized, and WT is key among them.

Important to this account is the differentiation of categories of WT and their dependence upon various discourses of technology, fashion, and dress on the one hand and historical narratives in science fiction, media, and culture on the other. This study looks beyond the abstract notion of a system of symbols and language and considers how the works perform ideas within societies whose relationships with technology are in flux. In the process of bringing a diversity of ideas together with a multitude of artifacts, some omissions are required. There are several areas this study does not examine, but I hope it will encourage others to do so. Among these are issues of gender bias connected with dress and fashion as subject matter. I follow Lipovetsky and others who see the development of dress in modern times as not the same across genders, but with universal relevance, and the idea of fashion in dress being sexually marked but occurring culturewide. Regarding how technology has been combined with dress, the well-trodden issue of the masculinity of technology appears as a factor in my account of the framing of WT in the 1990s, but I leave specific feminist theoretical analysis to future scholarship.

In terms of content, this study has to be selective in order to be interpretive. It can hardly include everything, or even everything important. After the first chapter, it focuses on wearable devices and garments built on active technologies or that combine both active and passive ones. Active and passive are imprecise terms, even in electronics, but, broadly speaking, my interest is in developments of WT that feature a power source, or control electrical flow, to make something happen, where there is an active component, like a controller, and a field component, like conductive circuitry that might be thread or fabric. I also focus on WT that in some way supports or critiques dress as a social medium. This all means a reduced focus on e-textiles, and WT in military, sports, and medical applications. Although these are enormous areas for ongoing industrial research, they are not the focus of this study.

Despite the magnitude of the subject, there have been no book-length critical studies of WT. While numerous publications catalog the range of wearable technologies or provide technical support for designers, none of them considers the cultural context or the theoretical debates inherent in WT. Perhaps due to millennial fever, a spate of books appeared beginning in 2002 (most would have gone to press in 2001), all directed to audiences in the fashion industry and the academy. Unsurprisingly, the overall themes of futurism or futuristic fashion prevail. Some of those books, like

Bradley Quinn's *Techno-Fashion*, discuss an assortment of garments and technologies that emerged in the 1990s and early 2000s and feature major designers.[8] Other publications accompanied major exhibitions, like Andrew Bolton's *The Supermodern Wardrobe*, a catalog for a show at the Victoria and Albert Museum.[9] More lushly illustrated books followed in the late 2000s and early 2010s, from Suzanne Lee's *Fashioning the Future*, and Sabine Seymour's *Fashioning Technology* and *Functional Aesthetics*, through Quinn's recent *Fashion Futures*.[10] Most of the books rely on visual material and organize their lists of subjects with thematic headings that show little consistency from one publication to another, headings like "Surveillance," "Cybercouture," and "Intelligent Fashion" (Quinn), or "Interactive Interfaces," "Scientific Couture," and "Wearable Explorations" (Seymour). One serious textbook, *Smart Clothes and Wearable Technologies*, edited by Jane McCann and David Bryson, was published in 2009; it contains the same wide range of topics yet also contributes historical and practical discussions. But the book is geared toward teaching students in workshops and classrooms, not toward exploring the subject of WT as a whole.[11]

Another group of publications that appeared during the past two decades focuses on the language of e-textiles, approaching the matter both from technological and feminist viewpoints. These include one of the earliest definitive publications, one not limited to dress and fashion but covering architecture and fiber-based art as well: Sarah E. Braddock and Marie O'Mahony's *Techno-Textiles: Revolutionary Fabrics for Fashion and Design*, revised and expanded as *Techno-Textiles 2*.[12] Though its texts are short, they account for the sequence of key innovations and discoveries in the field. Bradley Quinn's *Textile Futures* also contains a wealth of information about e-textiles and their applications.[13] For the most part these books are filled with data but provide little interpretation. The same is true for O'Mahony and Braddock's *Sportstech*, which covers materials and designs for the important industrial niche of e-textiles as athletic performance attire.[14] By the late 2000s, reflecting the growing influence of DIY and its convergence with open-source media, handbooks for beginners appeared (to be discussed in chapter 5). In all, the WT literature testifies to an enormous and growing field, with designers from several generations working around the world on wearable devices strapped onto, or inserted or woven into, garments and accessories. The makers have backgrounds in science or technology, fashion, interface design, or art; or they work in teams representing diverse skills and backgrounds, since WT is multidisciplinary in the extreme. But much of this activity has gone untouched by historical and cultural examination. Perhaps the most frustrating characteristics of this landscape of WT literature are, first, a persistent editorial voice that assumes an eternal present and does not historicize its subjects. Chronology is mostly ignored, as is any sense of past and future—even dates are scattered and scarce. The situation reflects a functionalist prejudice that suggests technology always lives in the present. But dress and fashion, WT's alter egos, are markers of moments in time. The second objectionable aspect of

the literature is its consistently affirmative and advocative tone, reminiscent of marketing and journalism, and the absence of any negative remarks, or any critical perspective whatsoever.

Wearable Technologies and Critical Practice

The dearth of interpretive and critical literature on WT reflects real confusion about its very nature. Indeed, WT has become a contested ground, claimed by diverse groups from industry to art as its practices have evolved and diversified. Historically, the associations between dress and technology have always been close, but the connections became even closer and turned ideological in the modern period. As it emerged in the late 1980s and 1990s from computing labs in academic institutions across the planet, WT (or simply "wearables," in industry parlance) proceeded along several different paths. The most mainstream of these conceives of wearables in terms of display and functionality—products are worn by subjects whom intelligent systems sense and manipulate. This approach, imprinted with its origins in military research, has been advanced under rubrics like "Smart Clothes," "Responsive Clothes," "Computational Garments," and "Fashionable Technologies," but also includes "Smart Textiles" such as Yoel Fink's breakthrough piezoelectric fibers that detect and produce light and sound. While such fabrics have wonderful expressive potentials, their research and development is funded primarily for military and medical-sensor applications.[15] Wearables research takes a diagnostic approach, such as sensing and displaying wearers' emotions. Philips's Design Probes, one of that company's lifestyle research initiatives, has long explored biometric sensing and produced prototype garments such as Fractals, digital jewelry or scarf arrangements that read somatic changes and react with changing LED light configurations. Scentsory Design's therapeutic clothing both diagnoses and cures. It pioneered the use of nanotechnology and microfluidics in garments that sense body heat and other indicators of stress, and then provide aromas that affect the limbic system in the brain, our emotional center. The result is an antidepressive form of dress, which diagnoses and remedies involuntary emotional conditions. In sum, much, though certainly not all, wearables research assumes a view of the body as readable and manipulable text or data, a site of externally conditioned subjectivities.

Other applications of wearable technology subjectify the body not through diagnostic or protective initiatives but by the function of garments as spectacle. CuteCircuit's Galaxy Dress, for example, a dress designed primarily for display, would transform its wearer into a digital extravaganza; it conforms to the trend toward high-tech special effects in celebrity culture (singers and rock stars). Ultimately, whether for military, medical, or media purposes, the goal of WT research is to generate innovative marketing concepts and coordinate with invasive regimes of control societies based on the speculative reach of digitized global capitalism.

On the other hand, designers and artists have repurposed WT innovations and responded to them as systems of meaning. Their often noncommercial work (either as hypothetical prototype or outright critique) has expanded the realm of WT and developed new possibilities for expression in the context of dress. Many designers have recognized the growing importance of positioning their work as both prototype and commentary, or something in between. Yet others intentionally pursue a radical practice, creating a third, "critical" space of WT. But commentary can sometimes become lost when it is reabsorbed as technological innovation. Many designs demonstrate this. For example, CuteCircuit's award-winning Hug Shirt (2006) enhances cell phone contact by recreating senders' sensations of bodily warmth and heartbeat rate, and even transmits to its receivers the physical pressure of a hug—providing the physical dimension of contact usually lost with digital communication. However, repeated Internet publicity for the garment absorbs the larger critique of disembodiment. Rather than provoking thought, it appears as just another cool application. Simon Penny wrote about this in 1993, discussing artists working with technology.[16] He calls the phenomenon "disappearing esthetics": "Electronic commodities are consumer commodities. . . . Artists who engage these technologies also simultaneously engage in consumer commodity economics." In spite of this, two decades later artists and designers remain fascinated with technology, not just with what it can do but with what it tells us about ourselves. In any case, Penny's point applies to clothing and fashion in general, showing how difficult it is to unscrew the expressive design component from its commodification. This expressive or conceptual component is often judged elitist or is simply homeless outside the market system. The situation is amplified with WT, and there is much disparity and confusion about how works are culturally positioned and how they are to be understood. Margot Lovejoy, Christiane Paul, and Victoria Vesna have pointed out that new-media artists have been considered cultural producers and content creators, but that they must also be thought of as context providers.[17] They point to the example of literary studies. There context, once considered a subordinate or supplementary matter, has become a primary concern, and the same is true of digital technologies in which, for example, the appearance of hypertext renders the traditional distinction between text and context entirely in flux. Something like this is true of WT, which draws upon the already culturally interactive domain of dress, where garments produce context as often as they are themselves produced by external forces. Understanding the interaction of WT and its contexts, and how it makes the body "culturally visible," are tasks I hope to initiate with this study.

Wearables as Performance in the Context of Theater

An important direction that has crystallized in the past decade, which will not be a focus of this book, is that of wearables as pure performance, or the use of digital media

within specific theatrical and dance arenas, incorporating soft and sensory technologies, movement, voice, sound, and environments. An example is Michèle Danjoux and Johannes Birringer's *Telematic Dress* (2005). Developed at the Design and Performance (DAP) Lab in London, the project visually, acoustically, and sensorially connected remote dancers (in Europe, the United States, Brazil, and Japan), wearing dresses that responded, through sound and light, to their own, and each others', movements, to create a telematic "garment composition" or "open-source performance" in which dress expands to become a virtual environment.[18] Wearables in the context of performance present opportunities for exploring our relationships with our bodies and how we move them, how Arduinos (modular microcontrollers), communications interfaces, and other soft and sensory technologies allow us to experience or transcend our bodies, and how the concept of theatrical performance can be expanded in virtual space. Such work has been intelligently discussed, primarily in the context of phenomenology (especially the work of Maurice Merleau-Ponty), by authors like Johannes Birringer and Susan Kozel.

Theater-based wearables provide an unparalleled platform for experimentation in the area David Bryson has called HGI (human garment interface), a counterpart to HCI (human computer interface).[19] Unlike functional wearables, they are not market driven, and have no targeted end users in the commercial sense. But by their very nature they exist within the institutional frameworks of art genres, specifically "theater," however expanded or networked. As Di Mainstone (designer of performable wearables like the musical garment Serendiptichord) writes, "Performance is a great medium to explore reactions and spur fantasy in an encapsulated and innocent environment."[20] The characteristic performer-audience paradigm, the limitations of theater as a "special space of fantasy" (sequestered, and often commercialized, like museums), and the perception of such work as "costume," are at once opportunities and encumbrances, since theatrical wearables are cut off from everyday social interactions. But they are not cut off completely, as the distinction between theater and public reality is by no means an absolute one, and these contexts are not always discrete. So, though my story tries to focus on dress conceived within the fabric of real life—its performativity is related more to language and culture than to sensation—the imprecision of the distinction must be kept in mind.

Dress Acts

I am interested in our awareness of our garments in a highly technological, but still physical and social, daily landscape. Despite the poststructuralist tendency to subjectivize the body, Umberto Eco has noticed the power of clothes to amplify our sense of connectedness to our bodies and our ability to mirror others—our outward experiences of display. He describes the sensation of wearing a tight pair of jeans, how they

pinched and restricted his movements, creating an "epidermic self-awareness." Eco writes, "I assumed an exterior awareness of one who wears jeans . . . [my garment] obliged me to live towards the exterior world." It is his dress, in other words, not his body alone, that makes him a part of "exterior life": "in imposing an exterior demeanor, clothes are semiotic devices, machines for communication."[21]

Increasingly, given our digital environment, we depend on mobile devices for communication. WT, and especially designs that are critically or tactically conceived, comprise a pragmatics of dress as enhanced communication in the social field. Thinking of dress as articulation or enunciation has obvious precedent in linguistics, where it was first postulated by the Russian structuralist Nikolai Trubetskoy in *Grundzüge der Phonologie* (*Principles of Phonology*, 1939). Trubetskoy distinguishes dress (language) from dressing (speech), a distinction similar to the semiological principles formulated by Ferdinand de Saussure. Roland Barthes (Trubetskoy's French translator) similarly addressed the subject of garments, and it is interesting that, outside of his major work on language and myth, Barthes focused so much attention on dress and clothing in his writings. As early as 1957 he began publishing articles like "The History and Sociology of Clothing," declaring that "in fact, the whole institutional perspective on dress is missing, a gap all the more paradoxical given that dress is both a historical and a sociological subject if there ever was one."[22] Barthes introduces his ideas in a section called "The Garment System" in his well-known theory of structural linguistics, *Elements of Semiology*. But his most complete exposition on the subject is the 1967 *Système de la mode* (*The Fashion System*), and there Barthes finds he must distinguish between garment writing (magazines, etc.), garment images (photographs, etc.), and the garments themselves, of which he says, "The structure of real clothing can only be technological," because of clothes' embeddedness in industrial production (their "traces of the actions of manufacture"), and their structural fabrications (textiles, seams, zippers, etc.). Therefore, he writes, clothes "cannot exist at the level of language, for, as we know, language is not a tracing of reality."[23] So Barthes focuses his search for higher-order communicative structures—linguistic structures—in cultural systems of representation. The problem with Barthes's model, as with structuralism in general, is the obsession with a "higher-order" language from which individual wearers draw, a set of standards, just as structuralism assumes a higher-order verbal language. Sociolinguists like Valentin Volosinov and William Labov criticize this fixation on frozen structure at the expense of spoken communication. It is the kind of thinking Volosinov calls "abstract objectivism": a "preoccupation with the mathematical relation of sign to sign, or the inner logic of the sign system," which is part of a rationalist and ultimately political project.[24]

By contrast, J. L. Austin and John R. Searle, founders of speech act theory, suggest that meaning in language depends not only on the linguistic system employed, but also on the force of utterance and its relationship to space, place, and time. Speech is

action performance within a social situation. Speech acts have power and direction
called "illocutionary force."[25] I say something, "I am excited," and the desire or inten-
tion of that utterance is embedded in the moment of speaking (and the physical sensa-
tions of my body), who is hearing it, and where it is being said. Austin and Searle
define a complex typology of illocutionary acts—declarations, propositions, and per-
formative utterances—as well as rules or conventions. Thus speech act theory as a
discipline also seeks higher orders of structure, and is based in what Therese Grisham
calls "collective assemblages of enunciation . . . a whole aggregate of juridical texts,
acts, and speech acts—the law."[26] Ultimately, speech act theory commits its own errors
of abstract objectivism. It is this characteristic of speech acts that is attacked by Deleuze
and Guattari in their "Postulates of Linguistics," their critique of linguistic disciplines
in *A Thousand Plateaus*.[27] For them, linguistics freezes language unrealistically. More-
over, all language systems comprise what they call "order words" in machinic assem-
blages—they work to define us politically. But Deleuze and Guattari look beyond such
systems. They say *all* utterances are continuous variations, and they point to the
impossibility of delineating finally between types of utterances, say, between music
and speech. Not only is there no ultimate set of rules and relations, but utterances
cannot even be restricted to language, since language cannot be pinned down, and,
when it is, it reterritorializes. Language produces subjectification, but something else
is possible: in its continuous variation of variables, it also enables lines of flight.

This is the context for what I call "dress acts," which are nonetheless distinct from
speech acts. First, dress acts are hybrid forms of communication in which the behavior
of wearing is bound up with the "technological" (in the case of WT, literally so) mate-
riality of garments, accessories, and devices (Barthes's "reality"), as well as their evolv-
ing historical and linguistic associations. Moreover, dress acts refer to any act of dress,
from donning a motorcycle jacket to wearing the Galaxy Dress or dancing with the
Telematic Dress. All might be considered performative utterances—if, like Deleuze and
Guattari, we can expand the notion of "utterance"—in continuous movement and
variation. Unlike speech acts as defined by the pragmatists, dress acts are constantly
in the process of reformulation. Rather than illocutionary force, they produce an
exhibitionary force understandable in their social contexts. Dress acts are not unsys-
tematic but they are heterogeneous; they draw upon endless and diverse connections
between garments and meaning, including the vast ideas behind historical dress and
its continuous self-plagiarism, rampant revivals, and cultural references.

In focusing on dress acts, then, I am interested in works that use technology—the
enhanced actions it embeds in dress—as part of their systems of meaning, and I am
especially interested in works that deterritorialize our experiences of digitized society.
Certainly dress, like language and like other technologies, is influenced by codes and
susceptible to protocological control, though the realities of dressing often outrun
these controls. Here I reference another of Deleuze's ideas, what he terms "control

society," the formation that he says has replaced Michel Foucault's "disciplinary society," which was based upon institutional spaces like hospitals and prisons.[28] Control society's lack of enclosure, its nomadic present, is the very environment for dress acts. Dress is everywhere. It is our primary interface with our changing environments and transmits and responds to emotions, experiences, and meanings. Rather than diminishing dress's power to communicate, our contemporary technologies have added layers to dress's materialities and networking activities. We dress with our technologies now, sometimes as subjects but often as agents. More and more designers and artists utilize garments empowered with their own abilities to act or react, to reveal the moment-by-moment nature of dress and the ironies in our hybridized, digital/physical relations. Performance researcher Danielle Wilde has written about how WT has developed a "performative pre-verbal discourse": it "connects to collective desires— to go places but also sometimes to stop and pass time in a reflective activity; to engage in playful distractions, or collective dreams."[29]

Whether it is prototypical (aspiring toward altering a market context) or purely performative (ephemeral), WT works by drawing on the overages of digital culture. Wearing technology materializes time-based events in line with Paolo Virno's notion of virtuosity. As the potential for ephemeral creativity, dress already qualifies as virtuosity, a potential for virtuosity that is shared by the multitude. As Virno says, "Every utterance is a virtuosic performance."[30] Virtuosic WT uses digital technologies' potential to amplify the already perennial capabilities of dress to articulate ideas about social sectors and roles, to signal cultural/ideological positions to others in a larger community, and to evaluate the irruption of ubiquitous technologies in our lives.

For Deleuze and Guattari, the overage of signification, its excess, is usually given a negative value by the system. They warn: "Anything that threatens to put the system to flight will be killed or put to flight itself."[31] Certainly, the realm of dress that surpasses fashion or function is still homeless in our systems of commerce and technology, an unclassifiable behavior that uses signification as its launch pad. Italian philosopher Giorgio Agamben, who concerns himself with aesthetics, the philosophy of language, metaphysics, and political theory, also writes about this unrecognized overage in the embodied (and dressed), and (by extension) technologically enhanced, individual. Agamben is deeply influenced by writers like Heidegger, Benjamin, and Foucault. But in opposition to Foucault's focus on corporeal regimentation, Agamben has a more optimistic view, incorporating a concept of potential or possibility that he calls "whatever," or the "whatever singularity," which we might take as a kind of dark matter or dark energy of being, if it did not seem so much like the opposite, a kind of aura or halo.[32] Ironically, Agamben put forth his "whatever singularity" at the very moment in time when mathematician and futurist Vernor Vinge coined the term "singularity" to denote the moment when technology surpasses human intelligence.[33] It is as if Agamben seeks to reclaim the technological moment for human experience.

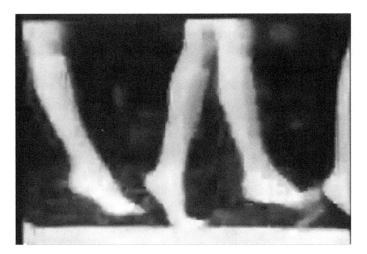

Figure 0.1
Dim Stockings. Still from 1971 advertisement.

Agamben writes about the "whatever singularity" at the outset of his 1990 book *La comunità che viene* (*The Coming Community*): "In this conception, such-and-such being is reclaimed from its having this or that property, which identifies it as belonging to this or that set, to this or that class (the reds, the French, the Muslims)—and it is reclaimed not for another class nor for the simple generic absence of any belonging, but for its being-*such*, for belonging itself. . . . The singularity exposed as such is whatever you *want*, that is, lovable."[34] Agamben goes on to explain how the lovable is based in a kind of desire that does not dissect its subject: "The lover wants the loved one *with all of its predicates*, its being such as it is." In seeing something as being-thus, Agamben means being-in-language.[35] He helps us to see ourselves within our social lives as highly complex and hybridized, but with an active potential that manifests itself in various ways. One way of being-in-language is exemplified by dress. Agamben comments on ideas about dress and fashion, and though these are not central concerns in his oeuvre, they come up often enough.

In some of his books Agamben discusses technology and media as wielding biopolitical power that renders language into bodiless speech, pure spectacle (following the concept of the "society of the spectacle" formulated by Guy Debord).[36] But sometimes more is at work. For example, meditating on an image he saw of stockinged legs in a 1971 fashion ad for Dim Stockings shown in Paris movie theaters, Agamben writes of the irony he found there, in the emergence of the modern commoditized body at that time, rendered strange through the effects of cinematic technology: "That facile trick, that calculated asymmetry of the movement of long legs sheathed in the same

inexpensive commodity, that slight disjunction between the gestures, wafted over the audience a promise of happiness unequivocally related to the human body."[37] In an odd reversal, the fantastically imaged body in the advertisement illuminated the body as if "for the first time," and gave it a strange promise, what he calls the "whatever body." He writes, "While commodification unanchors the body from its theological model [the garments of Paradise: for Agamben, Adam and Eve's gauzy robes prior to the Fall], it still preserves the resemblance." Its recognizability has an uncanny potential that exists despite industry's attempt at appropriation: "What was technologized was not the body, but its image."[38] Agamben's ideas provide an additional, useful, and certainly hopeful context for considering WT, in which dressing as technological embodiment is full of uncategorized possibilities. This is something I seek to illuminate in the following pages.

Chapter 1, "Disparate Histories," connects the ideas of dress and technology in three ways: historically; in terms of major discourses of art and culture; and in terms of mass media and media culture. Chapter 1 first discusses writers who have either traced the connection between dress and technology to its origins in language, like Gottfried Semper, or have used the connection in their own analyses of modernism and post-modernism, like Benjamin and Foucault. The discussion then traces the convergence of discourses for dress and technology to the decades surrounding World War II, from the connections between emerging technologies and textiles, and the association of dress with science and industry in the New York World's Fair and its literature, to the sartorial repercussions of the characterization of the new, technologized urbanscape, in which the promise of perfectibility was expressed through dress in science fiction, comic superheroes, popular eugenics, and fashion itself. Finally, this chapter looks at World War II-era technologies, including unrealized projects designed to enhance the bodies of soldiers and pilots, and concludes with the first wearable computer, designed to win at casino gambling.

Chapter 2, "Wearable Computing," examines the early history of WT as it emerged in research labs, particularly at MIT, in the late 1980s and 1990s, with an emphasis on the upright body, enhanced by visual and data-processing capabilities and actively embedded in its environment, a legacy of wartime investigations but also of postwar popular culture and science fiction. The result was two trends and two ideologies: ubiquitous computing, on the one hand, and, on the other, the unexpected position-ing of wearable computers within late twentieth-century futuristic fashion trends and formats such as the runway show.

The longer-range impact of ubiquitous and affective approaches to computing, and their construction of a view of the body as a passive entity in the late 1990s and 2000s, is discussed in chapter 3, "The Invisible Interface." In this dominant view, the agency of the subject who wears the technology is repressed or rendered invisible, as is the nature of the communication between subject and machine. The perfectibility of the

body via technology, touched on in chapter 1, and the conception of the body as pure information, are themes with ancient origins that have a persistent presence in the field of WT.

Also during the late 1990s and early 2000s, an opposite development occurred: the rise of interest in WT as the domain of interaction design, taught in computer design curricula. This is the subject of chapter 4, "The Material Interface," where WT is discussed in terms of the cultural dissemination of this design framework. Within it, speech act theory is applied to information technology, but WT is also postulated as a language of embodied technology, an experimental language, or (after Agamben) a language-as-such, that produces varieties of iterations and manifold meanings among designers who form their own self-sustaining communities, connect online and at conferences and workshops, and do not necessarily subscribe to a priori platforms or agendas regarding what WT must be. The work of these designers demonstrates the working-out of WT as a space of creative possibilities.

Chapter 5, "The Critical Interface," looks at a range of designers who use WT to respond to twenty-first-century criticisms about proprietary industries and technologies. Responses proceed from the merging of WT with open-source ideology and take two primary forms: on the one hand, the use of WT in a self-consciously tactical or political manner in a way that engages critically and socially responsive art; and, on the other, the proliferation of DIY electronic components and devices (digital craft) that are too often still proprietary. Chapter 5 also considers the modern background of dress as social protest and discusses wearable computing as enabling "sousveillance," the reversal of surveillance, whereby the object is positioned in digital control.

Finally, chapter 6, "Augmented Dress," describes the conflicting ideologies that persist, as wearable devices like Google Glass and programmable illuminated clothing offer new possibilities for physical enhancement and always-on connectivity, and as the wearing of technologies becomes an increasingly naturalized and, hopefully, self-aware aspect of our social behavior.

1 Disparate Histories

In 1956 the Japanese art group Gutai held its second exhibition in Tokyo and published its manifesto. At the exhibition, artist Atsuko Tanaka presented a series of changeable and electrically wired clothing pieces, culminating in her *Electric Dress* (or *Electric Clothes*), a kind of kimono made of wiring plus differently shaped and colored incandescent bulbs that flickered on and off in random patterns.[1] When Tanaka wore this techno-robe, it produced what was described as "an irregularly flashing image of clothes," projecting "a visuality of a body transforming itself in quick succession . . . a body which alters minute by minute."[2] Moreover, the dress created an emotional experience for the wearer, heightened by the perceived potential for electrocution (Tanaka: "I had a fleeting thought, is this how a death-row inmate would feel?").[3] *Electric Dress* has been interpreted against the backdrop of overwhelming changes in Japan, where everyday life became rapidly technologized after World War II and the Korean War.[4] Tanaka's garment serves as a figure for this, but it also conveys something essential about the possibilities inherent in wearing clothes, which create, as one fashion writer described it, "a hum around yourself."[5] *Electric Dress* adumbrates both the voltage and volatility of WT in daily life.

Since the 1950s Tanaka's work has taken on a life of its own as a pivotal icon, drawing together disparate realms of dress, art, and technology. The original dress was dismantled and has since been replicated and exhibited on numerous occasions, always to appreciative audiences, although never (after the original event) worn by the artist herself as performative display. Unworn, the dress became disembodied, and, as such, an even more powerful icon. A *New York* magazine reviewer of the piece in an exhibition in 2005 remarked: "Atsuko Tanaka's plugged-in dress has managed to do what most other performance art can't: maintain its power for decades."[6] It ignited a spark many still comprehend because of their own experiences of dress.

Like much Gutai "anti-art," Tanaka's *Electric Dress* had little context in the art world of its day, but its connections with burgeoning movements like light art, women's performance, and high-tech fashion would have been read into the piece, at least by some viewers, and it has since been frequently discussed in all those connections.[7] But

Figure 1.1
Atsuko Tanaka wearing the *Electric Dress* at the 2nd Gutai Art Exhibition, 1956. © Ryoji Ito. Photo © The former members of the Gutai Art Association.

in its original appearance, Tanaka performed the dress itself. It was a "dress act," in that it created a proposition (nonverbal speech) in a space between art, fashion, technology, and the body, and delivered that proposition with a certain force—not illocutionary force as a speech act, exactly, but force born of the physical body and the lived moment in time, the force of action within a living context. The result was original and transgressive, both understandable, because based on collective knowledge of preexisting systems (art, dress) and their rules, and inventive, in its articulation of new possibilities.

Nearly a half century later, in 2003, another young Japanese artist, Noriko Yamaguchi, covered herself with comparable but updated technology: not light bulbs but cell phones (*Keitai Girl*, 2003). In 2006 the artist directed a pair of similarly dressed "mobile phone girls" in Boston, their faces covered with white Butoh-style makeup, as they performed a traditional Japanese ParaPara dance to "Eurosound," and touched each other's keypads to emphasize the tactile dimension of this digital technology worn on the body. In other performances audience members called the cell phones embedded in the suits, creating a performer/audience teleconnection.[8] Yamaguchi's twenty-first-century technology-clad figure acts as a kind of homage to Tanaka's *Electric Dress*, but with imagery that speaks to a very different culture. Yamaguchi's mobile-phone girl is merged with technology at the skin. She is conceived as a mutant, related to anime like the cyborg Motoko Kusanagi in Mamoru Ishii's iconic *Ghost in the Shell* (1995). *Keitai Girl* is accompanied by a biographical anime-type story that describes her as a factory worker who fell into a "chemical tank with used cellphones."[9]

Tanaka's and Yamaguchi's performative dressing occurred within multiple contexts, providing the artists with fluid bases of signification. Both *Electric Dress* and *Keitai Girl* are strong modern figures that render concrete the idea of dressing with technology. But the clothing-technology connection is ancient and fundamental. This chapter considers the lineage of that connection and provides a historical background for the emergence of late twentieth-century research and design in the emerging field of WT.

Ancient Connections

It is a commonplace among archaeologists, anthropologists, and even historians that textiles and garments (and the construction of these) exist alongside other technologies that drive cultural change in all periods.[10] Among the standards by which civilization is measured is the development of weaving in the Neolithic period, but the woven cloth had to be structured and fastened to cover the human body, and shaped garments, engineered from fur or skins, almost certainly existed even earlier, from the Upper Paleolithic period, though they have left few traces. Early ground looms appeared

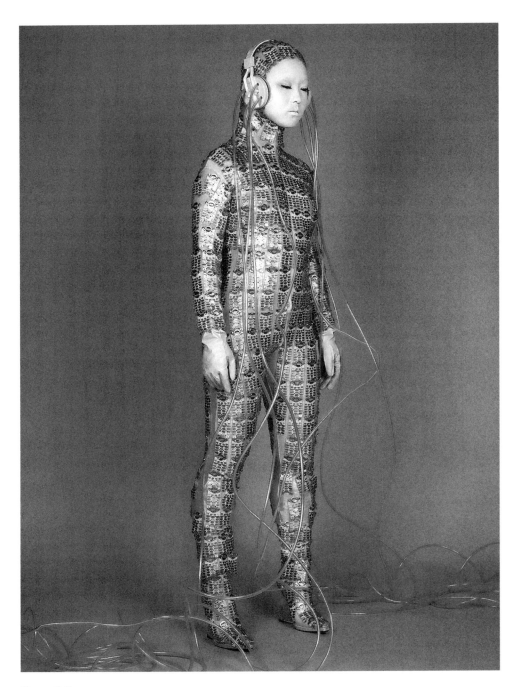

Figure 1.2
Noriko Yamaguchi, *Keitai Girl*, 2003. Courtesy of the artist.

in the Late Neolithic period (4th millennium BCE) in Egypt, with more advanced looms appearing throughout Europe, South Asia, and South America by the Late Bronze Age.[11] Textiles, clothing, and armor production were milestones that advanced early civilizations. The development of textiles, in particular, gave rise to sometimes elaborate systems of preindustrial factories, with rudimentary divisions of labor (obtaining fiber, spinning, and weaving, often as piecework) dominated mostly by women, often in business for themselves. There is also evidence of prehistoric demand for textiles that distinguished between types of fabric based on taste or style.[12]

The nineteenth-century German philologist Ernst Kapp, who first used the term "philosophy of technology," advanced a theory that the origins of all technological inventions can be found in the organs of the human body. In his *Philosophie der Technik* (1877), Kapp proposed a line of thinking that Carl Mitcham has called the "engineering philosophy of technology," "which emphasizes analyzing the internal structure or nature of technology." Kapp expanded that understanding to explain nearly every form of material culture. "The engineering philosophy of technology" is opposed to the tradition of the "humanities philosophy of technology" (personified by Lewis Mumford, José Ortega y Gasset, and Martin Heidegger), which is more concerned with the relationships between technology and other things, and with the meaning of technology.[13] Both perspectives are represented in the history of WT as described in the pages ahead. The "engineering philosophy" school of thought that was embedded in the developments in the late 1990s in areas of industrial innovation continues today, while the humanities variant of the philosophy of technology became much more apparent in the 2000s, as designers moved into the wearables field, a development described in chapters 4 and 5.

Philosophie der Technik, Kapp's organ-origins theory of technology ("die organprojection"), is based on our drive for what might be called prosthetic enhancement. It views technologies as tools categorized according to the part of the body that requires them: "The bent finger becomes a hook, the hollow of the hand a bowl; in the sword, spear, oar, shovel, rake, plow, and spade one observes sundry positions of arm, hand, and fingers, the adaptation of which to hunting, fishing, gardening, and field tools is readily apparent."[14] According to Kapp, dress is also a technology, and, like architecture, it is projected from the entire human body, and ultimately from the mind or unconscious, in a process of increasing our evolutionary self-consciousness.[15] It is a short step from Kapp's ideas to the modern one that WT is an enhancement of both our bodies and our minds.

Historically clothing has been considered the technology that interfaces most intimately with the body, a condition that can also apply to some wearable devices. An example is eyeglasses, which extended human vision due to advances in lens grinding that occurred in the 1200s. Steve Mann, one of MIT's so-called "cyborgs" in the 1990s, and now professor at the University of Toronto, writes:

There are those who argue that wearable computing has been around since the beginning
of time, whether in the form of the wristwatch (which computes time) or eyeglasses (which
mediate visual perception of reality with optical computing, no less!). Is a slide rule or a pocket
calculator a wearable computer? After all, they perform computations, and can be worn in a shirt
pocket. . . . Even before the important terminology of cybernetics and cyborgs was established,
work was being done on portable technologies, some of which we might loosely define as wear-
able computers. Of course, all this simply underscores the difficulty of exploring the history of
the development of the wearable computer.[16]

Mann's statement raises the question of technologies that are wearable versus portable,
as with portable (personal) computers, a distinction we will return to.

Textile technologies drove the industrial revolution. In the early eighteenth century,
textile industry inventions, such as the programmable mechanical loom developed by
Basile Bouchon, Jacques de Vaucanson, and Joseph-Marie Jacquard, are today consid-
ered progenitors of the development of computer technologies and have become part
of their mythos. As a record of change and material advancement, textiles and dress
are intrinsically bound up with technological invention: the prehistoric appearance of
the sewing needle in Russia and Slovenia as early as thirty thousand years ago to seam
together furs or hides for better body covering, the invention of the sewing machine
in the mid-nineteenth century, the response among clothing designers, in the mid-
twentieth, to advances in chemistry that yielded new materials like nylon and poly-
ester. But the importance of garment-related behavior among humans in pre- or
non-Western cultures has often been limited to pure archaeological or anthropological
contexts, disciplines marked early by imperialist expansionism, that traditionally sub-
jectify their objects of study. As fashion historian Elizabeth Wilson has pointed out, a
succession of prominent twentieth-century writers, including Thorstein Veblen and
Jean Baudrillard, have argued for a dismissal of dress as significant cultural knowl-
edge—even Roland Barthes, who applied his semiological system to fashion, assumed
that, like all signifiers, dress is irrational and fashion is devoted to "naturalizing the
arbitrary."[17]

All these writers grounded their disdain for dress, and the fashion of their own day
in particular, partly in the latter's seemingly random and fluctuating nature. But the
notion of dress as process has received some constructive attention. Cultural historians
have noted that the invention of mechanical time in the form of the clock promoted
a society increasingly preoccupied with change and mutability. The proliferation of
clocks coincides with the emergence of the concept of fashion, something more sig-
nificant than dress, a phenomenon tied to the notion of perpetual change, a corollary
of time itself. Gilles Lipovetsky dates this transformation of dress in Europe to the
mid-fourteenth century and to particular changes in society: "Change was no longer
an accidental, rare, fortuitous phenomenon; it became a fixed law of the pleasures of
high society. Henceforth the transitory would come to function as one of the

constitutive structures of modern life."[18] That structure is fashion in its broadest sense, as the term refers to a characteristic of society as a whole, and at the same time an attitude toward dress in particular, an attitude that has dominated Western and Westernized cultures since the beginning of the modern period and is generated by an ongoing dialectic between garments, temporal structures, and production.

Gottfried Semper: Dressing as Foundational Technology

In the chapter entitled "Explaining It Away" in her book *Adorned in Dreams: Fashion and Modernity*, Wilson writes: "The serious study of fashion has traditionally been a branch of art history."[19] As a result, its limited role in the canonical hierarchy has been determined by art history's conservative ideologies. Critical literature in the field of fashion studies has broadened considerably since Wilson wrote that in 2003. Still, the assessment of dress as elided by art history remains at odds with the status of dress and textiles in certain foundational writings of the discipline that address the evolution of making and building things as both technologies and systems of articulation. Gottfried Semper (1803–1879) was a German architect and art historian who contributed to early debates about style in his *Der Stil in den technischen Künsten; oder praktischer Äesthetik* (*Style in the Technical Arts; or Practical Aesthetics*), published in 1878–1879. Semper's account of the origins of architecture is based historically on textiles, or "decoration." Semper elaborates this as his "Principle of Dressing" (*Bekleidung*), in which, contrary to the structural basis of prior architectural theory, the notion of clothing, even of the veil or mask, is put forward as the proper basis for understanding architectural development. He devotes one of the two volumes of *Der Stil* entirely to the history of textiles, explaining that the hanging of weavings or cloth preceded the building of walls, and these cloths, or "dressing" (a word applied to both architecture and the body), led to the conceptualization of space: "*The beginning of building coincides with the beginning of textiles. The wall is the architectural element that formally represents and makes visible enclosed space as such.*"[20] Architecture as dressing, then—as "decoration"—is akin to clothing. As Mark Wigley puts it, "Buildings are worn rather than simply occupied."[21] Likewise it is dressing that creates social relations through the production of specifically social spaces.

Furthermore, for Semper, culture is not simply based on material developments but is also driven by an urge to deny reality, and this urge is grounded in the compulsion to symbolize inherent in dressing: "I think that the *dressing* and the *mask* are as old as human civilization . . . every artistic creation, every artistic pleasure presupposes a certain carnival spirit, or to express it in a modern way—the haze of carnival candles is the true atmosphere of art. The denial of reality, of the material, is necessary if form is to emerge as a meaningful symbol, as an autonomous human creation."[22] Though Semper uses the term *Bekleidung* in the wider sense of covering or cladding (bodies or

buildings) for his principle of decoration as a veil or mask (we might say "outfit" or "look" today), the emphasis is the same: decoration, not function. This idea of the mask is also for Semper a reference to early Greek drama; in a similar manner, bodies and buildings can use the veil or mask theatrically, a principle "according to which the viewing of a work of art makes one forget the means and the material with which and by which it exists."[23]

Despite Semper's emphasis on the symbolic basis of art and architecture, he was associated by some of his followers with the opposite approach, the technical-materialist perspective. That association was criticized by Austrian art historian Alois Riegl, who wrote the first history of ornament, *Stilfragen: Grundlegungen zu einer Geschichte der Ornamentik* (*Problems of Style: Foundations for a History of Ornament*, 1893), in which Semper's textile-based origins of early ornament are nonetheless upheld, if not given center stage. Wigley has argued that Riegl, who had served as curator of textiles at the Vienna Museum of Art and Industry, tried to diminish Semper's argument but in fact only displaced it—it winds up persisting and infiltrating much of the discourse of later modern architecture.[24] In a roundabout way, these foundational treatises for the discipline of art history influenced both the materialist-technical theory of historical development (basing part of the idea of form on technical advancements like building materials or textiles), and the somewhat opposite thesis that form is above all decorative and symbolic. Oddly, this fundamental art historical debate never found its way into histories of dress.

Walter Benjamin: Dress and Death

Among the most well-worn views of modernity, exhaustively discussed in existing literature, are ones that place fashion at the center. Charles Baudelaire, Marcel Proust, and Georg Simmel all established the prominence of fashion in an unfolding discourse of modernity and stressed the importance of what Ulrich Lehmann calls fashion's "ephemeral, transient, and futile character, which changes with every season."[25] Of Walter Benjamin, Lehmann remarks: "[He] went one step beyond Simmel. Once fashion's rationale had been explained, its political potential had to be explored. In the tiger's leap [*Tigersprung*], Benjamin applied that rationale, taking it in the obvious direction."[26]

Benjamin was fascinated with the redevelopment of Paris following the citywide modernization undertaken by civic planner Georges-Eugène Haussmann, particularly the emergence of the arcades. These were covered urban spaces of iron and glass, triumphs of the industrial technology of their day and progenitors of twentieth-century shopping malls. They reshaped the process of buying goods, leaving behind earlier personal exchanges with craftsmen to embrace an orchestrated leisure experience, in which the visitor was immersed in shop windows' scenic tableaus and imaginative

advertising. "The first condition for [the arcades'] development is the boom in the textile trade," Benjamin wrote in notes for his Arcades project, which spanned the last thirteen years of his life.[27] The modern concept of fashion, itself newly industrialized by that same trade, became an object of fascination for Benjamin, who sensed in the Parisian arcades a dissociation of time and place similar to that which he witnessed in the surrealists' work in his own day. Benjamin quotes a surrealist comment (attributed to Apollinaire): "Any material from nature's domain can now be introduced into the composition of women's clothes. I saw a charming dress made of corks. . . . Steel, wool, sandstone and files have suddenly entered the vestimentary arts. . . . They're doing shoes in Venetian glass and hats in Baccarat crystal."[28] Susan Buck-Morss describes Benjamin's enthusiasm for surrealism's "radical concept of freedom" and "profane illumination" of the material world, at a time when other Marxists in France were critical of the avant-garde.[29]

Benjamin caricatured fashion's incessant change and obsession with time as a deal with the devil. Fashion was dress elevated to a frenzied morbidity: "For fashion was never anything other than the parody of the motley cadaver, the provocation of death through the woman, and bitter colloquy with decay whispered between loud bursts of mechanical jubilation. This is why fashion changes so quickly: she titillates death and is already something new, as he casts about to crush her."[30]

Fashion for Benjamin was the social force of the arcades, in constant motion, representing new models and new velocities, fueled by a machinic eroticism. "Every fashion stands in opposition to the organic," he writes. "Every fashion couples the living body to the inorganic world. To the living, fashion defends the rights of the corpse. The fetishism that succumbs to the sex appeal of the inorganic is its vital nerve."[31] Benjamin knew—was he inspired by?—the female robot in Fritz Lang's *Metropolis* (1927), a mechanized corpse, in effect, and a matriarch of later operative, perhaps wished-for cyberbodies that seductively integrate metal and flesh. Buck-Morss even suggests that Benjamin, who thought that knowledge in the historical sense was dead, or at least not politically advantageous for the struggling classes, wondered if fashion might provide a new metaphor for philosophy itself, a "metaphysics of transiency."[32]

If, according to Benjamin, technology enables the capitalism that flourishes in the arcades, then technology itself is fashion. Benjamin's understanding of it is easily brought to bear on later writings concerning futuristic fashion and even on WT as it developed in labs, from the early fashion-conscious designs of the 1990s through the new millennium. In 2002 Andrew Bolton curated "The Supermodern Wardrobe" exhibition at the Victoria and Albert Museum, a combination of futurist fashion, WT, and wearable art. Bolton opens the show's impressive catalog with Andrew Gurskey's well-known 1992 photograph of the network of tubular escalators in Charles de Gaulle airport in Paris, a latter-day version of Benjamin's arcades, an image that supports the

theme of transiency. Bolton claims that "supermodern clothing is defined by the contemporary urban metropolis," and "the physical and psychological demands of transitional spaces such as roads, railways, airports and the street."[33] Bolton's idea of transitional spaces references Benjamin but also Marc Augé's concept of "non-places," transient loci of nonattachment occupied not by a "public," but by a "regulated flow." Bolton's thesis is that non-places (and our existence in a flow) make up a greater and greater part of contemporary life and require behavior (including dress) that "anticipates all contingencies."[34]

Fashion or Dress

In the wake of Benjamin's metaphysics of fashion, numerous historians have contradicted reductivist assumptions that fashion equals "change." Radu Stern writes, "It is Procrustean to define fashion as simply any type of change in dress style. . . . [It is the] offspring of emerging European capitalism, from which it cannot be separated."[35] Stern also recognizes, just as Benjamin did, the prejudice against fashion by the intellectual left, and the perpetuation of that bias by writers like Thorstein Veblen and Pierre Bourdieu. Gilles Lipovetsky puts it bluntly: "The question of fashion is not a fashionable one among intellectuals."[36] On the contrary, and like Benjamin, Theodor Adorno asserts fashion's value in his *Aesthetic Theory*:

The usual tirades against fashion that equate the fugitive and the futile are not only allied with the ideology of inwardness and interiority, which has long been exposed politically and aesthetically as an inability to externalize something and as a narrow-minded concern with the thusness of the individual. Despite its commercial manipulation fashion reaches deep into works of art, not simply exploiting them. . . . Fashion is one of the ways in which historical change affects the sensory apparatus and through it works of art—in minimal traits, often hidden from themselves.[37]

While fashion is implicitly entangled with both modernity and, by extension, technology, it is impossible to entirely disentangle fashion from the broader phenomena of dress, which fashion draws upon in myriad ways. The idea of fashion as a cultural construction with no material separation from dress is discussed by fashion theorist Joanne Entwistle. She determines the distinction as ultimately an academic one: fashion, a subject often treated by cultural historians, supposes an abstract system. "You're either in, or you're out," admonishes Heidi Klum on a typical episode of *Project Runway*. But in the academy dress study falls into the traditional domain of anthropology. It is interpreted as human behavior, usually the behavior of non-Western cultures.[38] Writers like Ted Polhemus and Dick Hebdige have contradicted these frozen genres by looking at particular aspects of urban dress in the contemporary period, and historians like Nancy Troy and Lipovetsky, following Benjamin, have

shown that fashion is a historical phenomenon specific to a particular moment in capitalism. If fashion is the dress of an era with particular socioeconomic characteristics, we may yet see a different phenomenon evolve in the future, as these characteristics change.

The idea that I want to emphasize is that, not only has dress always been a technology contributing to the advance of civilizations, but fashion—the particular construction of modern European society—too is a technology, a technology of social transformation, an idea we find in Benjamin. Michel Foucault, who says nothing about fashion, says a great deal about discourses of power and their grip on the body. In *Discipline and Punish*, for example, he describes how the organization of space in prisons and the visual regime of surveillance are marshaled to manage and control inmate populations.[39] Foucault treats social power in itself as a technology (or "technique," a word he uses interchangeably with "technology" in the essay "Les Mailles de pouvoir" [The Meshes of Power]), and connects the advances of technological power (through scientific inventions and industry) in the seventeenth and eighteenth centuries with advances in political technology, including "biopower," the training of subjects: "The discovery of population is, alongside the discovery of the individual and the body amenable to dressage (*dressable*), the other great technological core around which the political procedures of the West transformed themselves."[40] In *The History of Sexuality* Foucault defines biopower as "what brought life and its mechanisms into the realm of explicit calculations and made knowledge-power an agent of transformation of human life," requiring "individual disciplines and constraints" (*dressages*).[41] Interestingly, the French "dressage" and English "dress" both stem from the Latin root, *directus* (n.) or *dirigere* (v.), meaning to arrange, direct, or demarcate. In his discussion of biopower, Foucault only discusses disciplinary, medical, psychoanalytical, and sexual constraints, but it has been noted by Entwistle and others that Foucault's notion of biopower enables "the analysis of fashion as a discursive domain which sets significant parameters around the body and its presentation," including parameters set by systems of power that function to support wealth, class divisions, and boundaries of sexual difference.[42] This view of dress as a political or commercial regime that regulates the covering of the body has contributed to the negative view of fashion within academic scholarship.

Following Foucault, Judith Butler describes a genealogy of gender whereby a subject is constructed through a performance of cultural signs. The subject's interiority is fabricated: "There need not be a 'doer behind the deed,' but . . . the 'doer' is variably constructed in and through the deed."[43] Identity becomes a negotiation with a regulatory ideal that takes place as enacted fantasy produced "*on the surface of the body.*"[44] In such a negotiation, dress comprises one important and culturally complex set of terms and—when performed on the body—technology comprises another. Moreover these terms have broad cultural associations as normatives: dress is a

female allegiance, while technology is sign of masculinity. As such, Butler's notions of masquerade and drag, as ways of unveiling the superficial codes by which falsely naturalized and unified identities (specifically sexual identities) are upheld, are particularly useful for considering the transgressive convergence of dress and technology that WT frequently either presents or parodies. In Tanaka's *Electric Dress*, for example, the exposure of circuitry upends the idea of women's dress as a tacit exposure of their sexuality; moreover, the danger of the electrical wiring itself threatens normativity. Gender considerations are a part of my discussion of technology as dress acts; however, the broader implications of these terms for a theory of gender and technology is beyond the scope of this book. The point I wish to make here is that there is a distinction between the use of technology on the body as a cultural dress or mask (going back to Semper's ideas of the origins of dress), on the one hand, or as pure body enhancement in a strictly functionalist view, on the other, admitting that both ideas are often present as forms of WT develop.

The Future in the Past

If dress is a type of technology in its essence, a technology put to work not only to clothe but to support political agendas, and if fashion is the political dress of democratic people under capitalist industrialism (following Lipovetsky), it is hardly surprising that the urge to explore technology in the context of dress has a long history in the modernist era.

The eighteenth century's interest in time no doubt drove the appearance of one of the earliest wearable technologies: the wristwatch (as opposed to the type of clock that was carried in pockets or on chains, which appeared earlier). Although its history is somewhat murky, the earliest wristwatch may have been created by the Swiss firm Jacquet-Droz and Leschet in 1790, though examples may have appeared somewhat earlier. But for their first hundred years wristwatches, called "wristlets," were almost exclusively women's accessories (an early example of technology's association of femininity with the body that is also characteristic of modernism).[45] At the beginning of the industrial age it became important for women, who did not have pockets for watches but were expanding their public lives, to know the time. Men's wristwatches appeared only in the late nineteenth century, as military devices. Whether male or female, these wearable pieces situated the body within the flow of temporal existence.

There was a flutter of interest in adapting the new technology of electricity to jewelry presented at industrial expositions, beginning with the International Exposition of 1867 in Paris, when ladies brooches and men's cravat pins were given moving parts powered by tiny batteries. A hummingbird brooch with movable wings was reportedly owned by Princess Pauline Metternich. Despite reviewers' disdain for the

novelties, they were popular attractions when on display at the 1867 exposition.[46] After the invention of incandescent lamps with carbon filaments in the 1870s, the French doctor and watchmaker Gustave Trouvé produced and publicized a line of electronic jewels and jewelry with tiny four-volt bulbs, notably hairpins in the form of crescents or stars, as well as earrings, rings, bracelets and brooches with large illuminating stones to attract admirers, or even light the wearer's way. Trouvé's electrically lit pieces were successfully adapted to theatrical performances in the 1880s.

The Italian futurists speculated about combining new technologies with clothing designs before and after World War I. In his 1914 "Male Futurist Dress" manifesto, Giacomo Balla wrote that he found the traditional dark sartorial garments inherited from the nineteenth-century dandy to be depressing. In his own designs, he suggested that men wear dynamic, variable suits with "modifiers": attached shapes that varied the forms of the garment and sometimes added scent.[47] In another manifesto "transformable clothes" were even suggested to include "mechanical trimmings, surprises, tricks, even the disappearance of individuals."[48] These imagined devices were to allow wearers to gain control over the rigidity of commercial garments and become more interactive or "open." Balla advocated that clothing be "light giving." He speculated about phosphorescent cloth and supposedly devised a celluloid tie with a battery and electric bulb.[49] Balla also wrote about the way that dress—and especially unconventional dress—would influence the wearer by preparing him for conflict, for example, or making him more joyful.[50] By 1920 other artists addressed the idea of futurist dress for women. Vincenzo Fani (who called himself Volt) published the "Futurist Manifesto of Women's Fashion," advocating the principles of genius, audacity, and economy. As for audacity, he evoked fantastic images like the "machine gun woman," the "radiotelegraph antenna woman," and the "motorboat woman," and garments that were noisy, deadly, or explosive, outfitted with springs, stingers, photographic lenses, electric currents, reflectors, and fireworks. Regarding economy, Volt rejected traditionally costly fabrics, such as silk, in favor of dress made of materials at hand, like glass, tinfoil, aluminum, rubber, gas, and even living animals.[51] None of this was executed, of course, or even reached professional designers, except in one instance: the Parisian couturier Madeleine Vionnet used futurist artist Ernesto Thayaht as illustrator for her 1922 collection. This was devoid of "audacious" devices or materials but dependent on line, bias cuts, and movement depicted with the cubo-futurist "fields of force" in Thayaht's renderings, which appeared in the leading fashion magazine *Gazette de Bon Ton*.[52]

In "The Futurist Re-Fashioning of the Universe," Cinzia Saratini Blum suggests that the futurists were strongly influenced by theories of pragmatism and self-empowerment, including Nietzsche's notion of the *Übermensch* (the futurist *superuomo*), as well as by the Italian "magical" pragmatism of Giovanni Papini, who wrote of "a collection of methods for expanding man's power."[53] One such method celebrated the

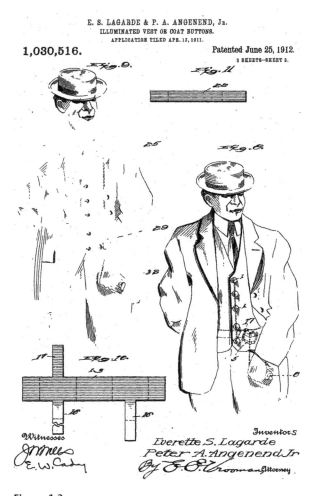

Figure 1.3
E. S. Lagarde and P. A. Angenend Jr., Illuminated Vest or Coat Buttons, U.S. Patent 1,030,516, filed April 13, 1911.

masculinist "myth of a regenerating union between man and machine," evidenced in the heroic symbiosis of human bodies with automobiles and trains in futurist art and literature.[54] Blum notes that Papini and the futurists embraced a utopian notion of human power paradoxically based both on technological ideals and on primitive forces, which Norbert Elias describes as the "dialectic of expansion and contraction of bodies and the world."[55] Deleuze and Guattari likewise identify this paradox as the double movement of progress: "the social axiomatic of modern societies," which are torn in two directions: "archaism and futurism."[56] These two directions are clearly discernible in the development of morphologies and typologies for WT in succeeding decades.

The same enthusiasms that drove the futurists may have reached some followers in the United States. One can find patents for early twentieth-century wearables that smack of avant-garde speculations, like E. S. Lagarde and P. A. Angenend Jr.'s Illuminated Vest or Coat Buttons, filed in 1911, which the creators described as a "portable electric light apparatus [that] has special reference to that class of devices which constitute electrical novelties" and may have been inspired by Trouvé's work or his reputation.[57] The lights were controlled by a button concealed beneath the clothing so that they could be turned on or off at will, and they were powered by a battery in an interior pocket.[58] Clearly Lagarde and Angenend envisioned a market for garments with electronic display capabilities, and they may not have been alone. On a more functional note, a patent was filed in 1925 for an "electrically heated garment," a prototype for overalls for pilots or truck drivers.[59] In this case the wiring that heated the garment was integrated with the garment itself, a one-piece suit with connecting gloves, which targeted body parts normally exposed to weather while still allowing "action of the wearer." Interestingly, these two examples represent the divergent schools of WT: cultural mask and technical function. Legarde and Angenend's illuminated vest-button "novelties" reflect the former, while the heated overalls represent the idea of pure physical enhancement.

By the 1930s, rapid changes in clothing began to take place due to a variety of influences, the most important of which were advances in textile technologies. While a few artificial fibers like rayon emerged in the late nineteenth century, it was not until the twentieth century that the potential applications for industrially produced textiles were realized: they were cheaper, they imitated more-expensive fabrics, and they served emerging markets in sports and other activities.[60]

Aligned with progress, fashion was reframed within the masculine world of technology. This was epitomized in 1939 with the presentation of new fibers at the New York World's Fair, especially the unveiling of nylon stockings. Nylon fiber was developed by Wallace Carothers, Julian Hill, and other researchers and used for fishing line and toothbrushes. But at the fair nylon was presented as a material for stockings at the Wonder World of Chemistry pavilion, built for E. I. du Pont de Nemours &

Company. The pavilion featured a 105-foot tower that suggested a fantastic, giant chemical apparatus, lit at night so that it would evoke the bubbling of liquids in a giant laboratory. Inside, it brashly resembled a chemical plant.[61] But the humanization of technology as a market strategy was accomplished by connecting chemistry and fashion. DuPont appointed a Miss Chemistry, who appeared in a nylon lace evening gown, a "costume of tomorrow," since nothing like it was commercially available.[62] There were also demonstrations by smartly dressed models putting hosiery to various tests. DuPont even decided not to patent the word "nylons" in hopes that it would replace the word "stockings" in common parlance. But DuPont never mass produced stockings, and when the United States entered World War II in 1941, nylon was taken off the market, being targeted for use in parachutes, tents, and other essential military gear.

The 1939 New York World's Fair itself was wholly futuristic, a landmark of American art deco and industrial design. It promoted mottos like "The World of Tomorrow" and "Dawn of a New Day," exhibits like Futurama and Westinghouse's Elektro robot, and was filled with empyrean urban vistas like the giant model Democracity. The fair has also been viewed as an embodiment of fascist modernism in its accomplishment of what Walter Benjamin described as the aestheticization of politics. It presented mass exhibition as a kind of redemptive myth, engendering participatory enthusiasm and ultimately an enhanced sense of collective vision, one that threw off the historical paradigm of progress discredited by the recent Great Depression and focused on a future fantasy of democracy driven by technology.[63]

Vogue magazine devoted nearly an entire issue to the fair, centered on commissioned designs for futuristic fashion. The editors explained that it could not consult fashion designers, who "live too much in the present." Instead the magazine invited several major industrial designers of the fair's exhibitions to contribute *Vogue*'s "Fashions of the Future."[64] That feature represented an incursion into the magazine's normal business of high style; its pages otherwise almost never addressed technology during that period. The mass utopian vision also contradicted *Vogue*'s normally class-oriented offerings. Industrial design and fashion design were hardly reconciled in this series of spreads, in which models posed uniformly and unrealistically within abstracted contexts, their eyes trained up and outward in distracted gazes.

Interestingly, the emphasis of the feature was not solely on material but also on genetic technologies—bodies of the future were abstracted as well. One of the editorials in the issue speculated, "To-morrow's American Woman may be the result of formulae—the tilt of her eyes, the curve of her chin, the shade of her hair ordered like crackers from the grocer. She may be gentle, sympathetic, understanding—because of a determinable combination of genes."[65] Indeed, the fair's scientific progressivism incorporated some radical biosocial theories, notably eugenics, a subject of great worldwide interest in the 1920s and 1930s. In 1922 Harry Laughlin, a chief promoter of the

field, published *Eugenical Sterilization in the United States*. It helped create a basis for the U.S. Immigration Act of 1924, which set quotas for the number of East Asians, South Asians, and Southern and Eastern Europeans entering the country. Laughlin's document was used as the basis for numerous state laws enabling the forced sterilization of persons with "degenerate or defective hereditary qualities . . . potential parents of socially inadequate offspring."[66] Although the laws were frequently challenged on constitutional grounds and often abandoned, many states forcibly sterilized individuals under eugenics legislation even as late as the 1960s.

In 1930 John Carl Flügel wrote a text, long considered classic, called *The Psychology of Clothes*, from a eugenics point of view. The book argued that dress was a primary area of dispute between the id (equated with the desire from childhood to exhibit one's naked body) and the superego (resulting in the social prohibition of nudity for the sake of modesty), a conflict that he associated with authoritative and repressive societies. He was a social evolutionist, proposing that eventually society would outgrow authoritarian politics and the need for arbitrary rules regarding clothing. He envisioned that we would be able to control our environment so that clothes would either be unnecessary or be reduced to minimalist, rationalized versions.[67]

After World War II the idea of eugenics soured because of its connection with Nazi racial cleansing, but as Susan Currell writes, "Eugenics was a continuing presence in the public psyche" in the 1930s.[68] In 1939 the language of eugenics permeated the New York World's Fair (as it had Chicago's Century of Progress Exposition of 1933–1934). In the *Vogue* spread, the garments of the future were envisioned on bodies improved through eugenics, something noted by most of the *Vogue* feature designers. Christina Cogdell has explored the popularity of eugenics-based ideas among American industrial designers during the 1930s and revealed their obsession with health and fitness, even their application of streamlining concepts to human physical efficiency.[69] The *Vogue* feature bore this out. One engineer among the designers, William Sakier, wrote: "The woman of the future will be tall, slim and lovely; she will be bred to it—for the delectation of the community and her own happiness. She will move in a world of vast horizons."[70] Likewise, Walter Dorwin Teague (a designer of the DuPont pavilion) wrote that, in the future, "Most women will have beautiful bodies. . . . [G]owns will be designed to reveal the beauty of their bodies and will afford only the minimum of covering. . . . [M]aterials will be of chemical origin, and many will be either transparent or translucent, with an individual life of their own."[71]

The designs themselves, or at least the designers' explanations of them, artfully conjoined perfectibility with American notions of freedom, and they were not totally confined to women's fashions. One of the nine designers chosen by *Vogue* (all male), Gilbert Rhode, dressed his version of the "man of the future," representing a "revolt" from woolen suits and "a lifetime spent buttoning and lacing, . . . the ritual of fitting;

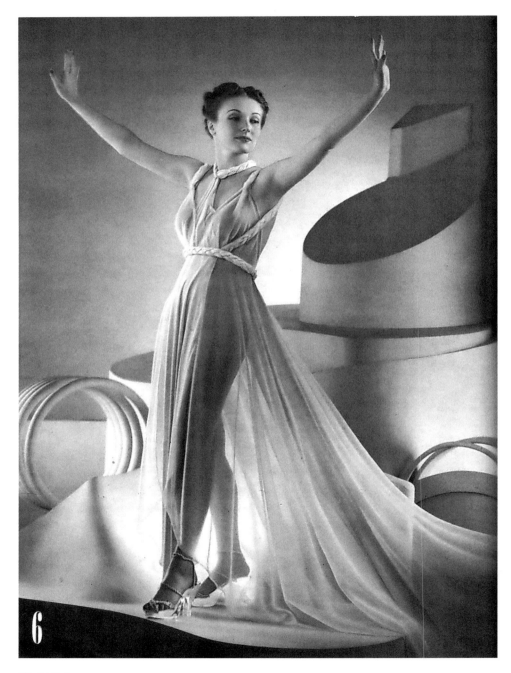

Figure 1.4
Walter Dorwin Teague, Nearly Nude Evening Dress, *Vogue*, 1939.

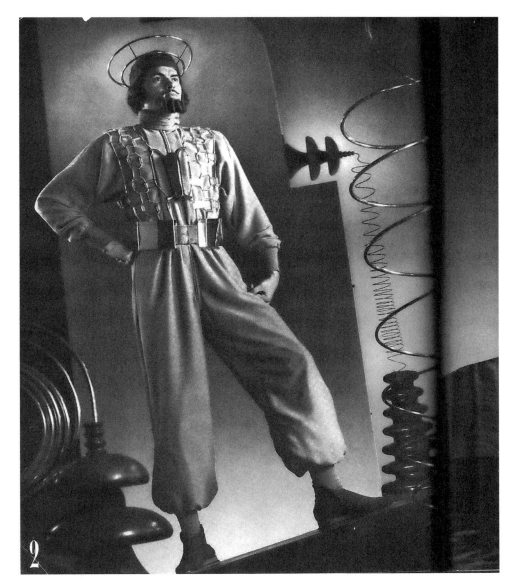

Figure 1.5
Gilbert Rhode, Man of the Future, *Vogue*, 1939. Vassar/Vogue; © Condé Nast.

. . . the futility of pressing knife-like edges." Instead Rhode's garment, called the "Solo-suit," was a loose-fitting jumpsuit woven of beryllium thread, a suit so simple in design that Rhode speculated it could be cheaply manufactured and bought in any drugstore. Atop the overalls Rhode added a "Plastivest"—a vest made of pieces of Plexiglas and chrome-plated ball-chain with wires to accommodate some sort of two-way telephone, worn on the body, presumably working in concert with the military-style utility belt and "Antenna hat" on the man's head (which looks rather like a halo). In fact, with his curly beard ("shaving the face has disappeared" he wrote), Rhode's man of the future looks exactly like a traditional Christ figure dressed in Flash Gordon attire—a holy saint of technology.[72]

Of the eight other designers featured in the February 1939 *Vogue* (entitled the "Americana Number"), most designed understandable futuristic dresses and coats incorporating new materials and technologies. George B. Platt designed a simple, electrically heated coat, "woven with a fine wire that carries heat, generated by con-densed batteries" housed in the coat's generous pockets.[73] Russel Wright created a demure but broad-shouldered coat of gilded aluminum foil developed into a fabric ("untarnishable, waterproof, insulating"). The coat was worn over a wrinkle-free gown of viscose fibers and accessorized with a gem-cut "flashlight" hair ornament that could be electrically lighted. In fact, most of the designers embedded new func-tionality in clothes that hardly merited it, like Egmont Arens's wedding gown of spun-glass fibers, which, he said, would be "practically everlasting."[74] But some of the design details, like Wright's conductive fabrics and Rhode's mobile communica-tions device, adumbrated technological ideas that would reemerge and evolve after World War II.

Machinic Bodies

It was during World War II that sense-enhancing technologies became a focus of mili-tary research in an effort to extend the physical capabilities of the soldier. Most physical-enhancement research during the 1940s and 1950s was devoted to "heads-up displays" (HUDs) and, to a lesser extent, hands-free devices, which expanded the soldier's senses and abilities while in the field. These developments were necessitated by the increasing complexity of war technology and were designed to launch the soldier beyond his body, echoing the calls of the futurists who saw embodiment as an encumbrance that needed to be overcome in order to empower an individual's vital force.

Cockpit HUDs were developed for military aircraft personnel. They were not strictly wearable but were anatomically fitted so that a flier, without moving from his front-facing position, could receive information from a drop-down or fixed display overlaid on his view window. The progenitor of this miniature instrument panel, displayed in

the sightline of the operator, was the reflective gun sight technology developed by Sir Howard Grubb around 1900, but which did not come into wide use until after World War I. The more advanced gyroscopic gun sight, devised by Maurice Hancock, was in use in 1943 by the RAF Hurricane fighters. It corrected for flight maneuvers and employed crosshairs and a targeting circle of six diamond shapes, which considerably advanced the gunner's targeting capabilities. Fully wearable HUDs that expanded the flier's field of view, corrected more accurately for error, and supplied basic flight information in addition to a weapon-aiming image did not appear until after World War II, in the 1950s.[75]

Other devices emerged that provided the soldier with information with a minimum of manipulative effort, such as the field wristwatch. As noted earlier, the wearable timepiece appeared as jewelry for women in the eighteenth century, while the pocket watch remained the preferred masculine form until 1907, when Alberto Santos-Dumont, one of the early experimenters in heavier-than-air flying machines, commissioned the famous jeweler Louis Cartier to manufacture a small timepiece with a wristband to his specifications. But even earlier, during the Boer War in South Africa (1899–1901), British soldiers had created makeshift wristwatches. By World War I wristwatches with metal protective grilles over glass faces were common components of military garb.

Other equipment enhanced soldiers' senses in the field. Night vision instruments using infrared detectors were deployed by the German army, and infrared sighting devices (sniperscopes) were used by the U.S. Army, though these were attached to weaponry. Night vision goggles were developed by William Spicer at Stanford University and deployed late in World War II.

Manuel De Landa has discussed the evolution of what he calls (after Deleuze and Guattari) the "machinic phylum," a disposition that he says fueled research into "smart" technologies during World War II and led to the development of computers—and ultimately, of "wearable" ones. De Landa writes:

Out of his participation in [antiaircraft] research, Norbert Wiener created the science of cybernetics, the forerunner of modern computer science. The military, for its part, however, got a first taste of what computers could do to get humans out of the decision-making loop. Smart devices began to penetrate not only launching platforms, as in the case of gun directors, but the delivery vehicle, the missile itself.[76]

And, we have seen, researchers sought to automate not just the platforms and missiles, but the body of the soldier as well.

Fantastic body enhancements were envisioned early in the twentieth century in the genre of science fiction—for example, answering the urge to overcome gravity. In 1928 the popular serial *Amazing Stories* featured "The Skylark of Space" by Edward Elmer Smith and Lee Hawkins Garby, about a rocketeering scientist in a skintight suit who

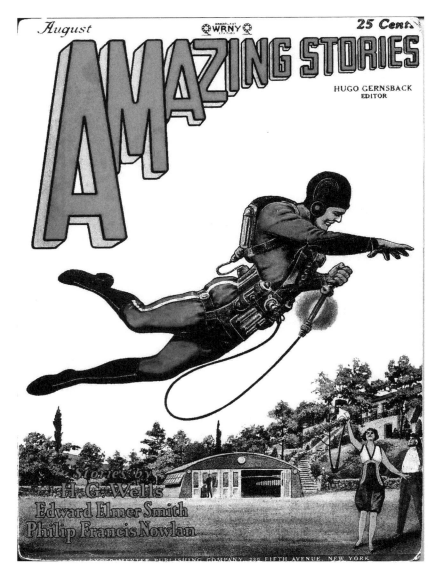

Figure 1.6
Frank R. Paul, "The Skylark of Space," 1928. Courtesy Frank R. Paul Estate.

discovered a substance to release "intra-atomic energy."[77] In the 1940s Germany conducted many experiments with wearable jet packs designed to propel soldiers (called *Himmelstürmer* or Sky Stormers) over mine fields, fences, and bodies of water, but such devices did not receive attention in the United States until after the war, apparently because few American soldiers were willing to test them.[78] Eventually the Aerojet General Corporation and Bell Labs continued this work, developing, for example, the Bell Rocket Belt. The effort eventually led not to military use but to entertainment-oriented versions like James Bond's use of a jet pack in the 1965 film *Thunderball* and the comic book *Rocketeer*, which appeared in 1982 but with stories set in 1938 Los Angeles.

Paralleling the pace of military research was an increasing popular interest in superhuman, even superterrestrial, powers as displayed by characters in pulp fiction, detective magazines, and comic books, which were still in their infancy in the years leading up to World War II. Superheroes appeared in the environment of the futuristic New York World's Fair, amid mounting fears of fascism abroad and as a response to the National Socialist exaltation of the Nietzschean *Übermensch*.[79] Enthusiasm for superheroes may also have drawn on ideas like Max Weber's "charisma," a term legitimizing leadership through personal qualities rather than political roles, which gained circulation in the United States in the late 1930s.[80] Like the models in *Vogue*'s 1939 "Fashions of the Future," the early male superheroes embody a fascination with extraordinary human qualities, couched in eugenics discourse. Male superheroes were typically based on physical ideals drawn from the canon of Polykleitos and figures in Greek vase painting, but possessing faces reflecting the eugenicists' obsession with Nordic masculine types with high foreheads and strong square jaws, a synthesis that advanced racial and mythical connections between Anglo and Nordic races and classical Greek culture.[81]

Buck Rogers appeared earliest, in 1928, and was the least mesomorphic of the type. This character was a futuristic veteran of World War I who falls into suspended animation as a result of exposure to radioactive gas and wakes up in the twenty-fifth century to help defend America once again. Five years later, the more muscular looking Superman was created by a pair of teenagers, Jerry Siegel and Joe Schuster, and became the protagonist of his own comic book in 1938, the first of many heroes whose costumes are their signatures. Superman was soon joined by Batman, Captain America, Captain Marvel, Green Lantern, and others; many of these characters had well-dressed and well-mannered alter egos (Clark Kent, Bruce Wayne, etc.), while their superhero appearances follow a consistent formula with somewhat drag or effeminate accoutrements: a powerful, muscle-bound individual in a skintight suit (essentially a catsuit) with mask and cape.

The character type suggests any number of sources, and those most frequently cited in comic-book literature include mythical heroes like Hercules and Gilgamesh, classical strong men such as gladiators, and medieval heroes like Robin Hood.[82] But the

comic-book heroes at the dawn of modern technology incorporate the popular residue of scientific research on the one hand and, on the other, parade their bodies in an unprecedented way. The skintight suit can be traced to circus performers: in particular, trapeze artist Jules Léotard, who was widely known for (and who supposedly designed, in the 1850s) the knitted attire that bears his name.[83] The costume was aerodynamic and unlikely to be entangled in the ropes he used, and showed off his physique at a time when nudity was inappropriate. The leotard persisted in circus and acrobatic attire as a stand-in for nudity, a garment that mirrors or "doubles" a powerful physique, and was later adopted by many comic-book superheroes. The cape also has historical precedents: in ancient Rome and medieval Europe, in men's evening wear in the Victorian period, and as a component of many military officers' dress uniforms since the eighteenth century. Superman's cape was science fiction technology: beginning in the 1950s it was indestructible, as was his suit. From Batman's appearance in 1939, his distinctive "batsuit" consisted of a leotard with briefs, cape, bladed gloves, eared and hooded mask, and utility belt reminiscent of military utility packs. Because he had no superpowers, Batman's belt held his special gear, including items that would have been familiar to Allied soldiers—night-vision goggles, gas filters, flashlight (called a "batlight")—as well as signature items like the "batarang" (a boomerang/shuriken) and "batrope."

The comic-book heroes present a paradox: on one hand, their superpowers and gear reflect wartime wearable technology and popularize the futurist dream of surpassing the body through the acquisition of impossible abilities. On the other hand, superhero bodies are revealed and present in an unprecedented way. They are body builders, nearly naked in their outfits, and their suits establish their identities. Superman cannot go to a disaster without changing, nor can the others. George Hersey interprets superheroes' musculature as an outer garment of small animals (from the Latin for "muscle": "little mouse") or as "kinetic subcutaneous clothing" made of small "creatures" that can dart around under the skin.[84] The early comic superheroes resemble, through body type and postures, male bodybuilders as seen in the 1930s and 1940s in magazines like *Health and Strength*, which were sometimes regarded as soft gay porn.[85] Gillian Freeman identifies the heroes' latent eroticism as a subject for juvenile fantasy and the basis of adult fetishism.[86] Umberto Eco, Roberto Giammanco, Fredric Wertham, and Mark Best, among others, have written about the homosexual or homosocial aspect of superheroes like Superman and Batman (shared by their female counterparts like Wonder Woman, who appeared in 1941), which is based on the mythology of enhanced physical prowess and fear of its delimitation by normative social bonds. For Eco, Giammanco, and Wertham, homosociality reinforces the notion of "superpowers," which require abnormal socialization and, at the same time, represent Superman's (and the others') lack of ability to enact change on a larger, more "real" political level (their classic enemies are small-town gangsters, not social injustices).[87] The superheroes act

out a dichotomy between the body as an armature for beyond-the-body abilities, and the body as an earthbound corporeality that articulates itself through appearance and costume. This dichotomy became further established in postwar mass media, then entered the discourse of wearable computers. After all, Superman, as the "man of steel," prefigures the cyborg, another kind of technological drag figure. Referring back to the goal of recovering the historical contexts surrounding the emergence of WT, then, this dichotomy resolves itself in two evolving scenarios: one based in the "homosocial" community of scientists and engineers, and the other in the spectacular ("feminized") world of mass media and fashion.

First Wearable Computing

In the postwar years, personal technologies of all kinds rapidly emerged, keeping pace with the taste for superhuman heroes within an expanding mass culture. For example, after the development of transistor-based radio receivers in 1947 (replacing vacuum tube radios and allowing marked diminution in size), Texas Instruments created a viable but unsuccessful prototype in 1954. But it was a new Japanese company, Sony, that first released truly popular, battery-driven transistor radios, in 1957. They came in bright "pop" colors (lemon, green, and red, as well as black), and were advertised as "pocketable" (though they only fit rather oversized pockets). In comic-strip fiction, radios were already small and wearable: Dick Tracy's signature 2-Way Wrist Radio appeared in 1946.[88] By the early 1980s, real wrist radios were popular retail items in Japan.[89]

Research that extended the "heads-up" and "hands-free" abilities of soldiers and pilots during World War II was pursued after the war both in America and abroad. Cockpit HUDs that combined targeting and navigation functions appeared in the 1950s and were in wide use by the RAF from 1958. But in 1945 Vannevar Bush, previously an organizer of the Manhattan Project associated with the development of the atom bomb, published an influential article in the *Atlantic Monthly* describing how wartime technologies like the HUDs could be used during times of peace. Among other visionary projects, Bush outlined the concepts of future wearables:

The camera hound of the future wears on his forehead a lump a little larger than a walnut. It takes pictures 3 millimeters square, later to be projected or enlarged, which after all involves only a factor of 10 beyond present practice. The lens is of universal focus, down to any distance accommodated by the unaided eye, simply because it is of short focal length. There is a built-in photocell on the walnut such as we now have on at least one camera, which automatically adjusts exposure for a wide range of illumination.[90]

Bush's 1945 proto-cyborgian camera included a head-mounted display in a pair of glasses:

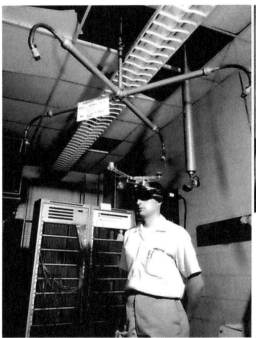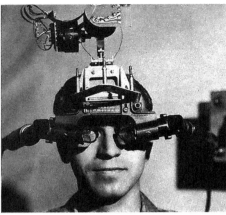

Figure 1.7
Ivan Sutherland wearing the Sword of Damocles, c. 1968.

The cord which trips its shutter may reach down a man's sleeve within easy reach of his fingers. A quick squeeze, and the picture is taken. On a pair of ordinary glasses is a square of fine lines near the top of one lens, where it is out of the way of ordinary vision. When an object appears in that square, it is lined up for its picture. As the scientist of the future moves about the laboratory or the field, every time he looks at something worthy of the record, he trips the shutter and in it goes, without even an audible click.[91]

Initial application of Bush's visionary wearables ideas emerged in a different context, from a mathematician who was not interested in photography but rather in computational problems like games of chance. In 1955 Edward O. Thorp, a graduate student in physics at UCLA, began thinking about roulette wheels, in particular how to calculate the position and velocity of the ball and rotor to predict where the ball would stop on any given roll. During his research he also studied blackjack games and arrived at a predictive program using the IBM 704, the first mass-produced computational computer. By this time, 1961, Thorp was at MIT and sought out Claude Shannon, with whom he copublished the blackjack program results.[92] Both men were gadget and toy enthusiasts, and together they resumed the roulette research, looking for a computer

processor that would be no bigger than a pack of cigarettes. The resulting device included microswitches installed in the player's shoes and a wired earpiece for hearing the musical tones to which the programming was coded. The earpiece arrangement involved a kind of masquerade; as Thorp wrote, it was "painted to match our skin and hair" so as to go unnoticed.[93] Thorp and Shannon, together with their wives, tested the resulting device, which most accounts have called the first "wearable computer," in the summer of 1961 in Las Vegas. Claude Shannon acted as a diversion. Betty Shannon and Vivian Thorp served as lookouts, and Thorp operated the contraption, though the earpiece was far from invisible and its wires broke repeatedly: "Except for the wire problem, the computer was a success. We could solve this with larger wires and by growing hair to cover our ears, a conspicuous style at the time, or persuade our reluctant wives to 'wire up.'"[94]

Another device, Ivan Sutherland's first computer-based head-mounted display for augmented reality, the so-called Sword of Damocles, was developed in 1968 with student Bob Sproull and funded by the Department of Defense's Advanced Research Projects Agency (ARPA). The invention was named after the Greek story of King Damocles, who reigned with a sword hanging above him. Sutherland's device was part of a complete setup for viewing computer output in binocular display, but because it involved a large amount of equipment suspended over the user's head, the system was too heavy to be workable. It merely pointed the way to later virtual reality developments.

About the same time, Hubert Upton developed a wearable analog computer with the first eyeglass-mounted display for speech reading using light-emitting diodes (LEDs)—a kind of augmented reality for the deaf. The computer analyzed a speaker's voice, and different phonemes were output as differently colored lights in the special eyeglasses, which were placed to overlap with the speaker's lips. Upton himself, who was hearing-impaired, was a researcher at Bell Labs and developed the glasses for military applications, for example as a pilot's heads-up display.[95]

Technology as Fashion

The 1950s and 1960s are a period associated with an intensifying technological orientation, popularized through culture, media, and advertising. In this period, conceptions and representations of dress responded to the activity taking place within the military and scientific-industrial arenas, which was spread through comics and mass literature, elite literature, radio, television, and movies spanning diverse levels of sophistication. Even so, spaceman Klatu's outfit in the film *The Day the Earth Stood Still*, released in 1951, is comparable less with HUD technologies than with Gilbert Rhode's 1939 Man of the Future design for *Vogue*. Paralleling research in military-based wearable devices, there was a more popular trend toward the display of technological

ideas in the fashion of the 1960s. In a decade credited with initiating the mass market for trickle-down retail styles, young designers, revolting against the exclusiveness of haute couture and the rigidity of the fashion industry, were turning to "space age" shapes and materials.

Fashion's postwar New Look, promoted by Parisian houses like Christian Dior for small, wealthy markets, dominated the couture scene. The New Look was an aristocratic holdover from the past employing traditional luxury materials and techniques and featuring feminine profiles engulfed in massive amounts of fabrics like silk. Such clothes were available to the middle class after the war only in restricted quantities. In response, industrial firms like DuPont in the 1950s mounted campaign after campaign for new synthetic fibers and struck deals with couturiers like Dior and others to include in their collections synthetic polymers like nylon, Orlon, and other acrylics, and cellulose-based fibers such as rayon and viscose. The aftermath of World War II also saw an expansion of materials technologies and a range of new, easily and cheaply manufactured plastics. In 1957 Roland Barthes included an essay entitled "Plastics" in his collection *Mythologies*, after attending an unnamed exhibit of the material that apparently included a look at how plastic was manufactured. Barthes remarked upon the material's "almost infinite" transformability; it was a "magical" yet "prosaic," insubstantial substance (in that it imitates everything but has few qualities of its own), which destroyed the hierarchy of natural materials: "a single one replaces them all," he wrote.[96]

Indeed, advances in plastics enabled the emergence of PVC- and polyurethane-based pneumatic structures for toys and furniture (for example, Lomazzi, D'Urbino, and DePas's famous Blow Armchair, of 1967). Industrial applications of abundant new materials created a host of low-cost commodities that gave plastic the connotations of being at once space-age and lowbrow. Writing about plastic fashions in 1965 for the *Sunday Times*, Meriel McCooey stated, "In the last two years plastic has been much improved and scientists are discovering it has as many permutations as the football pools . . . it's a material you can't work with nostalgically." Once again, it was all about the future.[97]

Among high-profile Parisian designers, André Courrèges, who had studied engineering and flown as a pilot in World War II, premiered futuristic concepts in his 1964 Space Age collection of dresses made of simple geometric shapes using a range of materials including PVC and metal, accessorizing the models with huge goggles—which presented a humorous interpretation of the pilot goggles and gangster glasses seen in sci-fi literature and comics—and superhero-sized boots.

Even earlier, in 1960, Paco Rabanne (fashion's Jules Verne, as he has been called) had an aluminum dress featured in one of Givenchy's shows. But the house dismissed the jewelry Rabanne started making shortly afterward, fashioned from Rhodoïd, a cheap, rigid plastic easily cut in geometric shapes and connected by metal links.[98]

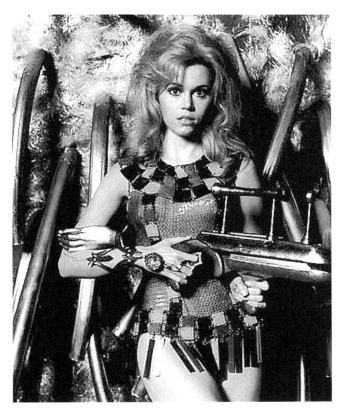

Figure 1.8
Paco Rabanne, costume for *Barbarella*. © 1968 by Dino De Laurentiis Cinematografica, S.p.A and
Paramount Pictures Corporation.

Rabanne, who harshly criticized the production and distribution traditions of high
fashion, made headlines in 1965 with a collection of twelve contemporary "mani-
festo" dresses, to which he gave the confrontational title "12 Unwearable Dresses in
Contemporary Materials," and which also included Rhodoïd and aluminum "chain
link" garments. "My clothes are weapons," he told an interviewer. "When they are
fastened they make a sound like the trigger of a revolver."[99] Rabanne, a follower of
artist Marcel Duchamp, showed related "chain mail" jackets and dresses accented
with feathers at Iris Clert's Paris art gallery, which premiered Yves Klein and the New
Realists, and Clert hung Rabanne's dresses next to paintings by Lucio Fontana.
Rabanne sought to capture a cultural mood rather than design clothes in the tradi-
tional sense: one of his dresses was worn onstage by Audrey Hepburn in 1966, and
Rabanne knockoffs were featured in *Casino Royale*, the 1967 James Bond film from

Columbia Pictures. A year later, Rabanne contributed to a new genre in science fiction when he dressed Jane Fonda as a sexy space-traveling fashionista in *Barbarella*, whose metallic outfits connoted not only futuristic technology but also liberated female sexuality.

The rebellious attitude toward traditional fashion emerged everywhere. It was also displayed by Rudi Gernreich, another stylist of plastic and vinyl as well as the creator of the topless bathing suit, who claimed, "For centuries, haute couture was based on the tastes of the aristocracy. Now all styles stem from the people, particularly the young."[100] As a result of the antics of the designers in the 1950s, who were working with new industrial materials in unconventional ways and in unlikely venues, the garment industry was revolutionized, beginning with the cost and accessibility of designs and extending to unconventional types of clothes. Elizabeth Wilson compares the fashion of the 1960s with pop art, op art, and performances and happenings, movements that were emerging in galleries at the same time: "Pop Art attempted to dissolve the distinction between high and low art. The further expansion of a mass fashion industry directed at the young dissolved the distinction between high class fashion and the vulgar; self presentation and performance were substituted for any lingering notion of the sartorial as good manners; 'understated chic' was on the wane."[101]

Paraphernalia

Puritan Fashions Corporation, a mass market women's clothing company, was founded in Boston in 1910. By 1965 its director, Carl Rosen, wanted to cash in on the exploding youth market, which was affecting all kinds of commodities but clothing above all. He contacted British entrepreneur Paul Young, and the pair opened a New York boutique entitled Paraphernalia, modeled on London's popular shops like Mary Quant's Bazaar (opened 1955) and Biba (opened 1964), which sold vinyl miniskirts and psychedelic prints. At the corner of 57th Street and Madison Avenue, Paraphernalia's shop was designed by modern architect Ulrich Franzon, all curved steel, chrome, and white walls. Paraphernalia retailed clothes by young designers that were made by Puritan and also imported new "mod" labels, including Mary Quant, who had been using PVC in clean, geometric clothes since the early 1960s. The store's opening, hosted by Andy Warhol and accompanied by his band the Velvet Underground, coincided with the Beatles' first American tour in August 1965. With an adventurous business model, Paraphernalia expanded to forty-four stores nationwide by 1968, though all of them were gone by the mid-1970s. But in its heyday the brand drew attention to unknown young designers with offbeat ideas whose lines were unlikely to turn up in department stores: Deanna Littell, Betsey Johnson, Joel Schumacher, and Brits Marion Foale, Sally Tuffin, and Ossie Clark. Paraphernalia thrived in the contexts of pop music

and pop art, and sold clothes in limited editions, the way many artworks also promoted as "multiples." This idea derived ultimately from Duchamp's multiple readymades, but gained purchase at the time through Marion Goodman's New York gallery Multiples, Inc., which sold not only prints, but series sculptures and artist-designed decorative items like rugs.[102]

The clothes at Paraphernalia were inexpensive and affordable by almost anyone. They were either sold or removed from the store within a few weeks—nothing was kept around, which supported the idea of newness, constant change, and expendability. Paraphernalia was part of the scene. "It was really about doing anything you could do that shook up the status quo," Schumacher said in an interview. "We all just sat around and thought of anything you could do that went *Fuck you* in the eye of convention. And that's what we'd do."[103]

Among the most distinctive aspects of the new design, other than its pop music milieu, was its use of industrial materials instead of fabric. Major designers had already applied plastic disks, vinyl, and chain mail to runway designs. Paraphernalia expanded the trend and made it affordable to young people. And it seemed related to pop art's affinity for shiny new household objects. Johnson recalls: "We were into plastic flash synthetics. . . . It was 'Hey, your dress looks like my shower curtain.'"[104] The designers took to foraging for materials in grocery and motorcycle supply stores (for hardware fittings), looking for essentially "readymade" elements entirely outside the realm of traditional textiles.

Alongside the plastic and metal garments were intentionally disposable ones made of paper that mocked highbrow disdain for commodity culture. According to Johnson, "It was the first era of throwaway clothes. . . . The look, the vibe, the groove, they were like *Laugh-In*—there for the impact. And they kind of fell apart."[105] In other words, the discourse surrounding contemporary fashion emphasized process and testified to the widespread view of the new clothes as a kind of performance art. Some dresses had detachable ornaments that could be removed or moved around. By the late 1960s, the Scott Paper Company inaugurated a line of paper dresses called "Paper Caper," made of 93% paper napkin stock and 7% rayon webbing. Selling for $1.45, the dresses came with coupons for other Scott products, because the Paper Caper dress was conceived as part of an advertising campaign. It was brought to an abrupt end when the manufacturers were overwhelmed by half a million orders.[106] Other fabricators brought paper dresses to all kinds of fashion outlets, from Paraphernalia to the more upscale women's clothier I. Magnin, for various prices. In 1965–1966, influenced by Paraphernalia, Warhol created Fragile Dresses with Gerard Malanga at the Factory, printing them or attaching silkscreened images, such as bananas. Warhol said he liked "the five and dime store" aspect of the paper dresses.[107] Alvin Toffler, writing in his 1970 book *Future Shock*, argued that the widespread trend supported a larger development toward a culture of transiency and nomadism.[108]

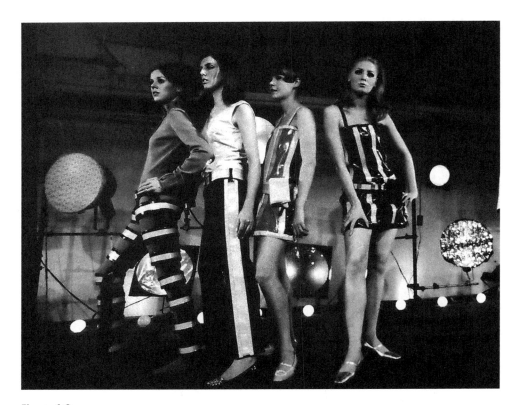

Figure 1.9
Designs by Diana Dew, c. 1966. Courtesy of Ken Regan/Camera 5.

A smattering of designers worked with DayGlo materials and electronic illumination. Joan "Tiger" Morse created dresses seeded with miniature light bulbs. The trend even appeared at the couture level when, in 1966, Yves Saint Laurent sent a bridal gown, with an incandescent flower attached, down the runway (a possible nod at Trouvé).[109] Working for the Paraphernalia group, designer Deanna Littell recalls that companies would arrive with unusual materials and ask if the designers could work with them. Eastman Kodak brought samples of a photosensitive, paper-backed linen and asked if photo-printed dresses could be made if the material came by the yard. Another company presented samples of leatherette and Naugahyde in fluorescent fuchsia and green. Little used it to make raincoats inspired by police-uniform raingear, with reflective strips, then made skirts and shirts to match. The outfits lit up and flashed under strobe and black lights, as when they were shown at the opening of the Washington, D.C., Paraphernalia boutique, where they created a kind of club scene as a band played.[110]

Figure 1.10
Diana Dew wearing electroluminescent dress with battery pack belt.

Figure 1.11
Model wearing battery-heated coat, February 2, 1968. © *Manchester Daily Press* / Science & Society
Picture Library.

Outstanding among the Paraphernalia designers was Diana Dew, a young woman who had experience in both fashion modeling and automobile repair and had spent a year in the engineering program at the University of Florida.[111] She designed and made clothes in a small shop named Isis near Harvard Square in Cambridge, Massachusetts. Somehow she connected with Puritan, which hired her for Paraphernalia in New York and a Puritan division called Experipuritaneous. Dew developed a range of dresses with lights strobing from various places on the human anatomy, and enabled wearers to control the effects.[112] *Time* magazine described her work in 1967:

By using pliable plastic lamps sewn into the clothes in segments and connected to a rechargeable battery pack worn on the hip, just like Batman, she has been able to produce mini-dresses with throbbing hearts and pulsating belly stars, as well as pants with flashing vertical side seams and horizontal bands that march up and down the legs in luminous sequence. . . . Potentiometers on the battery pack allow the wearer to produce from one to twelve flashes per second. The batteries themselves can be recharged by being plugged in, just like an electric toothbrush, and at full strength are good for five hours of flashing.[113]

The idea of wiring up garments as a hip strategy of the 1960s extended beyond Paraphernalia to other adventurous garment prototypes, like the battery-heated coat that appeared in the *Manchester Daily Press* in 1968, showing a model in a bikini and hooded cloth coat, holding up the fairly large battery that powered it.[114] The notion of technologized clothing made an initial entrance into the realm of mass culture, even if there would be pushback from the fashion industry in the next decade.

Electroluminescent Dresses and Machinic Phylum

Some nine years separate the outfits of Diana Dew from Atsuko Tanaka's earlier electric clothes, a period spanning the initial postwar period and encompassing the cultural assimilation of the industrial and technological boom engendered by the research and economy of war. These two creators represent opposite but increasingly interrelated cultural perspectives—New York and Tokyo. It is not known whether Dew was ever aware of Tanaka's project, but both women expressed the encounter between technology and the body through a specific cultural medium: electrified clothes. The Gutai group in the 1950s were translating what they knew of Western action painting into a body-centered art. Even the name Gutai suggests this: while the word is often translated as "concreteness," Alexandra Munroe has pointed out that it is composed of two Japanese characters, "*gu*, signifying tool or means, and *tai*, signifying body or substance," and Amelia Jones further interprets it as "means for enacting the body."[115]

Both Tanaka and Dew enacted the body by using the format of dress as its interface with technology, complicating the World War II-era body, which technology sought to uncover, as in the clothed nakedness of prewar comic superheroes or as suggested by several of the *Vogue* designers in 1939, who predicted that technology would result in healthy nudity and bodies perfected by design. Marshall McLuhan echoed this idea of pure, transparent technology twenty-five years later in "Clothing: Our Extended Skin," a chapter in his 1964 book *Understanding Media: The Extensions of Man.* Suggesting that Western civilization was moving toward postindustrialism, McLuhan equated industrial progress with the surge of the tactile over the visual in all aspects of society, including dress: "To a person using the whole sensorium, nudity is the richest possible expression of structural form." Clothing, "our second skin," McLuhan saw as the "direct extension of the outer surface of the body," and in the chapter he devalues dress and speech as associated with older historical eras. McLuhan seems to be echoing the early twentieth-century architect Adolf Loos (especially his essay "Ornament and Crime") in suggesting that dress is diminished in a Western culture that has become more "abstracted by literacy and industrial visual order."[116]

But in the dresses of Tanaka and Dew, electroluminescence made clothing more intensely meaningful as an expression of the body. It was a means to "speak technology"—to use technology as communicative action and innovation, not merely to covertly enhance a function, the way Thorp and Shannon used their wearable computer. Manuel De Landa's ideas about technological innovation are relevant here. De Landa describes two kinds of method, one following the logic of technological determinism, the discipline looking for the next, expected level of evolution; and the other method given to exploring complex and heterogeneous combinations of ideas (De Landa calls this "combinatorial richness") catalyzed by significant breakthroughs (singularities), which is how most technologies really develop over time. This is the realm of the machinic phylum, a term De Landa borrows from Deleuze and Guattari, who describe the phylum this way:

We may speak of a machinic phylum, or technological lineage, wherever we find a constellation of singularities, prolongable by certain operations, which converge, and make the operations converge, upon one or several assignable traits of expression. If the singularities or operations diverge, we must distinguish two different phyla . . . [but] at the limit, there is a single phylogenetic lineage, a single machinic phylum, ideally continuous: the flow of matter-movement, the flow of matter in continuous variation, conveying singularities and traits of expression.[117]

De Landa says it will take "conceptual breakthroughs" for us to understand the history of technological innovation in this way, and to get rid of "hylomorphic schema" (form imposed on matter from the outside), which are common viewpoints in military and industrial regimes. These tend to render the machinic phylum

as "invisible" or "unrecognizable," and what is needed, he writes, is a reinjection of "heterogeneity; and our bodies, so deskilled after two centuries of military routinization, need to relearn the craft and skills needed to 'hack' these heterogeneous elements into new combinations."[118] The creations of Tanaka and Dew represent such hacking. After the 1960s, conceptualizers of WT would still struggle with the linearity of scientific schema, on the one hand, and on the other with the extreme heterogeneities of mass market innovations and techniques, and the vagaries of dress.

2 Wearable Computing

While the flirtation with space-age fashion faded in the 1970s and 1980s, portable technologies surged in popularity. That period saw rapid research and industrial development of "personal technologies" that included wearable items using clothing or accessories, or even the body itself, as an interface for a variety of analog and digital functions. Commercial aspirations for such technologies accelerated while interactions intensified between scientific and industrial research, and developments at the cultural level that framed such research in popular literature, TV shows, films, music, and fashion—popular narratives that presented fantasies concerning technology and the human body. These images provided dramatic metaphors with which to think up and inhabit personal and cultural relationships with emerging technologies (both augmented experience and device-based aspects). But the dichotomy, even the irony, of irreconcilable differences—between, say, personal autonomy and mechanical empowerment—was just coming into focus. This chapter will elaborate that dichotomy as viewed through the development of wearable computing and its confrontation with the culture of dress and fashion in the late twentieth and early twenty-first centuries.

From Miniaturization to Eudaemonics

In *Me++*, William J. Mitchell argues that the shift from the nature of existence grounded in physical space to entirely mobile modes entails a fundamental shift in subjectivity. He describes a trajectory of miniaturization and mobility that culminates, in the Internet era, in the individual as "electronomadic cyborg"—a being with no physical roots, a changeling with no fixed identity but possessing multiple selves with digital points of reference: passwords, codes, and extensions that overlap with those of others.[1] But is the nomadic urge to either carry or wear our tools part of the general disposition to dress that seems always to have been part of human nature? Or is miniaturization a step in the history of automation, the encroachment of what Deleuze and Guattari call the abstract machine on the human body? Have computation and hardware

replaced the earlier eugenics as a pathway to perfection ("We too are on a quest for perfection," says the Borg Queen in the 1996 film *Star Trek: First Contact*)? In his *War in the Age of Intelligent Machines*, Manuel De Landa traces the migration of machine functions "from their point of departure in the human body to the miniaturized form through which they entered the body of predatory machines." In the military, the development of technology that no longer relies on human input to function was spearheaded "to get humans out of the decision-making loop."[2] De Landa cites Jacquard's first programmable loom and Babbage's analytic engine as the earliest steps toward the migration of control from the human body to the machine.[3] Wearable technology (WT) is an assemblage that seeks to bring autonomous machines back to the body, to "augment" it but also to render it compliant to systems of control. This reversal, within the larger history of computerized machines, compels us to investigate carefully the various stages in its development.

In the first chapter we looked briefly at the emergence of the wristwatch as a kind of WT first used as ornamentation and dress, then as a functional accessory on the battlefield. Ultimately watches overran the purview of the military to become cultural objects worn by most members of Western society, objects that attained complex symbolic value. The Hamilton Watch Company introduced the first electronic (battery powered) watch in 1957. The first digital watch was a Pulsar LED type, jointly developed in prototype in 1970 by Hamilton (parent of Pulsar) and a company called Electro-Data. But it was inspired by Hamilton's own futuristic (though nondigital) watch, designed for the 1968 sci-fi film *2001: A Space Odyssey* (cowritten by Stanley Kubrick and Arthur C. Clarke).[4] Made of 18K gold, the Pulsar LED was aimed at a high-end consumer. This changed when Texas Instruments, which had pioneered in developing the silicon transistor in 1954, rolled out a variety of cheap, mass-produced LED watches in 1975.

Still, LED displays used too much power and could only appear for short periods or when the wearer pushed a button, and LCDs (liquid crystal displays), which used much less battery power, soon replaced them. These were manufactured from 1973 by Seiko (which had absorbed Hamilton's Pulsar division). With positive consumer reaction to cheaper products, innumerable brands and versions followed. The next logical step was to expand or complicate functionality: to use the watch for something other than just telling time (an evolution repeated later by mobile phones)—to make it an information resource. Hewlett-Packard's HP-01, released in 1977, was a wristwatch calculator with LED displays and a stopwatch function. (The 1983 Japanese radio watch was mentioned in chapter 1.) Seiko produced watches with small televisions in 1982, and Casio brought out watches that could read ambient temperature or translate Japanese words into English (for a growing tech niche market). But these cheap, tricky LCD watches were ultimately trumped in the marketplace by the mid-1990s, when fashion demanded "look of luxury" timepieces with references to vintage and craft: expensive

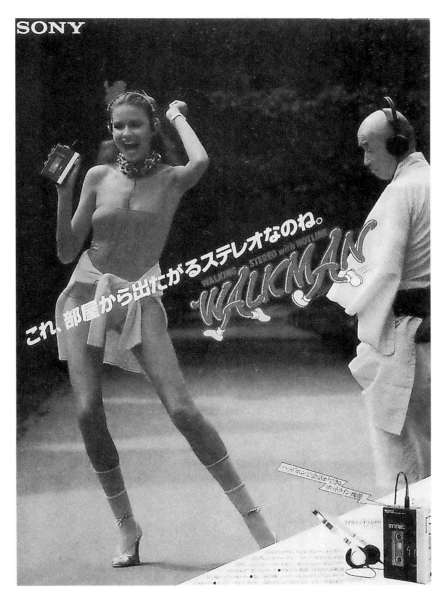

Figure 2.1
SONY, "Bridging the Difference" Walkman ad, 1979.

Rolex dial-faced watches and chronometers, and their vast progeny of competitors and knockoffs.

Another seminal product in the progression of miniaturized devices was the Sony Walkman, which appeared in 1979. Not as wearable as a watch, it was certainly portable, and tiny radios and portable cassette recorders—which you could carry from place to place, if not wear—had already been around for several years. One predecessor, for example, was a "stereobelt" built by Andreas Pavel, who several times challenged Sony (unsuccessfully) in court.[5] But Sony endowed its device with cultural cachet. There is even a legend that the company's chairman wanted something to bring on his transcontinental flights with which he could listen to opera, so he had an engineer throw a prototype together. (This is only one of several origin stories, the repetition of which signals an impulse to mythologize the Walkman birth.) In essence, Sony modified its preexisting cassette player (called the Pressman), added headphones, scaled it to pocket dimensions, and marketed it with the words "bridging the difference," aimed at emphasizing the "Japaneseness" of the project in a global market— where "Japanese" was associated with high technology and miniaturization, which was perceived by the late 1970s to be a profitable goal. The original Bridging the Distance ad campaign emphasized both cultural and generation gaps as well as the divide between technology and fashion. In it, a traditionally dressed Japanese man wearing older headphones stares at a young, barely clad Western woman dancing to music from her Walkman. The Japanese man stares at the dancer's crotch, while the words of the jingle are displayed in Japanese along his line of sight, making the sexual dynamic of the ad explicit.

For the same campaign, Sony hired chicly dressed models to walk around Tokyo with Walkmen to stimulate desire for the devices. As Paul du Gay and his coauthors have shown, beyond the connections Walkman made between miniaturization, Japan (or "Japaneseness"), and technology (Japan dominated the manufacturing of integrated circuits) was the connection between the portable music player and the very idea of mobility itself, often represented in the company's publicity by fanciful connections between the Walkman and shoes. This idea became literal in a poster campaign from the early 1980s: various images showed Walkmen "worn" by anthropomorphized footwear—shoes as heads with faces: a western boot, tennis shoe, leather sandal, and swim flipper.[6]

While wearable electronics developed on a steady path among corporate industries in the 1970s, individual research also existed, but with a lower profile.[7] Miniaturization was the goal not only of major corporations but also of small California industries and some bright individuals. Best known is a group of graduate students calling themselves Eudaemonic Enterprises, led by J. Doyne Farmer and Norman Packard, from the University of California at Santa Cruz. They were followers of Thorp and Shannon's research in roulette prediction; inspired by previous efforts, the students developed

two smaller systems: one had components located all over the operators' bodies; the second, which was never perfected, would have had all components implanted in shoes—specifically, repurposed Clark's walkers.[8] Both systems were designed for two wearers. In the case of the second design, one person would input roulette wheel data with his toes and transmit it to a second person, a player, who received the information through buzzes to his toes, creating a mutually interactive closed network. Both systems were integrated with the players' bodies and required them to work in tandem. The Eudaemons became a model for the development of wearable computing that integrates body and electronic functions in a symbiotic way, but the group's endeavors remained idiosyncratic. Thomas A. Bass's rambling account of the Eudaemons, their girlfriends, and their research trips to Las Vegas, *Eudaemonic Pie*, became a must-read for fledgling electronics futurists like Steve Mann.

Cyborgs: Contesting Embodiment

N. Katherine Hayles writes that with the coming of the computer age the erasure of embodiment was described in a series of steps, from Alan Turing's famous 1950 paper proposing a test whereby machines could be shown to exhibit intelligent behavior, to Norbert Wiener's thesis that information is an entity distinct from the body, and finally to Hans Moravec's argument, in the 1980s, that human identity is essentially an informational pattern—data that could, theoretically, be uploaded to a machine.[9] Bernadette Wegenstein has also written about the recurrence of disembodiment mythologies in techno-futurist writers from Warren McCullogh to Ray Kurzweil and Nicholas Negroponte.[10] Such projections further escalated in fiction. In 1984 William Gibson helped spark the cyberpunk genre with his novel *Neuromancer*, a key element of which is its characters' ability to upload themselves—their identities and consciousnesses—into an artificial environment, "cyberspace," a term Gibson coined. The disembodiment paradigm spread with the force of seeming inevitability. John Mullarkey has pointed out how Deleuze and Guattari's writings have often, wrongly, been cited in materialist arguments supporting information theory in terms of "flows of information," for example.[11] In fact, Deleuze and Guattari fault information science. In *A Thousand Plateaus*, they write that, far from being rhizomatic (or decentralized like the early Internet), "information science and computer science . . . still cling to the oldest modes of thought in that they grant all power to a memory or central organ."[12]

What Erkki Huhtamo calls the "trope of the cyborg" is at the center of cultural debates about information versus embodiment.[13] Most of it is well-trodden ground. Even what a cyborg is has many answers, depending on how the term is defined or in which discipline it is employed. For example, is it always an anthropomorphic entity? If so, does it involve real machinery or merely machine-enabled or nonliving parts, like the monster in Mary Shelley's *Frankenstein; or, The Modern Prometheus* (1818),

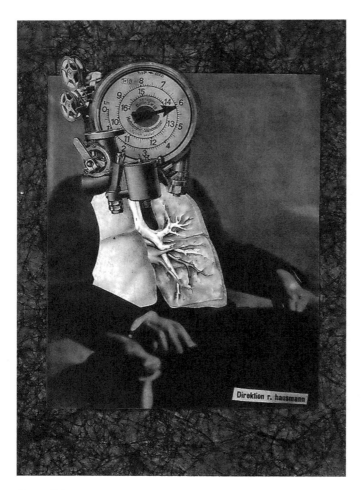

Figure 2.2
Raoul Hausmann, *Self-Portrait of the Dadasopher*, 1920. © 2014 Artists Rights Society (ARS), New York / ADGAP, Paris.

which was influenced by gothic fiction but incorporated elements of science? *Franken-stein* is cited as a progenitor of modern science fiction, but is also considered by some to be the first cyborg saga, even though the term itself is not used in Shelley's story.[14] L. Frank Baum's Tin Man, another early sort of cyborg, appeared in his novel *The Wonderful Wizard of Oz* (1900), on which the 1939 MGM movie was based. In art, cyborgs, as images of humans with machine parts, fill the Dada montages of Raoul Hausmann and Hannah Höch.[15] More science fiction stories about cyborgs appeared during World War II: the cyborg spaceship of James Blish's "Solar Plexus" (1941) and the burned dancer whose body is remade from sculpted metal in C. L. Moore's "No Woman Born" (1944), to name just two. It is the era in which we encounter superhe-roes and the discourse of eugenics—both offspring of a dream of ideal humans deliv-ered by science. But cyborg superheroes only grow in number as eugenics' dreams for human perfectibility go astray.

In fact, the cyborg recurs as a literary grotesque, often the product of some trauma to the body. It is kin to the figures of Freud's uncanny, the topic of an essay that itself was inspired by E. T. A. Hoffmann's 1816 story *Der Sandmann*, in which a man falls in love with a beautiful automaton who has removable eyes that remind him of a horrific childhood experience.[16] Machinery and the human soul, metal and flesh, combine only in violence. Istvan Csicsery-Ronay Jr. writes that cyborgs belong to the techno-scientific sublime—"too *real*, to be resisted": "The line between human and machine may be a perpetual injury: the wound-like transition from flesh to prosthesis in *Gundam* (1979) or the actual wounds that reveal the clockwork under the T-100's fake flesh."[17] The latter reference is probably to the T-101 Terminator from James Cameron's 1984 film of the same name, which was a robot covered in vulnerable and, in the movie, often torn human flesh.

The incredible diversity of early cyborg claims has been reviewed by Chris Hablas Gray in his 1995 *The Cyborg Handbook*. Definitions are myriad. Does the cyborg require the invasiveness of implantation? Or, as with humans using prosthetic limbs that can be removed at will, does WT qualify to make a cyborg? If so, as we have seen, Walter Benjamin should also be included in the cyborg's theoretical history because of his early identification of modern fashion as the combination of the human and the inorganic. By the time Nathan S. Kline and Manfred E. Clynes coined the actual term *cyborg* for a 1960 article they wrote about adapting humans for space travel, the concept was well in place, not just in fiction, but in the cybernetics research that influenced their work.[18] Cybernetics (from the Greek for helmsman, one who responds to conditions affecting the progress of the boat and keeps it on course), the science of human-machine interactions, arose out of Norbert Wiener's study of artillery opera-tions, and the use of computers to calculate targeting in terms of a human-machine system of control intelligible through data—Wiener's newly nuanced "information." Wiener's information is interactive, and cybernetics provided a set of principles and

terminology that enabled feedback phenomena to be compared across a range of disciplines—not just military tactics, but anthropology, biology, sociology, etc.—giving human sciences a hypothetical basis in computational fact. The Macy conferences (1946–1953), led by neurophysiologist Warren McCulloch and also in part by Wiener and Claude Shannon, helped promote the multidisciplinary validity of cybernetics and consistently stressed the notion of control and privileged computational information, or data, over ungainly material characteristics. This was a major stage in the "erasure of the body" that both Hayles and De Landa recount.[19]

Of course Wiener, the son of a philologist, was also aware of the values of face-to-face or in-person information conveyed through language, and he devoted a great part of his 1950 book *The Human Use of Human Beings* to discussing homeostasis and feedback mechanisms in comparison with language, which he acknowledged had a "visual" level, which he called the "third level of communication" or the "behavior level." This visual-behavioral aspect implies the involvement of the body. In fact Weiner himself experimented with a wearable communication device for the deaf, a "hearing glove," in which audio information was translated into tactile sensations by stimulating the deaf person's fingers with electromagnetic frequencies translatable into sounds.[20] Among Wiener's most lasting legacies, besides his advancement of cybernetics, are his warnings about it in *The Human Use of Human Beings* and other writings and his famous concern that, with the growth of machine automation, humanistic values not become lost. "When human atoms are knit into an organization in which they are used, not in their full right as responsible human beings, but as cogs and levers and rods, it matters little that their raw material is flesh and blood. *What is used as an element in a machine, is in fact an element in the machine.*"[21] But Wiener's struggle to keep cybernetics from endangering a humanistic world view—against the will to be cyborg—would eventually fail. Hayles writes:

It is to Wiener's credit that he tried to craft a version of cybernetics that would enhance rather than subvert human freedom. But no person, even the father of a discipline, can control single-handedly what it signifies when it propagates through the culture by all manner of promiscuous couplings. Even as cybernetics lost the momentum of its drive to be a universal science, its enabling premises were mutating and reproducing at other sites. The voices that speak the cyborg do not speak as one, and the stories they tell are very different narratives than those Wiener struggled to authorize.[22]

NASA and the United States Air Force pursued the idea of cyborgs with a post-eugenics-sounding research proposal, "Engineering Man for Space: The Cyborg Study."[23] Edwin Johnsen and William Corliss also provided NASA with a 1967 survey of research on "telematic" augmentation, discriminating between terms like "telepuppets"—the Elektro robot in the 1939 World's Fair, for example—and "telechirics," electronic prostheses that operated like "remote fingers."[24] The study also

Figure 2.3
Robert Johnson as cyborg on the cover of Kraftwerk's *The Mix*, 1991.

inventoried augmentation systems, for example a human exoskeleton built by Cornell Aeronautical Laboratory called a "man amplifier." Despite such intriguing research, Ronald Kline has written that scientific interest in the subject of cyborg systems waned after the 1960s, giving way to a fringe discourse mired in the extravagances of science fiction.[25]

Indeed, during the 1970s, in urban neighborhoods throughout Europe, a proto-cyberpunk style was making its appearance at raves, all-night music and dance events at which participants often wore assemblages of pop culture garments and artifacts, in what Ted Polhemus called "streetstyle." A key variant of this was techno (or cyber-punk), a style of dressing that included attaching a variety of mechanical components to otherwise leather-clad bodies, recalling the uncanny anatomies of the early dadaists. "Using the same *bricolage* techniques pioneered by the punks, they juxtapose 'found' industrial waste (hubcaps, gasmasks, rubber tubing) with state-of-the-art technology and holographic fabrics."[26] Cyberpunk bodies responded to a kind of technological sublimity created by, as Simon Reynolds puts it, "the *retinal intensities* of ultraviolet action, special effects, and, in sci-fi movies, futuristic mise-en-scène and décor." Technological sublimity translated to music and club effects, characterized by the

overwhelming clashes of timbre, rhythm, light, and space, creating an "immediacy machine."[27] Sci-fi influenced the processed sound of electronic musicians like Kraftwerk, as well as the dress of techno-style clubbers who looked "like a cross between *Mad Max* and *Blade Runner*."[28]

Worlds apart from the young West Coast Eudaemons obsessed with devices that could bust casino games, were youths for whom embracing the electronic meant dressing in versions of the punk-related street style sported by famous clubbers like Australian Donna Nolan or New York City's rubber-and-chrome-corseted "cyberslut" Falon. These were styles that quickly made their way to the runway. Even in his first collection, in 1977, Jean Paul Gaultier showed electronic jewelry designed by his partner, Francis Menuge. Techno-fashions appeared frequently in clubs and magazines through the mid-1990s, like the Machine Age spread by Helmut Newton for American *Vogue* in 1995, in which cyborg bodies work futuristic exercise machines, parodying earlier eugenics health regimens. Rather than keeping the technology hidden, as the Eudaemonic wizards sought to do, "faux" technology became a language of body and dress. Indeed, images of techno-fetishized bodies became ubiquitous, coincident with the rise of personal computers in the 1980s. The decade of cyberpunk sci-fi, dominated by William Gibson's 1984 *Neuromancer*, included cyborgs like Molly Millions, the girlfriend of Case, the novel's protagonist. Molly was an augmented femme fatale with carbon-fiber eyes and retractable nails.

Pop-culture cyberbodies during the 1980s were male or female; either way they were fetishistic and borrowed components from a repository of leather-and-metal and rubber-clad erotica in Western culture. The typology expanded with the popularity of sci-fi in popular media, bringing us, for example, the powerful Borgs of *Star Trek: The Next Generation*, appearing first in the 1989 episode "Q Who" and reappearing in multiple episodes, spin-off series like *Star Trek Voyager* (1995–2001), and movies like *Star Trek: First Contact* (1996). But while *The Next Generation*'s Borgs had been gender-neutral and androgynous (but effectively masculine), *First Contact* introduced sexual techno-fetishism in the character of the Borg Queen, a dominatrix described by Laura Frost: "She makes her first appearance as a glistening, bald head (with delicate, classical features and external arteries) floating across a room on a short piece of spine that waves like a tentacle. She plugs herself into her body—a shapely gunmetal-gray mechanical suit—and sets about her task: intergalactic domination."[29]

Techno-fetishism inhabited real-world locations like Click + Drag, a bar founded in 1995 by Rob Roth, Chi Chi Valenti, and Kitty Boots in the Meatpacking District of New York City. It was inspired by the fictive nightlife of Ridley Scott's *Blade Runner* (1982) and *Neuromancer*'s Chiba City, with its tribute to Japanese imaginary technobeings.[30] Sexy Japanese cyborgs abound, from Hajime Sorayama's robot Gynoids in the late 1970s and early 1980s to Major Motoko Kusanagi, heroine of Shiro Masamune's 1989 *Ghost in a Shell* manga, made into a 1995 film by Mamoru Oshii. As

Figure 2.4
Hajime Sorayama, "Sitting Pretty," 1985. © Hajime Sorayama, Artspace Company Y.

Csicsery-Ronay points out regarding the film's cyborg Motoko, "Most striking is the incongruity between the audience's erotic pleasure viewing her attractive . . . body in the opening scenes of Oshii's film and the subsequent disorienting witnessing of her artificial creation in a vat."[31]

Donna Haraway's 1985/1991 "Cyborg Manifesto," appearing within the thick of those fictions, deconstructed the genderedness of the cyborg, construing it as the representation of woman as an "Other" subjectivity, an outsider that opposes "normal," dominant (male, human, natural) gender.[32] Most importantly, the manifesto advocated boundary crossings and all manner of combinations between a range of genders and typologies, including the living and the dead (or the machinic—metal and flesh). In Haraway's mixtures, heterogeneity, not normalcy, and not the dominance of one form over another, prevails. Armed in part with Foucault's notion of "biopower" and Bruno Latour's early critique of the social construction of science, Haraway confronts the monolithic discourse of science and technology, the "informatics of domination" as she calls it, drawn from modernity and "white capitalist patriarchy."[33] The idea was to invent both a new, posthuman approach to technoscience and, simultaneously, a new approach to feminism, which had been mired in outmoded metaphors. The result was the figure of an impure being without clear origin or natural essence, a monstrosity that can jump genders as easily as political perspectives. Haraway's essay is an "'ironic dream' of a common language of technologically mediated hybridity and a politics of perverse affinity."[34] "The organism has been translated into problems of genetic coding and readout"—the world as code.[35]

Haraway's text came at a fortuitous moment, as her former student Zoë Sofoulis writes, coinciding with Foucault's influence in the United States, the surge in personal computing capabilities, and the emergence of the Internet. "The Cyborg Manifesto" also coincided with a focus on the body in art and with Stelarc's first stunning performances illustrating his own ideas about cyborgs and his commitment to the obsolescence of the body, demonstrated in works like *The Third Hand* project (1976–1981), which involved feedback experiments with Stelarc wearing a robotic arm that operated by sensing his muscle contractions.

The pop culture cyborg's signature leather, latex, and metal constituted a trope for the invasion of the organic boundary of the skin. But this "flesh-eating" cyborg image became overextended and, rather than signifying society's frightening future, as did Fritz Lang's 1927 robot in *Metropolis*, techno-fetishes of the 1990s tended toward domesticated, archaic, even medievalizing interpretations.[36] Consistently, and despite iconic cyborg-supermen like the bionic *Six Million Dollar Man* (1974–1978) or *Robocop* (1987), the popular cyborgs that appeared in that period were female if not feminist. It is surprising how nimbly this genre of dominatrix-as-wired-up-cyborg traveled from mass media to new media. In her iconic Psymbiote persona, cyborg performance artist Isa Gordon hosted the original "cyberfashion" shows, held at SIGGRAPH

Figure 2.5
Thierry Mugler, Rubber Robot Jacket, 1999.

conventions. As wireless wearables and video game avatars multiplied, catsuited cyborgs and superhumans projected a thrill of machinic deviancy couched in nostalgia and titillating fetishistic scopophilia (to use Laura Mulvey's famous Freudianism).[37] Relatives of media cyborgs turned up on runways and in fashion magazines during the 1980s and 1990s: for example, Thierry Mugler's iconic (but nonfunctional) Robot Jacket of 1999, shown here with a Geordi La Forge-type VISOR (in Star-Trekese, a Visual Instrument and Sensory Organ Replacement). The next season Mugler's cyborgs were followed down the runway by luminescent printed-circuit patterns worn by android-style models in Alexander McQueen for Givenchy's Fall/Winter 1999–2000 collection.[38]

Ubiquitous Computing and Science Fiction

Advancements in the mobility, accessibility, and wearability of electronic and computational devices were envisioned simultaneously in mass media and private research laboratories. In 1966 NBC TV first aired the series *Star Trek*, the technology-focused sci-fi adventure about the crew of the twenty-third-century starship *Enterprise*. The series was created by Gene Roddenberry, a former military and commercial pilot and policeman turned television writer. In the series the *Enterprise*'s computer was (partly) voice-activated, and crew members wore mobile communications devices and handheld instruments called tricorders—multifunction devices with sensor scanning, data analysis computation, and database storage capabilities.[39] Such devices call to mind the multifunction wearable camera device in Vannevar Bush's postwar essay "As We May Think," which Roddenberry probably read, and which paralleled ARPA-funded research in computational devices. The original *Star Trek* ran only three seasons, but twenty years later *Star Trek: The Next Generation* was launched. Its twenty-fourth-century Starfleet vessel had a fully voice-interface computer (a female voice, naturally), reconfigurable workstations, and a full-scale virtual environment called the holodeck, from which (at least in certain episodes) it was possible to operate some or all of the ship's systems. In addition, communicators were now fully functional badges, worn on the front of the uniform, that operated when pressed, giving the speaker access to a variety of communications channels and serving as emblems of a fictional ideology (as well as commercial brand logos for the real Star Trek franchise). Crew members themselves were integrated with technology. Helmsman (later Chief Engineer) Geordi La Forge's sleek, crescent-shaped VISOR provided enhanced vision despite the character's missing optic pathways, and second in command was an android named Data who continually analyzed "humanity" and earned legal status as an individual during the course of the series.[40] This was the fantasy.

In the real world the term "ubiquitous computing" was coined in 1988, around the same time *The Next Generation* was first airing, by Mark D. Weiser, chief technologist

at the Xerox Palo Alto Research Center (PARC). In a now legendary 1991 article in *Scientific American*, Weiser speculated about the future of miniaturization—including how computers would "weave themselves into the fabric of everyday life until they are indistinguishable from it."[41] By this he did not mean that technology would literally disappear, but that it would become an accepted and not anomalous component of our environment—he compared it, for example, to Heidegger's notion of "ready-to-hand." Weiser determined that computers, as they developed, would range in sizes represented by what he called "tabs, pads, and boards": inch-scale, foot-scale, and yard-scale, respectively, with inch-scale devices clearly being wearable on the body (Weiser mentions "active badges," like the *Star Trek* communicators, that would open doors, signal identity, and initiate other functions). With these categories Weiser created a rudimentary foundation for thinking about ubiquitous computing as a computational experience not framed by the computer console or desk paradigm. Weiser called this "embodied virtuality," by which he meant "machines that fit the human environment, instead of forcing humans to enter theirs."[42] This was the opposite of NASA's previous cybernetics approach.

The idea that ubiquitous computing emerged (in the late 1980s and 1990s) in tandem with popular science fiction narratives like *Star Trek* is explored by several authors, including Paul Dourish and Genevieve Bell. In "'Resistance is Futile': Reading Science Fiction Alongside Ubiquitous Computing," they say that "Design-oriented research is an act of collective imagining," and that in the late twentieth century, fictional narratives of the future, particularly collectively experienced ones, as in TV or the movies, have been a force in shaping technology.[43] Dourish and Bell focus on five British and American TV shows, in particular, as examples of how, in that period, TV had a dominant role in popular culture. As shows played out over multiple seasons as original series and reruns, often syndicated across a range of television and cable stations, they had a sustaining presence in daily life: *Doctor Who* (the original aired 1963–1989, prior to 2005 relaunch); *Star Trek* (the original version of 1966–1969 is discussed, but the 1987–1995 *Next Generation* series is just as pertinent); *Blake's 7* (1978–1981 on BBC1); and *The Hitchhiker's Guide to the Galaxy* (which ran one season, 1981, on BBC2). Dourish and Bell suggest that, by reading the emergence of ubiquitous computing alongside such science fiction, "common ideological strategies" are revealed, strategies that help shape technological development, because "any consideration of a technological future is inherently also an imaginative figuring of a world in which those technologies will be desired and deployed." Also, given this common imaginative purpose, such fiction will tend to reveal critiques of the relationships between technology and society, and expose "opportunities and problems that may attend ubiquitous computing technologies."[44] The idea of cultural fantasy—as opposed to actual life—as a driver for technological discoveries is an idea that pertains also to the emergence of wearable computers in the 1990s.

Figure 2.6
Screen grab from *Terminator*. © 1984 Cinema '84, A Greenberg Brothers Partnership, courtesy of MGM Media Licensing.

Heads-Up Systems

Science fiction television, cinema, and literature converged with the availability of newly flexible or miniaturized technologies in the late 1980s, enhancing the environment for the experiments in wearable electronics that took place at research facilities from 1991 to the early 2000s. But the development of wearable electronics and computers drew upon technologies that had developed elsewhere. Data glove technology dates back to the late 1970s (or even earlier, considering Wiener's hearing glove) but became popular with its use in early Nintendo games in 1987, along with the VPL DataGlove developed by Thomas G. Zimmerman and Jaron Lanier the same year. Full-function laptop computers that could support local-area networks (LANs) were also foundational technologies. HUDs, already developed for military cockpit operations as well as commercial piloting, accommodated the body's normal interface with the world—standing (or sitting) up, looking forward, accessing information with relative freedom of bodily movement. In 1989 a company called Reflection Technology in Waltham, Massachusetts, unveiled Private Eye, a two-ounce, monocular visual readout device that could be hand-held or incorporated into a head-mounted display (HMD) that scanned a lineup of LEDs across the visual field with a vibrating mirror.[45] Images seemed to float in front of the wearer's eyes. In earlier experiments from the late 1970s, hand-tracking functionality (the basis for the modern mouse but also for other mobile

```
Buffers File Edit HTML Help
intensive site due to scanned
pages.  If you are having very
delays in reading these pages,
the "no images" option on your
browser.  </P>

<IMG WIDTH=600 HEIGHT=6
SRC="blue-divider.gif"
ALT="-------------------------
----------------------------

<h2>What's a Wearable?</h2>

To date personal computers have not
lived up to their name.  Most
machines sit on the desk and interact
with their owners for only a small
fraction of the day.  Smaller and
--**-Emacs: index.html      7:43pm 0.25
Write file: ~/*scratch*
```

Figure 2.7

Thad Starner wearing Private Eye and showing display, 1996. Courtesy of Thad Starner.

or handheld tracking operations) was also the focus of several experiments.[46] Carnegie Mellon Computer Science Department, Georgia Tech, and the MIT Media Lab were the early centers for developing wearable electronics and computing systems.[47] Carnegie Mellon claims to have coined the term "wearable computing," and the entire February 1996 issue of *IEEE Personal Communications* was devoted to it.

The MIT initiatives focused early on the heads-up, always-on type of wearable computer. They explored visual displays sporting eyepieces or goggles connected to processing equipment and, in some cases, Twiddlers (one-handed, handheld keyboards). Thad Starner became interested in such systems in the late 1980s when, as an undergraduate at MIT, he watched the first *Terminator* movie and saw its rendition of a futuristic, virtual retinal display, which in the movie represented the viewpoint of the robot (played by Arnold Schwarzenegger). Starner was also influenced by interactive installation researcher Myron Krueger and his book *Artificial Reality II* (1991), in which Krueger discusses his own work, which encompassed computer simulations and data gloves, among other things, built into responsive environments that collapsed the distinction between science and art.[48] Starner argued that there were problems with the then-popular mobile PDAs that were flooding the market, such as the MessagePad developed for the Apple Newton program in 1993. Such systems, he wrote, were

awkward, required both hands to operate, and the handwriting-based interface was too slow and dysfunctional.[49]

Already in 1993 as a graduate student in the MIT Media Lab, Starner had begun wearing an actual computer, which he had adapted for the purpose, in his daily life. It was based on Doug Platt's 1991 invention, a 286-chip shoebox-sized "Hip-PC" with palm-sized keyboard and Private Eye display. Starner's system, built with Platt, was called the Lizzy, after the Ford Model T automobile nickname, "Tin Lizzy,"[50] and was billed as "the first MIT general-purpose wearable computer." The same year (1993) he posted "The Cyborgs Are Coming," a manuscript on wearable computers (which he called "the real personal computers"—as opposed to PCs) on his door at MIT (he had submitted it to *Wired* magazine, but it was not published). His activities attracted attention in the lab, and others, including Steve Mann and Bradley Rhodes, wore similar equipment around. Together they created a sense of momentum and a bizarre ambience, like some sci-fi cyborg hatchery. For a while Starner called the group "Wear-folk"; it became a completely self-funded unit, a student-run project within the Media Lab consisting of graduate and undergraduate researchers.[51] It soon earned the nickname the "Borg Lab," a direct reference to *Star Trek*. By 1995, the year *The Cyborg Handbook* was published—a book that built on Haraway's famous essay to expand the cultural reach of the cyborg model—some dozen students in the Borg Lab were working with wearable electronics or computers.

The MIT Borgs wore hard-shell, heads-up apparatuses that augmented or extended the body, driven by Weiser's notion of ubiquitous computing, which acquired a sexualized dimension. Cultural theorists like Anne Cranny-Francis have characterized this "geeky" period of wearable computing as "a straight-out erotics of power. The wearer was participating in the development of a technology that was seen as world-changing—always a buzz—and which offered . . . freedom from mundane physical reality."[52] A photo taken outside the lab in 1996 captures the spirit of the group (figure 2.8).[53] While Cranny-Francis overstates the case, reflecting the rhetoric of popular futurists like Ray Kurzweil more than the individual wearables researchers in the 1990s, the cyborg as specter of personal empowerment certainly inhabits the language of papers produced by the MIT group. As Starner wrote in 1993: "We are on the edge of the next stage of human development: the combination of man and machine into an organism more powerful than either."[54] Starner's statement and others like it assume a highly progressive vision of human evolution through physical enhancements, suggesting there is a self-organizing system at work that blurs the distinction between organic and nonorganic life, a type of "machinic phylum" that Manuel De Landa describes, one that seeks power.[55] Most early research papers by the members of the wearables group deal with what they called "personalization"—how the computer "remembers" where the wearer has been or what she has been thinking, or how the computer might be fueled by the wearer's own bioenergy.[56]

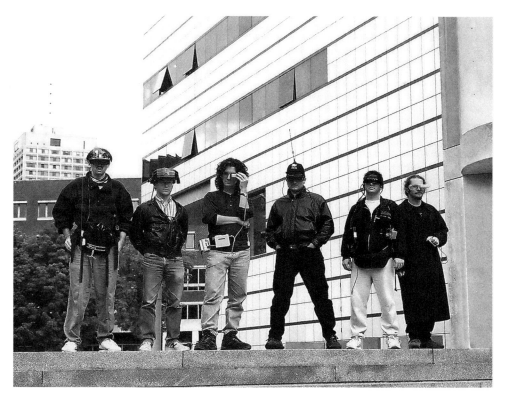

Figure 2.8
Members of the Borg Lab at MIT, 1996: Steve Mann on far left, Thad Starner far right.

As wearable-computer researchers became more ambitious, they took advantage of workshops as a way to promulgate their ideas about systems that enabled augmented lifestyles, especially to impress industrial supporters of the Media Lab. The concept expanded rapidly. In June of 1996 DARPA sponsored a workshop called "Wearables in 2005" (looking ten years ahead) that brought together industrial, academic, and military visionaries in the field. About the same time, David Mizell at Boeing contacted Starner about designing a system for a wearable interface to access wiring configurations for aircraft compartments; Boeing ended up sponsoring a conference in Seattle that brought together major wearables researchers with interested industrial and government partners.[57] A summary of that event outlines the nature of the discussion and demonstrates the desire to define the field and capitalize on its discoveries:

Several observations set the context for the discussion. The first observation is that wearable computers are different from desktop computers. In particular, the desktop metaphor of windows,

icons, menus, and pointers (WIMP) is not the metaphor for wearable computers. There was some discussion about what was a "wearable computer." The consensus was that wearable computers were "always on" in contrast to notebook computers which are "mostly off." Thus watches and cellular telephones could be considered instances of wearable computers. Second, a "killer application" would help launch wearable computer software. The microprocessor and operating system technologies already exist for wearable computers. What is missing is the word processing and spreadsheet type applications which drove the desktop computing revolution. Third, the main application for wearable computers would be acquiring, storing, and retrieving data.[58]

In September 1996 the shipping company FedEx (then FDX), a regular Media Lab supporter, held a wearables workshop with the MIT researchers to explore heads-up displays for their carriers. Starner recalls Rehmi Post pulling a scarf out of his pocket with components soldered onto metallic elements in the cloth.[59] Post was interested in developing wearables for drivers by incorporating functionality into their uniforms. Not only was there growing momentum for wearables research, but the wearable-computer students—the Borgs—were able to interact and collaborate with students in other Media Lab groups, like Post and Maggie Orth, who were intrigued by the capabilities of textiles.

Rhodes, Starner, and others from the Borg Lab became interested in the question of standards for wearables research and the need for disciplinary legitimacy. They helped coordinate an International Symposium on Wearable Computers (ISWC) in Cambridge in October 1997, under the auspices of the authoritative Institute of Electrical and Electronics Engineers (IEEE). The conference was hosted equally by MIT, Carnegie Mellon, and Georgia Tech, the three institutions where wearables research was most active. There were nearly four hundred international registrants for the event, with papers presented on topics like software, hardware, sensors, applications, and systems.[60] Though the range was extraordinarily broad, papers for the first ISWC featured many prototype applications for business and industry.[61] But the bulk of the research reflected the interest in personal physical augmentation. Since then, the ISWC conference has been held annually around the United States and internationally, and has seen a consistent rate of growth.[62] By 1999 wearables had become a part of the high-profile annual SIGGRAPH conference, attended by thousands of computer professionals and vendors.

Steve Mann

Another member of the Media Lab Wearable Computing group, Steve Mann, had grown up in Hamilton, Ontario, attending McMaster University in his home town in the 1980s, where he earned several degrees in engineering and electrical computing. As a high school student in the late 1970s, Mann constructed a wearable camera (he later called these first experiments Wearcomp0 and Wearcomp1, though no actual

computers were involved), described as a "photographer's assistant," with inputtable light sources for an imaging base station. There were several versions of the system, the result, he wrote, of years of tinkering and an interest in how wearable cameras, sensors, and (later) computers enhanced or protected a sense of personal space.[63] In 1981 he built a battery-operated, backpack-based videography system (Wearcomp2), part analog and part digital, which also worked in tandem with a base station and in variations capable of limited recording and playback. Mann was able to view a subject or scene remotely from the viewpoint of the base station. At the same time, an assistant seated at the station could view the subject from Mann's mobile viewpoint through a device Mann called the "aremac" ("camera" spelled backward). These early experiments using bulky, unreliable systems with cobbled-together components served to formulate "a practical application domain for wearable computing," as he wrote in his paper delivered at the first ISWC.[64]

With Mann's Generation 2 WearComp (WearComp3, 1982–1989), he adopted the term "smart clothing": "In particular, I decided that the apparatus needed to be more like clothing than like a backpack."[65] Mann's Generation 2 was intended for "personal documentary" functions (visual and sound recordings) and exemplified "augmented reality." Mann rated the appearance of his Gen 2 as "fashionable," suitable for performance art, and appealing to "artists" and "fringe-groups," though the latter are not specified. The system was integrated more closely with the body of the wearer by means of clothing items like pants and shoes (wired together), a "compute vest" and "radio jacket," as well as a helmet with a display over one eye. "[It] was found to be much more comfortable (e.g., could be worn for several hours at a time), but it lacked a certain kind of interactional constancy that can best be described as cyborgian"— Mann here alludes to Clynes and Kline's 1960 article "Cyborgs and Space."[66] In his book *Cyborg*, Mann recounts excursions in his hometown of Hamilton around 1982 while wearing the Gen 2 outfit. He gradually became more comfortable with his human-machine identity, because culture itself was becoming infused with ideas about physical transformation and body enhancement.[67]

Also in the 1980s, Mann experimented with various means of incorporating conductive threads into existing fabrics, with an eye toward expanding his clothing-based systems. He describes attempting to make wearable computing fashionable (from his perspective) in the mid-1980s, when he worked as a photographic consultant to two hair salons that produced fashion shows. But Mann's persistent focus was the heads-up apparatus. He began building on Sutherland's 1968 Sword of Damocles display, but made it truly mobile. With Generation 3, which Mann began as a grad student at McMaster (and continued to work on later at MIT), he advanced the "seamlessness" of the system and tried to make it more "normal" within certain limits (though not losing its essential "cyborg" character), while at the same time shifting the focus back from fashion to functionality.

When Mann arrived at MIT in 1991 he worked as a PhD student in the fledgling Media Lab, founded by Nicholas Negroponte and Jerome Weisner in 1985. Mann writes that he encountered initial resistance to his work with wearable systems, as he began developing his Wearable Wireless Webcam and wearing it continuously. Negroponte later told the *Boston Globe* that Mann "brought with him an idea that was very much on the lunatic fringe," but planted "an extraordinarily interesting seed, and it grew."[68] In 1994 Mann began transmitting images from the webcam, his head-mounted camera connected wirelessly to a base station and to a website on the Internet. In effect these were images of what Mann was seeing in his daily life. He became more interested in broadcasting optical experience and subverting surveillance, and looking into the phenomenon of obtruding into, rather than exploring, the social landscape of dress. He later wrote that "Many companies seek to replace one fiction with another. In morphing the horrifying ugly cyborg into the perfect runway cyborg nothing really changes: the cyborg is still a story, a style, a twenty-first-century charm bracelet, instead of one of the most important changes in technological implementation since the Industrial Revolution."[69] Despite his early interest in cyberfashion, already in his 1997 ISWC paper he had written that "function was more important than form." He may have been responding to another event involving the Media Lab that year, the year in which he graduated from MIT.

Beauty and the Bits

The remarkable thing about the early history of wearables at the MIT Media Lab was the confrontation that occurred there between the "serious" pursuit of cybernetics-derived and machine-based augmented reality, a world of looking and working, and the "frivolous" world of fashion, a spectacle of glamour and dressing, and the experience of being looked at.

Negroponte, as founder and director of the Media Lab, drew attention to the situation in a 1995 *Wired* magazine article called "Wearable Computing": "What single manufactured material are you exposed to the most?" he asked; "The answer is fabric." Negroponte went on to describe a future in which clothing (made of semiconducting polymer fabrics), accessories (especially shoes), and even the electrical currents in the body itself would converge through increasing miniaturization to turn the dressed body into a digital control center:

How better to receive audio communications than through an earring, or to send spoken messages than through your lapel? Jewelry that is blind, deaf, and dumb just isn't earning its keep. Let's give cuff links a job that justifies their name. . . . And a shoe bottom makes much more sense than a laptop—to boot up, you put on your boots. When you come home, before you take off your coat, your shoes can talk to the carpet in preparation for delivery of the day's personalized news to your glasses.[70]

For Negroponte, heads-up displays in headgear or glasses would become the norm: "Don't expect to see much computing featured in Bill Blass's next collection, but this kind of digital headdress will become more common." As it turned out, Negroponte's article was prophetic in its attention to wearables in the context of actual dress and environments, and may even reflect discussions concerning wearable computers and fashion that were taking place in the Media Lab.

In the same year, 1995, Alex "Sandy" Pentland, another professor at the Media Lab, worked with students and faculty of the Parisian design school Créapole École de Création. Couturier Jean Paul Gaultier, who frequently did advising for Créapole, consulted on the project, and a runway show was held in early 1997 at the Pompidou Center in Paris. Pentland and the Créapole faculty and students appeared on a French television talk show with models dressed in the students' designs.[71] They projected futuristic fashion in garments with embedded applications, such as the flyaway jacket, eyepiece, and hair arrangement shown in figure 2.9. While the jacket was intended to change with the wearer's mood, which did not happen, the hairdo was wired to sensors measuring galvanic skin response, so that when the model became excited, her hair would stand on end (reminiscent of Elsa Lanchester's coiffure in the 1935 film *Bride of Frankenstein*). The skirt had LEDs activated by circuitry, not sensors.[72] In spite of these shortcomings, the ensemble depicted on the poster was one of few outfits in the Créapole show that actually functioned at all. The rest presented an inspiration about what might be possible in the best marriage of sci-fi and runway fantasy. The project aroused so much interest at the Media Lab that a show of wearable-computers-as-fashion-design was quickly planned for Boston and held in October 1997, in conjunction with the first ISWC conference. Entitled "Beauty and the Bits," it was a collaboration involving Pentland, wearables designers at MIT like Thad Starner, Bradley Rhodes, and Margaret Orth (among others), and fashion design students from Créapole, Domus in Milan, Parsons School of Design in New York, and the Bunka Fashion College in Tokyo. The design students teamed up with technology collaborators from MIT, and regular Media Lab sponsors supported the show, including ASCII Corporation, Levi Strauss, L.L. Bean, 3M, and the U.S. Army.[73] "Beauty and the Bits" also showcased a range of technologies, from wearable computers, related to the systems being created in the Borg Lab, to wearables with no real computational capabilities but which utilized active materials like electronic textiles or piezoelectric sensors sending charges to illuminate or sense physical reaction. As part of the ISWC conference, a "Beauty and the Bits" symposium was held in Kresge Auditorium, and Leonard Nimoy (Mr. Spock from the original *Star Trek*) even hosted the event.[74]

In contrast to the Pompidou show, more of the pieces on the "Beauty and the Bits" runway actually functioned, though there were still many aspirational mock-ups. The show was accompanied by a brochure and website elaborating the fashion story:

Figure 2.9
Poster for a smart-clothes fashion show at Créapole École de Création, 1996. Courtesy of Alex
Pentland.

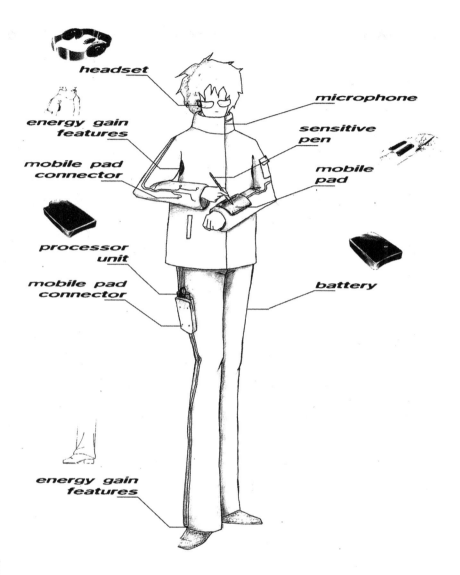

NEX
The Year 2034

Figure 2.10
NEX: The Year 2034; designers Arnaud Écobishon, Kit-Chung Poon, and Koji Kaise; technology collaborator Thad Starner, 1997. Courtesy of Alex Pentland.

much like in the world of couture, where collections often revolve around a persona or narrative, each "Beauty and the Bits" design was inspired by a particular character type, as well as a specific year in the future. For example, a minimalist Courrèges-inspired pantsuit called NEX was proposed to evoke the year 2034. The suit, designed by Arnaud Écobichon, Kit-Chung Poon, and Koji Kaise, with technology by Thad Starner, envisioned a computer embedded in a headset with eyeglasses, a controller pad embedded in a sleeve, and a lithium battery and processor unit, all connected through the fabric of the outfit. It was, literally, a power suit—surpassing the clichéd, broad-shouldered "power suits" of the 1980s—since the batteries were augmented with energy-gain pads in the shoes and under the arms. The glasses also were to have cameras feeding real-time information regarding the wearer's environment to the CPU. The NEX character, named Thera, was envisioned as a Broadway production assistant on the lookout for props, and the NEX suit enabled her to call up information about objects and devices she might need for sets and source them in a given geographical area.

The exotic-looking Lingua Trekka, for the year 2007, was designed for Irina, an imagined medical courier who gathered exotic substances from around the globe. Irina sports a cyborg-like vest (harbinger of Thierry Mugler's 1999 circuit jackets) with microphones, removable miniscreen, and keyboards, which allow her to communicate in any language. GPS and Internet access facilitate travel to remote locations like the South American rainforest. A battery box is installed in the back panel and connects to the front devices through flexiform conduits that can be positioned almost anywhere, making it easy to use the keypad and monitor. An example of work from the Bunka students (fashion design by Nao Muramatsu, Hisayoshi Kuroda, Junko Ito, and Keiko Minomo, with technology by Sumit Basu, Jennifer Healey, and Thad Starner), it suggests inspiration from sci-fi anime.

The show also included pieces designed for handicapped wearers, a frequent subject for research geared to physical enhancement and a common topic for ISWC conference papers. For example, there was a suit for a vision-impaired individual (Vision Suit: The Year 2017, with sonar grommets detecting proximity to objects), hats for the hearing-impaired able to translate American Sign Language (ASL) into speech and speech into braille through backpack computers and tactile chest displays (Van and WearASL: The Year 2017), and a fashionable security suit for anyone in need of assistance, which registered a wearer's startled response (by means of an accelerometer in the collar) and sounded an alarm (The Security Suit: The Year 2021).

Figure 2.11
Lingua Trekka: The Year 2007; designers Nao Muramatsu, Hisayoshi Kuroda, Junko Ito, and Keiko Minomo; technology collaborators Sumit Basu, Jennifer Healey, and Thad Starner, 1997. Courtesy of Alex Pentland.

Figure 2.12
Screen grab, "Beauty and the Bits" fashion show, video, 1997.

In conjunction with the activity surrounding "Beauty and the Bits" at the Media Lab, a piece of jewelry was produced through a collaboration between Maria Redin, a graduate student in Michael Hawley's Personal Information Architecture group, Hawley himself, and Ron Winston of Harry Winston jewelers. Winston was a technology enthusiast, despite the family business, and a personal acquaintance of Hawley's. The group was involved with Polar, manufacturers of heart-rate monitors, and Redin began to wonder what it might mean to display one's heartbeat continuously, as part of everyday appearance, rather than exclusively in hospitals and doctors' offices. Worn as jewelry, the technology "could become romantic, not medical."[75] Utilizing Polar's raw hardware, Redin developed chest strap monitor circuitry and brought it to the Winston headquarters in New York, where jewelers fitted it with real diamonds and rubies.

Figure 2.13
Vision Suit: The Year 2017; designers Gilles Wittoeck, Rémi Ozello-Brocco, William Leon; technology collaborator Leonard Foner. Courtesy of Alex Pentland.

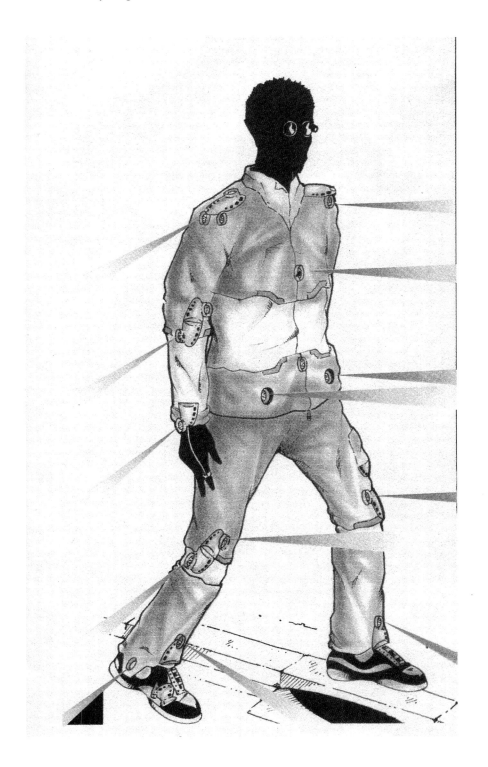

Maggie Orth

Another important contributor to "Beauty and the Bits" was Margaret Orth, who arrived at the Media Lab in 1995. Orth came to the lab with an art, performance, and industrial design background, so she was not the typical Media Lab student. She was not a member of the Borg Lab and did not walk around wearing a computer. She had earned a BFA in painting at the Rhode Island School of Design and an MS in visual studies from MIT's Center for Advanced Visual Studies (CAVS). She had been doing feminist performance and installations but was frustrated with the prospect of showing feminist pieces in art galleries, which were still not (in the mid-1990s) sympathetic to feminist art.[76] As Orth recalls it, at that time making feminist statements solely within the feminist community was like "preaching to the choir."[77] So she began building things for Tod Machover's Opera of the Future Group at the Media Lab, eventually joining that group as a PhD student in 1995.

Orth recalls that most of the Media Lab, except for the fledgling Borgs, were creating software and did not know how to design objects. Hiroshi Ishii and Neil Gershenfeld were just starting the Things That Think working group within the lab, which would explore embedded computation in objects and environments with physical interfaces. But Orth at first found herself exploring ways to embed sensors in rubber shapes for performance pieces, and students elsewhere in the lab began consulting her about making things. Thad Starner and the other wearable-computer students interested her in the idea of wearable computation, but Orth wondered if, rather than hard-shell components involving aluminum boxes with straps, actual clothes could compute. She began experimenting with fabrics to determine their conductivity. When she brought in a swatch of metallic silk organza from a wedding dress (made from "gimp thread"—with a cotton core wrapped in metal, common to Indian saris—which her fellow student Rehmi Post had also experimented with), she discovered that the fabric was conductive enough to support LEDs. Still working with the Opera group, Orth constructed a "musical potholder," a row-and-column keypad made of layered, conductive fabrics sandwiched with tulle. When pressed, the fabric "keys" sent piezo-electric charges to a CPU, which converted them into varying sounds.[78]

For Orth, working on the "Beauty and the Bits" project was challenging, because so many collaborators, with varying English-language skills, were trying to work together across disciplinary boundaries. Not only did the Media Lab students have limited knowledge of fashion for the most part, but the design students had no idea what kinds of technologies were even feasible and tended to envision clothing that could accomplish things like air-conditioning or changing shape, which were impossible at the time. One project that was spectacular to look at was the Red Roadster: The Year 2013, a crimson ensemble designed to be altered in shape and size (through a system of airbags) according to the wearer's desires by inserting an ID card into the

Figure 2.14
Margaret Orth, Rehmi Post, et al., Musical Jacket, 1996. Courtesy of Margaret Orth.

waist pocket. The hat was to serve as a solar power source, the knee pads as sensor-driven illumination, and a brooch as a GPS system. Though these technologies were in existence, they could not be deployed with the size and flexibility required by the Red Roadster design.

Orth contributed several important pieces to "Beauty and the Bits." One of these, the Electric Dress: New Year's Eve 1999 (with Nao Muramatsu, Hisayoshi Kuroda, Junko Ito, Keiko Minomo, and Emily Cooper), was a grand, rococo-inspired gown, almost a costume, covered in gold foil with microcontrollers nestled in the decoration. The dress was more fashion-aspirational—in today's term, more "red carpet"—and less cyberstreet or geek style than any of the other designs in the show. Two other Orth projects were not featured in the publicity for "Beauty and the Bits" but appeared on its runway: the Musical Jacket, with embroidered keypad, and the Firefly Dress. The jacket, which Maggie designed with Emily Cooper and Rehmi Post, was developed

within Tod Machover's Opera of the Future group.[79] It was an off-the-rack denim jacket (Levi Strauss was a Media Lab sponsor), but it had a functional embroidered keypad (designed by Post) over the left pocket, sewn with conductive thread. When a "key" was touched, it sent a signal to another processor, which in turn ran a small MIDI synthesizer (built by Motorola Fellow Josh Smith and graduate student Josh Strickon), worn on the jacket like an embellishment. Sound was projected through miniature speakers in the jacket's pockets. The jacket weighed less than one pound, with most of that coming from batteries and speakers, so it was both functional as a musical instrument and wearable as a garment. With its exposed circuit board and keypad, the Musical Jacket had an odd connection with earlier trends in couture. As early as 1981, Jean Paul Gaultier's High-Tech collection, one of the first to establish his unisex idiom, included leather coats with computer circuitry embroidered onto panels that were safety-pinned in place, punk style, and real, though entirely nonfunctional, microelectronic components as decoration.

Orth's other off-program piece ultimately became the most well-known garment from the "Beauty and the Bits" exhibition: the Firefly Dress and accompanying necklace. The embroidered image on the front of the dress, difficult to make out in photographs, depicts a firefly, an example of bioluminescence in nature. The dress and necklace are constructed of metallic silk organza, conductive yarns, LEDs, and conductive Velcro, so that circuitry and textiles are merged. The hand-sewn electrical circuits complete themselves when the wearer moves, making the skirt and necklace flicker and change color. Thus the movement is not "read" by the system; rather, the wearer activates the system consciously. This was the only garment in the show that was designed for wearability and commercial appeal, though the prototype was too heavy and expensive to be reproduced.

In fact, the aspirational technocouture—functioning little if at all—that characterized much of "Beauty and the Bits" contributed to a general confusion regarding what kinds of technologies could actually be used in garments and what was still fantasy. After the runway show, Orth received numerous phone calls from clothing lines, ranging from Victoria's Secret to sportswear specialists like North Face; frequently the designers had extravagant ideas and no sense of how much technology cost.[80] They wanted lots of different designs, because fashion is based in cycles of change and seasonal turnover. The problem was that, once an electronic module was tooled, hundreds of thousands would have to be sold to realize a profit, whereas clothing producers projected on a scale of tens of thousands of units. Moreover, every company wanted proprietary technology. In 2001 Orth started a company in Boston with Joanna Berzowska called International Fashion Machines (IFM) and worked on creating electronic textiles for companies like DuPont, North Face, E-ink, and Motorola, finally creating stand-alone modules, such as animated flowers that used an E-ink circuit. Orth chose E-ink, later commonly used for e-readers, because it does not light up. She reasoned

Figure 2.15
Margaret Orth, Emily Cooper, et al., Firefly Dress, 1996. Courtesy of Margaret Orth.

at the time that LEDs and other illuminated components would lack broad appeal ("I saw [these] as limited to rave-wear"),[81] a story that shows the difficulty of predicting trends in a highly complex behavior like dress.

IMF also worked at solving some elementary industrial problems—making the textiles withstand washing machines, dryers, and dry cleaning. But rather than concern for such basics, the industry as a whole had extravagant visions for technology products. The publicist for Tech-U-Wear: The World of Wearable Computing, a conference held at Madison Square Garden in New York in 2001, wrote:

IDC [International Data Corporation] predicts in the region of 450,000 wearables worth $719 million will be shipped by 2004 in the U.S. alone, up from $11.5 million in 2000. Outside the U.S.A. the value of devices shipped could top a [sic] $1 billion by that time. That may seem small potatoes when compared to the revenues in other computing Sectors, but it's only the beginning of a market that's set to explode as the ultimate in mobile/PC convergent technology comes off the leash.[82]

But the explosion of the market was not realized. The collapse of the technology bubble and the market pullback after 9/11 terminated risk-oriented segments of the industry. By the mid-2000s, the potential for WT to succeed in commercial designs was overtaken by the development of increasingly multifunctional mobile phones.

Technology on the Runway

Looking back, the leap from wearable computers to fashion on the runway was an easy step in the mid-1990s, a time when fashion shows were being defined as media spectacles. Designers abroad (particularly British-trained John Galliano and Alexander McQueen, designing for Givenchy and Christian Dior, respectively) spent lavish amounts of money on events that became theme-based performances, representing an adaptation to new, intensively media-driven market conditions using high-technology effects. Ironically, such runway extravaganzas seldom targeted sales of specific items but served instead to expand the prestige of fashion and the reputations of specific designers.[83] The precedent was already set in the 1980s by Thierry Mugler, who had staged a series of theatrical shows, including one in which the models and clothes enacted the Virgin Birth on a runway "peopled with hooded nuns, cherubs, and a Madonna and child," which set him up for the press's complaint that "the show overshadows the clothes."[84] In 1994 McQueen's "Nihilism" show featured models made up to look bruised and battered, who wore deconstructed garments down runways covered in dirt and fake blood. In 1997 Galliano's first couture show for Dior was staged in the Grand Hotel in Paris, which was made to look like the original House of Dior, complete with the famous staircase on which Cocteau and Dietrich had sat in the 1950s. In London in particular during the 1990s, fashion shows were billed as "the

new performance art," the art/fashion connection drawing energy from the unprecedented expansion of the art market during the same period.[85] Carolyn Evans compares the situation with Guy Debord's idea of capital as image, noting that the new fashion-centered theatricality reflected a different commodity condition than the neo-Marxist spectacle:

As electronic media and global markets developed, and service industries replaced older forms of industrial production, information became a valuable commodity in its own right. In the shifting constellations of the culture industries fashion began to signify in a number of different registers. Debord's sour denunciations of the image seem curiously redundant in a culture in which the fashioned garment circulates in a network of signs as both image and object: no longer representation, the image is frequently the commodity itself.[86]

Of course the MIT fashion show had no such grandiose sets or drama. Nevertheless, it gained a certain legendary status as fashion spectacle, if on a smaller scale, because it substituted for couture theatrics the technological masquerade of enhanced outfits worn by fantasy cyborgs, outfits that lit up or made noises on the runway. "Beauty and the Bits" was covered on local and national television, including a spot on CBS's *60 Minutes*, and in print, with features in *Vogue* and *USA Today*.[87] And it resonated with the fashion context of 1997, when wearable computers and high-tech materials were turning up in fashion venues. The same year, Walter van Beirendonck, a Belgian menswear designer, used flashing LEDs on T-shirts in his Avatar collection. Gaultier unveiled his Cyberhippie collection for spring/summer 1996. In some cases celebrities paired with designers, often appearing in their shows, like singer-songwriter Björk, who walked Hussein Chalayan's spring/summer 1995 runway the year she wore his Tyvek "postal jacket" on the cover of her album *Post*.

Even new commercial enterprises, geared to sell wearable computers to commercial customers, leveraged themselves with some sort of fashion connection. A company called Xybernaut was the first to retail a complete wearable system with HUD, camera, wrist keyboard, and belt-mounted CPU. Xybernaut's Mobile Assistant IV was used to show off Stephen Sprouse's fall/winter 1999/2000 collection. Sprouse was a street-inspired designer who had won attention in the 1980s with 1960s- and 1970s-revival runway collections, often using techno street themes, including an urban graffiti pattern done with Marc Jacobs for Louis Vuitton in 2001. Sprouse commented to the press that he "had no idea that the computer industry has advanced to the point that people can be wearing computers" and that he thought the wearable computer made "the audience think beyond clothes to the new millennium and added an element of excitement to the show."[88]

In 1999 Thad Starner and Sandy Pentland, together with the well-connected futurist Alexis Lightman, founded a company called InfoCharms, later renamed Charmed Technologies, as a way to capitalize on wearables as a field that was popularizing, even

Figure 2.16
Model wearing Charmed Communicator with Charmed Eyesite display and thumb mouse, proto-
types, 2000. Courtesy of Jarrell Pair.

glamorizing, technological research. Lightman was a charismatic spokesman for futurist technologies. In his 2002 book *Brave New Unwired World: The Digital Big Bang and the Infinite Internet*, he embraced the wearable interface as the way of the future, anticipating that 4G technology, not yet in use when the book was published, would enable widespread wearable ubiquitous computing, and that heads-up, hands-free systems would "take advantage of people's perceptual capabilities in order to present information and context in meaningful and natural ways."[89] Charmed Technologies launched three projects. First was the production of a wearable computer in the form of the CharmIT Developer's Kit, built by Greg Priest Dorman at Vassar.[90] This was an industry-standard PC/104 processing unit with a 10-gigabyte hard drive, cable/connector kit, and lightweight aluminum housing, which could be ordered from Charmed (for $2,000, a low price at the time) or built by anyone, since all plans and specifications were released as open-source hardware and software in an effort to popularize the concept and stimulate commercial applications. Charmed Technologies also developed a computerized event badge with LED lights, the CharmBadge, as a way to record contact information, navigate conference crowds, and create affinity connections between conference-goers with specific interests. Finally, Charmed launched an international program, its Brave New Unwired World (BNUW) fashion shows, beginning in 1999 with two highly publicized shows in New York and Hong Kong and subsequent ones in Singapore, Tel Aviv, Los Angeles, London, Berlin, Sydney, Seoul, Chicago, Stockholm, and Paris by the end of 2000, finally totaling about a hundred events in all. Produced for a large fee, they carefully allied fashion with technology using the runway format, and were features at a variety of Internet trade shows. BNUW events showcased their own technologies alongside products by Xybernaut and Motorola—even Starner's Lizzy—on stylish professional models. Slovakian ex-model and, according to legend, ex-spy Katrina Barillova helped found the original company (InfoCharms) with Pentland and served as operations manager.[91] She was so compelling that some accounts of Charmed, Inc. cite hers as the primary name associated with the company.[92] In fact Charmed drew on numerous investors and researchers, including Jarrell Pair as human-computer interface specialist and Shannon Davidson, a high-profile fashion show producer.

More Cyber Fashion Shows

SIGGRAPH is the annual computer graphics conference hosted by the Association for Computing Machinery (ACM). It was founded in the late 1960s and began to hold conferences annually and around the world from 1974. SIGGRAPH's thrust is digital animation and design in all forms, notably computer games and animated cinema, but spin-off workshops at the conferences have explored the whole range of digital and interactive media. In the early 1990s a regular feature was the Guerilla Studio, in

which vendors set up new or prototype equipment and attendees could explore the technologies, creating digital art prints onsite in the early days, for instance, and participating in hands-on learning and theme-based projects later on. The Guerilla Studio was the place where enthusiasts, whatever their corporate affiliation or lack thereof, came to explore the possibilities of diverse new technologies.

In 2001 Dan Collins, a professor at the progressive art and technology-oriented Institute for Studies in the Arts (ISA) at Arizona State University, was asked to run SIGGRAPH's Guerilla Gallery. (The gallery was renamed the Guerilla Studio for the Los Angeles conference that year and received outside resources and support for a new endeavor in the area of wearables.) Collins enlisted ISA's students, which included mechanical jewelry designer Jesse Jarell, costume designer Devon Brown, and performance studies graduate student Isa Gordon, whom Collins asked to help technology designer Jason Brown create a "digital fashion show" in the next Guerrilla Studio, at the 2002 SIGGRAPH conference in San Antonio. Gordon spent a year calling upon industrial and academic developers of WT like Greg Priest Dorman, Thad Starner, and Alex Lightman. The result was the first SIGGRAPH Fashion Show, designed as a runway event with a cyborgian theme showcasing industrial products like Xybernaut, CharmIT, Spectre's digital night vision glasses, and products to support wearable systems, like a backpack by Tek Gear and the SCOTTEVEST.[93] While the 2002 show content was cobbled together—almost a trial run—Gordon assembled an array representing the state of WT and achieved a provocative, part goth, part high-tech, part sci-fi theatrical atmosphere unlike the high-fashion shows of Charmed, Inc., and geared less to corporate investors and more to young technology enthusiasts.

Gordon appeared as show host in the guise of Psymbiote, a sexy cybernetic creature in a latticed catsuit layered in latex and leather and wearing a clawlike titanium cyberglove fitted with flexible sensors (though not fully functional). She narrated the show from a script accessed through a head-mounted display. In all, she performed as a figure of transformation between body and technology, a "human/machine chimera" worthy of Haraway's predictions.[94] The body-augmenting costume was a cross between, say, Steve Mann's wearable systems of the 1990s and *Star Trek: Voyager*'s Seven of Nine, incorporating elements of apocalyptic, post-*Road Warrior*, techno-club style and topped off with a Medusa headdress of wiring and dreadlocks. Best of all, Psymbiote's technology malfunctioned at several points in the show, allowing Gordon to narrate the technological fix that she executed on the spot, drawing in the specialized audience members who had intimate experience working with wearable systems and knew about their glitches. Gordon created Cyber Fashion Shows for the succeeding three SIGGRAPH conferences, culminating in the 2005 show (coproduced by Alex Lightman) in Los Angeles, which expanded to include not just products and commercial prototypes but one-of-a-kind conceptual works in WT. These were created by artists/designers

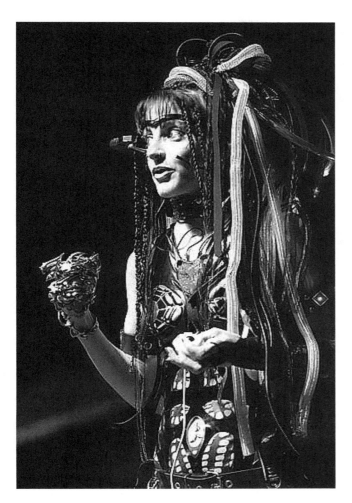

Figure 2.17
Isa Gordon as the Psymbiote, 2005 SIGGRAPH CyberFashion Show. Photo by Jeff Koga for Greg Passmore Photography and Z Media Studios. Courtesy of Isa Gordon.

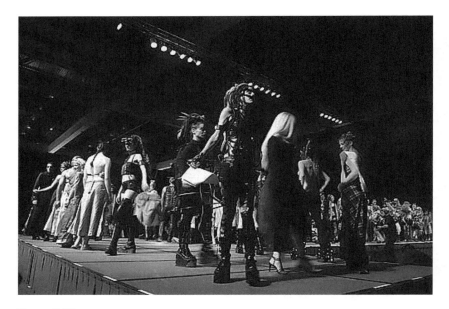

Figure 2.18
Runway, 2005 SIGGRAPH CyberFashion Show, Los Angeles. Photo by Jeff Koga for Greg Passmore Photography and Z Media Studios. Courtesy of Isa Gordon.

like Katherine Moriwaki, Sara Diamond, Di Mainstone, Elise Co, and researchers at Keio University Akira Wakita and Midori Shibutari, who developed an elegant coat and dress that changed color according to galvanic skin response and acceleration of movement.

In all, the 2005 SIGGRAPH fashion show represented every approach, from highly instrumentalized wearable computing like the Fire Warrior Micro Thermal Camera, designed to help firefighters see through smoke, to smart clothes and accessories of all stripes. Press coverage was extensive, including items in *Wired*, the *New York Post*, the *Hollywood Reporter*, *CA Apparel News*, and *LA Weekly*, and spots on NPR and BBC Radio.[95] Unfortunately the production had become too large and dependent on local resources to survive.

Instead, in 2006, a successor show entitled UnRavel was created for SIGGRAPH in Boston by Amanda Parkes, a graduate student at MIT. UnRavel was less of a spectacle. All references to cyborgs or science fiction were expunged. The emphasis was on serious aesthetics. Exploratory and performance-based work by artists and designers not affiliated with commercial firms dominated, a fact that cut the WT event off from the mainstream focus of SIGGRAPH on industrial research and development. Parkes also created an UnRavel show for SIGGRAPH 2007 in San Diego,

where it was held way off site at a bar rented to host the members' party. Finally, in 2008, the WT fashion show was dropped from the SIGGRAPH conference events calendar.

By then numerous technology fashion shows had cropped up at universities and institutes around the country.[96] Beginning in 2005 a series of three annual WT shows, under the title "Seamless," were presented at the Museum of Science, Boston, inspired by the reality TV show *Project Runway*, which first aired in 2004. The first "Seamless," in 2005, was organized by MIT Media Arts and Sciences students Nicholas Knouf and Christine Liu and sponsored by MIT's Council of the Arts and Media Lab partners Puma and Motorola.[97] It showcased invited work by design students from the lab as well as from Rhode Island School of Design, Parsons School of Design, and New York University. The pieces were conceptual and playful for the most part and did not pitch commercial ideas. Of the 2006 "Seamless" Knouf said, "We want to showcase an alternative view of the future of fashion, one that combines technology and clothing in an engaging and aesthetically pleasing way."[98] As with the SIGGRAPH shows, the "Seamless" shows ended in 2008. That year I curated a runway show exhibition called "Social Fabrics" at the annual meeting of the College Art Association.[99] "Social Fabrics" looked at WT in the context of socially conscious art practice, reflecting the fact that the nature of the subject had changed. In general, the early lavish support from industry disappeared as research and development budgets shrank after the stock market downturn, and many questioned the importance of wearable devices after the appearance of the sleek, multifunctional iPhone in 2007.

Already in August 2005, in a post to the media theory discussion list Empyre on the topic of "clothing [and/as] technology," interaction designer Scott Patterson had wondered if the field was becoming hindered by limited metaphors or scope, or perhaps presentation problems. "What is the criteria [sic] for success?" he asked, a valid question as wearables began to emerge with seemingly different strategies and goals. The center of gravity for wearables exploration had passed from computer science and laboratories to industrial design departments in universities and academic centers. At that moment, with so much at stake, Patterson questioned the drive for spectacle. "Why have fashion shows become the prevailing mode of presentation?" he inquired, suggesting that such shows target an elite audience.[100] Setting aside the fact that, in the field of technology studies, many venues seem elite anyway, or at least specialized, and that Empyre is one of the most elite (theoretical) technology discussion forums in existence, fashion is extraordinarily broad-based in popular culture. Fashion incorporates contradiction, expressing the desire for fantasy along with function and the amalgamation of the "once was" with the "will be" (think steampunk, or goth and cyborg, or, for that matter, augmented reality with piezoelectric sensing). Giorgio Agamben has written about the disjointedness of fashion, always too early or too late,

"an ungraspable threshold between 'not yet' and 'no more'"—and how, as a result, fashion exemplifies the contemporary condition.[101] This "special experience of time" demonstrated by fashion also characterizes technological innovation—epitomized in the search for an elusive "killer app" for wearables that reveals itself only in an imaginary future, or in the wisdom of hindsight. Nothing could better illustrate the untimeliness of wearable technology as it was, amid the fading futurism of the first decade of the twenty-first century.

3 The Invisible Interface

WT Terminology

"Wearable technology" (WT), the blanket term used here, has various meanings. The original term was "wearable computing," which started with Edward O. Thorp and Claude Shannon's pocket-sized analog computer developed in 1966 to predict results in Las Vegas roulette games. Since then this term, shortened within the technology community to "wearables," has applied to generations of wearable computers as well as to other mobile devices right up through the iPhone.[1] "Wearables," of course, in the wider culture means (or used to mean) simply clothing, so the use of the term to refer specifically to wearable computers is evidence of how technological language impacts common speech.

In addition, the term "WearComp" (initially coined by Steve Mann) or, more broadly, "wearcomp" bears a relationship to "ubicomp"—the short form for "ubiquitous computing" (also known as "pervasive computing"), also in common use.[2] In line with ubiquitous computing's technology-driven environment, wearcomp aims at augmenting or empowering the user in some way, either by enhancing her perceptual reality or access to knowledge or by enhancing her physically. Early wearable computers were not actually *worn*, they were carried or held, or placed out of sight in pockets or installed in shoes, and ultimately have little to do with the bodily display that is the nature of dressing. Where wearable computing is actually wearable (and visible on the body), it appears as a technological prosthetic—as demonstrated by the members of the MIT Borg Lab. But pocket-sized or prosthetic, wearable computing suppresses the body in favor of the mind or intellect, or the body itself is comprehended as biometric data. Wearable computing is generally not conceptualized in the contexts of dress; instead it favors positivist wearable systems that ignore clothes' cultural connotations and seek the pure functionality of the invisible body. This is a theme common in sci-fi literature, as in the polycarbon suit in William Gibson's influential 1984 novel *Neuromancer*, a garment that appears to erase the body altogether.[3] In the end, most wearable computing accords with modernist, masculinist views that subordinate the physical body.[4]

Terms that do signify dress are many, including "smart clothes," "fashionable technology," and "fashionable wearables," terms that, as we have seen, got their start in the late 1990s, when technology and fashion drew upon ideas in popular culture. In 1995, when Alex Pentland began collaborating with the Paris Créapole to create the Pompidou show, the project was termed "smart wear."[5] Later, Sabine Seymour, who claims authorship of the term "fashionable technology," uses it in a general way, encompassing everything from wearable systems to smart textiles. She writes that she is concerned with "designed garments, accessories, or jewelry that combine aesthetics and style with functional technology."[6] Related nomenclature revolves around the idea of "embedded technologies," the actual circuitry or devices worked into a garment or fabric, for example, "electronic textiles," "e-textiles," or "techno-textiles"—all meaning roughly the same thing. With her background in art making, set design, and feminist art, Maggie Orth first brought to the MIT Media Lab ideas about flexible or woven circuitry and conductive fabrics. In 2000 Woodrow Barfield and Thomas Caudell, in their comprehensive anthology *Fundamentals of Wearable Computers and Augmented Reality*, put forward the term "computational clothing" to refer to "clothing that has the ability to process, store, retrieve, and send information," but this term did not achieve wide circulation.[7]

The umbrella term "wearable technology" circulates throughout the discourses of these fields in a general way that can seem contradictory or confusing. Sometimes it refers to devices that are actually worn, and sometimes not (as with pocket-held devices). It can apply to work that is, in the end, functional in application and potentially commercial in distribution. But at the other end of the spectrum are works that are experimental and conceptual in nature and aid awareness of embodiment. They may be based on research that could eventually have functional applications, but they exist as artworks or creative designs that have noncommercial or primarily conceptual content. Circulating in art, fashion, and academic systems, they are often seen or performed at workshops and conferences of professional societies, but sometimes they are found in art galleries and museums. I call this work "critical WT," or "critical dress," and it will be discussed in chapter 5.[8]

Personal Affective Computing

A field entangled with WT is "affective computing" or "affective wearables," which developed from the larger domain of ubiquitous computing (ubicomp), initiated in the late 1980s by Mark Weiser. Weiser's fundamental principle was technology's drive to disappear. In a talk given at Xerox PARC in 1994 he said, "Good technology is invisible . . . ubiquitous computing is about 'invisible' computing."[9] To Weiser, the term "interface" inferred a boundary, something to be eliminated. Weiser envisioned ubicomp as the opposite of virtual reality. He imagined it would become a

natural and empowered way to deal with the everyday realities around us, to release us from the stresses of information technology overload and calm us down.[10] Weiser was a thoughtful techno-scientist, but his untimely death in 1999 prevented the evolution of his ideas and any reassessments he might have made as technologies advanced.

Rosalind Picard, a computer engineer from Georgia Tech, joined the MIT Media Lab in 1991, when she began working with search and retrieval tools for digital images and video. Later she oversaw Steve Mann's graduate research (his "photographer's assistant" project). Also at MIT she formed a new working group based on the concept of affective computing, a term she coined. The idea, based on the fundamentals of ubicomp, was that computers need to be able to read and respond to the emotions of their users. Ironically, her view of the body as a source of emotions advances the idea of the body as manipulable text or data. Picard explains affective computing as "computing that relates to, arises from, or deliberately influences emotions." Computers that read our emotions and/or simulate having them are within her purview; however, Picard explicitly does not address "how people feel about their computers, and how and why their feelings evolve as they do."[11] Picard's theory and subsequent research served to entrench this view of the body as code or data, especially in military and medical applications.

Affective wearables do not merely augment the wearer; they also deal specifically with human emotional states, and often deal with them proactively. A 1997 paper by Picard and wearable computing grad student Jennifer Healey, titled "Affective Wearables" (given at the first ISWC conference), described a wearable system, built at MIT with the help of Thad Starner, that focused not on input and retrieval of images and data in the wearer's environment, or what is accessed through digital media (Internet and email), but rather on sensing the wearer's autonomic biosystems. Called the Startlecam, it consisted of a wearable camera, worn as a piece of jewelry around the neck, that continuously recorded images. Small electrodes attached to the wearer's hand or foot measured skin conductivity, and pattern recognition software was programmed to recognize the wearer's "startle response," "a skin conductivity pattern that occurs when the wearer feels startled by a surprising event." In other words, Picard and Healy wrote, when the wearer is extremely affected by something she sees, a response is detected. The triggering images picked up by the camera could be saved and/or sent to be analyzed by friends and family, enabling action (like contacting the police) if the wearer were to be, for example, threatened in some way. "StartleCam is an example where analysis of a wearer's affective patterns triggers actions in real time."[12] The authors also experimented with an "affective CD player" that read bodily indicators of emotion and then played an appropriate piece of music, supporting a light mood or ministering to an unhappy one, because, as they wrote, "Music is perhaps the most popular and socially accepted form of mood manipulation."[13] This

mention of what might be socially acceptable is the only indication in the article that there could be any concerns about psychological or social control mechanisms. In fact, there is some discussion of how to create a personal-area network that would wirelessly connect sensors, processors, and other devices located in the wearer's shoes and jewelry, making them inconspicuous or, in fact, invisible.

Picard's book *Affective Computing*, also published in 1997, has a short chapter entitled "Potential Concerns." Some of these concerns are ones "we will likely never encounter," like the fictional computer HAL in *2001: A Space Odyssey* and other "famous computers and robots who have run amuck," in part because of their affective functions—they do not work well and the computer misunderstands or badly imitates human emotions. These, Picard writes, are technologically improbable, at least in the foreseeable future.[14] Among her more serious concerns is the potential for affective computers to mislead people and engender mistrust—software agents might be programmed to appear sincere but to lie, for example. Moreover, in cases where a computer might (in the future, say) have emotions itself, should it be allowed to direct them toward a human? Or if a computer can sense our moods, how is it supposed to act? (Picard cites the Happy Vertical People Transporter from Douglas Adams's *The Restaurant at the End of the Universe*, 1980, which tried to cheer everyone up but only made them happy when it broke.)[15] In Picard's view, "If a software agent found its user feeling down and out while cruising on the net one night, it should not engage in juvenile responses such as spewing forth 'Cheer up!' messages, or worse, selling the user's name to advertisers who might bombard her with slogans such as 'Drink Pepsi' to feel better." Instead, she proposes, it should point its user toward other people to chat with, or find some distracting news item. In other words, it should be cunning and effective. Picard acknowledges the potential problem of privacy, as computers gather increasing amounts of data about our emotional states, but she suggests this is only a problem if we begin to feel out of control. She assures us that alarmist scenarios of overt political or centralized emotion control are far-fetched (although fifteen years down the road, we are now encountering these very issues in the wake of leaks and whistleblowing concerning government surveillance).[16]

In the end, *Affective Computing* does not really address the idea of manipulation, or consider how people might become subjectified by computers that control information about our personal behaviors and are programmed to exploit such data. In the chapter on affective wearables, Picard indicates how jewelry and clothing, being relatively unobtrusive in our daily lives, can effectively gather information about our habits and reactions to stimuli.[17] Adjacent to our skin, they have perfect access to our pulse and sweat glands. Such biometric items, like Starner's and Mann's more ungainly wearables, would be "always on," but so unobtrusive as not to interfere with the wearer in any way. They could collect unprecedented amounts of information, not just about our behaviors but about our emotions.

Affective computing grew out of the interest in wearable computers and the expanding capabilities of technologies like sensors that measure simple bodily processes. Although wearable computers began with the intent of personal empowerment—to win at gambling, for example, or to store and process larger amounts of information than ordinary memory can handle, or to access online communications—research and development focused increasingly on an interpretation of augmentation that transfers agency to the computational system. In a 1997 paper entitled "Augmented Reality through Wearable Computing," the authors (a collaboration including Picard and Starner) surveyed the field at that time and identified what they saw as its long-term goal: "to model the user's actions, anticipate his or her needs, and perform a seamless interaction between the virtual and physical environments."[18] In affective computing it is the computer, not the human "host," that is aware: reading physiological data (biometrics), making decisions, responding to external conditions. "Aware" or "context-aware" intelligent wearable computers conduct an increasing array of medical, field, and office labor, and have many leisure and lifestyle applications. But the focus of these applications, the human wearer, is represented by default as unaware and so, ultimately, as a regulated or mediated subject.

Affective Computing and Emotional Awareness

Recent directions in cognitive science emphasize embodied emotion and experience as existing in opposition to cybernetic, mind-centered theories. Antonio Damasio's work is useful in reconsidering how emotion might apply to wearable technologies. In his book *Descartes' Error* he points out that, far from a Cartesian mind or self existing at the core of, and in opposition to, the body, the mind—and any sense of self we might fleetingly possess—is an interplay of processes distributed throughout the body.[19] Indeed, Picard cites Damasio's ideas about embodied emotions, but she does so in the context of a discussion of how computers, not humans, might have them.

In Damasio's later book, *The Feeling of What Happens* (published after Picard's *Affective Computing*), he focuses on the importance of emotions for consciousness. He says we propagate emotions intentionally by surrounding ourselves (and, I would add, adorning ourselves) with things we emotionally respond to, and we do this because emotions are bound up with our ability to think, imagine, and even reason.[20] Emotions are bodily functions in humans that foster higher thought processes. Damasio contends that emotions are not exceptional states—rather, we are always having them.[21] Furthermore, this experience is a complex, distributed, and constantly changing form of behavior. He bolsters his arguments with research done on patients with brain damage that can be located physically through brain-mapping techniques. Significantly, Damasio distinguishes between emotion and feeling: the first is a collection of

responses that form a pattern. Emotions come in many forms, not all of which are publicly displayed. The second, the feeling, is the private, mental experience of an emotion. "We can feel our emotions consistently and we know we feel them . . . [they are] part of a functional continuum."[22]

Emotions are impossible to enumerate—there is no finite list of primary emotions, in Damasio's view—although he thinks that certain broad categories can be distinguished, because they involve different locations in the brain and different chemical conditions in the body. Furthermore, beyond having an emotion and feeling it, we know we feel it. "Feeling feelings," as Damasio calls it, involves a second order of representation necessary for core consciousness, and it is of extraordinary value in the orchestration of survival. "Emotions are useful in themselves," Damasio says, "but the process of feeling begins to alert the organism to the problem that emotion has to solve."[23] It might be fair to speculate, then, that any mediation in the circuit of having emotions and feeling them—any system that administers to the physical emotions before we can mentally process them—might create problems.

In her book *Materializing New Media*, Anna Munster criticizes Damasio's approach to emotional embodiment as one that nonetheless instrumentalizes the body in the manner of affective discourse: for Munster, feeling feelings might be expressed in the phrase, "the feeling that one is in the mapping of one's self"—an affectivity "produced in relation to the body rendered as information."[24] Perhaps so, and perhaps the instrumentalization of the body is so internalized in scientific discourse that it cannot be avoided. Nevertheless, Damasio's view offers a dynamic encoding of mind-body experience that is not static and cannot be predicted. His notion of "feeling feelings" is a process expressed in performance works by artist Riitta Ikonen, who creates nontechnological garments that demonstrate felt emotions like anger, emotions that arise from specific physical sources in the everyday, like being overheated on subways—or perhaps rage at nothing we can name. These garments are presented in staged photographs, but Ikonen imagines that they might be worn experimentally in the real world, so the wearer tests the impact of the garment, on herself and others, as a way of both inducing feeling and contemplating exaggerated levels of emotion.[25]

The Disappearing Body

Numerous writers, including N. Katherine Hayles and Barbara Wegenstein, have shown how technology's virtualization of the body has become part of the discourse of posthumanism. They have portrayed postmodern subjectivity as an ongoing action that, as Munster writes, feeds into a "system of disembodied optics." It refers to a habit of thinking that began with Descartes.[26] In the wake of cybernetic theory and the advance of informatics, emotions became part of a lost corporeality. The implications of this have permeated our culture, especially our notions about the body.

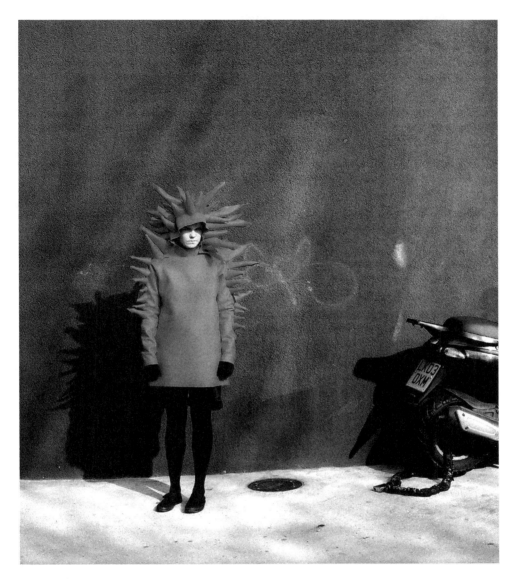

Figure 3.1
Riitta Ikonen, *My Unexpressed Anger at Nothing in Particular*, 2008. Photograph by Anja Schaffner.
Courtesy of Riitta Ikonen.

Linkages between emotion and dress have rarely been investigated in cultural history and theory, which have only begun to critically investigate the realm of fashion. Joanne Entwistle suggests that this omission is due to the persistence of notions about the body as textual or as acted upon by culture, exemplified by Marcel Mauss's "Techniques of the Body" and Foucault's notion of "technologies of the body," both of which presume bodies, and consequently embodied subjects, that are constructed by external social regimes.[27] In *How We Became Posthuman* Hayles ascribes the progress of disembodiment to Foucault, who described the body as a play of discourse beholden to semiological structures. Accordingly, Entwistle argues that "Foucault's work may contribute to a sociology of the body as discursively constituted but is limited by its inattention to the lived body and its practices, and to the body as the site of the 'self.'"[28] Hayles quotes Elizabeth Grosz, who summarizes more broadly "that the mind/body split, pervasive in the Western tradition, is so bound up with philosophical thinking that philosophy literally cannot conceive of itself as having a body."[29]

New-media theorists have addressed the body, but usually as a mediated phenomenon. In his book *New Philosophy for New Media*, Mark Hansen bemoans the virtualization of the body expressed by twentieth-century cybernetic theory. He combines ideas from Henri Bergson, Walter Benjamin, and Gilles Deleuze to argue for embodied affectivity at work in digital media art, but his argument for recorporealization is hampered by his focus on virtual and screen-based forms.[30] In *Getting under the Skin* Bernadette Wegenstein treats phenomena from popular culture and feminist performance art to argue that the body has taken on the characteristics of a medium: mediality is the new corporeality.[31] For media theorist Lev Manovich, however, the phenomenon he calls the "externalization of the mind," a process in which technologies objectify reasoning and control or augment it, goes back at least to Francis Galton. Manovich maintains that an "assumption of isomorphism" between "the mental process of reasoning and the external, technologically generated visual forms has haunted us at least since the end of the nineteenth century."[32]

In a similar if more historically abstract vein, Paul Virilio writes about the fading of the physical with the rise of motors and cinematic machines. One figure that Virilio sees as representing this process is the late nineteenth-century photographer Étienne-Jules Marey, who specially clad his subjects to achieve his special effects: "The whiteness of birds or that of horses, the brilliant strips pasted on the clothes of the experimental subject, make the body disappear in favor of an instantaneous blend of givens under the indirect light of motors and other propagators of the real . . . the aesthetics of disappearance renews the enterprise of appearance."[33] Virilio's other figure, from the early twentieth century, is the reclusive Howard Hughes:

Hughes was already aping our future, the abandonment of the vehicular speed of bodies for the strangely impressive one of light vectors, the internment of bodies no longer in the cinematic

cell of travel but in a cell outside of time, which would be an electronic terminal where we'd leave it up to the instruments to organize our most intimate vital rhythms, without ever changing position ourselves, the authority of electronic automism reducing our will to zero.[34]

Similarly, in his *War in the Age of Intelligent Machines*, Manuel De Landa writes about the military push "to get humans out of the decision-making loop," to create a machinic phylum capable of ever more efficient armies and (ultimately) systems of government that approach the sci-fi-sounding dystopia of the "computational society."[35]

Italian philosopher Giorgio Agamben brings up the ethics of affective technologies in his essay "Identity without the Person," in which he cites the ongoing proliferation of biometric technologies, such as optical scanning to obtain fingerprints and iris patterns, and notes that in Europe a biometric identity card is making an appearance (in fact, the *Carte nationale d'identité sécurisée*, or CNIS, has been put in place in France as a noncompulsory identity document since his book was published). Indeed, there is movement toward creating digital archives of DNA to implement systems of managing health and security. This goes beyond the mining of our online activities by companies like Google and Facebook for continual commercial expansion; it treats our very physical beings as data.[36] Agamben asks, "What kind of identity can one construct on the basis of data that is merely biological?" He goes on: "If, in the final analysis, my identity is now determined by biological facts—that in no way depend on my will, and over which I have no control—then the construction of something like a personal ethics becomes problematic. . . . How can I take on, and also take distance from, such facts?"[37] Agamben characterizes the situation we face in terms that hark back to the Freudian uncanny:

Following the rule that stipulates that history never returns to a lost state, we must be prepared . . . for that new figure of the human. Or, perhaps, what we must search for is simply the figure of the living being, for that face beyond the mask just as much as it is beyond the biometric *facies*. We still do not manage to see this figure, but the presentiment of it suddenly startles us in our bewilderment as in our dreams, in our unconsciousness as in our lucidity.[38]

Invisibility and Modernist Dressing

WT rehearses an age-old dialogue between society and the body that proposes a process of invisibility based on an ideal of pure functionality and pure information, and ultimately a uniformity of dress. Historically, the technological view of wearable computing is anti-dress and essentially modernist in its cultural viewpoint, in accordance with traditional science. The idea that clothing must be minimized, standardized, and muted reflects a tendency known among fashion historians as "functional anti-fashion." That tendency maintains there is a neutral or natural way to dress, or even that

Figure 3.2
Vladimir Tatlin's New Way of Life worker's clothing, 1924.

Figure 3.3
Susumu Tachi, Invisibility Cloak, 2004. Courtesy of Susumu Tachi and Tachi Laboratory, University of Kyoto.

it is most natural to dispense with dress altogether. "Not fabric but skin" became the mantra.[39] Functional anti-fashion ignores clothes' cultural connotations and seeks a simplicity that harks back to early twentieth-century modernist prototypes, such as Vladimir Tatlin's unisex worker's clothing. Moreover, as Radu Stern points out, nearly all modernist utopias—from Thomas More's imaginary island (*Utopia*, 1516) to Aleksandr Bogdanov's sci-fi novel *Red Star* (1908, about a socialist society on Mars), George Orwell's *Nineteen Eighty-Four* (1949), and even Mao Zedong's Chinese Cultural Revolution (beginning in 1966)—envision functional universal dress, often blocky suits or overalls with little or no difference between individuals.[40]

The perfect technological translation of this sartorial purism might be Susumu Tachi's Invisibility Cloak (2004), a prototype employing a real-time video feed and an external projector. Designed as active camouflage for medical and military applications, the Invisibility Cloak is more like a "cloaking device," echoing episodes of *Star Trek* as well as William Gibson's *Neuromancer*.[41] A trope of the modernist body, Gibson's mimetic polycarbon suit is heir to Philip K. Dick's camouflaging "scramble suits" in his 1974 novel *A Scanner Darkly*. Such a suit revives an older fantasy of the Invisible Man, popularized in H. G. Wells's 1897 novella of that name (as well as by the 1933

Figure 3.4
Screen grab, *The Invisible Man*, 1933. Courtesy of Universal Studios Licensing LLC.

movie version), in which the protagonist, a scientist named Griffin, theorizes and carries out a procedure that changes his body's refractive index to that of the ambient air, so that his body cannot reflect light. It is another instance of the reductivist myth about the visual body.[42]

That myth is also a perennial one because of its superhuman promise of stealth advantages in intelligence and military operations. Protective camouflage, of course, exists in the animal world. Passive camouflage—fabrics printed with textures matching combat environments—was widely used in World War I. The importance of camouflage was underlined by the development of precision optics for airborne observers, telescopy, and photography, and massive research on camouflage was undertaken during World War II.[43] Recent work in active camouflage technologies, which adapt as the user moves around, like Tachi's cloak, also includes research with battery-powered, flexible organic light-emitting diodes (OLEDs). Several wearables design teams are exploring metamaterials, surfaces that can deflect radio or light waves so that they pass around the object, rendering it invisible.[44]

Almost simultaneously with Tachi's and other researchers' work toward active camouflage, corresponding effects turned up on fashion runways: British designers Viktor & Rolf's A/W 2002–2003 collection utilized blue-screen (chromakeyed) fabrics throughout. In what might be called a satire of techno-invisibility, as the models passed the audience the fabric of the clothes streamed with video of traffic, clouds, and other moving images, so that the models tended to partially disappear. From the fundamental metaphor, grounded in Cartesian thought, that the invisible body is the corollary of reason, or mind, follows the judgment of the negative value of dress that is equally fundamental in Western culture, a judgment that witty designers seize upon and upend with their ironic designs.

But a body unclothed is not a body erased. In his essay "Nudity," Giorgio Agamben says the unclothed body is always, in our culture, inseparable from a "theological signature."[45] Everyone is familiar with the story of Genesis and the origin of clothing. Agamben recounts that Adam and Eve in Paradise wore not nothing but "clothing of grace" (in some versions called "clothing of light"), of which they were denuded or stripped and forced to cover themselves with sewn fig leaves (Genesis 3:7) and, later, garments fashioned from animal skins. So it is the brief, self-aware nakedness—or the binary state naked/clothed—that signifies sin. In later accounts, the animal-skin clothes are symbols of death.[46] And nudity itself is, in fact, what is identified with fallible human nature. So the unknowable, unseeable garments of Paradise, Adam and Eve's dress before the Fall, become a theological model for a perfect garment that clads being but covers nothing (bad), a kind of magical anti-fashion distinguishing the divine. Medieval adaptations of the garments of Paradise occurred in folklore, in tales of magical creatures like fairies who have the ability to cover themselves with fern cloaks or *Tarnkappen*.[47] Conversely, according to Agamben, material clothing emerged with the sinful (erotic) body, and shares its curse in an unending dialectic that propels our conflicted attitudes toward dress and our modern condition as inevitable creatures of fashion.

Augmenting the Invisible Body

In terms of dress, two related, reductivist notions about the body pertain here. First, that the body (complete with its emotions) can be understood as invisible data or be reducible to data, and second, that communication between persons and machines, or between posthuman "persons," can be seamless, instantaneous, and without physical mediation. The latter idea is viewed by Lone Koeford Hansen as the modernist dream of telepresence, or ideal communication, rooted in a long-range project that included, in the late nineteenth century, widespread interest in mental telepathy, a concept that emerged alongside the exploitation of electricity and the discovery of radio waves, providing a context for the notion of "thought waves" as acceptable

Figure 3.5
Starlab with Walter van Beirendonck, prototype for i-Wear, 2000.

popular science.[48] According to Hansen and others, even the writings of Sigmund Freud contributed to this popular belief: his theories about communication between the conscious and the unconscious challenged traditional beliefs about the relations between the brain and the body.[49]

Invisibility, then, could be said to exist on two levels: the invisibility of the body itself (in a theological state of grace or a technological state of data) and the invisibility of ubiquitous and wearable personal and affective technologies that read, tag, and track bodies in the social sphere. As Eric Kluitenberg writes, "The assimilation of computer technology in the environment introduces a new issue: the problem of invisibility. When technology becomes invisible, it disappears from people's awareness," making it difficult to discuss or even to react to its presence.[50]

In the late 1990s, after the dot-com bubble burst, fashion, as an arena for seasonal innovation and cyclical marketing, became less committed to embedded technologies in general, and particularly so in the United States. This contributed to a slowdown in industrially funded wearables research. In her book Picard does not consider what the economics of a world of wearable affective computing would be, though efficient and beautiful affective wearables would surely be expensive investments for their owners. And while there are many individuals who will pay any price for fashion, the

idea of wearing the same wired-up necklace and bracelet configuration day in and day out flies in the face of how dress actually operates, how by its very nature it changes and evolves, and we with it.

The research situation was somewhat less austere in Europe. The project of adapting high-cost electronics to existing habits of dress was undertaken by the 1999–2000 collaboration between Belgian menswear designer Walter van Beirendonck and the Belgian research initiative Starlab to create i-Wear.[51] They produced a testing ground for the application of ideal communication and affective computing processes in real-world apparel design, with the electronic components modularized in such a way as to overcome the divergent economic trajectories of fashion and technology.

As a wearables line i-Wear was based on situating individual system modules within multiple layers of traditional clothing (which might appear as a series of shirts all worn at once, as in figure 3.5). For example, there could be a memory layer, an energy supply layer, a motion-sensing layer, and a storage layer. Aside from the energy layer, others were optional and "modular." On its website i-Wear announced, "The team has developed a wireless communication system, the Fabric Area Network (FAN), to enable networking of sensors and data, [allowing] communication between various layers (at very short distances), without danger of radiation to the body."[52] These layers talked to each other, and certain functions, like accessing the Internet, were initiated by voice command—at least in the project plan. Other functions would require no conscious user interface whatever, functions like learning the wearer's schedule and issuing prompts to leave for the airport, or compiling advertising for services in the vicinity of a department store. The clothes might even guide a wearer to a geographic destination by heating up to indicate the right track or going cold to signal the wrong way.[53] Since traditional clothing elements were used (albeit in an unusual way), the technology was doubly invisible, first because it was out of sight, hidden in fabric, and second because the use of standardized clothing items was itself unremarkable (yet oddly fashionable, as in the attraction of redundant collars and lapels). Unfortunately, i-Wear was short-lived; the project went bankrupt within a year.

Wearables and ANT

The dynamics of communication are at the heart of the factors that Ana Viseu found problematic in her case study of technology in the workplace. In 2002 she studied Bell Canada field technicians who participated in a three-week wearable-computer pilot program involving the Panasonic CF-07, a scaled-down computer made wearable by means of a shoulder bag and customizations, some fashioned by the workers themselves. In the study the computers handled dispatch, communications, and all logs of work done in the field, and the field technicians were to wear them all the time. The technicians therefore did not have to take orders from a dispatcher and had

considerably more information about each job, the components and procedures involved, and its context than they normally would have had. These were seen by the company as the advantages that wearable computers were offering—in other words, they were billed as enhancing the agency of the workers.[54] On the other hand, the technicians who wore the computers reported, at the end of the study, feeling less in charge. They could only input information in prescribed fields with no spaces for notes explaining details of a job, for example, and no ability to correct their work later, and they felt removed from the actual presence of their overseers. In other words, they perceived their sense of agency, of being able to control what they were doing, as reduced. In fact, the workers experienced a critical change in their very identity. To them, CF-07 became a millstone and an embarrassment. Even worse, it was originally planned to include head-mounted displays, which in the end were only employed at the outset of the project and in the publicity campaign surrounding it. Images of the HMDs used in promotional materials made Bell Canada seem like a futuristic company, and project directors often alluded to *Star Trek* or *Robocop*, and spoke of "cutting-edge technology" in interviews.[55] But the technicians were averse to going out into the field wearing them. Even without the HMD, just wearing the computer in its sling tended to alter the self-perceptions of the technicians. They began employing derogative terms for the equipment, like "Mickey Mouse stuff." Beyond its good or bad functioning as equipment or tool, the CF-07 functioned as personal display in a social context, display that marked its wearer as having lost a degree of dignity and self-command.

Viseu uses the study to critique actor-network theory (ANT), a dominant method of analysis in the domain of science and technology studies. ANT considers humans and computers as equal agents in a dynamic system of relationships. According to Bruno Latour, a pioneer of ANT, society should not be considered "a special domain, a specific realm, or a particular sort of thing, but only as a very peculiar movement of re-association and reassembling."[56] ANT is not a unified theory but rather a set of ideas based on the writings of contributors like Latour, Michel Callon, and John Law. ANT poses a critique of traditional social theory that assumes distinctions between nature, society, and their artifacts. Latour argues that modernity relies upon the "complete separation between the natural world (constructed, nevertheless, by man) and the social world (sustained, nevertheless, by things)."[57] In reality, according to Latour, humans and nonhumans function as equal partners—equal actors—in social networks, and the stability of each actor's role must be negotiated and locked in position inside the network. It is a relational situation. In the Bell Canada study Viseu argues that, in real life, the nature of the actors was not so clear cut. "This project was not ultimately successful in creating a stable actor-network of augmented field technicians, hybrid entities of body and machine." Part of this failure lies in the facts that (1) the field technicians proceeded from an already stable ANT (their relationships to their existing materials and technologies) and (2) the wearable transformed the body in ways that

the system had not anticipated. For Viseu, "One of the main tenets of ANT is the presumed symmetry between the social and the technical." But this symmetry is not always upheld in specific cases involving humans and technologies in direct physical relationships.[58] In fact, a fundamental asymmetry persists insofar as devices on our bodies give us certain ideas or make us feel particular ways about ourselves, without any equivalent self-awareness on the part of the devices.

Besides actor-network theory, another way of considering any WT is to think of it as a dynamic of the interface, or an "interfaciality," as Anna Munster calls it. She argues that the interface provides machines with, literally, a "face," though of course she is talking about screen-based interaction (the screen as a natural face is discussed by a number of authors including Jacques Lacan). Munster applies Deleuze and Guattari's concepts of "facialization" (poles of smooth versus striated, surface versus depth—a dynamic assemblage of subjectivization) to the "faces" of users and digital technologies.

The major achievement of interfaciality is not so much in escaping the face but rather multiplying it. We increasingly find ourselves running the gamut of a slippery middle ground, bouncing back and forth between the surfaces of new technologies and those of our own skin. What we need, then, is a way to rethink this area in terms other than those offered to us by the intermediary positioning of the interface between two opponents: the human and the inhuman machine. For from this position, one side will always be required to conjoin with or eradicate the other.[59]

In other words, the interface, which strives to be invisible, shows an "other" face that tends to erase our own.

Of course, Munster's interfacial "area" (the screen) collapses in the case of wearables. Here the "surfaces of new technologies and those of our own skin" are in contact and, as with the cultural perception of wearing clothing, identified as one, yet with multiple sensations of inside versus outside, look versus touch. The mechanics of faciality are distributed throughout our bodies. As Deleuze and Guattari point out, the face's "white wall/black hole" system extends to the body, a vehicle for its discipline: "The difference between our uniforms and clothes and primitive paintings and garb is that the former effect a facialization of the body, with buttons for black holes against the white wall of the material."[60] They say, "The face is a politics." It is a "faciality machine because it is the social production of face, because it performs the facialization of the entire body and all its surroundings." Wearable computers do the same. The screen (face) still exists, but its "body" extends across ours, morphing machinic personalities in multiple ways. In this case, the body might be a battleground. In the Bell Canada scenario, for example, the technicians interacted with the technology on their bodies, their distributed and wearable interface, but that interface was unstable and generated, in effect, multiple "faces"—multiple agendas and demeanors—among which the users erratically bounced.

Philips Design

Ana Viseu itemizes the categories of wearables research as follows: health, to monitor the body; work, to improve efficiency and productivity; military/security, to enhance physical and cognitive abilities; and leisure/lifestyle applications.[61] While the MIT Media Lab worked creatively on all those fronts, speculating on multiple applications for their inventions and methodologies (such as affective computing), Philips, in the private sector, set about developing specific industrial prototypes. In 1995 Philips Design, a branch of Koninklijke Philips Electronics, initiated its Vision of the Future project to "propose ideas and solutions that will enhance people's lives."[62] The project used standard design methodologies starting with creative, multidisciplinary workshops to identify user needs and technology forecasts and ending with presentation strategies that included website videos and design exhibitions to garner feedback. A large part of the research was devoted to wearables. According to the 1999 account by CEO Stefano Marzano, who uses the expansive language of utopianist technology we have already encountered, Philips was responding to "the goal of our species" to be omnipresent, omnipotent, and omniscient.[63] Moreover, he writes, "We don't want to be bogged down by material encumbrances": "What people really want . . . is to be free of any attachments. We don't want to bother with tools at all. We don't want to fly in an aircraft, we want to fly like a bird. We don't want to sit in a car in a traffic jam, we want to be beamed around by the transporter in *Star Trek*." Marzano proposes that Philips Design move beyond miniaturization to "progressive integration." He proposes clothing as an important locus for our technologies, as it is the least of human encumbrances—but he suggests that the fashion industry must be transformed so that clothing design is no longer simply a choice of colors and styles, but a choice of functions. "The technology industry will have to learn how to deal with fashion" and think emotionally. At least until the "ultimate step" can be accomplished: functional applications incorporated directly into our bodies.[64]

An outcome of Philips's Vision of the Future initiative was a book entitled *New Nomads* (2000), intended to publicize the company's exploratory research in wearables design. The concept of "nomads" is never discussed, oddly enough, but clearly relates to Marzano's concern for physical encumbrances. It also reflects a broader discourse that began to appear in wearables research, concerning an ideal user who would be young, mobile, and, presumably, tech-savvy. This user type, projected as the one most likely to want to use, or already be using, computers and mobile phones, was being targeted by market research among companies developing mobile telephony in particular: the "young, urban nomad."[65]

Accordingly, Philips's *New Nomads* reads like the product of corporate workshopping. It begins with sweeping claims about culture and lifestyle, organized into catchphrases, or "scripts," like the Mosaic Society, the Explorer Society, the Caring Society,

and the Sustainable Society. In fact, the problem the team set for itself (in the late 1990s) was based on the fact that portable devices like phones and PDAs were inefficient (Starner's earlier argument) and hindered the nomadic lifestyle. Philips aimed for an "installed base of electronic clothes."

As phones and other devices become modular, we will move from a situation where we own one phone to a situation where we have many phones integrated into garments. By modularizing the product we can separate the "brain" from the other components. The "phone" module will be no more than a button that simply plugs into the clothes that are already equipped with an infrastructure to support it.[66]

In a telling turn of phrase, the text says that clothing would be explored as new "interface real estate," a term that conjures up hard-core images of financial speculation.[67] Acknowledging the example already set by MIT Media Lab research in wearable computers and e-textiles, the text of *New Nomads* recounts the assembly of multidisciplinary collaborations between designers, engineers, and "non-technical" students and academics in fields like animation, writing, industrial design, and business. This process resulted in a Philips research team comprised of a fashion designer (Nancy Tilbury), an industrial design engineer, and an electronics engineer, plus additional experts once the project got started, who convened at Philips's labs at Redhill, Surrey, in the United Kingdom. Ultimately the group produced prototypes that claimed a strong expressive agenda, attire that would reflect "the ritual of dress—how people assembled their personal identities through clothes that combined the functionalities of protection, thermal insulation, waterproofing, etc., with the personal and cultural qualities of aesthetic and identity."[68] This representation of dress as ritual pays lip service to the social phenomenon of dress while interpreting it primarily as a technical challenge to fulfill physical needs that in some vague and ancillary way add up to "aesthetic and identity"—whatever either term is taken to mean, which is not discussed. Likewise, the "cultural qualities" of dress, cited in the statement, are not examined.

The Redhill team concluded that five categories of clothing best reflect the needs of those they consider potential early adopters of digital clothing, the "new nomads": (1) digital suits for business professionals, (2) electronic sportswear, (3) children's clothes, (4) wired streetwear for youth, and (5) a category called "enhanced body care and adornment," encompassing a "new age" approach to clothing that makes the wearer feel good. Most designs are based on the body-area network concept, with conductive textile components and assorted modular devices. The *New Nomads* business suit, for example, a traditional men's dark suit, is enhanced specifically for professional networking in a competitive work environment (prescient, since social media sites like LinkedIn were just a few years away). The jacket has a sleeve flap that uncovers an embroidered keypad (similar to Maggie Orth's design) and a limited flexible

display, with a separate small phone earpiece and speaker device—essentially the suit is what it was billed to be: a mobile phone. The power source is not discussed. A similar suit is envisioned for an "air hostess," only the embroidered keypad is replaced with a specialized flexible PDA on the sleeve with full digital display including a diagram of cabin seating. Philips suggests the adaptability of the suit type for numerous work environments.

The section on electronic sportswear is the largest, and features a jogging suit whose functionality includes wireless connections to a digital audio player. A "virtual coach" monitors and regulates the pace of physical performance with verbal commands. Another design, a high-performance workout ensemble, features full biometric sensing and digital music access.[69] Several designs for wearable gear for extreme sports like mountaineering or snowboarding include similar devices along with a GPS monitor and, in the case of snowboarding, a proximity sensor on the back of the jacket (with warning light) to help the athlete avoid collisions (those from behind, anyway), and motion detectors that modify the digital music selections to complement the rhythms of the athlete's body.

Children's interactive clothing designs consist of rather large coats with fabric antennas, radio tagging, and miniature remote-controlled cameras to track a child's whereabouts. The coats have flexible sleeve panels displaying interactive games in which they and their playmates are iconized as animal or monster avatars that run around in sync with their wearers, creating a playful online network. Wired streetwear for youth, on the other hand, proffers fanciful versions of rave attire. An outfit called the Queen of Clubs is a skimpy workout ensemble with added texture and detail that interacts with the club lighting controls. A single wearer might affect the overall environment, so perhaps the garment is designed for professional dancers. A DJ's outfit called In the Mix consists of denim jacket and pants in baggy, clubwear style (of the late 1990s), with remote sampling capability that allows the DJ to leave the turntables and move among the audience. In an addition, separate small devices such as a phone, an audio system, and PDA modules can be "buttoned" into the system and accessed through a flexible interface patch. The streetwear section also includes a winter parka (Surround Sound Audio Jacket) with a "smart pocket" that connects its digital audio player to the interface with a jack plug. A flash loader for audio memory is integrated into the sleeve, accepting cards in a connecting Velcro-flap pocket. The hood, equipped with headphones, inhibits unwanted ambient noise, and an electroluminescent display on the back of the jacket, called Electrophonique, emits patterns in response to the frequencies of the music being played.

Perhaps the most well known of the *New Nomads* designs involve the category of body care and adornment. The example called Feels Good is a cream kimono made of a synthetic sheepskin type of fabric, with woven panels of conductive thread down the back and sleeves. A pocket device disseminates electrostatic charges, creating a

Figure 3.6
Philips Research, *New Nomads* Surround Sound jacket, 1997–2000. © Philips.

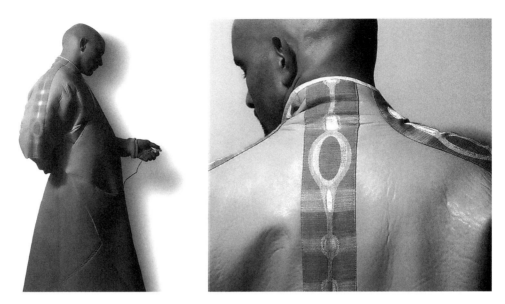

Figure 3.7
Philips Research, *New Nomads* Feels Good kimono, 1997–2000. © Philips.

tingling sensation designed to relax the wearer. The outfit becomes a wearable leisure drug, but the experience is under control. Biometric sensors in the kimono monitor the degree of relaxation of the wearer, and adjust automatically. The overall effect of the long kimono, worn by a skinheaded model over an embroidered Japanese skirt, or *hakama*, is exotic and evokes martial-arts culture and extreme fashion trends like skirts for men—the Feels Good kimono outfit recalls several launchings of fashionable men's skirts in the late 1980s, most notably by Jean Paul Gaultier.[70]

The body care and adornment category also includes a Micro-Climate sweatshirt containing an embedded audio system, with speakers inside the hood and a volume control over one ear. The hood also contains an electronic mask to filter out urban and industrial pollutants, oddly prefiguring the biofiltering masks that would become common in Asian cities during the early 2000s, a response to SARS and bird-flu scares.

The *New Nomads* prototypes, which were photographed for elaborate spreads in Philips's publication, like MIT's "Beauty and the Bits" designs, were partly functional and partly aspirational, but based on research that was under way.[71] A few of the designs incorporated feedback systems to monitor the wearer's location or health and drew on existing GPS and medical sensing technologies. But there is a controlling ambition behind the project: that all our needs or wants might be anticipated if only the right technology can be found, if only the right combination of application and

Figure 3.8
Philips Research, *New Nomads* Feels Good kimono, 1997–2000. © Philips.

garment can be determined, that will absolutely modernize our habits of wearing clothes and allow Philips to commandeer this new market for dress.

Moreover, Philips's approach to WT, while trying to address the problem of technology cost by breaking the systems down into modular units, never comes to terms with the nature of dressing. Only extended wear and a wide market for such items could mitigate the cost, a formula that flies in the face of the way we actually interact with clothing: continually donning and shedding, reconfiguring pieces and moving on. Dress without change becomes uniform, and indeed the Philips *Nomads* wearables are activated or signaled by symbols akin to the insignias of uniforms, or computer desktop icons, or designer logos. The "body as desktop" image adapts the body to the technology, the opposite of what Philips's Marzano claimed their project sought to do, and the emphasis on "nomads" is reduced to a sporty professionalism, a professionalism with a new wardrobe but professionalism nonetheless, so that the emphasis on the functionality of clothes promotes not nomadic freedom but the body at work, a socially productive body, one that might act but is ultimately acted upon.

About the same time as the *New Nomads* designs were being developed, Philips collaborated with American denim company Levi Strauss to create the ICD jacket, designed in part by Italian garment engineer Massimo Osti, with specially constructed pockets for electronic devices like a cell phone and MP3 player.[72] The resulting product, the ICD+, was an elaborate item custom-designed for the portable electronics that came with it (all for about $900 in 2000). But the jacket was not in itself WT in any sense. Nor was it original as garment design—it compared to many gear-oriented, rugged outerwear jackets from North Face or other sports apparel brands. Moreover, garments with pockets designed for technological devices were already on the market. "Technology-enabled" vests, for example, by Scott Jordan for SCOTTEVEST appeared at the same time and were highly popular (and cheaper, since the user loaded it with her own electronics).[73] But the ICD+ project received an enormous amount of media attention after being launched by its two global corporations. Publicity featured trendy descriptions like "smart" and "intelligent," not really accurate for the project but terms that nevertheless became attached to it. Despite the media blitz, ICD+ was ultimately a commercial failure. But it was the first item launched that tried to capture the public imagination and accomplish what *New Nomads* predicted, to appear chic and hip to "early adopters" and "young urban nomads" and try to alter their conception of dress.[74]

Response and Display (Skin Probes)

Since women have traditionally been culturally positioned as objects for display, they are more likely than men to be represented as clothes-conscious and more likely to be portrayed as emotional (though these stereotypes are slowly changing). Thus women

have been frequent subjects for emotion-sensing devices. An example from 1970s popular culture was the mood ring, a piece of jewelry made of thermochromic material and marketed mostly to women.[75] The mood ring epitomized the notion of a "faciality machine" (a face on the body), as it claimed to indicate the wearer's level of excitation to onlookers. The same notion—the feminine body as the generator of mindless emotions available for display and marketing—tended to persist in affective computing-based WT efforts.

In a similar vein, in 2004 Lisa Stead and her collaborators at Central Saint Martins College of Art and Design developed a computing platform, known as AffectiveWare, to create clothing incorporating personalized display, "an emotion wardrobe."[76] They proposed garments that connect internal sensing and external display (through LEDs sewn into the fabric). These would be programmed beforehand to respond to epidermal conditions using emotional templates created by measuring the sensors' responses to actresses simulating emotional states. Eight such emotional states were specified, in accordance with psychologist Robert Plutchik's somewhat outdated, mid-twentieth-century categorization of primary human emotions.[77] The wearer could control aspects of the display within certain predetermined limits, but this was not essential for the system to function. The project was sophisticated, but was still rooted in the notions that clothes are enhancements to visual and emotional subjectivity, and that emotions are categorizable autonomic responses that can be encoded as data.

Since *New Nomads*, corporate designers have envisioned works that index the body in much the same way as the mood ring or AffectiveWare but are much more advanced. In 2006 Philips premiered their Design Probes program under Clive van Heerden, a cluster of "far-future" research initiatives "that aim at identifying long-term systemic shifts and anticipating future lifestyles."[78] Probes initiatives have explored housing, food (diagnostic kitchen, multisensory gastronomy, and home farming), dress, jewelry, and tattoos. Best known is their SKIN research initiative linking skin surface and light emission through biometric sensing technology. SKIN: Dresses, designed in collaborations between Nancy Tilbury, Lucy McRae (who calls herself a "body architect"), and Rachel Wingfield, are pure prototypes, impractical and photogenic, garnering extensive media coverage, which was their main purpose.[79] The project won the Red Dot Design Award in 2007 (a prestigious corporate design competition held annually by the Red Dot Design Museum in Essen, Germany). Images of the dresses were made available as high-resolution downloads on the Philips website and subsequently went viral on countless news posts, other websites, and blogs. Notably, one of the dresses appears on the cover of Sabine Seymour's book *Fashionable Technology*. SKIN: Dresses were positioned for distribution by social media and were for several years among the best-known images of WT in existence—the perfect Internet spectacle.

Moreover, in true modernist, utopianist style, they are not dresses at all, but are, as their name implies, second skins, typical anti-fashion, or "invisible clothes," clothes

Figure 3.9
Philips Research, Philips Design Probe, Bubelle Dress, 2006. © Philips.

designed for response and display. Their visual appeal makes them (and their wearers) objects to be looked at, skins that show. The SKIN: Dress called Frisson is little more than the familiar bodysuit—a catsuit—with an attached structure of long copper antennae surrounding the upper body that react like gooseflesh. The ends of the antennae light up (via LEDs) when brushed or blown on, a phantasmic representation of a normal skin response to sudden movement or temperature change. Bubelle, a homophone of "bubble," is a frothy, light cage around the body. Actually, it is made of two layers, with a "slip" (undergarment) equipped with heart-rate and galvanic skin-response sensors that project LEDs onto the surface of the outer skin/screen. Thus the dress simulates a blush, a coloration of human skin—specifically the face—in response to emotion or anxiety. Both Frisson and Bubelle "digitize" physical responses of the human skin and display them in spectacular, facialized form. As Philips says in its press material, the two outfits "have been developed as part of SKIN to identify a new way of communicating with those around us by using garments as proxies to convey deep feelings that are difficult to express in words"—another way of saying that our native responses are too illegible. Lone Koefoed Hansen suggests that Philips's concept "implies a split between mind and body," a split that the garment miraculously mends: "Philips Design has ended up equating the wearer's body to a computer in which the flow between input and output is a matter of cause and effect. . . . While the dresses are permeated by hypermediacy (they display technology as fashion), they also embody the dream of ultimate communication transparency."[80] As interplay of information and media, Bubelle does what Gibson's polycarbon suit or Tachi's Invisibility Cloak do, render the body invisible altogether, only in Bubelle's case the body not only loses its own visibility but becomes a spectacular vision of brand marketing, the surface (the bubble) as face. As Anna Munster interprets Deleuze and Guattari, "Facialization is a system of codifying bodies according to a centralized conception of subjectivity or agency in which the face, literally or metaphorically, is the conduit for signifying, expressing, and organizing the entire body. In human-technology interactions, the generation of the agency of face tends to erase the living body and suggest the immediacy of communication 'face-to-face.'"[81] In the case of Bubelle, it is a lovely, machinic face that forms a brilliant cover for a particular subjectivization, one dominated by industry and commerce.

In 2008 Philips released their SKIN probe Fractals, digital jewelry or scarf arrangements that propose to be a hybrid between clothing and jewelry. Fractals sense bodily changes as well as the proximity of other bodies and react with pulsing LED configurations. Philips explains, "Traditional LED lighting can be cold and uninviting but Fractal uses materials to diffuse, focus and filter the light, giving a warmer, soothing lighting experience." The goal here was not to use textiles or apparel assembly methods at all, but to look forward to a replacement for garments "in the year 2020."[82] The publication of Fractals arrayed on nude female models in poses familiar to fashion

Figure 3.10
Philips Research, Emotions Jacket, 2009. © Philips.

photography suggests the context into which Fractals were projected, one of business and marketing. In 2009, in another Philips research initiative, designer Paul Lemmens created a prototype for a unisex Emotions Jacket. Looking like a typical athletic jacket on the outside, it is wired to intensify the physical effects of emotions in the setting of the movie theater, coordinating with the narrative onscreen. When the hero is fighting for her life, the wearer-viewer feels a pulsation that simulates a rapid heartbeat. Here the emotions are imposed and directly commercialized, and are designed, ultimately, to help sell movies.[83]

Therapeutic Dress

The discourse of WT as industrial research and commercial prototype follows the rhetoric of fashion, as we have seen with Philips (the use of models, photography, hype, allusions to a better life, etc.), but with a particular emphasis on the psychology of the "new" or the "future." French philosopher Gilles Lipovetsky discusses the changing appeal of newness, especially in fashion. Rather than being a commitment to modernism, the choice of something new has taken on the implication of "doing something, becoming different, . . . getting off to a fresh start. 'Make me over': as fashion ceases to be a directive and uniform phenomenon, the purchase of fashion items is not governed by social and aesthetic considerations alone, it has become a therapeutic phenomenon."[84] Moreover, Lipovetsky writes, the rise of media technologies has led people to pay more attention to themselves and their bodies, to react to the flood of information by actively managing their appearance and health.[85] However, the situation has also brought about Deleuze's control society, in which individuals are not only monitored but trained—perpetually trained and challenged but never finished with anything; a kind of control that modulates and molds individuality in an ongoing, never-satisfied manner.[86] In control society, attention to the body never reaches its goal.

Jenny Tillotson is a researcher in the field of aroma and medical applications of clothing for health and well-being, an area she calls Scentsory Design. She too is interested in a garment that creates a second skin, one that communicates not just visual signals but olfactory ones—a "main line to the brain," as she says. Like all ubicomp researchers, she contextualizes her WT in futuristic narratives, or "science fashion."[87] Influenced by Picard's affective theories, Tillotson brings an extensive background in the technology of scent and scent delivery to the futurist promise that WT will improve our lives in order to create what she calls "emotional fashion," explained as "responsive clothes integrated with wireless sensor networks that offer social and therapeutic value in a desirable fashion context."[88]

Scentsory Design's 2003–2005 silk organza dress both diagnoses and cures. This therapeutic garment, by Tillotson and designer Adeline André, uses nanotechnology

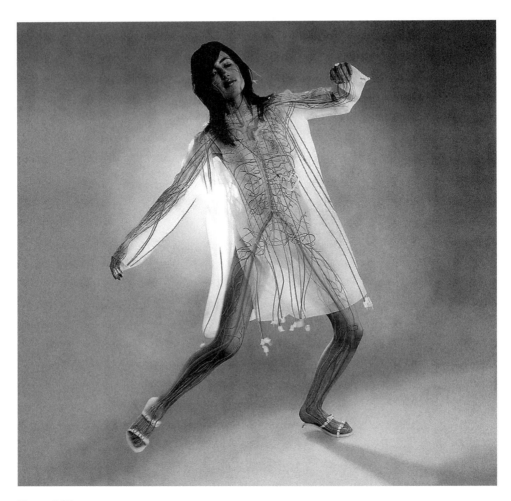

Figure 3.11
Jenny Tillotson and Adeline André, Smart Second Skin Dress, 2003. Photo by Guy Hills. Courtesy of Jenny Tillotson.

and microfluidics to sense the wearer's body heat and other indicators of stress; the garment then provides aromas that boost the limbic system in the brain, our emotional center. Like Philips's Design Probes, Tillotson's garments are conceived as a "smart second skin":

Clothing (and jewelry) become almost living as if copying the human skin, our senses and circulation system. A micro pump is integrated within the design which represents the "heart," micro tubes represent the "veins and arteries" and various biosensors mimic the senses to create a new interactive fabric communication system in clothing. . . . Fragrances are actively "pulsed" electronically through a micro cabling system in the fabric web.[89]

Additionally, the system can administer deodorant, which is triggered by a sensor and delivered in response to human sweat. According to the website, when we smell certain scents around our bodies, not only our emotions but our body chemistry changes. The Smart Second Skin prototype can alter mood, encourage sleep or energize action, increase self-esteem, and stimulate the imagination.[90] The result is an antidepressive form of embodiment that interprets self-expression as an involuntary emotional condition that is instantly addressed by the system. The wearer can control the scents, or the system can do it for her. But self-therapy here, as with Philips's Feels Good kimono, trains the body to receive administration and accept emotional manipulation. Tillotson has also designed jewelry based on the behavior of insects—a "bombardier beetle" (the kind that squirts predators with hot fluids), which forms a neck ornament and releases scents to a wearer, and a "spider" necklace, which contains sensors that read its wearer's humidity levels and wirelessly signals the beetle to release scent and aromatically "communicate" with oneself, or with another wearer in an aromatic network. The pieces are expressive and fascinating but incorporate the same principles of affective control.

Wearable affective computing—the idea of using wearables to read and index our emotions—continues to drive research in ways that reveal attitudes toward the body. In 2010 Paul Brokenshire, Azmina Karimi, and April Pierce at Simon Fraser University initiated a long-term project to sense and visualize human emotion. Their initial prototype jacket, called Heart on Sleeve, does not read emotions at all but represents them. The jacket senses and distinguishes various kinds of touch—for example, a gentle embrace or a blow cause differently colored lights and pulsations to be initiated on the wearer's sleeve, signaling the level of contact. Here the body is underestimated: "One of the concepts we explore is the unawareness of being touched." Heart on Sleeve purports to let not just the wearer but onlookers know about the quality of physical contact.[91]

More unsettling is Rachel Zuanon and Geraldo Lima's wearable video game interface, NeuroBodyGame (2010), which allows users to play games using their brain signals. The authors quote Mark Weiser's writings in their discussion of the project:

Figure 3.12
Jenny Tillotson, Scent Whisper Project, Aromatherapy Beetle Brooch, jewelry design by Don Baxendale. Photo by Tomak Sierek. Courtesy of Jenny Tillotson.

Figure 3.13
Jenny Tillotson, Scent Whisper Project, Spider and Beetle, 2006, jewelry design by Don Baxendale.
Courtesy of Jenny Tillotson.

they say they are using ubiquitous computing as a "method of enhancing computer use by making [the computer] effectively invisible to the user."[92] But the game actually creates a convergence of ubiquitous technology and virtual reality (which Weiser felt were opposite goals). Here the wearable is not conceived for fashion but purely to heighten engagement with the game. Using galvanic skin response sensors and blood volume pulse sensors, the vest sends these signals directly to the game system, which adjusts itself accordingly, responding moment by moment to the electrophysiological data from the user. As a result, the game gets slightly easier if anxiety runs too high, or increases in intensity if the user seems too calm. In addition, the vest displays the user's degree of nervous tension in blue, green, red, and yellow lights, and will even administer a soft back vibration, a calming massage, if the system senses extreme tension during play. It is all intended to enhance the user's immersive experience of the game, so that it seems to respond to her unconscious desires.[93]

The piece can be compared with Philips's Emotions Jacket. The garments function differently, rendering cinematic action tactile in Philips's piece and incorporating

Figure 3.14
Rachel Zuanon and Geraldo Lima, NeuroBodyGame, 2010.

biometric data in NeuroBodyGame. However, both seek to enhance the user experience of a commercial media product, ultimately removing distinctions between the inside and outside of the user's body, or between subjective experiences and the effects of a media simulacrum.

Wearable Technologies and Bare Life

In *Affective Computing*, Rosalind Picard writes, "Perhaps the most ominous scenario with any digital information is that of some powerful centralized organization using the data in a pernicious way."[94] She says such concerns conjure up Huxley's *Brave New World* (1932) and are not unimaginable, since in reality people are given medications like tranquilizers every day without their consent. Picard's explanations of why this is not a major threat are not compelling: according to her, healthy people remain in control of their lives (begging the question of who is to be considered healthy), and in any case controlling, or even recognizing, all of our emotions is too complex a task for current (as of 1997) technology. It was a shortsighted argument. Ultimately Picard, like Mark Weiser, subscribes to a benevolent conception of technology that seeks to do good: "George Orwell's powerful image of 'Big Brother' is largely political, antithetical to the image of affective computing as a personal technology."[95]

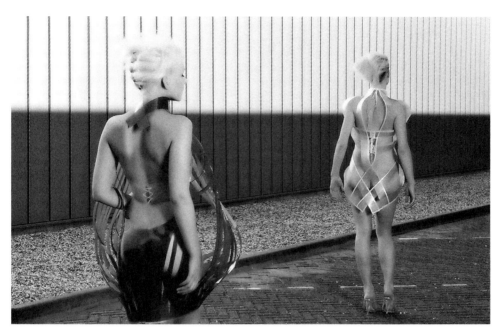

Figure 3.15
Left: Daan Roosegaarde with Anouk Wipprecht, Intimacy Black, 2010; right: Daan Roosegaarde, V2_Lab, and Maartje Dijkstra, Intimacy White, 2009.

Monitoring and manipulating bodily processes like emotions is not right or wrong by degrees (which senses can be monitored, how much, how often), but must be thought through in terms of a larger context. Instead, too often, biometrics is granted a state of exception on the assumption that technology has nothing to do with politics. Picard's influential model of affective computing simply does not consider its operation as part of larger systems of behavior and organization—as part of a larger biopolitics, to use Foucault's term. According to Alexander Galloway and Eugene Thacker, "The methodology of biopolitics is therefore informatics, but a use of informatics in a way that reconfigures biology as an information resource. In contemporary biopolitics, the body is a database, and informatics is the search engine."[96] Galloway and Thacker refer to Giorgio Agamben's manipulable body. Agamben has written about how power works to reduce the individual human to "bare life," for which he uses the ancient Roman term for the disenfranchised citizen, *homo sacer*.[97] "Bare life" is the physical and technical, but not the political or spiritual, condition of life—it is life insofar as it can be measured and counted. Accordingly, the absent or invisible body is a cultural trope for the posthuman subject as biopolitical organism.

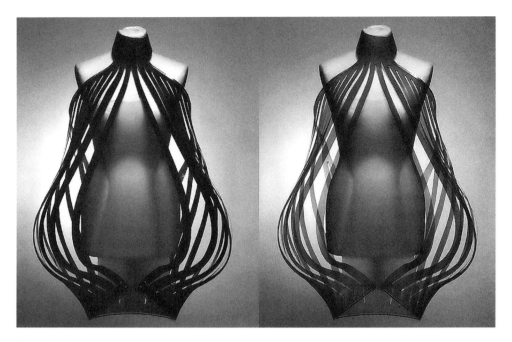

Figure 3.16
Daan Roosegaarde with Anouk Wipprecht, Intimacy Black. Courtesy Studio Roosegarde.

A project called Intimacies, by the V2_Lab at the Institute for Unstable Media in Rotterdam, is an example of research in wearables that provides a fashionable portrait of a biopolitical organism and portrays the intricacies of body-technology disappearances. It is a collaboration between V2's designers and Studio Roosegaarde (Daan Roosegaarde). Sometimes called an installation and shown as such, it consists of two dresses (Intimacy White, 2009; and Intimacy Black, 2010) utilizing e-foil, a commercially produced polymer-dispersed liquid crystal, layered between plastic, which reacts to an electrical charge by varying the intensity of light. The dresses contain infrared sensors and microcontrollers that activate the e-foil in reaction to human proximity and transform the material from nearly or completely opaque to transparent, depending on the distance from other dresses.[98] According to the V2 website, Intimacy White, designed by Maartje Dijkstra, acts as "an emotional meter that measures and makes visible the level of transparency, disclosure, and thus intimacy experienced by the user/wearer in social interaction." Studio Roosegaarde explains, "Social interactions determine the garments' level of transparency, creating a sensual play of disclosure."[99] In the case of Intimacy Black, designed by Anouk Wipprecht, the dress was actually programmed to react biometrically, changing with the rate of normal breathing at

moderate proximity, and accelerating to the pace of a heartbeat as another human body approaches closely.

The dresses are also aspirational as contemporary fashion. Cyberpunk author Bruce Sterling, in his *Wired* magazine-affiliated blog entitled *Beyond the Beyond*, commented on the Intimacy project: "Interesting to see Dutch wearables designers getting dresses to do more of what dresses do (be provocative) as opposed to getting dresses to do more of what computers do (blink and beep a lot)."[100] In fact, the Intimacy dresses make an interesting comparison with Philips's translucent, bubble-shaped Bubelle dress from about three years earlier. Both are portrayed as a second skin, or face, by taking on the qualities of skinlike blushing. Both aim to be highly photogenic and to be presented in the context of high fashion, with sartorial details like defined waists, halter necklines, and cutaway hemlines.

In 2011 Studio Roosegaarde released a new set of dresses under the title Intimacy 2.0. These dresses update the earlier designs, making them even more understandable in a contemporary fashion context (there is more traditional dress material, mostly leather, and less overall nakedness), and they have a direct biometric component: the dresses monitor the wearer's heartbeat, which in turn controls the transparency of the e-foil material on each garment. In addition, Studio Roosegaarde extended the project by issuing a call to haute couture designers to collaborate on new versions of the Intimacy collection.

In the end, the dresses seem to equate intimacy with the naked body, giving us the very image of disappearing dress. The level of nudity recalls both Agamben's evocation of the gauzy garments of Paradise and Teague's Nearly Nude dress in the 1939 *Vogue* "Fashions of the Future" spread, both abstractions symbolizing visions of corporeal perfection: one theological, the other technological. But for the Intimacy projects, the modernist reference is a ruse. Rather than predicting perfection, as the eugenics touted by *Vogue*'s designers sought to do, these invisible dresses reveal our failure, or at least our discomfort, with proximate bodies and with dress that undresses us. And they do so in terms of technology that virtualizes, codes, and even manipulates our intimate fears.

4 The Material Interface

The previous chapter dealt with the topos of disappearance: specifically, WT conceived as an extension of the body, part of a larger modernist project to eliminate the body and its concomitant, messy functions and emotions, treating it instead as pure data or a site for ideal data exchange (the myth of transparent communication). As we have seen, from the viewpoint of engineers in the discourse of ubiquitous computing, the goal was to make the interface disappear. This chapter will deal with the opposite position, primarily held by designers, to render the interface fully present, visible, and tangible. This well-known debate between the invisible and the material proceeded in the world of the computer screen with the rise of computer graphics.[1] But in "Interface Criticism," Christian Ulrik Anderson and Søren Bro Pold claim that the term "interface" has overrun the screen entirely, and we considered in the last chapter how the interface can be distributed throughout the body.[2] In fact, the very development of the interface has involved a critical dialogue between engineering and design, a dialogue in which aesthetics has become a major player. And who can argue with the impact of elegance and appearance on the expansion of mobile interfaces in the twenty-first century, an expansion that goes beyond the "ubiquitous" (invisible) interface to the design of lifestyle devices that organize our very modes of being?

As a result of technology's expansion in our everyday lives, the word "interface" has become common language. We use it for everything. Writing within the field of digital research in the arts and humanities, Maria Chatzichristodoulou and Rachel Zerihan define it broadly as "the boundary or shared space between two areas or systems. It allows for interaction between two entities that would otherwise be unable to communicate with each other."[3] The term interface does not even belong to the history of computers. "Interface" entered the language in 1882 (in James Thompson Bottomley's *Hydrostatics; or, Theoretical Mechanics*) but increased in usage during the 1960s, when it served in a variety of contexts. Peter Weibel emphasizes the connection between the terms "surface" and "interface" and writes that the study of interface is part of "surface science," as in the chemistry and physics of liquid-gas interfaces, for

example, or the investigation of our planet's surface, as in cartography.[4] The idea of a tangible user interface, where people interact with digital information by means of physical objects and materials, not just on the computer but elsewhere in the user's environment, became a field of research pioneered by Hiroshi Ishii at MIT in 1995, about the same time MIT's wearable computer lab was getting started.

In *The Language of New Media* Lev Manovich says that human-computer interfaces (HCI) were developed to control digital environments while at the same time drawing upon earlier media, like print and cinema, to provide an immersive experience. The emergence of the desktop metaphor (resulting from the graphical user interface, or GUI, invented by Alan Kay at Xerox PARC in 1970 but popularized by the Apple Macintosh in 1984) increasingly spatialized our understanding of screen-based systems and allowed users to access and manipulate real-world cultural data, creating what Manovich calls "cultural interfaces."[5] The screen became a battlefield, ultimately, between opaqueness and transparency. Manovich concludes that "the language of cultural interfaces is a hybrid. It is a strange, often awkward mix between conventions of traditional cultural forms and conventions of HCI . . . between an immersive environment and a set of controls, between standardization and originality."

The idea of a "cultural interface" and the spatialization of experience suggest new hybrid forms involving both the screen and the human body. Barbara Wegenstein has written about how the new millennium has exchanged visual images for the haptic realm of the skin as the new order of new media, and the representation of the skin has increasingly gained presence in recent discussions. But, in addition to skin, embodied cultural interface is dress, and dress as specific social behavior. If skin is surface, dress adds layers. Gottfried Semper, with his "principle of dressing" (*Bekleidung*), would have agreed. Dress is already a cultural interface between ourselves (our bodies, but also our minds) and the environment, or various forces in our environment.[6] Sylvie Parent and Angus Leech write, "In the field of smart clothes, the trend today is towards a subtler and more complex integration of technological elements . . . while taking our needs and desires into account."[7] Kaja Silverman, writing about the psychoanalytical dimensions of dress, also maintains that, in articulating the body, clothing simultaneously articulates the psyche. "As Freud tells us, the ego is a 'mental projection of the surface of the body,' and that surface is largely defined through dress."[8]

Skin/dress/tissue/textile—these are interconnected interfaces, so that many different kinds of surfaces are synchronously at play. Garment construction itself encompasses multiple layerings. For example, "interfacing" is a traditional sartorial term for an internal layer of stiffened fabric that supplies body and shape and helps edges lay straight. Technology adds physical and behavioral layers and can further articulate, or give shape to, its role in constructing the body and its subjectivity. What David Bryson has called HGI (human garment interface) is a complement to HCI.[9]

With the focus on affective systems involving sensors and accelerometers and the like, much WT is hyperreactive to both the body and its environment (the focus of context-aware wearable computing). Affective wearables reflect the biometric information registering on or through the skin, from on or beyond the body, and activate either a remote display or one that is worn as clothing or accessory. Skin as information suggests the conjunction naked/clothed, which John Carl Flügel identified in the 1930s as one of our basic psychological conflicts. According to Agamben, naked/clothed is the essential axis of evil since the Fall—the body's binary "theological signature."[10]

Interaction and Critical Design

The study of human-machine organization has focused on power and control. Alexander Galloway and Eugene Thacker distinguish between the earlier conception of feedback (cybernetics) and more recent interactive models of control. Both enable two-way communication; only with feedback, "one part is always the controlling party and the other the controlled party. A homeostatic machine controls the state of a system, not the reverse. . . . Interaction, on the other hand, corresponds to a networked model of control, where the decision making proceeds multilaterally and simultaneously."[11] But of course, interaction and multilateral lines of communication do not necessarily mean equalized power relations: "We expect to see an exponential increase in the potential for exploitation and control through techniques such as monitoring, surveillance, biometrics, and gene therapy." This serves to introduce the emergence of interest in interaction, at the point when interface design in actual computers became a topic of interest on both functional and aesthetic grounds.

"Interaction design" is a term coined by Bill Moggridge and Bill Verplank in the mid-1980s.[12] HCI studies, the foundation for human interaction design, gained ground with early work in major centers—Xerox PARC and the MIT Media Lab—and later on at Interval Research Corporation, a Palo Alto research lab created by Microsoft cofounder Paul Allen and David Liddle. Margaret Minsky (daughter of artificial intelligence specialist Marvin Minsky) did pioneering work in haptic interfaces (computational objects you can touch and feel). She graduated from the MIT Media Lab and became one of the founding faculty at Interval in 1992. Minsky had her own interest in fabrics and sewing, which may have contributed to the emergence of wearables and e-textiles in both locations.[13]

Outside of the computer sciences, the Royal College of Art's Computer Related Design curriculum (CRD—later called Interactive Design), initiated in the mid-1980s, was one of the first of its kind. It was initially part of the Design for Manufacture sector of the Industrial Design department. Gillian Crampton Smith, a graduate of Cambridge in art history and philosophy, became course leader for CRD in 1989 and began

delivering papers on the subject at SIGGRAPH. She later wrote the first graphical desktop publishing software at Apple, and became founding director of the influential Interaction Design Institute Ivrea (Italy), established in 2001 by Telecom Italia and Olivetti for advanced teaching and research, and operating until 2005 when it merged with Domus Academy.

Anthony Dunne, who completed his PhD in CRD under Crampton Smith in 1997 after working for Sony in Tokyo, also became a professor in the department. His dissertation reveals a position that would become common to designers of WT in the 2000s. He wrote that he wanted to explore "how critical responses to the ideological nature of design can inform the development of aesthetic possibilities of electronic objects." Influenced in part by the radical approaches of New Wave Italian designers like Andrea Branzi, Dunne's "critical" approach to design opposed both the seamless functionality of engineering and the semiological functionalism of marketing, "to develop a position both critical and optimistic."[14] It questioned the prejudices of ubiquitous computing. Dunne's critical position centered on identifying assumptions about electronic objects—he questioned why they must create a seamless user experience, for example. He then countermanded those assumptions in designs geared to make us more intellectually aware. The position supports design that is sometimes less user-friendly and more provocative and poetic. Moreover, Dunne felt that the academic setting was crucial as it "allows design to function as socioaesthetic research into the way electronic products shape our psychological, social, and cultural experiences of inhabiting the 'electrosphere.'"[15] In 2001 Dunne, with his partner Fiona Raby, coined the term "design noir." Described as electronic products that refer to "the world of misuse and abuse, where desire overflows its material limits and subverts the function of everyday objects, this genre would address the darker, conceptual models of need that are usually limited to cinema and literature."[16] Dunne and Raby suggest that unsubtle objects are sometimes required to draw our attention to the invisible products of technologies, like electromagnetic field (EMF) waves. For example, they include LessEMF's Personal Protection Devices in their book *Design Noir*: slightly comical, silver-plated nylon underwear for men and women (with lace trimming) that "you can wear over your regular underwear to shield yourself from powerline and computer electric fields."[17]

The Royal College of Art CRD program generated a few wearable student projects, such as Lorna Ross's phone gloves, which allowed the user to operate her hand as a speaker and receiver (with separate armband-keypad). The piece takes a similarly aesthetic, rather than efficient, approach to a mobile telecommunications object. The slightly punk look of the fingerless and black banded-strap versions of the glove is understandable from a youth-oriented, streetwear perspective, given the revival of bondage style in early 1990s couture fashion (Versace's bondage collection, 1992, and musical performance attire worn by Madonna).

Figure 4.1
Lorna Ross, Wearable Phone, 1994. Courtesy of the designer.

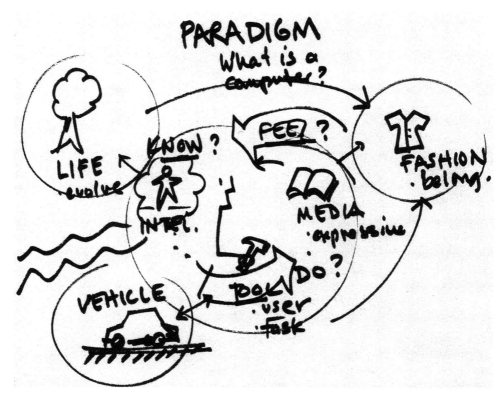

Figure 4.2
William L. Verplank, diagram of interaction design, 2000. Courtesy of the designer.

At Ivrea in Italy in the early 2000s, Bill Verplank was teaching a high-profile analysis of computer-based interaction design around the notion of paradigms. Verplank, well known for the diagrams that were visual aids for his lectures at Interval, Ivrea, and later Stanford University, proposes "fashion" as one of the five principal design paradigms for computer interaction (the others being "tool," "media," "life," and "vehicle"). His notion of fashion is linked to the display function of computers but also to wearables, and, in his opinion, appearance counts: "People want to be seen with the right computer on. . . . Aesthetics can dominate in this world of fashion, as people move from one fashion to another, from one style of interaction to another."[18] According to Verplank, fashion denotes the goals of belonging, recognition, style, and pleasure. It is part of the communication process of interactive design. His is a very open and abstract interpretation of fashion and computers, but it clearly prioritizes the concept of fashion wearables in the landscape of interaction design. At Ivrea, Francesca Rosella

and Ryan Genz, who would later form CuteCircuit, were influenced by Verplank, who, they recall, thought "wearable tech was probably one of the ripest unexplored areas within the field of Human-Computer-Interaction."[19]

Clothes as Communication

As it developed in the first decade of the new millennium, WT continued to reflect the dichotomy of clothes versus devices (dress versus phones, for example). But, as Verplank points out, both participate in a common language of display and the communication of ideas like recognition, style, and pleasure. If we consider dress itself as communication, both intrapersonally (communication with oneself) and across individuals and social groups (ranging from in-group communication with close relations to public display), then we can think of it in different ways: (1) linguistically, as a semiological system; (2) rhetorically, in terms of a system or philosophy of language (structural, poststructural, etc.); or (3) as communication behavior—i.e., action. In fact, the linguistic and rhetorical approaches are often combined in discussions of language and postmodernity.

Although there is very little theoretical literature on WT, fashion has been an attractive subject for postmodern linguistic theory and semiotics. The idea that clothes constitute communication suggests obvious analogies with language. Anne Hollander's 1975 *Seeing through Clothes* takes an art historical, iconographic approach to systems of meaning in clothing, though it does not cite linguistic theory.[20] Alison Lurie, in *The Language of Clothes*, dredges up a metaphor from Balzac's *Daughter of Eve* (1839): dress is "a continual manifestation of intimate thoughts, a language, a symbol."[21] Lurie suggests that in all periods dress has a "grammar" and a "vocabulary," though dress is theoretically a larger field than verbal language.[22] However, Lurie's book takes an anecdotal approach to its subject and bypasses semiotic and linguistic analysis. As a result, Elizabeth Wilson points out, Lurie contributes to the long-term myth about fashion's ultimate irrationality.[23]

The best-known model for classifying aspects of fashion according to a language model emerges from structural linguistics: Roland Barthes's *Système de la mode* (1967). But not only does Barthes focus on fashion (as opposed to dress), he actually focuses only on fashion texts, i.e., how fashion is written about in magazines and, to a lesser extent, how it is photographed (or used graphically on the page)—fashion representation, in effect, which is essentially frozen in time. Barthes recognizes (after Benjamin) that fashion itself is a construct whose reality is in constant flux, so that only its representation in media provides the "structural purity" that enables analysis. As Joanne Entwistle has pointed out, this means that Barthes's enterprise brackets off a myriad of important aspects of fashion, such as its industrial and commercial aspects: "The 'structural purity' of the text comes from its being a 'frozen' or 'static' moment,

whereas social action is complex and dynamic and difficult to capture."[24] Barthes does not attempt to address the nature of the first-order language, fashion as worn, at all.

Sociologist Fred Davis specifically focuses on dress as speech, calling the "clothing code" a system of "low semanticity," inferring, like Barthes, that the relations of clothing to meaning are not very systematic.[25] He also suggests this could be because garment code is continually shifting or in process. Umberto Eco also says fashion is "less articulate, more subject to historical fluctuations than linguistic codes." But it still participates in the perpetual process of semiosis, of signifying, as a "continuous movement": semiosis "transforms into signs everything it encounters. To communicate is to use the entire world as a semiotic apparatus."[26]

Performing Meaning

The more useful view is not that dress is like language on a Saussurian model, an ideal or frozen system of signification, but instead that it is like speech, or utterance, in the domain of human behavior. Dress as a behavior cannot be limited to interpersonal communication, but must also consider pure reflection (this outfit is "me" or "I want to wear this")—in other words, communication with oneself within a cultural matrix. Speech as behavior has been the subject of two principal theories that are alternatives to systems of linguistics.

Russian philosopher Mikhail Bakhtin never wrote directly about fashion or dress, except obliquely in terms of the relation of masquerade to carnival and his discussion of carnival as medieval performative resistance to authority.[27] Bakhtin's idea of language is perhaps not, strictly speaking, performative, but it is time-based and not structuralist. His central concept of the utterance (as opposed to the semantic unit) is highly dependent and situated: "Utterances are not indifferent to one another, and are not self-sufficient; they are aware of and mutually reflect one another. . . . Every utterance must be regarded as primarily a *response* to preceding utterances of the given sphere."[28] Bakhtin understands utterance as social behavior—it is part of his "dialogical" approach. His ideas might be applied to dress. Clothing, after all, depends on other clothing and a responsive view or experience of garments, at the levels of both designer and user. But in the end Bakhtin's notion of utterance is problematic for dress, not only because he does not actually discuss it (he restricts his theoretical writings to the subjects of language and literature), but because it is difficult to show that dress proceeds only or even primarily in a dialogic pattern (though it certainly seems to do so often enough).

Speech Acts and Interface Design

As a second alternative opposed to structural linguistics, which posits a fixed system of language, speech act theory concerns language use and comes under the heading

of pragmatics. J. L. Austin and John R. Searle, founders of speech act theory, have suggested that meaning in language depends not only on the linguistic system employed but also on the force of utterance and its relationship to space, place, and time. Speech is action, performance within a social situation. Speech acts have power and direction called "illocutionary force."[29] I say something, and the desire or intention of that utterance is embedded in the moment of speaking, who is hearing it, and where it is being said. In Austin and Searle's analysis of how utterances affect us (both ourselves and others), many different kinds of acts are distinguished, including Searle's "indirect speech acts," in which the result of the act draws upon shared background information, both cultural and contextual.[30] Austin also considers the context of speech to have significant effect on its force.[31] Explicit illocutionary speech literally acts, by accomplishing something in the real world ("I apologize," for example, or "I thee wed").

It is interesting to note that speech act theory has also been widely employed in the design of information technology. Computer scientist Terry Winograd applies Austin and Searle's ideas about natural language to nonnatural language communication paths, as in programming and human-computer interface designs. In other words, digital operations in a program are executed by manipulating systems of signs as language. And code is a language of commands that are instantly acted on. Winograd calls this the language/action perspective.[32] Chilean computing theorist Fernando Flores worked with Winograd in applying speech activity to work flows between users and computers, what they call "conversation for action."[33] In such cases of speech acts as interface infrastructure, Austin's original identification of speech acts with intentionality and planning are fundamental, as are Searle's conditions for the successful performance of speech acts.[34] Speech act theory's complicated rules for language constitute considerable baggage when applied to other circumstances. One reason seems to be that when performing speech in everyday life, factors like context and inflection qualify meaning, but language in computer workflows is pure and cannot draw (or not very much) on extralinguistic phenomena. Critics like Jan Ljungberg and Peter Holm have pointed out the limitations of the too-easy application of speech act theory to HCI, an approach that fosters rigidity and routine over cognitive development in the human user.[35]

Embodied Speech

The problem with most of the linguistic models, beginning with structural linguistics, is the idea that there might be a "higher order" language from which individual speakers (or wearers) draw, a "set of standards." It is what Valentin Volosinov calls "abstract objectivism," that is, a preoccupation with determining strict and logical sign systems.[36] Despite their emphasis on actions, Austin and Searle's speech acts are replete with rules

and categorizations that fall prey to errors of abstract objectivism as well. As we have seen, Deleuze and Guattari, in "Postulates of Linguistics," point out the difficulty of categorizing utterances—even to distinguish between music and speech (and, I would add, between speech and dress: imagine orders given by a person in a certain uniform, where clearly the uniform carries part of the force of meaning).[37]

It is Agamben who takes language not only as action but also as an essence and a starting point for questions surrounding the relationship between language and experience, or self-awareness. In his early work *Infancy and History*, he focuses not on the limits of language but on "the experience of language as such," its self-referentiality. This was inspired in part by his teacher Heidegger's idea of having an experience with language, and how that experience happens when we are stuck, when speech "breaks on our lips": this moment is "the backward step on the road to thought."[38] For Agamben language is experimental, and this experimentation is clearest in infancy, when language has not yet become a "voice," that is, a crystallization with an ideological reference, and a vehicle for subjectification.

Judith Butler takes a comparable approach, one that accepts the slippages and imprecision of language. Butler points to Austin's emphasis on the "total speech situation." But how do we circumscribe that situation, and what is included? She says that the difficulty is compounded by Austin's distinction between the previously mentioned illocutionary speech acts (where the act is accomplished at the moment of speech) and "perlocutionary" ones (such as those of persuasion, inspiration, fright, and so on, e.g., "She persuaded me to shoot"). In the latter case the element of time is involved, but to what degree? The speech might use historical context to create its effect.[39] Furthermore, even illocutionary utterances presuppose cultural knowledge—they are not only conventional but ritual or ceremonial as well, and so the utterance has a temporal dimension: "It is never merely a single moment." If we suppose that the techniques of dress—and by extension technological dress—also constitute a process of enunciation, a type of speech, they, too, incorporate the temporal dimension and extend it to cultural memory and history, as Butler says Austin's speech acts must be taken to do.

Butler also discusses connections between speech and the body, and, not surprisingly, finds that "*speaking itself is a bodily act.*"[40] If speech is embodied, it must extend to gesture, "body language," all manner of bodily makeup and markings, and dress itself. It is these very aspects of embodiment that generate much of the "force" in illocutionary force. Think of the 1980s "power suit," the strong-shouldered business attire aimed to elevate women's utterances within masculine corporate environments. Butler cites Shoshana Felman's discussion of Austin's speech act theory (which correlates with Agamben's view), where she suggests that "the speech act, as the act of a speaking body, is always to some extent unknowing about what it performs, that it always says something that it does not intend, and that it is not the emblem of mastery

or control that it sometimes purports to be."[41] These slippages and misfires reiterate the connection between mind and body. It is this mind/body problematic that technology often overlooks—or, more to the point, that rationalist approaches to wearable computers and augmented-reality systems have overlooked—and that WT designers of the 2000s and 2010s often have made their subject.

Wearable Technology as Discourse

"Making a statement" is what we say when we select something out of the ordinary to wear, and we say it regardless of our awareness of philosophies or systems of meaning. It is the way we dress, or not; sometimes the point is to not make a statement. Either way, dress is a matter of the assemblage of performative utterances. But how does the combination of dress and technology enunciate, and what does it mean?

Beginning slightly before the turn of the millennium with the work of Maggie Orth, WT designers began using the material aspects of textiles and circuitry, garments and hardware, to create clothing that placed more emphasis on interfaces at multiple levels. The materiality of the body coordinated with the materials both of garments and of technologies. But at the same time, this abundant new WT practice targets the speech/action capability of technological dress. There emerged what I would call a materialist-conceptualist approach to design, an approach that draws from actual design disciplines—fashion, industrial design, and interaction design, plus the experience of wearing clothes—rather than purely on engineering and computational priorities.[42] Moreover, these materialist-conceptualist works gain force as utterances because, rather than being prototypes, they are worn and seen, albeit as one-of-a-kind items, within specific contexts, namely in academic and research arenas, at runway shows or product demonstrations held throughout the world, and at conferences like the International Symposium on Wearable Computers (ISWC), the International Symposium for Electronic Art (ISEA), and SIGGRAPH. Notable noncommercial events have included "Boundary Crossings" (2004) at the Banff New Media Institute, "Wearable Futures" (2005 and 2011) at the University of Wales, Newport, the "Seamless" fashion shows at the Museum of Science, Boston (2005, 2006, and 2008), the "WearNow" ANAT Symposium at the Australian National University, Canberra (2007), my own "Social Fabrics" exhibition at the College Art Association in Dallas (2008), as well as numerous workshops at V_2 in Rotterdam and Eyebeam in New York City, and countless other shows including "Technosensual: Where Fashion Meets Technology" at the MuseumsQuartier in Vienna in 2012, which encompassed six months of residencies by wearable technologies artists, and "Shifting Paradigms of Identity: Creative Technology and Fashion" at Kent State University in 2013. Popular online blogs and social media communities surround sites like *Fashioning Technology*, *By-Wire*, and *Talk-2MyShirt*.[43] To some extent these have been encouraged by the award-winning fashion/

art website *SHOWStudio*, founded by Nick Knight in 2000, which set a precedent for unconventional approaches to fashion and its representation in a range of media, often through interdisciplinary collaborations. The sense of WT as research also reflects Anthony Dunne's idea that critical electronic design is best done in academic settings.

Wearable Technology as Cultural Utterance

The materialist-conceptualist approach to WT first emerges clearly in an MA thesis written for the MIT Media Lab in 2000, Elise Co's "Computation and Technology as Expressive Elements of Fashion," which described a different approach to wearable systems than we have seen with any earlier Media Lab work. Co came to the lab with a BS in architecture from MIT, but she had had limited contact with established figures there like Orth or Picard and had never met members of the Borg Lab like Starner. Co worked in John Maeda's Aesthetics and Computation Group, which emphasized a broad approach to rethinking the tools of design for any purpose. As research for her thesis, Co created a number of what she called "computational garments" and analyzed them not from the point of view of user enhancement or computational functionality but from that of expanding the potential for clothing. She opens her thesis with a historical analysis of fashion in its roles as "protection, expression, and communication," and includes examples from a range of dress, from indigenous tribal garb and streetwear to haute couture, covering artists, fashion designers, and WT designers like Giacomo Balla, Christian Dior, Issey Miyake, Walter van Beirendonck, and Erina Kashihara. Her goal was to provide "a new design space, synthesized from technology, computation, and fashion." In her thesis this design space "is outlined and its characteristic axes are defined."[44] The eight axes are:

1. Ornamental/not ornamental
2. Practicality/nonutilitarian
3. Storage/mobility
4. Communication/identification
5. Mutable/fixed
6. Remote (to body)/body-coupled
7. Reactive (to stimuli)/nonreactive
8. Light-emitting/light-shielding.[45]

These axes are composed of qualities drawn from both fashion history (ornamental display) and the discourse of wearable computers (storage/mobility, etc.). Some axes are hybrids between technology and dress. For example, communication/identification addresses the relationship between clothes' perennial performativity as utterance and technology's ability to enhance communication in new ways: "Traditional fashion

allows people to express themselves and communicate personal information to the general public; electronics allow targeted communication of specific data to specific people."[46] Similarly, the light-emitting/light-shielding axis deals with a common human response (our attraction to shiny objects) manifested in the love of jewels, crystals, sequins, and iridescent fabrics long before LEDs and interactive displays. Co's axes also acknowledge technology's ability to enhance garments' responsiveness to context: remote to body/body-coupled, reactive to stimuli/nonreactive.

Co proceeds to discuss her designs based on her design axes. The result is the first analysis of WT as garments that participate in a larger world of dress—really, the first attempt to create any theory of WT. She opens her thesis with the following questions:

What modes of expression can be realized through technology? How does computation on the body affect the way we think of ourselves related to society, to those around us, to those far away from us? How can computational clothing address the concepts of constructed image, personal environment, and social communication? What are wearable, beautiful things we can make with electronics? These are the questions I address through my research.[47]

One of her earliest projects, a visionary design that overran the technology available in 1999, was Chimerical Garment, a back covering or backpack. A highly evocative piece, it literally projects her backbone through the technology, as it were—her "inner core"—and projects her body-as-back-as-fantasy-creature in an LCD display. When worn, an animated representation of a classical nude back appears, with graphics suggesting transparent, billowing skin and fernlike wings. When the chin sensor picks up strong inhalation or exhalation, the graphics flutter, expand, and contract; and when the wearer raises her arms, sensors cause the wings in the image to unfurl—all of which recalls the breath-navigation body suits of Char Davies's immersive virtual reality environments like *Osmose* (1996), only in Co's case the wearer is implanted in the real world. Chimerical Garment offers an unusual means of personal imaging as streetwear that illustrates Damasio's ideas about how emotion combines with imaginative capacities of consciousness to formulate alternative, creative scenarios in dealing with physical limitations.[48]

On Co's design axes, she rated her Chimerical Garment as highly ornamental, moderately mobile and functional, burdened with bulky hardware, and also somewhat "off-body" (though worn, it creates a body-linked virtual reality). Above all, it is highly communicative.[49] Co writes: "The Chimerical Garment enables the projection of imaginary clothing into the physical world. This piece was created as a prototype for garments that take account of unrealistic or impossible fantasies about our bodies and ourselves as exotic, changeable creatures, and use these figments of imagination as expressive elements on the body."[50] Like a real-world wearable avatar, the backpack becomes a personal projection of corporeal existence: "I wanted to explore how people

Figure 4.3
Elise Co wearing Chimerical Garment, 1999. Courtesy of the designer.

Figure 4.4
Elise Co, Chimerical Garment, hypothetical mock-up, 1999. Courtesy of the designer.

Figure 4.5
Elise Co, Chimerical Garment, back animation detail, 1999. Courtesy of the designer.

conceive of themselves as fantastical beings, or even . . . how clothes themselves might dream of flying."[51]

Co's Puddlejumper, a responsive garment created in 2001 (and so not part of her thesis), demonstrates the importance of bringing the cultural context of fashion into the material play of WT. Puddlejumper is a hooded raincoat, made of latex-coated double-knit fabric, with electroluminescent lamps, silkscreened in an ornamental pattern on the front, wired to interior electronics, and with conductive water sensors on the back and left sleeve (and hood, in some versions). When hit by water droplets, the sensors activate the lamps, "creating a flickering pattern of illumination that mirrors the rhythm of rainfall."[52] The original version of the hooded jacket was also intended to recall the "retro-futuristic" 1960s designs by Pierre Cardin and André Courrèges, and so creates its own genealogy within fashion's matrix of past and future.

This compares with a similar idea in the Day for Night Solar Dress (2006) designed by Despina Papadopoulos/Studio 5050, an homage to Paco Rabanne but made of hardware modules, more than four hundred white square circuit boards hinged together with metal wires so it can be lengthened or shortened. Each module is addressable from a central control unit at the back of the dress; some modules contain solar

Figure 4.6
Elise Co, Puddlejumper, 2001–2002. Courtesy of the designer.

Figure 4.7
Pierre Cardin, coat from Cosmonaut collection, 1966. Photograph by Yoshi Takata. © Pierre Pelegry.

Figure 4.8
Elise Co, Puddlejumper, 2001–2002. Courtesy of the designer.

Figure 4.9
Paco Rabanne, dress, 1967.

Figure 4.10
Despina Papadopoulos/Studio 5050, Day for Night Dress, 2006. Photo Ion Constas. © Studio 5050.

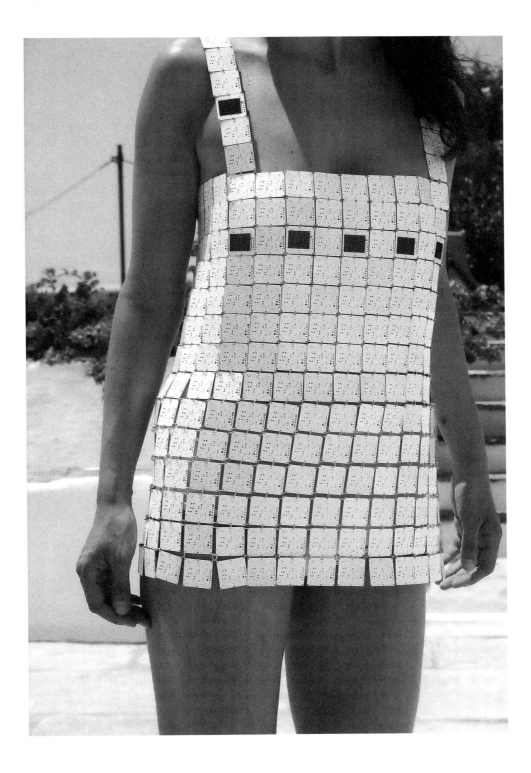

cells and LEDs, so that the dress can charge during the day, illuminate at night, and be programmed in special configurations.[53]

Hussein Chalayan

Within the world of fashion and couture, technology receded as a theme or subject in the 2000s, just as cyborg studies receded in the culture at large. But there have been exceptions to the former, notably Hussein Chalayan, a Turkish Cypriot graduate of Central Saint Martins College of Arts and Design, who approaches the profession of fashion design as an exploration of cultural and temporal interfaces. He often does this through the use of narrative, to enable clothes to "speak." Chalayan, who wanted to be a pilot when he was a child and is fascinated with airplanes and flight, has frequently used technology to illustrate the operation of clothes within time, space, and culture, and his approach is unique in the profession. His technological pieces are one-offs, provocations for his collections of "normal" clothes. Possibly the first fully functional electronic garment ever shown in actual couture was part of a regular runway event, his Aeroplane Dress (Echoform collection A/W 1999), a molded fiberglass dress with flaps that opened up or folded down, operated from offstage. His related Remote Control dress (S/S 2000, the year he was named British Designer of the Year for the second time in a row) is a svelte, white, modernist shell over a tulle underlayer, with rear hinged panels (the "fuselage") that raise and lower electronically (also with an offstage remote control).

At that time Chalayan was conscious of the discourse of invisibility, and he made use of it: "The dress expressed the body's relationship to a lot of invisible and intangible things—gravity, weather, flight, radio waves, speed, etc. . . . Part of it is to make the invisible tangible, showing that the invisible can transform something and say something about the relationship of the object—the dress in this case— between the person wearing it and the environment around it."[54] Again, this dress served as a keynote or archetypal object for a collection of largely nontechnological clothes that were for sale. Chalayan routinely crosses genres, making films, participating in art exhibitions, and, as he says, "creating a bridge between different worlds and disciplines."[55]

Technology is a tool for Chalayan and occasionally a subject, so it has appeared in his runway shows intermittently but consistently. His famous thesis show for Central Saint Martins, "The Tangent Flows" (1993), however, incorporated not technology but organic decay: the clothes were buried with iron filings, then dug up and worn on the runway, summoning to mind Walter Benjamin's connection between fashion and death. Chalayan said he was researching Isaac Newton, René Descartes, and Carl Jung, and developed a story "about a character who, in her attempt to integrate Eastern and Cartesian thought," creates a dance in which dancers have clothes with magnetized

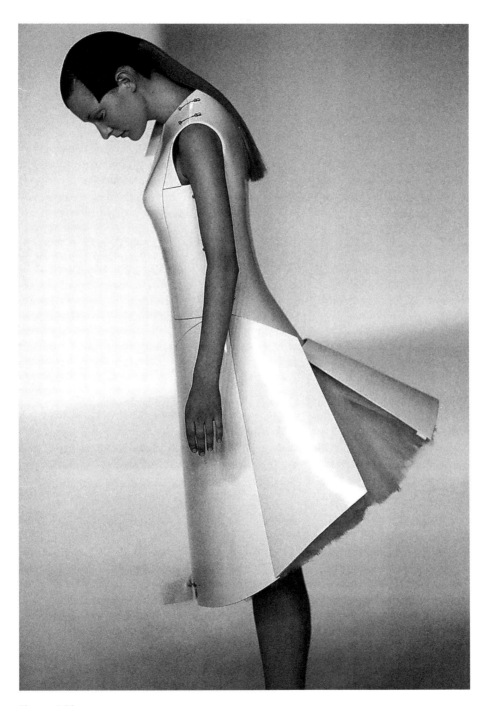

Figure 4.11
Hussein Chalayan, Airplane Dress, S/S 2000. Courtesy Catwalking.

panels that interact with each other, but the public mocks the dancers, bombards them with iron filings, and murders and buries them. It was about the fear of science.[56]

Ideas of flows, flight, and migrancy recur in Chalayan's oeuvre, concepts facilitated by technology, as Carolyn Evans writes: "It is precisely the homelessness of the cultures of new media and technology that generates the language with which Chalayan goes exploring."[57] Chalayan's One Hundred and Eleven (S/S 2007) collection showed six dresses that used remote-controlled animatronics to make them expand and contract. Beneath each model's skirt was a computer-driven system designed by Moritz Walde-meyer (a former robotics researcher at Philips) and the creative engineering firm 2D3D. The collection performed changes in fashion occurring over the course of a century, narrating several transformations within a single dress. In one case a dress with square, metallic scales flares out to form three different profiles; then the scales invert, creating three more looks, all while the model's wide-brimmed hat morphs to become a pillbox. In another piece the entire dress retreats into the model's hat, leaving her naked onstage. These computerized fashions all served to drive home the force of constant change. In the next collection he explored climates and seasons (Airborne, A/W 2007, sponsored by Swarovski). Chalayan showed illuminated dresses made of flexible liquid crystal displays, coats with telescoping hoods, and hats that emitted red lights to brighten dark winter nights. For Readings (S/S 2008) he worked with Waldemeyer, using Swarovski crystals on dresses with embedded lasers. The laser light was refracted through the crystals into scintillant beams as a way to explore the energy between the devotional object and its audience, a commentary on icons and celebrity. You might say that the designer dreams of garment fantasies and uses technology to materialize them. These technological fantasies have nothing to do with function, and his work has carved out its own space on the periphery of commercial fashion while using fashion's conventional orientation toward display. In doing so, Chalayan gives us a perspective on how WT can evolve as dress.

The Aberrant Apparatus

One might ask whether or not WT in the hands of materialist-conceptualist designers like Co or Chalayan contributes to a novel "apparatus," a different regime of dress and its enunciation, than previous regimes of either technology or fashion.[58] WT is not an overarching social regime like the state, the relations of which Foucault identified as an "apparatus"; WT is more like a creative motion inside the regime of technologized, urban society, our dominant apparatus. The combination of technology and the body through dress, in the hands of a designer like Chalayan, does seem to change our relation to the new, our actuality. Moreover, as Agamben considers Foucault (or, rather, tries to correct Deleuze's reading of Foucault), the apparatus also involves the relation between human beings and history, which is something not only hypothesized by

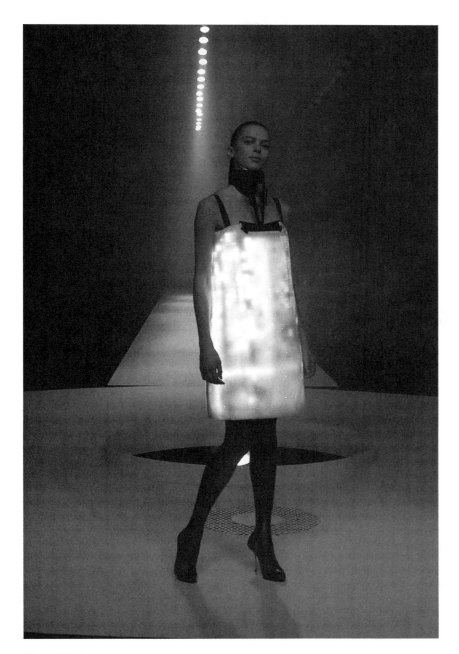

Figure 4.12
Hussein Chalayan, LED/LCD dress for Airborne collection, A/W 2007. Courtesy Catwalking.

fashion itself (its quotation from the past as always something new), but clearly inter-rogated by designers like Co and Chalayan when they amalgamate history, fashion, and technology.[59] According to Agamben, who seeks to improve on Foucault's term *dispositif* (a difficult word to translate, but usually given as meaning "apparatus"):

> Further expanding the already large class of Foucauldian apparatuses, I shall call an apparatus literally anything that has in some way the capacity to capture, orient, determine, intercept, model, control, or secure the gestures, behaviors, opinions, or discourses of living beings. Not only, therefore, prisons, madhouses, the panopticon, schools, confession, factories, disciplines, juridical measures and so forth . . . but also the pen, writing, literature, philosophy, agriculture, cigarettes, navigation, computers, cellular telephones and—why not—language itself, which is perhaps the most ancient of apparatuses.[60]

In this line of thinking, both technology and fashion might be added to his list of orienting or determining apparatuses.

But rather than being merely a subjectifying force, as in Foucault's disciplinary society, Agamben's apparatuses today leave individuals in limbo: "What defines the apparatuses that we have to deal with in the current phase of capitalism is that they no longer act as much through the production of a subject, as through the processes of what can be called desubjectification," something akin to the numbing or torpor evoked by Andy Warhol's violent imagery.[61] For Agamben, the human body is massively manipulated and commoditized, yet in a way it is also emancipated, making possible a "whatever body"—"whatever" not because it is indifferent, but because it operates at a juncture of possibility as a singularity.

It is this aberrant remix of the apparatuses of fashion, design, and technology that allows WT to convey a glimpse of Agamben's "whatever body," creating experiences of dress that enhance technological awareness, not obliterate it. For example, Suzi Webster's *Electric Skin* (2006) is performance based on a bioresponsive garment. When it is put on and turned on, the dress creates a space and time simply to experience technology. It turns the intimate breath of the wearer into pulses of aqua blue light. A breath-controlled electroluminescent panel is embedded in the hood that flares off the garment. It does not diagnose its wearer or suggest a treatment. It merely focuses the experience of breathing in both metaphysically and digitally enhanced ways, and, at the same time, it buzzes, encouraging an awareness of connectivity to electrical circuitry. With her eyes covered, the wearer does not become the subject of a cycle of self-image and display. Vision (our predominant sense) is exchanged for heightened awareness of hearing and touch (light as heat).

Speculative Design

Joanna Berzowska is a researcher in electronic textiles and responsive garments who practices in the breach between function and self-reflective ideas. She is another

Figure 4.13
Suzi Webster, *Electric Skin*, 2006. Courtesy of the artist.

graduate of the wearables decade (the 1990s) at the MIT Media Lab, where she also worked (like Co) with John Maeda, and with Hiroshi Ishii in Tangible Media. At MIT she was a bit skeptical of affective computing because, she says, it was "not representative of the complexity of human experience, since affect is only one part of human emotion."[62] She says she was a feminist in those days, and her own turn to soft materials and conductive textiles was more purposeful and political than that of Maggie Orth, with whom Berzowska collaborated briefly on the start-up company International Fashion Machines.

Later, at Concordia University in Montreal, Berzowska collaborated with Di Mainstone, another fashion design graduate of Central Saint Martins College, on Skorpions (2007), five electronic garments made of nitinol (a shape memory alloy, or SMA), circuitry, and various other materials.[63] Skorpions move and change on the body, controlled by their own internal programming. The series was intended to explore an adversarial relationship with technology: how we sometimes fear it and how, in opposition to the perfection technology is supposed to represent, it is ultimately unpredictable. The Skorpion garments do not create sound or light, nor do they augment the wearer's abilities; rather, the opposite. They slide around the wearer's body on their

Figure 4.14
Suzi Webster, *Electric Skin*, 2006, detail of 2007 performance. Courtesy of the artist.

Figure 4.15
Joanna Berzowska and Di Mainstone, Luttergill dress from Skorpions, 2007. Photo Nico Stinghe.
© XS Labs.

own like live skins or animals, opening pulsating gashes that resemble breathing gills. Rather than embodying function, they malfunction; they are the agents of the otherness of garments—as if clothes are not just consumed but "possessed," and threaten to possess us.

Skorpions bring Dunne and Raby's idea of design noir into the world of fashion and technology. They exploit characteristics such as control, anticipation, and unpredictability. They integrate electronic fabrics, nitinol, mechanical actuators such as magnets, soft electronic circuits, and traditional textile construction techniques such as sculptural folds and drapes of fabric across the body. Like many of Co's pieces and Chalayan's One Hundred and Eleven, Skorpions reference the history and culture of garments, but theirs is a story of vestments of pain and desire. Skorpions also situate us in the digital world: they emphasize our lack of control over our dress and our digital technologies.

Skorpions have an animal nature, and the series pays homage to their formidable namesake arthropod and its iconic elegant but deadly tail. Like it, the garments move with a slow, ominous quality, though each garment possesses its own feral character. For example, the dress called Skwrath ("Skorpion wrath") has a quilted leather bodice lined with blood-red silk. Its winglike collar can conceal the face of the wearer or be torn open. The insectile abdomen is made up of three interlocking leather segments, embroidered with threads of SMA, which, when activated through a custom electronic board, curl away, revealing slashes of red silk. Skwrath warns people to stand back. When they get too close, its plates crawl and retract, and red silk suggests blood gushing forth. In contrast, Luttergill is a soft, quilted cotton cocoon that mirrors the female form. Several seams roll open and closed, controlled with the aid of SMA and custom electronics. Luttergill appears to come apart slowly at the seams, revealing the serene blue silk inside. As garments, Skorpions revisit Donna Haraway's notions about "companion species" by animating digital technology and wrapping us in its uncontrollable interface.

The dark side of garments rendered as abusive electronic creatures is also suggested in other Berzowska projects, like Leeches (2009), LED-illuminated components that resemble fingers or worms, or leeches. These attach to a garment substrate by means of magnetic snaps that act like electrical connections (to a hidden power module at the shoulder).[64] Like bloodsuckers, these "leeches" literally drain power in order to glow red, representing technology as power-thirsty and dangerous. Berzowska refers to such pieces as "reactive garments": rather than dress responding to us and ministering to some perceived need, as with affective technology, we, as wearers, react to what we are wearing. She says, "My work fits into this category of speculative design, what we might call design fiction. It makes you step back and has a weird switch that undermines our expectations about technology. These works are not meant to solve problems but pose questions about how design might operate."[65]

Figure 4.16
Joanna Berzowska, Leeches, 2009. © XS Labs.

Figure 4.17
Joanna Berzowska, Sticky from Captain Electric and Battery Boy, 2007–2010. Photo Guillaume Pelletier. © XS Labs.

Berzowska's Captain Electric and Battery Boy (2007–2010) is a collection of garments that takes, for its subject, fear and our tendency to overcompensate for it. These pieces revive the 1930s superhero, whose costumes performed futuristic powers, and respond to the modernist eugenics fantasy with a human enhancement comedy, specifically electricity generated by the human body. The individual garments, called Itchy, Sticky, and Stiff, which reference safety or hazard attire, contain inductive generators that convert kinetic energy from the body into electric energy and store it within power cells in the garments. Itchy contains a series of fabric tube elements encircling the neckline, calling to mind necks thick with scarves and turtleneck sweaters. But, being scratchy, they cause the wearer to constantly grasp and turn them, causing them to light up in ways intended to evoke the lighting of safety buoys and airplanes' emergency tracks. One of the neck tubes contains a geared servomotor that charges the battery. Sticky is a hooded leather dress with sleeves tethered to shells on the abdomen such that the wearer must strain against them (think artist Matthew Barney's early "drawing restraint" performances). The energy generated by doing so

powers blue LEDs located inside the garment's pockets and visible to the wearer: "Sticky binds the arms, restricting their motion, keeping them close to the body. It coerces the body into a state of isolation. Attempts to free oneself from the restraints, by reaching away from the body, generate energy to soft luminescent pebbles in the pocket . . . concealed silicone forms [which offer] a comforting glow" that persists after the wearer has stopped struggling.[66] The glowing "pocket pebbles" are warm, tactile objects, similar to calming stones, and serve as a soothing relief, an unexpected spoof on Mark Weiser's notion of calm technology.

Social Interaction Design

In the designs described above, the goal of augmentation or enhancement sought by builders of wearable computers and personal-area network systems is entirely overthrown and replaced by non-product-based, experimental or ironic design that is highly coded but references the world of dress and culture, especially technological culture. These unusual body-based wearables are not only commercially unfeasible but preposterous, fantastic, or comic. Some designers of technologically activated clothes bring this same attitude toward creating external relationships between wearers and their environment, or between offline and online social relations.

As part of her 2000 Media Lab thesis, Elise Co created Halo, an interpersonal interactive illuminated belt that creates a social unit in a public space. The belt is made of electroluminescent jewellike pebble or bezel forms connected by curved aluminum tubes (housing connector wires), hinged so that they move and swing like any chain belt (Co mentions Halston's silver hip pendants of the 1970s as inspiration).[67] The configuration and rhythm of the lighting units of Co's belt can be determined either by its wearer, via PDA, or by a second person wearing a similar belt who can transmit a lighting configuration to the first wearer, creating what Co calls a "multi-person garment," whereby two or more people, similarly outfitted, can engage in nonverbal conversation through the reconfiguration of lights on their own and their neighbors' belts.

In 2002 Katherine Moriwaki and Jonah Brucker-Cohen created a participatory urban network by means of a clothing accessory, the umbrella, or rather a series of umbrellas that emit an electronic signal when opened and light up when nearing others of their kind, but only in the presence of rain. The designers' umbrellas were equipped with PDAs running software in an ad hoc network (self-configuring network of mobile routers and hosts connected by wireless links), and with LEDs: they pulse red if searching for nodes, pulse blue when connected to other umbrellas, and flash blue when information is transmitted between the umbrellas, such as via the built-in chat program accessible via the PDAs. Umbrellas are a common and classic accessory that we use to carve out personal space, especially in inclement weather, and always make an

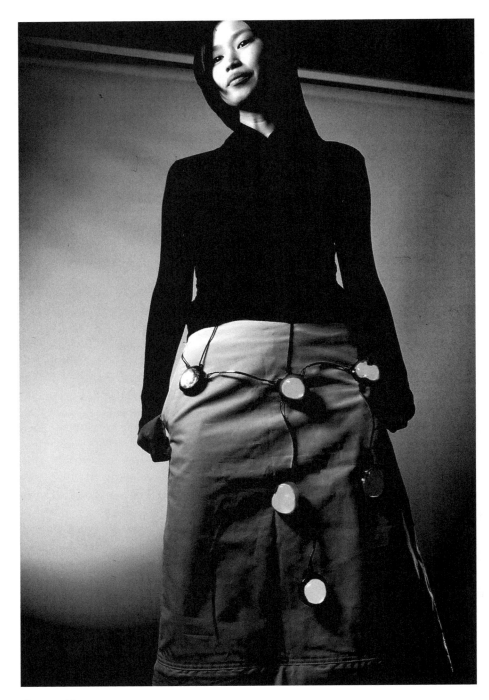

Figure 4.18
Elise Co wearing Halo, 2000. Webb Chappell Photography.

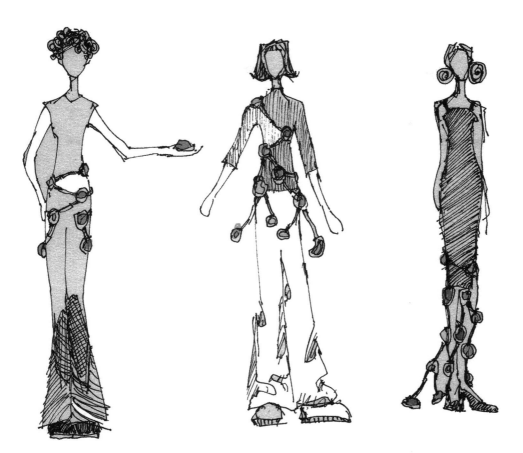

Figure 4.19
Elise Co, drawing of Halo as a multiperson garment, 2000. Courtesy of the designer.

appealing display for pedestrians in any rainy urban landscape. Umbrella.net references this picturesque phenomenon and discloses offline awareness of the online network to passersby. Moreover, the designers point out the psychological power of shared experience in public spaces, a feeling of shared commonality that is often lost in the crush of urban life, where too often we perceive other bodies negatively and protect ourselves from them, rather than participating in a shared awareness and "unexpected and poetic relationships between people and the environment."[68] In a related project, Inside/Outside (2003), Moriwaki created two handbags that sense and display information about the environment. Their decorative elements are sensors that read either air pollution or environmental noise levels. The bags also store a data diary of levels that create a cumulative map of their wearer's environmental exposure, so they function both as accessory and instrument. Moriwaki used the bags to make clear her position on sensors and storage technology and control: "I like to advocate a playful response to technology that ultimately places ownership and control in individuals' hands."[69]

Other designers have explored the notion of using enhanced garments to interface with the physical environment, a notion based in wearable and ubiquitous computing but susceptible to materialist-conceptualist elaboration. An example of an interactive garment still dependent on affective computing principles is Diller and Scofidio's visionary Braincoat, a "smart raincoat" of minimal physical design—almost transparent, and similar in appearance to common hooded raingear. It was designed to assist viewers interfacing with the architects' Blur Building, literally a pavilion (for Swiss Expo 2002) made of filtered lake water shot as a fine mist through thirteen thousand fog nozzles creating an artificial cloud three hundred feet wide, two hundred feet deep, and sixty-five feet high. Blur Building's built-in weather station controlled fog output in response to shifting climatic conditions such as temperature, humidity, and wind direction and velocity. The coats, which were planned but never employed with the completed building, would have protected visitors from the damp mist. Additionally, they were to be programmed to store identity and location data as character profiles in the Blur data cloud network, and to change color when people with compatible profiles came into proximity with each other; so the coats were to operate as social media programs like online dating services, matching strangers up.

At the other end of the spectrum is the absurdist approach of Valérie Lamontagne's *Peau d'Âne* (or *Donkeyskin*, 2005–2008), a series of three baroque-inspired costumes designed to represent a fairy-tale theme: literally, Charles Perrault's 1695 story of the same name, in which a princess requests that impossible, immaterial dresses be made to ward off marriage to her evil stepfather: one made of sky, one of moonbeams, and one of sunlight. Lamontagne's versions of the three dresses, made of more common fabrics like nylon and satin, interface with climate conditions in various ways, two of them using Max/MSP programming and running data from a small Davis weather

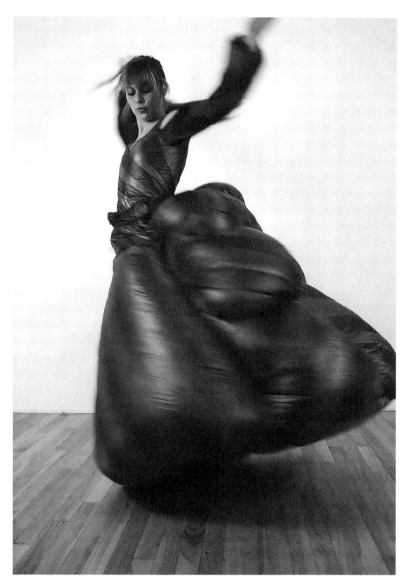

Figure 4.20
Valérie Lamontagne, Sky Dress from *Peau d'Âne*, 2005–2008. Courtesy of the artist.

station that functions wirelessly. For example, the Sky Dress uses wind velocity and direction data. Wind conditions picked up by the station are sent to the dress, where microcontrollers relay the information to customized circuitry, and fourteen vibrating air pockets in the dress modulate the fabric's volumes and surfaces according to the data. The Sun Dress acts on a UV index and solar radiation, and was programmed into a twenty-eight-day cycle without the need of the Davis console.[70]

"Seamful" Design

Designer Sarah Kettley created an alternative approach to corporate-owned, phone-based mobile networking that is comparable to, but more involved than, Moriwaki and Brucker-Cohen's Umbrella.net: a set of multiperson, interactive necklaces. Called Friendship Jewellery, the five neckpieces, made in 2005–2006, are wirelessly networked to form a friendship group (see figure 5.10). Built at a workbench and deliberately merging traditional craft techniques with new technologies, each piece incorporates a prototype wireless sensor node, or "speck," which acts to locate and identify other specks within a range of approximately twenty meters. This information is then visualized on five dedicated LEDs on each necklace, which flash at different rates and colors to reflect three social distances. These are distances at which modes of greeting have been observed to change: intimate (under thirty centimeters), social (thirty centimeters to one meter), and distant (one meter to a limit of twenty meters). Kettley based her system on Edward T. Hall's observations and identification of proxemics (in *The Hidden Dimension*, 1966). When wearers of Friendship Jewellery observe their necklaces flashing, they can choose whether to act on this information or not.[71]

In her 2007 PhD thesis in Interaction Design at Napier University, Edinburgh, Kettley refers to the ambiguity of WT in the academic environment.[72] She refers to a concept she calls "seamful" design (as opposed to Weiser's "seamless" design), whereby "revealing seams (literal seams, or other incursions in user experience) in a design will offer useful opportunities for user understanding."[73]

If so, Laura Beloff, Erich Berger, and Martin Pichlmair's Seven Mile Boots (from 2003) provide an example that is absurdly seamed. The boots enable their wearer to search for audio chats on the Internet by walking actual ground, manifesting the idea of searching as really striding, and evoking Baudelaire's *flâneur* (the Baudelairean persona is, appropriately, a common theme for material-conceptual WT). Internet conversations are broadcast by the boots, allowing passersby to hear. Digital space is thereby converted into real-world public domain, dramatizing the fiction of Internet privacy. Big and covered with hardware, the boots are showy and evoke fabled footwear like the seven-league boots of European folklore.

Beloff takes what she calls the "third approach" to the problem of WT (the first approach being wearables as ubiquitous computers, the second being e-textiles and

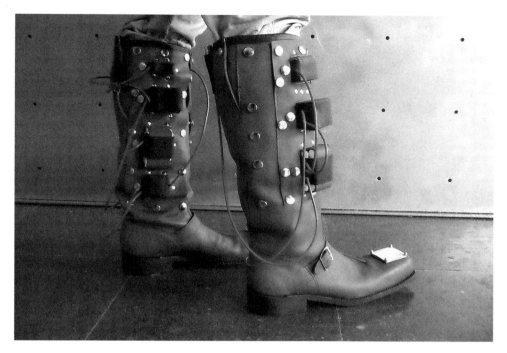

Figure 4.21
Laura Beloff, Erich Berger, and Martin Pichlmair, Seven Mile Boots, 2003–2004. Courtesy of Laura Beloff.

fashionable technology—in other words, product-oriented designs). The third approach is similar to what I have called the materialist-conceptualist mode. It is characterized by an "overall ironic attitude, peculiar functional structures and a sense of exaggeration in visual aesthetics," as well as by its very existence as a research style, unhampered by the need to arrive at "smooth and purposeful functionality."[74] Moreover, the Seven Mile Boots "challenge the standardized ways in which technology is usually understood and used in wearable technology. Secondly, the projects create awareness about the processes that make technology transparent and seemingly resist it. And lastly, while posing questions about the meaning and purpose of technology in our everyday life, these projects propose new viewpoints into the field."[75]

Discussing this approach in dealing with the integration of bodies and networks, Beloff has cited the writings of Adriana de Souza e Silva concerning how the widespread use of mobile interfaces has led us all to experience a hybridized sense of space, merging real, physical space, in which our body exists among other bodies, and digital space, the arena of our virtual encounters.[76] Likewise, Andraž Petrovčič, in his 2008

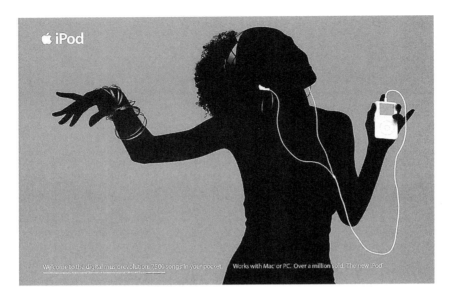

Figure 4.22
iPod 2006 television advertisement, screen grab.

study of personal networks in Slovenia, found that users tended to combine multiple media modes to sustain their personal networks. Furthermore, he found that "results regarding the distance of ties in the personal networks of ICT [information and communication technologies] users and offline socialization indicate that the new forms of sociality, although promoting spatially extended personal communities, are firmly embedded in physical settings," and that the rich mixture of exchanges is manifesting a trend toward fine-tuning of social relations in both realms.[77] This quotidian real/virtual blend is what Sherry Turkle calls "life mix," and mobile and social technologies have made it possible to rapidly cycle through our multiple online and offline identities at an accelerating pace.[78]

Wearable or Bearable

Apple launched the first mobile digital music player (replacing mobile CD players, like the Discman) in 2001, a clean, white unit with minimalist earbuds, designed by Jonathan Ive and the Apple design team. On its heels, iTunes, the "digital hub" online media store that centralized and branded users' music (at first) and video (later), was rolled out in 2003. From the beginning, iPod advertising aimed at conveying to consumers a new, personable, body-centric media device in commercials that iconized hip, young, black-silhouetted figures tethered to their devices—snappy dancing forms

Figure 4.23
iPod Nano (sixth generation) advertisement, 2010, screen grab.

against bright-colored backgrounds that had instant visual appeal and suggested ghostly counterparts to the legs in the Dim Stockings ad that occasioned Agamben's description of the "whatever body." But the Apple dancers are not "whatever"—not ultra-aware or figures with potential, but rather blind images of the body that lack specificity and appear as blank as they are branded.

Mobile phones are variously thought of, on the one hand, as customizable and contributing in unique ways to personal identity and, on the other, as intimate devices that absorb our personhood into configurations of tags and networks. Sherry Turkle writes about how digital communications create a "place for hope." She talks about her own observation of MIT's Borg Lab in the 1990s, how the students she had talked to there felt like new, better versions of themselves. Some fifteen years later, she writes, "like MIT's cyborgs, we feel enhanced." At the same time, she finds that "networked, we are together, but so lessened are our expectations of each other that we can feel utterly alone. And there is the risk that we come to see others as objects to be accessed—and only for the parts we find useful, comforting, or amusing."[79] This is the risk of life lived tethered to our devices. Studies have been done, especially among youth in Japan, demonstrating the dependency we have developed on carrying these devices around at all times.[80]

The advent of the Apple iPod Touch and then, famously, the iPhone introduced a touch-based interface that engaged the body substantially more than just peering at a relatively small screen. The iPod Nano (sixth generation), offered in 2010, has a small square touch screen, the content of which is navigated by a variety of gestures—swipes,

taps, even shaking the pod (which changes the music being played). Designed as a clip-on Nano, and small enough to function easily that way, the sixth-generation model was immediately advertised as a true wearable, a little piece of musical jewelry. Interestingly, the campaign for this Nano showed actual young users—not silhouettes—clipping it onto their clothes and stroking screens that are turned toward a "viewer" (i.e., facing away from themselves), thereby transforming the isolationist experience of mobile music into embodied public display: the Nano appeared as actual WT participating in an anticipated landscape of dress centered on communications devices. Here Apple, the commercial enterprise, was able to influence a major market the way individual designers, working with jewelry that made phone calls or generated sound, never could.[81] The Nano "wearables" and, to a lesser extent, earlier iPods with their earbuds (like generations of Walkman and Discman before them) enabled a heads-up-style integration of the subject within the external environment, even if users' external awareness was proportionately decreased as they became absorbed in the music. As we have seen, this orientation toward the environment is nothing new; it harks back to World War II pilot displays as well as to the MIT cyborgs' head-mounted data screens.

The iPhone, which appeared in 2007, heralded a completely different relationship between body and technological device. Not only did it contribute to a smart phone escalation in the late 2000s, but these phones became convergent media devices, centralizing layers of communication modes and other applications simultaneously: phone calls, voice messages, text messages, online chats, personal pictures and videos, social media (Facebook, Twitter, and others), plus a range of apps enabling a variety of activities, most prominently games. Communications scholar Isabel Pedersen has discussed the iPhone's appearance as a pivotal cultural event that structured a fundamental shift in subjectivity: "While the iPod campaign encourages a sense of embodied freedom and play, the iPhone campaign encourages a preoccupation with work and consumerism."[82] She characterizes the iPod subject (or wearer) as "centric" but the iPhone subject as "eccentric," as the device has moved into the subject target space.[83]

Accordingly, and as opposed to the somewhat wearable, smaller iPods and Nanos, I call the iPhones and their commercial progeny "bearables," because they must be carried or borne around, and because the fragmentation they unleash on our lives must be borne psychologically as well.[84] The smart phones demand to be kept close, despite potential dangers to human tissue from increasing exposure to electromagnetic fields, but because they enable multiple communication capabilities—texting, video, and social media apps are in play even more than phone calls or music—users are often no longer upright, participating in their environments. Instead they are hunched over, immersed in the escalating programmable and virtual social relations supported by these phones.

Figure 4.24
CuteCircuit (Francesca Rosella and Ryan Genz), Hug Shirt, worn by Ryan Genz, 2004. Courtesy
of the designers.

The experience of recentering mobile communication on a human subject is a major concern for critical wearables designers. Working in collaboration as CuteCircuit, Francesca Rosella and Ryan Genz developed the Bluetooth-enabled hoodie, the Hug Shirt (2004) mentioned earlier, that links with Java-enabled mobile phones. First, the shirt carries the mobile device, putting its wearer back into a central position as a subject controlling its own spatial field. Second, the Hug Shirt reasserts physical emotion. Designed to be worn by both caller and receiver, the shirt delivers a "hug" (by applying pressure to points on the body), representing the physical dimension that phone-based digital communication lacks. CuteCircuit proceeds on the assumption that design is added value to an already expansive mobile-media market, and that the result users want is not human-computer interaction but human emotional interaction, through a material interface.[85] The shirt builds on existing telecommunications platforms and can be activated by either phone or messaging system, so the receiver can also get a hug from a text. The Hug Shirt is one of numerous wearable designs intended to reembody digital information or communications. Another example is Barbara Layne's Jacket Antics (2007). While not involving a phone interface, the Antics are a pair of garments designed to scroll programmable messages on their backs (the LED scrolls on the original versions of the coats carried texts about technology in Canada and Australia). When the two jackets are joined—by the wearers holding hands—magnets in the cuffs act as switches, activating circuits connecting to the panels through silver threads woven into the linen yarns, and the jackets' texts scroll in tandem, sharing continuous messages across both wearers' backs.

Ricardo O'Nascimento, Ebru Kurbak, and Fabiana Shizue's Taiknam Hat (2007) represents a different approach, a wearable but metaphorical head covering that raises awareness about ambient technology. It is a feathered chapeau that exists in multiple versions evoking both fashion and folklore.[86] Its feathers are animated in accordance with changes in surrounding radio frequencies. The artists write that the hats "materialize the invisible and contribute to our awareness of the increasing level of electromagnetic radiation in our environment." The electromagnetic waves radiating from our electronic devices create an invisible landscape that interacts with physical space and its inhabitants. This landscape is transformed into a new form of pollution, "electrosmog," which has biological effects on humans and animals. Taiknam Hat attempts to render the electrosmog visible by emulating horripilation, the erection of hairs or feathers in various species under irritation and stress (such as "goose bumps" in humans). In some animals, especially birds, horripilation is also attached to another instinct, that of self-display and signaling. Taiknam Hat utilizes horripilation as a metaphor to express our bodies' conflict with technological conditions. The headwear employs actual movable feathers that become activated and move according to the intensity of radio frequencies in the surroundings, and can be set off with the use of a phone by the wearer.

Figure 4.25
Ricardo O'Nascimento, Ebru Kurbak, and Fabiana Shizue, Taiknam Hat I, 2007. Courtesy of the artists.

Figure 4.26
Ricardo O'Nascimento and Tiago Martins, Rambler, 2010, microblogging sneakers. Courtesy of the artists.

While the first version was meant to reference elegant women's hats from many periods of history, O'Nascimento designed a second version for men, inspired by the hats hunters still wear in the countryside around Linz, Austria, the location of a well-known new-media festival, Ars Electronica.[87] This version is a comic reference to the festival, and the prominent feathered ornament, which rises in a jerking movement (unlike the gentle levitation of the feminine hat's crest), mimics an action associated with male sexuality.

O'Nascimento (with Tiago Martins) addressed the absurdities of our relations with mobile and social media in the Rambler, a pseudo-brand athletic shoe that microblogs as the wearer, another digital *flâneur*, walks around. A sensor on the sole of one shoe measures pressure; together with time intervals between steps, the information is processed by a microcontroller inside the shoe and posted to a Twitter account as steps, or "taps." Social media as protocological panacea—a phenomenon by which we microblog our lives, often mindlessly, minute by minute—is comically automated by the shoes, which produce a meaningless babble of taps that nevertheless accurately records the wearer's "ramblings."[88] While the Taiknam Hat imitates

Figure 4.27
Rambler Twitter page, screen grab.

ornithological sign language, the Rambler shoes generate the voiceless speech of online chatter.

Speech and Spectacle

Since the 1990s, fashion's history as spectacle has become its perpetual subject. Carolyn Evans writes that, in the mid-nineteenth century, Walter Benjamin linked women, commodities, and consumption in an atmosphere of surface and illusion—the arcades—whereas today all of media has become our arcades.[89] She describes how fashion, as codified in collections and runway shows from the 1990s through about 2002, was obsessed with images of death and ghostliness, often hinging on the resurrection, fetishization, and destruction of garments of the past: Christian Dior's AW 2000–2001 collection, based on a narrative of an Edwardian family read through imaginary correspondence on fetishism between Jung and Freud; Rei Kuwakubo's misuse and abuse of garment elements, like shirts sewn on top of skirts, or torn and frayed fabrics; even Chalayan's diploma show of garments that he buried in the ground and dug up again

(1993). Evans quotes Derrida on the specter or ghost as a "spirit of capitalist striving [so that the] the specter is 'the becoming-fetish of the commodity'" described by Marx: "The ghost and money are inseparable in capitalist logic."[90] This figure of mounting commoditization can be compared with Benjamin's image of the Angel of History (based on Paul Klee's painting *Angelus Novus* of 1920):

> [The angel's] eyes are staring, his mouth is open, his wings are spread. This is how one pictures the angel of history. His face is turned towards the past. Where we perceive a chain of events, he sees one single catastrophe which keeps piling wreckage upon wreckage. . . . A storm is blowing from Paradise. . . . The storm irresistibly propels him into the future to which his back is turned, while the pile of debris before him grows skyward. This storm is what we call progress.[91]

Celebrity appearances, from red carpet to music mega-performances, are among the most viral of social media subjects in recent years, but as contemporary spectacles they often mine the past in their deluge of images that render us like angels of history. In recent years, WT has reentered fashion as spectacle, like a Freudian "return of the repressed." Douglas Kellner is one (among many) who discusses fashion in such terms: "In fashion today, inherently a consumer spectacle, laser-light shows, top rock and music performers, superstar models, and endless hype publicize each new season's offerings. . . . The consumption spectacle is fundamentally interconnected with fashion, [and] the stars of the entertainment industry become fashion icons for imitation and emulation . . . in a Postmodern image culture."[92]

But Evans points out that the difference between this situation and the spectacle Guy Debord once wrote about is that the media is no longer mere representation, mere image; the image itself is a capitalist object that circulates in an increasingly dense network of signs.[93] As the fashion industry backed away from WT for economic and conceptual reasons, its effects and devices reappeared in celebrity scenarios, the expanded runway of the twenty-first century. WT is thus fully recontextualized, moving away from its attachment to futurism and toward media and celebrity. Illuminated stage wear, especially when visually or sonically interactive or programmable, has become a common component of music and media performances, its deployment even increasing during the Great Recession. In 2008 singer Kanye West debuted a coordinated flashing LED jacket and scarf at the Grammy Awards ceremony. In 2009 wearables engineer Moritz Waldemeyer designed a jacket with 240 lasers for Bono to wear in U2's 360° Tour, which had a futuristic stage with a gigantic video display suspended from a claw-shaped supporting rig, designed for 360-degree performances in stadiums. The jacket's lasers radiated red lights from Bono's body as he moved in the smoky atmosphere, recycling the idea Waldemeyer had already employed in Chalayan's Readings (2007) collection, which dealt with modern-day celebrity as a version of ancient sun worship. But the U2 version received even greater circulation through the Internet and social media than did Chalayan's gowns. 2010 was a banner year for

Figure 4.28
Moritz Waldemeyer, laser jacket for Bono, U2 360° Tour, 2009. Courtesy of U2 Press Office.

technology-driven stage outfits, like Lady Gaga's robotic and LED-illuminated Living Dress, created by costume designer Vin Burnham, who had earlier created the super-hero and futuristic costumes for films like *Batman Returns* (1992) and *The Fifth Element* (1997), the latter along with Jean Paul Gaultier. As she sang "So Happy I Could Die" (during the Monster Ball Tour), Lady Gaga's dress sprouted wings, the floor-length skirt retracted and fluttered, and her headpiece morphed from a halo to a cross, all orches-trated through remote wireless connections. Burnham reports that Lady Gaga was also inspired by Chalayan's technological work, and an engineer from Chalayan's team, animatronics specialist Adam Wright, worked on the Living Dress.[94]

In 2010 Waldemeyer teamed up with Paris designer Alexandre Vauthier to create a long black dress with red LEDs for Rihanna's Last Girl on Earth Tour. Other 2010 appearances of illuminated dressing included Katy Perry's appearance at New York City's Metropolitan Museum of Art Costume Institute Gala, a particularly fashion-conscious red-carpet event. Perry's dress was designed by CuteCircuit's Francesca Rosella and Ryan Genz, the same team that created the Hug Shirt. The two designers had originally met at the Interaction Design Institute in Ivrea and had studied there with Massimo Banzi (who would later go on to cofound the Arduino project), Casey Reas (who had recently launched Processing), Bill Verplank, Bill Moggridge, John Maeda, and Gillian Crampton Smith. Rosella had already designed an electrolumines-cent dress as an intern at the couture house Valentino in 1998, and pitched a GPS

Figure 4.29
Vin Burnham and Adam Wright, Lady Gaga's Living Dress, 2010.

Figure 4.30
Katy Perry wearing CuteCircuit dress at the Metropolitan Museum of Art Costume Institute Gala, 2010. Photo Reuters.

handbag to Esprit (unsuccessfully) a few years later.[95] At Ivrea, Rosella coined the phrase "human-human interaction" to describe what would become CuteCircuit's approach to designing interactive systems that seek to put human experience at the center. In 2008 the team created the Galaxy Dress, an over-the-top garment studded with crystals and twenty-four thousand LEDs, commissioned by the Museum of Science and Industry in Chicago as part of their permanent collection, and in line with science's always futurist viewpoint on WT. Displayed as the centerpiece of the museum's "Fast Forward: Inventing the Future" exhibition, it received massive attention in social media, much of it repostings, retweetings, and multiple uploads to YouTube. Soon afterward, CuteCircuit was contacted by stylist Johnny Wujek, who worked for singer Katy Perry. What they created for her was classic red-carpet style: a retro "old Hollywood" strapless chiffon gown with ruffles, but also with strobing mini-LEDs (hot pink, yellow, blue, electric green) in vertical stripes the length of the dress, running on flat (iPod-size) batteries, with a controller inserted in the star's bra enabling her to interact with the dress and cause it to light at will. Azerbaijani singer Safura also hired CuteCircuit in 2010 and wore the team's customized interactive dress in performance at the Eurovision Song Contest in Oslo. The dress was controlled in real time by an offstage VJ who streamed video of the stage lighting directly to it, illuminating LEDs in accordance with the performance, in particular suggesting raindrops ("Drip Drop" was Safura's song) and at one point creating a red glow to highlight the music's emotional crescendo.

In 2011 CuteCircuit worked closely with U2's wardrobe department to create interactive jackets for the entire band, following the success of Bono's laser jacket the previous year. CuteCircuit also created a wireless system that could be controlled remotely in real time. Each jacket was made of leather, with laser-cut openings for more than five thousand LEDs, whose circuitry was hidden under the lining. Again they were controlled using a live video feed to coordinate with the onstage lighting effects, so the jackets interacted with the stage environment, an intricately lit cylindrical lattice in the case of the band's song "Zooropa," performed on the North American leg of the 360° Tour. The lattice itself streamed a variety of light configurations, including actual videos as well as a text feed from media sources, which recalled Mark Hansen and Ben Rubin's new-media installation *Listening Post* (2001–2002). Bodies "disappear" into such lighting effects, but, just as plausibly, they reemerge as images with multiple levels of symbolic potential.

There is no denying the spectacular and commercial nature of these performances. It is clear that artistically ambitious designers like Chalayan and CuteCircuit understand something that industrial wearables developers have been slower to comprehend: that to encourage widespread interest in WT, it would have to permeate the fashion and celebrity milieus to enter the broader discourse of dress, which has now, like everything else, become mediatized. It is interesting to note, as Pamela Church

Gibson does in her book *Fashion and Celebrity Culture*, that celebrity has mushroomed to the extent that it is now a significant branch of cultural studies, with an increasing literature and its own academic journal. Gibson notes that celebrity today is intertwined with spectacular appearances of dress—red-carpet moments—and that such moments create the habitus of celebrity much more than the quality of any theatrical performances.[96]

What is interesting about the recent appearances of celebrities featuring garments that are robotic or otherwise electronically enhanced—but especially those with interactive illumination and programming—is the degree to which the commodity image of the celebrity is not so much abstracted as refracted. Debord warns us that the spectacle's "*manner of being concrete* is, precisely, abstraction. . . . The spectacle thus unites what is separate, but it unites it only *in its separateness.*"[97] Indeed, technology adds an additional layer of abstraction that operates not so much in person as in an interactive social ambience (the Internet) that is remote from Debord's world of radio and TV. Today's wired-up celebrities are contemporary spectacles bathed in a technological aura that we all share to some degree through our participation. Henry Jenkins calls this "participatory culture."[98] Claire Bishop has also commented on participation's eclipse of the spectacle, citing Boris Groys's remark that "we have spectacle without spectators."[99] It is not a matter of receiving a representation of the commoditized body; rather, we inhabit the moment of experience, even the connection, that draws on our investment with our social networks. When Bono's lasers invade the audience space, his garment points at and illuminates his viewers. This is not an abstraction that distances us from origins, as Debord says, or as Vilém Flusser writes when he discusses the photographic image; rather, it is a refraction that engages us physically, and often through our own digital media, as in the preponderance of smart phones among audiences today. Audiences disseminate their viewer images via social media, and they use their small lighted screens directly, to interact simultaneously with performances.[100] Anna Munster writes about how digital information is engaged by artists as an embodied aesthetic:

A number of artists and designers are increasingly aware of the potential of new media for providing intensive sensate engagement via abstract forms and displays of data. We can discern here one trend of experimenting with sensory modes of engagement that have been displaced from a visual economy concerned with extensive and fixed space. Corporeal experience is now relocated within a mesh of intersections between shifting patterns, maps and forces of digital information.[101]

Another convergent and participatory red-carpet garment was the Twitter Dress worn by British singer-songwriter Imogene Heap to the Grammy Awards ceremony in 2010. Designed by Waldemeyer, it was a black chiffon dress with flexible LED sign-collar that displayed messages sent to the hashtag #twitdress. She carried a Fendi

Baguette purse, a fashion fetish of recent years, articulated with a video screen that showed pictures posted to the Twitter account as Heap walked the red carpet. The sheer-bodiced dress and flowing skirt were of traditional design, and Heap held a Japanese umbrella, which (except for the bag) helped all of it to reference romantic nineteenth-century outfits. The fans' post-and-display time frame was collapsed, because their responses became part of the garment.[102] Unlike O'Nascimento's Rambler shoes, which posted their every step, Heap's outfit did not perform a commentary on social media so much as simply used it to fold time and space: performer and fan, celebrity and base, enclosed within the outfit. Waldemeyer's dress for Heap elevated the media-based garment's moment within the new spectacle of the participatory Internet.

Perry's and Heap's gowns are no longer just two among many celebrity costumes photographed and reproduced on the Internet (though they are certainly still that). And they are not quite accurately "capital to such a degree of accumulation that it becomes an image" (in Debord's catchphrase), since the garments just described begin to suggest an alternative form of speech that I have called a "dress act," one that uses technology to amplify the usual language of appearances. Agamben writes, "In the spectacle our own linguistic nature comes back to us inverted."[103] Dress, which for Agamben always ultimately refers to our conflicted nature represented by the unattainable garments of paradise, makes such references overtly in these wearable extravaganzas, and this ambitious irony becomes part of the display. Our era goes beyond Debord's understanding of the spectacle; in our time language is rendered meaningless, and the real separation is between humans and their own communicative powers. Agamben goes on, "The era in which we live is also that in which for the first time it is possible for humans to experience their own linguistic being—not this or that content of language, but language itself . . . the very fact that one speaks."[104] Or shows, one might add, or even flashes or pulsates.

Wearables designers working away from the limelight have used media spectacle not so much as an expressive launching pad as a method for materialist-conceptualist speech. Ying Gao earned a degree in French literature from the University of Lausanne in Geneva before she studied fashion design and multimedia communication at the University of Québec in Montréal. Gao's interest in dress in relation to visionary architecture is inspired by the British architects of the 1960s known as Archigram, and she created a series of white, geometric dresses called Walking City (2006) based on Archigram's fantastical Walking City and its pneumatic living structures, like Mike Webb's Suitaloon (1967), a project for an inflatable house that could be deflated and worn as a suit.

Gao's 2011 pair of dresses called Playtime is based on the 1967 film of the same name by Jacques Tati, which deals comically with the dehumanization of the modernist urban landscape.[105] The dresses, built of layers of translucent superorganza (a very

Figure 4.31
Ying Gao, Playtime, 2011, two interactive dresses. Photo Dominique Lafond. Courtesy of the
designer.

Figure 4.32
Anouk Wipprecht, with Marius Kintel and Jane Tingley, DareDroid, 2011. Courtesy of the designer.

sheer woven polyester) and custom circuitry, resemble very little in Tati's film except its reflective surfaces. Instead, the dresses "make their appearance" in the twenty-first-century world: they aspire to be unphotographable by responding to cameras in ways that blur the image: one dress is covered with fluttering ruffles that move too fast to register; the other has light-sensitive light pads hidden in layers of the fabric so that it glows from within, interfering with the camera's light reading. Gao presents her dresses in a video that supports the photography theme through the continuous sound of camera shutters in its soundtrack.

Gao believes that fashion has lost meaning in recent years and become too narrow and "incestual," but she fears that technological garments are years away from being accessible: "I do not believe interactive fashion can be popular any time between now and 2020. I do not want to compromise . . . so I just work as an artist on the one hand, and a designer on the other."[106] But her incorporation of multiple platforms and media formats, in both the content and display of her work, corresponds precisely to the place of media in the dress discourse of the present.

Dutch designer Anouk Wipprecht also creates ironic spectacle, as in her DareDroid Dress (2011), a robotic cocktail-making frock, done in collaboration with hacker Marius Kintel and sculptor Jane Tingley.[107] A parody of the cocktail dress and the red-carpet outfit, the DareDroid (a comic variant of "android") has a high-fashion profile and presentation, with tubes, molded dispensers, wires, and circuitry designed to articulate the white leather garment, which is body-conscious and revealing. It makes its wearer part cyborg-nurse, part bondage-fashion model, part waitress. The dress, triggered by proximity to nearby viewers, dispenses either milk or actual cocktails, depending on the degree of viewer interaction and success in a game of Truth or Dare (hence the name DareDroid), which viewers play with the wearer by means of a "bracelet," a touch-screen game device on her arm. Viewers have to win the stronger drink, which is dispensed from between the wearer's breasts (recalling lactation), by committing to self-disclosure in the game play. But if the viewer comes physically too close to the wearer, the dress shuts down, denying intimacy and proximity. The piece makes an obvious reference to 1990s cyborgs by turning assumed positions of server/served and human/machine control into physical comedy.

But WT need not use social media to create participatory spectacle. American designer Tesia Kosmalski's Echo Coats (2009) explore spectacle at the level of the quotidian, and use technology to invert "contemporary relations between women, sound, and public spaces." Her line of stylish coats was inspired by modernist music and the Baudelairean *flâneur*, resulting, in the designer's words, in "a female-centered narrative of embodied wandering."[108] Conceived for urban environments where women walk—the architectural spaces of retail and transportation—the coats utilize the RjDj 1 platform and open-source PD GEM software to process sounds in real time, from the wearer (footsteps, especially high-heel strikes) and from the wearer's surroundings, calibrated to the rhythm of her walking, remixed and projected as a wearer-centered sound environment. The series' Andante Coat, for slow retail walking—window shopping—combines ambient sound (picked up with a microphone on the hem of the coat) with seductive phrases from cosmetics advertising. The Staccato Coat, on the other hand, synthesizes the wearer's footsteps and their echoes with other local sounds, and broadcasts the resulting mix through circular, domed speakers on the coat's shoulders. Rather than the silence that society once required of women, the garment facilitates wearer noise. We watch and hear as she enunciates her presence in a context where the subjectification of women is the norm: she may be an object of the gaze within public spaces, but dress like this can respond variously to processes of objectification. Staccato Coat is worn by the modern female counterpart to Baudelaire's urban voyeur. But in this garment the walker is sonically at the center of her own scenario within the public space.

The works discussed in this chapter embed a range of technologies via material or haptic interfaces in garments (human-garment interfaces, or HGI) that do not

Figure 4.33
Tesia Kosmalski, Andante Coat, from Echo Coat series, 2010. Courtesy of the designer.

purport to have futuristic functionality. They do not direct our attention to the technologies themselves, nor do they erase them. We are not confined to the rhetoric of ubiquitous computing. As Genevieve Bell and Paul Dourish have pointed out, "Ubiquitous computing research is characterized primarily by a concern with potential future computational worlds," and this visionary framework has characterized ubicomp for more than twenty years.[109] If we see ubicomp as a continuation of the modernist dream of technology, the time frame has been even longer. Instead, the materialist-conceptualist garments discussed here, and others like them, punctuate and dramatize our lives as we live them and perceive them, often through the lens of other media. Recent designs make us aware of things, from the camera flashes of paparazzi to the noises of our own movements in public spaces. Byron Hawk and David M. Rieder discuss the upsurge in this direction of design. They see a need for criticism and theory of what they call "new-media studies," as opposed to (earlier) "cyberculture studies" which focused on network communications, virtual society, and online identity and ethnography, and which received the greatest attention among researchers in the United States who depended on corporate funding. On the other hand, according to Hawk and Rieder, the field of new-media studies, including

Figure 4.34
Tesia Kosmalski, Staccato Coat, from Echo Coat series, 2010. Courtesy of the designer.

interface design and public installation art, grew quickly in Europe in the 2000s, largely because public funding was more prevalent there than in the United States, and materialist-conceptualist wearables designers, who were not seeking sales, benefited from that funding.[110]

Beyond merely exploring materialist-conceptualist WT, some designers still seek to go beyond academic research and see their work integrated with everyday life. They aim toward the naturalization of technology, which will enable it to be, not invisible, but rather part of an evolving language of dress (rather than a commercial prototype, art work, or oddity). For example, Jane McCann and Hannah Bigmore at the Smart Clothes and Wearable Technology Research Centre at the University of Wales, Newport, are interested in how clothes can enhance seniors' self-image and ability to continue outdoor exercises like climbing and biking. Style and comfort are combined with self-monitoring to give wearers confidence and a greater sense of being in control.[111]

WT has indeed been slow to grow in the garment and fashion systems we inhabit, and the chaotic political and economic landscape has discouraged futurist projects, so that even manned space exploration has stalled in the United States.

But WT research in the realms of academic research, conferences, museums, and sports, and among special populations like the disabled and the aged, is mounting, as is its steady infiltration into media and celebrity display. As an area of new-media studies, it has barely been mapped. But unburdened by theories and metaphors of futurism, WT will likely enter the mainstream of dress just as Benjamin's Angel of History enters the future, witnessing what seems to be chaos, with its face turned to the past.

5 The Critical Interface

Near the end of Fashion Week in Milan, 2005, a Japanese designer named Serpica Naro became the focus of protesters. They showed up at Prada's runway show and warned about an attack on Naro to take place the following Saturday. Another warning appeared a couple of days later, when the same protesters leaped onto a catwalk among the models, disrupting the show. The media began covering the story, and by the time Naro's collection was supposed to launch, the location swarmed with activists, journalists with cameramen, and members of the industry and public, most of whom had never before heard of the designer. In fact, Serpica Naro was a spoof: the name is an anagram of San Precario, the "patron saint" of Italian precarity activists, and the show was a tactical media event, using the spectacle to expose social inequities suffered by workers in the garment industry. With slogans like "Precarity Is Fashion," the high-profile launching of designer collections was exposed as a cover-up for abuse sustained by cutters, pattern makers, and sewers. Serpica Naro's spoof preceded a "fashion" show of seven outfits designed to convey ideas about the perilous nature of productive life, in this case the garment industry, like the Mouse Trap, a skirt with metal traps attached by little gold bows, to ward off the "wandering hands" women fall victim to in the workplace.

Serpica Naro asks, "Why save the world when we can design it?" Rita Raley, who discusses the piece in her book *Tactical Media*, identifies this method, whereby design is placed "at the center of political engagement."[1] Designing, rather than saving, the world is a parody of a dominant apparatus, and Serpica Naro's satirical spectacle has elements of "destruction, interference and interruption that interpret dominant modes of political organization." While the group in Milan deployed no technology other than the media itself, their use of dress spectacle to critique a social and cultural formation is familiar among artists who deploy technology for purposes of social critique. Such critique is in line with Italian autonomist Paolo Virno's notion of virtuosity: works that are performative (ephemeral) rather than prototypical (they are not productive or even practical in a market context). Virno references both J. L. Austin's *How to Do Things with Words* and Heidegger (more generally) when he raises the notion of the specific nature of enunciation as performance:

Figure 5.1
Serpica Naro, Mouse Trap skirt, 2005. Photo by Marco Garofalo. Courtesy of Serpica Naro Association.

It is in idle talk that it is possible to recognize the fundamental nature of performance: not "I bet," or "I swear," or "I take this woman as my wife," [all standard illocutionary acts], but, above all, "I speak." In the assertion "I speak," I *do* something by *saying* these words; moreover, I declare what it is that I do while I do it. Contrary to what Heidegger presumes, not only is idle talk not a poor experience and one to be deprecated, but it directly concerns labor, and social production.[2]

This chapter focuses on WT's critical interface, or, more broadly, what I call critical dressing. It considers the work of artists and designers who, since the 1990s, have worked with dress as social speech developed through wearables and WT practices that resist categorical branding. Most of the work is designed for public display—performed, or simply worn on the street or perhaps in an exhibition. Such works refer to dress as a public phenomenon contributing to a notion of a counterpublic sphere similar to that described by Oskar Negt and Alexander Kluge: a space to generate fantasy and consciousness outside of structures and regimes of appropriated existence, what the authors call a "framework of valorization."[3] Dress here acts as resistance.

Considering WT as critical interface also conforms with media designer Carl DiSalvo's concept of adversarial, or political, design. For DiSalvo, adversarial design brings the workings of agonism, the persistent contestation of ideas characteristic of democracy, to notions of design, including works that might not be overtly political but engage with ideas that prompt debate or "serve as a kind of material evidence in political discourse," while maintaining a "fluid notion of the political."[4] One might argue that the practice of dress already folds in the adversarial, since individual interpretations of dress behavior in any culture routinely include rebellious garment acts, and it is through such acts that dress behaviors change. But since WT is the aggregate of computational and garment technologies, awareness of critical or adversarial components is especially important as this aggregated practice evolves. We have already encountered adversarial design in chapter 4, with the design noir approaches of Anthony Dunne and Fiona Raby and the materialist-conceptualist work of Joanna Berzowska, Laura Beloff, and Ricardo O'Nascimento. This chapter will cover several related topics: the background of critical WT; dress that targets social problems, from the fashion industry (like Serpica Naro) to labor relations and political inequities more broadly; technological dress that, through its specific associations with the worlds of dress and culture, constitutes acts of resistance; wearables (technological) as personal resistance or "sousveillance"; and, finally, DIY and the "maker movement," and the role played by digital communities in critical WT.

Artists have used dress, with or without additional technology, to assemble social critique since the time of the futurists. In part, Tanaka's *Electric Dress* (where this book began) was a reaction to cultural changes impacting women in post-World War II Japan. Fabric and dress played an important role in the women's movement in the 1970s, often deployed as art that could be worn or hung (as on a gallery wall)—dresses

by Harmony Hammond, for example.[5] By the 1980s and early 1990s, with the development of the feminist art movement and its interest in fabric as art medium and critique as art practice, wearable art had become a more common theme, though not always an accepted one. A well-known exception is Annette Messager's *History of the Dress* (1990), a series of garments with texts encased in boxes hung on the wall, again like paintings or reliefs, so the context is the gallery architecture, not the body or even dress itself. The garment message is rendered neutral by aesthetic distance. The overall marginality of dress (as opposed to fashion) as creative statement is perhaps epitomized by the fate of Hunter Reynolds's *Patina du Prey's Memorial Dress* (1993–2007), a ball gown embroidered with the names of thousands of AIDS victims. It was widely exhibited and performed (worn) internationally for more than a decade, but remains relatively unknown. On the whole, wearable art has been until recently a critically invisible practice.

Today designers like Otto von Busch interrogate not just the fashion spectacle but its top-down structure, taking ideas from computer hacking culture to suggest how a bottom-up practice is possible, engineered to critique the fashion system without destroying it, to "hack reality"—using a term coined for the virtual world in the real one—in order to encourage an eyes-open engagement with fashion as a cultural and industrial practice.[6] An example would be the Hacking Couture initiative to create "open source fashion: fashion for the masses by the masses." It was undertaken by a group of young New York designers in 2006–2009 who attempted to analyze component "codes" (meaning a systematic analysis of consistent stylistic features, their materials, and methods of construction) of brands like Chanel and release these codes on an open-source website, encouraging DIY "hacks" (illegitimate, reconfigured remakes, including illegal usage of brand logos) and assembling hacked pseudo-designer lines annually.[7] A New York counterbrand, Slow and Steady Wins the Race, features such hacked designs, which remix designers' signature references or simply deconstruct and repurpose garments, like a handbag made from gloves, or a belt from shirtsleeves.

Critical Dressing

Couture hacks are dress acts of the most public nature and involve the notion of action as speech suggested by Michel de Certeau when he discusses the hijacking of speech by "consumer producers," that is, users or subjects of culture who manipulate cultural codes:

We privilege the act of speaking; according to that point of view, speaking operates within the field of a linguistic system; it effects an appropriation, or reappropriation, of language by its speakers; it establishes a *present* relative to a time and place; and it posits a *contract with the other* (the interlocutor) in a network of places and relations. These four characteristics of the speech

act can be found in many other practices (walking, cooking, etc.). . . . Such an objective assumes that . . . users make (*bricolent*) innumerable and infinitesimal transformations of and within the dominant cultural economy.[8]

Like Virno, Certeau applies the characteristics of speech act theory to a multiplicity of actions in the urban landscape, where there is a top-down vision (Certeau uses the metaphor of the 110th floor of the now-demolished World Trade Center in New York) as well as a bottom-up perspective, manifested in actions in the street. For example, he writes of a "rhetorics of walking":

The walking of passers-by offers a series of turns (*tours*) and detours that can be compared to "turns of phrase" or "stylistic figures." There is a rhetoric of walking. The art of "turning" phrases finds an equivalent in the art of composing a path (*tourner un parcours*). Like ordinary language, this art implies and combines styles and uses. *Style* specifies "a linguistic structure that manifests on the symbolic level . . . an individual's fundamental way of being in the world." . . . Use defines the social phenomenon through which a system of communication manifests itself in actual fact; it refers to a norm. Style and use both have to do with a "way of operating" (of speaking, walking, etc.), but style involves a peculiar processing of the symbolic, while use refers to elements of a code. They intersect to form a style of use, a way of being and a way of operating.[9]

Certeau's "rhetorics of walking" also applies to another aspect of what I have termed dress acts, as practices that either take place in public or suggest the act of dressing and wearing garments in public places, from sidewalks to runways.[10] Tesia Kosmalski's Staccato Coat, discussed in the last chapter, is a perfect illustration of Certeau's walking that includes also wearing and making noise. So dress, like walking, is not purely symbolic; it has straightforward physical dimensions as well (garments plus noise, empathic movement, and gesture). But the notion of style as a rhetoric, transferred to a realm where it physically operates in the world, is particularly applicable to dress, which we already think of in terms of style, a term that can have multiple, overlapping levels of meaning, anything from a fashion trend to a personal expression, or can even be meant pejoratively in reference to an unintentional or incomprehensible style.

Style can also be used by subcultures as a tactic, as dress historian Ted Polhemus and cultural historian Dick Hebdige have shown.[11] Certeau identifies the operations of the top-down environment as a strategy, while a tactic is not just a bottom-up action but actually "a calculated action determined by the absence of a proper locus": "The space of tactic is the space of the other [and] must play on and with a terrain imposed on it."[12] Certeau disagrees with futurists like Alvin Toffler, who suggest we are becoming more and more nomadic in our technologized lifestyles, and would no doubt disagree with the same point made by fashion futurists like Andrew Bolton in *The Supermodern Wardrobe*, who follows anthropologist Marc Augé's belief that we have an overabundance of space, information, and individuality. Instead, Certeau writes that true nomadism, the access to all cultural space, is limited to the wealthy and elite:

"Instead of an increasing nomadism, we thus find a 'reduction' and a confinement: consumption, organized by this expansionist grid takes on the appearance of something done by sheep progressively immobilized and 'handled' as a result of the growing mobility of the media as they conquer space."[13] Certeau was writing well before the appearance of virtual space and smart phones, generators of no-place spaces, and software like social media that further confine, or, more properly, control us by keeping us in our virtual place. As Galloway and Thacker say, "Confinement is on the wane, but what takes its place is control."[14] Tactics of everyday life, specifically tactics of dress, with which we are concerned here, operate, as Certeau points out (referencing Freud), as another "return of the repressed."

The repressed as dress has also been deployed as social intervention, with specific assemblages worn in everyday situations in public spaces. An example is Peggy Diggs's post-9/11 *Readiness Project*, in which she wore a layered garment, each layer covered with pockets filled with materials and resources for survival suggested by inhabitants of Lower Manhattan she had interviewed, along with things public safety announcements recommended that people keep with them during terrorist alerts. Mimicking commercially produced, multipocket outdoor survival attire but taken to an extreme, the dress was filled with things like powdered milk, duct tape, hand sanitizer, etc.—everything locals who had endured the disaster thought important to carry. The result was a disturbing mirror image of people's fears. When Diggs wore the dress around Lower Manhattan, passersby alerted local police because they thought the "sacredness of the site," in the vicinity of the 9/11 catastrophe, was being disrespected.[15] The power of bodily presence borne by the assemblaged dress transformed advice about personal safety into a monster, a kind of golem of emergency preparedness.

Another way in which artists and designers have used dress for social comment has been not to focus on fashion as a social or commercial system, but to intervene directly into public space and affect group behavior. Perhaps the best-known practitioner of collective critical dressing is the team of Lucy and Jorge Orta. Lucy Orta was trained in fashion and, in response to the First Gulf War, began to work outside the studio to investigate how, in the words of Nicolas Bourriaud's relational aesthetics, "Art was about working well within social reality, not just about finding a means of representing reality."[16] She began piecing outfits together at the Salvation Army that were shown in the streets of Paris during Fashion Week, positioned in direct counterpoint to that dominant institution associated with beauty, wealth, and privilege. Then Orta created the series known as Refuge Wear, collectivist garb in the form of multiperson and inhabitable garments. These have hung bodyless—as art—in museums and galleries in numerous exhibitions, but the garments have also been worn, to much greater effect, on mobile bodies in interventions around the globe. Orta's pieces succeed not because their imagery is new but because it is so recognizable. It references our physical vulnerability and need for support. Orta's Refuge Wear, like her *Nexus Architecture*, alludes to

Figure 5.2
Peggy Diggs, *Readiness Project*, 2004. Photo by Ed Epping. Courtesy of the artist.

survival dress: space and hazmat suits and "clean room" attire, garment typologies familiar from cinema and television sci-fi, from the *Star Trek* EV suits of the 1960s to the quarantine garb crucial to the plots of *The X-Files*. But Orta's garments also point to the political performance of bodies in the counterpublic sphere.

Protest Wear

Some of this work would conform to what Gregory Sholette has termed the "dark matter" of the art world—work so embedded in reality that it is off of the dominant art radar.[17] Sholette's "dark matter" includes garment-based political activities occasioned by regional and global threats: for example, projects by the Barcelona antiglobalization collective Las Agencias, or Italy's Ya Basta and Tute Bianche (White Overalls or White Monkeys), active from 1994 to 2001. "If, as Foucault wrote, the body is the object of the power's micro-physics," reflects Sergio Zulin, one of the organizers of Tute Bianche, "if all social and political control exercises its mastery of the body, if the market economy has converted the body into merchandise, the 'white monkeys' have called for a 'rebellion of bodies' against world power."[18] Tute Bianche in action

Figure 5.3
Lucy + Jorge Orta, *Nexus Architecture × 50—Nexus Type Operation*, 2001. Installation at the Ange-
wandte Kunst Köln. Photograph by Lothar Schnepf. Courtesy of the artists.

Figure 5.4
Lucy + Jorge Orta, *Nexus Architecture × 50—Nexus Type Operation,* 2001. Installation at the Ange-wandte Kunst Köln. Photograph by Lothar Schnepf. Courtesy of the artists.

wore hazmat attire—white, in contrast to the police's black riot suits—and padded themselves to keep their bodies safe.

We can appreciate the richness of protest dress if we look at the August 2000 anti-IMF/World Bank actions in Prague.[19] Jeffrey S. Juris, a participant in the events, writes of a complex and highly aestheticized display involving color schemes and garment patterns that reflected an overall strategy of zones and levels of resistance: the Blue March, representing high-risk militant action (incorporating the hard-core Black Bloc); the Yellow March, representing low risk and nonviolence; and the Pink, and Pink and Silver, Marches, representing mobile and decentralized actions that brought together militancy and play, with participants wearing the most extravagant costumes and creating a feeling of carnival.[20] The garb of the hard-core Black Bloc, scattered throughout the demonstrations, was a severe version of the hooded sweatshirt and black pants popular throughout countless countercultural contexts.

In Prague the extended display created a rich visual discourse of bodies, a "compelling image event" as Juris calls it.[21] Allan Sekula distinguishes the IMF type of mass mobilization from the simpler street theater of the 1970s in three ways: "1. Unified opposition to the global diffusion of a largely intangible corporate capitalism; 2. the . . . carnivalesque nature of much of this protest; and 3. a connection between actual bodies in space and the disembodied realm of cyber space."[22] Gregory Sholette adds a fourth characteristic, the elevated visibility of creative forms of expression. Here, as always, dress elevates, further articulates, and aestheticizes such visibility, performing the function of masquerade. The intentionality of this is made clear by Las Agencias' Prêt à Revolter (a play on the phrase *prêt-à-porter*, or ready-to-wear), a line of colorful coveralls with huge hidden pockets for padding and protesters' gear.

Spin-offs from these ideas of countercultural display run the gamut from Orta's serious social aesthetic to random creations of activists or designers in a diversity of contexts. The Black Bloc garb developed among global protesters in the 1980s, anti-nuclear demonstrators in Germany, Italian and German autonomist demonstrators, and the Dutch Black Helmet Brigade. Black jackets and sweatshirts with hoods, balaclavas, and black kerchiefs tied around the face became elements of a uniform for the urban disgruntled and disenfranchised. It formed the subtext for a British line of hooded jackets by Vexed Generation. Formed in 1994 as a line of clothing and a guerrilla store/workshop in London's Soho, Vexed Generation was the creation of Adam Thorpe and Joe Hunter, neither of whom had garment design training. Their clothing responded to two issues: youth outrage with record air pollution levels in London and the revelation of massive surveillance camera installations throughout the city's poorest neighborhoods. The clothes they produced were defensive hooded parkas and sweatshirts (hoodies), combining new textiles with passive technologies.

The Vexed Parka was made of nylon with padding in strategic places to protect one's skull, kidneys, and nether regions, in the event of being attacked by riot police.

Figure 5.5
Las Agencias, Prêt à Revolter, 2002.

Its hood and high collar functioned to mask the wearer's identity, and some of the parka's many iterations had air-filtering, neoprene masks built into the neckline. Though the technology was passive, the jackets, hoodies, and parkas developed by Vexed Generation all communicated the idea of resistance, through their similarity not only to Black Bloc sweatshirts and hip-hop attire but also to archetypal ninja garments. Some versions incorporated Kevlar and ballistic nylon, which Vexed Generation sourced through the Ministry of Defence's own suppliers. For their winter collections they created coats with phase change materials like Outlast, developed for NASA for warmth, and they equipped the garments with built-in thermometers.[23]

Carnivalesque riot attire as WT is represented by Ralph Borland's Suited for Subversion, created in 2002. Like Las Agencias' Prêt à Revolter, it alludes to the activist as clown within a political circus. Borland is a South African artist based in physical computing, or "pcomp." His suit is a lurid red-vinyl, polyurethane-filled shell designed to protect street protesters from police batons and Tasers. It has a powerful speaker in the chest capable of amplifying recorded slogans or the wearer's own heartbeat (exaggerating his vulnerability in a menacing sort of way). Noting that Malcolm X had

Figure 5.6
Ralph Borland, Suited for Subversion, 2002. Photo by Pieter Hugo. Courtesy of the artist.

called the 1963 March on Washington a "circus, clowns and all," Borland writes "I am that clown." He says he was interested in merging the "pink, the black, and the white" types of protest and (like Orta) promoting vulnerability as a tool. He imagines a group of protesters projecting thunderous heartbeats, "a percussive soundtrack rousing people around them . . . simultaneously powerful and strong, and vulnerable, revealing, transparent."[24] Borland uses technology combined with tools to proclaim biology as enunciation in the conflicted urban street.

Still another iteration of repressed dress was demonstrated in Egypt, at the Tahrir Square demonstrations of February 2011. In an effort to create protective headgear, protesters strapped on rows of plastic bottles, hunks of Styrofoam, and even loaves of bread with bright strips of scarves or clothing, producing results that were almost comical in their strangeness and innovation.[25] A comparable language of expressive attire also characterized the Occupy Wall Street protests in the fall of 2011. For example, protesters' aggregations (especially at Zuccotti Park) of 1990s-style grunge garments, thrift shop items, Black Bloc gear, and Guy Fawkes masks (popularized by the 2005 film *V for Vendetta*) were the subject of articles in the *New York Times* and *Women's Wear Daily*, as well as numerous blogs.[26]

This idea of carnival as characterized by a particular practice of dress in the public sphere recalls Mikhail Bakhtin's notion of the grotesque body, for Bakhtin a basis for carnival, as a "figure of unruly biological and social change."[27] For this Russian critic, the rebel of the medieval world relied on primary bodily functions—eating, drinking, defecating—at religious holidays to initiate carnival and create a zone where rules were suspended. In a related way but in another historical epoch, the postmodern protester who exists in Lipovetsky's society of consummate fashion utilizes the notion of wearable display in more complex and symbolic ways. Borland's character, with its big red pneumatic shape, exaggerates the body as a giant internal organ, a beating heart pumping blood. Also reminiscent of Bakhtin's analysis is the notion of carnival as a counterspectacle subverting a concurrent dominant one: what was a religious holiday in Rabelais's time is replaced by a global capitalist summit at the dawn of the twenty-first century.

The image of the protectively garbed artist-clown projecting a counterpublic spectacle recurs with the Yes Men's garment-based hijinks. Their Management Leisure Suit (2001), created with Hollywood costume designer Salvatore Salamone, is a gold lamé suit featuring a "pop-up" communications center (with imaginary readout and visual displays) resembling a giant penis, called the Employee Visualization Appendage. The suit was the center of one of the group's early "identity correction" pranks. This involved the Yes Men infiltrating a Textiles of the Future conference in Tampere, Finland, impersonating officials of the World Trade Organization. Ironically it was the very type of conference that was proliferating in anticipation of market expansion of smart textiles. In their spoof lecture, the Yes Men (Jacques Servin and Igor Vamos,

Figure 5.7
The Yes Men, Management Leisure Suit, 2002. Courtesy of the Yes Men.

going under the aliases Andy Bichlbaum and Mike Bonanno) cautioned the audience that a growing problem would be maintaining a workforce over long distances, while allowing managers sufficient leisure time for their own health and well-being—a way of identifying both a problem and a self-image involved in the growth of cheap garments and industrial WT.[28]

The Yes Men's Halliburton SurvivaBall (2006) premiered at the Halliburton Catastrophic Loss conference in Florida, prompted by the Hurricane Katrina disaster. A ponderous pneumatic survival suit, with features and technologies that were claimed to shield its wearer from any natural catastrophe or assault, it suggests a preposterous version of Orta's *Nexus Architecture*. But, like the Management Leisure Suit, SurvivaBall brings social carnival from the street into the corporate conference room to infiltrate dominant media scenarios. Through grotesque bodily display, the Yes Men bring the counterpublic sphere into media space.

Bakhtin locates the core of the grotesque body below the belt, in its bowels and its contact with the ground.[29] Deleuze and Guattari, on the other hand, write not of a

Figure 5.8
The Yes Men, Halliburton SurvivaBall, 2009. Courtesy of the Yes Men.

corporeal plunge but of haptic reversal, and of nomads "entertaining tactile relations among themselves."[30] Both ideas—the base of the body and its means of mobilization—foreground footwear, suggesting shoes that are both fanciful and deadly serious, intended to provoke discussion, to circulate the ideas of carnival as personal performance and nomadology as individual survival. Judi Werthein's Brinco XTrainer Shoes (2005) are athletic shoes for refugees, particularly those who enter the United States from Mexico. In this case, Xtrainer is a metaphor for border crosser, and *brinco* roughly means "skip." Compartments in the shoes contain a range of practical devices like maps of covert routes, flashlights, and painkillers. The artist passed them out at shelters near the U.S.-Mexico border. Similar to the Brincos but constructed with Internet technologies are the Aphrodite Project's Platforms (designed by Norene Leddy in 2002–2006), flashy satin wedges for sex workers that also have storage compartments (in this case for keys and condoms) in their high-platformed soles, and sport a control panel that can sound a siren or send a signal that locates the wearer (via GPS) to sex workers' rights groups or emergency services. The shoes also enhance the wearer's trade, since they are equipped with a programmable LCD screen (in the chunky heel) for advertising videos, and the shoes have an online component that provides wearers

with email, calendar, client blog, and chat rooms that connect with other users, supporting group solidarity. The Aphrodite Project Platforms reference Marx's ideas about the prostitute as vendor and commodity, and as a specific expression of the "general prostitution of labor," as well as Walter Benjamin's views of the prostitute and the mannequin as emblematic of capitalist modernity.[31]

Reflexive WearComp

While Steve Mann was a member of the Borg Lab at MIT in the late 1990s, when he worked with Rosalind Picard as she developed her approach to affective computing, he became interested in the idea of reflexivity. In *Affective Computing* (1997) Picard had suggested that computers learn not only to recognize human emotions but also to register that understanding, to reflect those emotions back in some way.[32] A few years later Mann wrote about automatic face recognition as a feature of surveillance and environmental intelligence systems. Mann developed a tactic he called reflectionism. In his book *Cyborg* (2001), he gives an account of this work and his personal observations and beliefs concerning wearable and ubiquitous computing in terms of relations of power: "In Reflectionism I rely on parody to hold a mirror up to technological society by creating a ludicrously nonsensical, yet very nearly symmetrical, construct of the current way we understand the relationship between technology and the body."[33]

 Cyborg was written after Mann had left the MIT Media Lab and returned to Canada, taking a position at the University of Toronto that allies him both with the engineering and art departments. He grounds the idea of reflectionism in Dada and situationism, in which objects or events are recontextualized or otherwise alienated to reveal hidden biases or information.[34] Mann also cites the work of the Critical Art Ensemble, a New York-based tactical media group with a website that chronicles its interventionist art works and publishes online books on theory. Mann quotes the CAE's *Flesh Machine* (1998) in *Cyborg* and, even though he calls them paranoid, he agrees with their point: "The shift of attention away from AI and robotics and toward 'the flesh' [affective computing and wearables, for example] can be frightening and potentially devastating."[35]

 From 1994 to 1996, while at MIT, Mann continuously wore his WearComp system (the Wearable Wireless Webcam), but uploaded to the Internet his video camera view in real time. Long before social media, he made his private life public, and his actions began receiving considerable attention from the media, including *Wired*, CNN, ABC News, *Newsweek*, *Time* magazine, and even the *National Enquirer*.[36] This led him to consider how the action of watching is related to the situation of being watched.

 In Toronto Mann began doing experiments that were themselves framed more as art events than as systems research. In one called *Please Wait* (1998), Mann wears a camera helmet with a magnetic strip card reader, a keypad, and one-way glasses,

completely obscuring his face. A sign clipped to the keyboard indicates that he will not respond to others until a government-issued ID card has been scanned. Other instructions involve keying in numbers, and if the visitor wishes Mann's time or attention, it must be purchased with a credit card through a reader on the front of the system. Mann wore this cumbersome headgear in stores around Toronto, modeling the kind of remote anonymity enjoyed by corporate entities that surveil us or ask for our identity and patience while appearing as self-service interfaces, like automatic teller machines.[37]

In 2003 Mann published an article in *Surveillance and Society* in which he coined the term "sousveillance": "Reflectionism becomes sousveillance when it is applied to individuals using tools to observe the organizational observer. Sousveillance focuses on enhancing the ability of people to access and collect data about their surveillance and to neutralize surveillance."[38]

According to Mann, sousveillance, as a form of reflectionism, "seeks to increase the equality between [the] surveiller and the person being surveilled (surveillee), including enabling the surveillee to surveil the surveiller."[39] Examples Mann gives involve individuals photographing police and government officials and videotaping surveillance camera systems in stores, practices common since the 1980s among tactical collectives, like the Surveillance Camera Players, but which have become ubiquitous since the appearance of camera phones. Mann argues that wearing camera-computers is the best way to practice sousveillance, because government and corporate surveillance is generally spatially fixed while individuals are mobile. He constructed his own rudimentary clothing and jewelry with such cameras, identifiable either because the "dark dome," the familiar cover for surveillance cameras, was worked into the garment, or because Mann printed a message on the garment indicating that a camera might (or might not) be operating. Some of his experiences videotaping corporate entities were chronicled in the film *Cyberman* (2001, dir. Peter Lynch).

WT as Digital Craft

Steve Mann's writings are statements of belief combined with philosophical musings, but they provide no roadmap for how wearable sousveillance might develop as a broader social practice, though this is already under way. However, since the mid-2000s a literature and praxis have evolved centered on how to reconfigure not just the relations of power but the ways technology is used to reshape social relations. This involves a grassroots (or "netroots") approach to creating electronically and digitally enabled dress, one that joins technological and craft practices and tries to accommodate the different cultures proper to each: whereas the technological tends to be masculine, proprietary, and function-oriented, craft is generally distributed, collective, and oriented toward process over, or in addition to, product.

Figure 5.9
Sarah Kettley and Frank Greig, Friendship Jewellery on runway at "Social Fabrics," wearable technology runway show at CAA, Dallas, 2008. Photo courtesy of Santanu Mujamdar.

A thoughtful approach to this issue is taken by Sarah Kettley, whose Friendship Jewellery, necklaces with lights embedded in large "jewel" pieces as distributed wearable systems, was mentioned in chapter 4. Kettley's 2007 PhD thesis is called "Crafting the Wearable Computer." It contains an essay, "Visualising Social Space with Networked Jewellery," which attempts to contextualize her computing research done on groups of individuals wearing the necklaces to monitor proximity with each other, within larger concepts of social space. Kettley traces her approach to the writings of social philosopher Henri Lefebvre, who writes, "Social space emerges from a set of relations, corresponding to different social and productive arrangements."[40] Ultimately, she attributes her ideas about the management of physical space via the regulation of social space to Georg Simmel.

Around the turn of the twentieth century Simmel, partly inspired by Baudelaire, outlined a concept he called "social distance," which made him one of the first to consider social relations in terms of a spatial model. Ulrich Lehmann writes that

Simmel applied this spatial metaphor to his theory of fashion: "Fashion allows the individual a particular distance that is considered proper by society."[41] For Simmel, dress and its adherence to fashion was a system by which groups of people separated themselves in a perceived hierarchy. But in Kettley's group, social space is established by group behavior, because everyone wears the necklaces. LED displays are programmed to respond to three distances:

> These distances were chosen as a result of work with a specific group of women, the "user group," and roughly represent distances at which they used increasingly intimate modes of greeting. The algorithm also "remembers" interactions, retaining a visual record of the most recent social default display over time. . . . [The] jewellery will serve to visualize the social space as it is enacted. This happens in an extremely subtle manner through the choices made by interacting humans, reflected in their clothing, adornment, speech patterns and, probably most easily recollected, in the modifying of accent to meet another person halfway, as it were. These changes are dynamic, if often very slow, but serve as powerful social indicators. [The jewellery] takes social interaction in the form of greetings at three distances and translates that into visible output worn on the body [and] read as another social language as its wearers become expert in recognising the various combinations of pattern and frequency that result.[42]

Kettley cites actor-network theory in assigning active value to artifacts involved in social relations. And she makes an important point: "It is not the job of these artifacts to disappear, rather they play an integral role in the experience of the socially active human, and we cannot attribute meaning to something that cannot be engaged with."[43]

Moreover, Kettley grounds the design of her minicomputer necklaces in craft theory based on the need for "authentic experience." The users did not make the necklaces themselves. However, in an effort to provide authentic appearance, Kettley designed them with a craft aesthetic "somewhat reminiscent of early modernist design, when radio or mechanical engine parts were hidden in sleekly styled casings, a metaphor for progress." Kettley's association of her necklaces with craft humanizes them and emphasizes their role in everyday life. She utilizes the concept of craft symbolically, referencing both labor and experience.

In the past decade the culture of WT that developed in universities and evolved at workshops and panels at conferences like SIGGRAPH, ISEA, and ISWC has integrated with growing online communities, which means much more diversified participation and appeal to young adults favoring a DIY or "maker" approach to WT. "Makerism" is a movement that began on the U.S. West Coast and focuses on a DIY approach to design and technology.[44] It builds on increasing command of computers and the Internet and the use of rapid prototyping and 3D printing, but it is also fueled by the democratization of knowledge and the emergence of easy-to-use devices, physical interfaces (apps), and hacker values. Like the resurgence of craft based in digital communities, makerism is not just a return to traditional material practices but a political

Figure 5.10
Sarah Kettley, Speckled Jewellery computer pendants, 2005. Courtesy of the designer.

position. Dennis Stevens writes of the new crafts: "Often, on the surface the work looks like common and sometimes kitschy objects intended to be disarming, but at second glance these works are frequently subversively loaded with signification."[45] Makerism is related to the growth of digital crafts, but it is distinct from traditional studio crafts, since makerism in the area of soft materials represents the convergence of informationally dense "geek" culture and intuitive, traditionally domestic or feminine skills like needlework. In "The Digital Touch: Craft-Work as Immaterial Labour and Ontological Accumulation," Jack Bratich notes the deeply intertwined relationship between craft and technology, both in terms of history—the early development of computerized control techniques in the textile industry—and in language. Of the latter, he writes, "Our names for the digital realm carry crafty connotations: the Web, the Net, the network, the node (derived from knot)."[46] Bratich makes the point that craft's historical, especially domestic, associations challenge the newness and immateriality of other digital work. And craft work "finds its value in affect, defined as the

power to act," as opposed to the drive to produce. Unlike affective computing, craft is affective in ways described by Hardt and Negri as embedded in, and upholding, social relations.[47]

Growth of interest in digital craft, and in DIY e-textiles and electronic dress in particular, accelerated in the 2000s due to a series of rapid innovations in the micro-controller elements and platforms for physical computing. The Arduino Project was begun in 2005 at the Ivrea Design Institute by Massimo Banzi and David Cuartielles, who named their new, simple-to-build and easily programmable units after Arduin of Ivrea, an ambitious medieval monarch and local historical figure. The Arduino's pro-gramming was built around an Ivrea master's thesis by Hernando Barragán describing a program called Wiring that was based on the popular Processing programming lan-guage developed by Casey Reas and Ben Fry. The Arduino's availability and simplicity immediately transformed computing-based art and design education and sparked Arduino communities (the Arduino website itself includes an active blog where users share their inventions and innovations).[48]

But the first Arduinos were still hard rectangular units. E-textile developers like Maggie Orth had long been aware of the need for components that would be both physically and economically flexible enough to drive development of wearables and other soft design. (Years earlier Orth had helped establish the usefulness of conductive threads and fabrics.) In 2006 Leah Buechley, working in the Craft Technology Group of the University of Colorado at Boulder, launched an E-Textile Construction Kit to serve an educational function: encouraging greater diversity among electrical engineer-ing and computer science students.[49] The kit was based on generations of successful teaching toys like Lego, Erector sets, and other modular kits. It had no Arduino but instead contained a microcontroller package designed for soft materials (a fabric printed-circuit board made with iron-on circuits, socket, filtering capacitor, and stitch-able microcontroller), as well as an assortment of input and fabric-based output devices like light, temperature, and pressure sensors, LEDs, and vibrating motors. It also used an infrared transceiver module that allowed the components to communicate with PDAs or with units in other garments or craft items. However, the kit used the C pro-gramming language, a stumbling block for amateurs. Buechley's report on the kit describes its function in a number of simple projects, like a temperature-sensing knitted cap with illuminated pom-poms and a basic shirt and jewelry with pro-grammed LED lighting. The report also includes observations from workshops held with children and novice adults, which suggested the popularity of the project but reported students' difficulties with the programming component.

In 2007 Buechley launched the LilyPad Arduino, developed initially to solve the earlier E-Textile Construction Kit's programming difficulties and problems in adapting old models for printed-circuit components. In the end, the new kit consolidated the editing and compiling of code into a single application (still based on the original

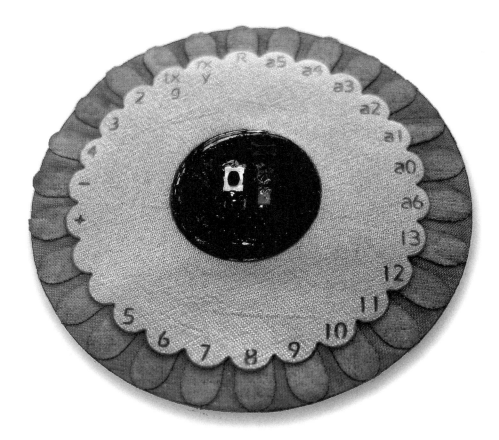

Figure 5.11
Leah Buechley, LilyPad Arduino on fabric PCB, 2007. Courtesy of the designer.

Arduino language) and redesigned all components to new sewing-friendly shapes and sizes, most significantly the circular LilyPad microcontroller module shaped like a flower with analog input and output pins located on the "petals." In 2008 LilyPad underwent additional redesign and was released for sale by SparkFun Electronics. Between 2007 and 2009 alone more than ten thousand LilyPad boards were sold.[50] But the unit's schematics are also online, released for free under Creative Commons licensing.

When Buechley became a faculty member of the MIT Media Lab in 2009 she founded a new working group entitled High-Low Tech, which sought "to engage diverse audiences in designing and building their own technologies by situating computation in new cultural and material contexts, and by developing tools that

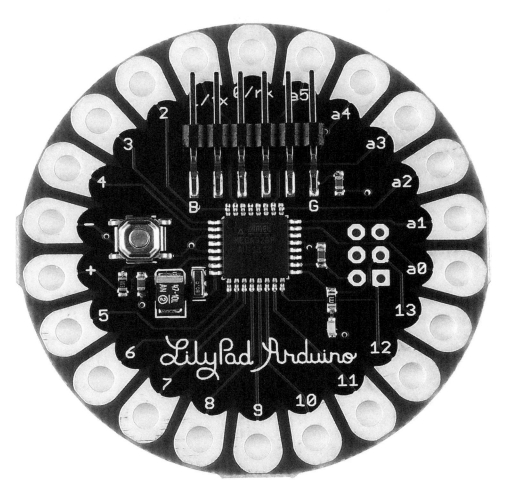

Figure 5.12
Leah Buechley, LilyPad Arduino, 2008. Courtesy of SparkFun Electronics.

democratize engineering." The High-Low Tech group explores the intersection of computation, HCI, manufacturing, traditional crafts, and design to take advantage of niche marketing.[51] In an article entitled "LilyPad in the Wild: How Hardware's Long Tail Is Supporting New Engineering and Design Communities," Buechley, with Benjamin Mako Hill, discusses Chris Anderson's theory of the "long tail," an economics model based on the idea that feedback is fundamentally changing market predictions. Anderson wrote specifically about digital media and entertainment. The long tail is a counter to hit-driven economics, the old marketing strategy that meant consumers were only exposed to preselected short lists of options ("hits") in any category. With the advent of Internet sites like Amazon and Facebook, an exponentially larger set of possibilities is sifted through by larger numbers of viewers, whose browsing generates feedback from a variety of viewpoints. So while high-profile products still sell to greater numbers of people, there is also a long tail of diverse products that find smaller but still substantial numbers of buyers. The long tail represents so much diversity that only big Internet companies like Amazon or Netflix are positioned to supply it, but for them it ultimately represents a greater market share than the popular hits.[52] Buechley and Hill apply Anderson's idea to online craft communities, the potential buyers of the LilyPad Arduino kit. They write: "Online marketplaces like Etsy and Threadless are making it easy for individuals to design, manufacture, and sell their own physical goods. . . . Ever growing communities of people are sharing advice on how to build real world stuff from dresses and rockets to robots and windmills in sites like Instructables."[53] (Etsy is a well-known retail site for vintage and craft items and art and craft supplies founded in 2005 by IoSpace, an Internet startup company; Threadless is a community-based T-shirt design marketplace founded in 2000 by Jake Nickell and Jacob DeHart in Chicago; and Instructables is a clearinghouse for user-created DIY projects founded in 2005 by MIT grad Eric Wilheim, a mechanical engineer.)[54] In their article Buechley and Hill argue that LilyPad is the perfect long-tail technology. Erich Zainziger, former Philips designer and founder of the *Talk2MyShirt* WT blog, writes, "The LilyPad was the igniter for the huge interest in wearable technology as the heavy lifting of complex electronics and software is taken care of by LilyPad and creators can focus more on new ideas and designs than spending most of the time with circuit design and software development."[55]

LilyPad has also played a role in enlarging and making more visible communities of Arduino users, especially at the nonprofessional level and among women, notably mothers and teachers, presumed to be the primary consumers of craft materials. Buechley and Hill's analysis of the sales records through 2010 of SparkFun suggests that a large percentage of women did purchase a LilyPad and built a project that they shared online through linked sites like LilyPad's Flickr or Instructables pages, or on the dedicated community site *Lilypond-MIT*. Buechley and Hill also use SparkFun's data to argue that women, who normally would not participate in male-oriented, geeky maker

communities, were unusually active participants in LilyPad projects, and were demonstratively more likely than men to post their work on the community sites. Buechley and Hill claim that LilyPad "enabled a new and unique engineering community to develop and grow," one which is "engaging large numbers of women in designing and engineering technology, women who most likely never would have engaged in this kind of activity in the past."[56]

The discourse surrounding the LilyPad community is ardent, even zealous, and exhibits the kind of expansive optimism common to claims for emergent technologies and broad participatory enterprises: "Our possibly utopian hope is that e-textile design can, over time, become a means through which hobbyists, craftspeople, and . . . children can become technologically fluent—and can express themselves creatively as well."[57] LilyPad's expansiveness is supported by the fact that it has spawned generations of extensions and variations, like the LilyPad XBee for wireless communication (by Kate Hartman and Rob Faludi)—many of these developed by users and shared or sold on the community sites. Moreover, even smaller and simpler units have been developed outside of the Lilypad community, like Sparkle by Aniomagic, a mini-Arduino that only runs LEDs but is extremely easy to program and sew into garments; or the Adafruit Flora, an open-source wearable electronics platform smaller than the LilyPad, with simple built-in USB support. Because of the broad demographics, the extended community of these smaller wearable and washable microcontrollers is craft- rather than design-oriented, in the sense that design is customarily thought of as a professionalized social practice and craft viewed as more personal. Buechley and Hill go so far as to say that the LilyPad enables "complex, innovative, technological artifacts that are soft, colorful, and beautiful," and that these qualities encourage a "new female-dominated electrical engineering/computer science community."[58] In other words, the kind of technological craft items produced by these new communities of makers is portrayed as based on personal emotional expression. This amounts to added value for the engineering and computer science sector, and transforms the work of craft technology's user/producers into immaterial labor. Buechley and Hannah Perner-Wilson also conducted an online survey of craftspeople and their perceptions of their work using Amazon's Mechanical Turk. The Turk itself, a crowdsourcing site on which employers post jobs ("Human Intelligence Tasks" or "HITs") for pennies, has itself been criticized as a digital sweatshop, a perfect example of microtasked labor that is decentralized, invisible, and vastly undervalued.[59]

Digital Craft and Immaterial Labor

The use of the term immaterial labor is elaborated from Maurizio Lazzarato's concept, defined as the activity that produces the "cultural content" of the commodity in the post-Fordist economy: "Immaterial labor involves a series of activities that are not

normally recognized as 'work'—in other words, the kinds of activities involved in defining and fixing cultural and artistic standards, fashions, tastes, consumer norms, and more strategically, public opinion."[60] But it might also include menial intelligence tasks like sorting lists or answering surveys on sites like Mechanical Turk.

Immaterial labor is a subset of the Italian tradition of *operaismo* (workerism), which recognizes the changes in production and the worker's role within systems of capitalism driven by developing technologies. Precarity, the condition of workers subjected to the new digital economy, was the focus of Serpica Naro's runway intervention discussed at the beginning of this chapter. Lazzarato notes that immaterial (precarious) workers characteristically fill the fields of advertising, fashion, marketing, entertainment, and cybernetics (digital labor), but that they are common throughout the service sector. Immaterial laborers participate in their own subjectivization by being producers and consumers at once. In his article "Affective Labor," Michael Hardt identifies the particular type of immaterial labor that concerns itself with the quality of life and produces materials that are self-fulfilling and expressive or emotional—particularly labor that is gendered (domestic and feminine), like craftwork and fabriculture, which had little cultural value in the past.[61] As Bratich writes, "Craft-work has historically been performed as a gift-giving practice and as a form of care for others. . . . The material object is produced out of, and for, community relationships. In this way craft-work is saturated with use-values."[62]

But the resurgence of craft is not simply a return to preindustrial values. Bratich points out that "fabriculture's recent popularity arose alongside the exposure and scrutiny of sweatshop practices" in the 1990s, suggesting that the interest in craft was ignited in part by popular awareness of the crimes of industrial outsourcing.[63] Textile craft is at once productive and liable to be integrated into current decentered production models, thus subversive of capitalist industrialization, which after all began with the mechanization of spinning and weaving. In recent years DIY crafts, along with their supporting digital communities—in particular anticapitalist and antiauthoritarian "craftivist" projects like Anarchist Knitting Mob and MicroRevolt—have expanded, even participating in movements like Occupy Wall Street. These exemplify practices like DiSalvo's political or adversarial design. However, the growth of local and online communities centered around digital crafts, utilizing simplified tools like Arduinos, is different and not overtly politicized. And since such work is less self-consciously politicized, it is more like immaterial labor.

Claims of the educational and social benefits of disseminating engineering skills to women and children must be considered in a larger socioeconomic framework that includes understanding the inherent ambivalence of technological craft and community websites. The technology end is grounded at major universities with big research plants, like MIT. And the technology's community platforms (such as the LilyPad and Arduino sites) have agendas like user research and sales. Bratich points out that Etsy,

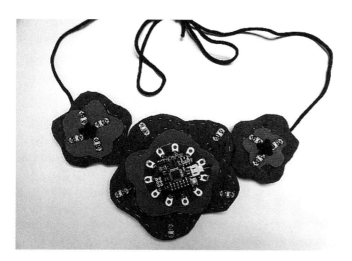

Figure 5.13
Stareyes, Poppy Necklace, hand-sewn felt necklace with LEDs and prominent LilyPad micropro-
cessor.

the predominant Internet crafter market, is not only a for-profit company but "also a gendered site insofar as the majority of producers and consumers who use it are women, but the site founders are male."[64] Whether or not any gender bias can be shown, Threadless and Instructables are also profitable Internet companies founded and mostly managed by men. This suggests that claims for the feminist values and benefits of the long-tail view of crafting might be reexamined. In the end, as Bratich writes, "It is capitalism that cuts into this fabric to split subjects from objects in order to professionalize and commodify them."[65]

Dennis Stevens notes that, within digital culture, symbols of hand cutting, stitch-ing, and assembling that are common to craft, particularly women's craft, represent "the last remnants of the real": "The importance of valuing the handmade becomes increasingly relevant the further technology takes us away from the tangible experi-ence."[66] But he notes that DIY craft at its best is distinguished by what he calls "nos-talgic irony": "Commitment to creative expression via craft materials and processes is often saddled with certain baggage, and thus certain sacrifices." The recent return to craft is not innocent; it positions itself as "witty, nostalgically ironic, and somewhat aloof."[67] Its naïveté is a political strategy serving to distance the craftworker from professional design and commercial practices, like video artists practicing "refusal of mastery" as a conceptual tactic in the 1970s in order to distance themselves from television. But the situation is different with digital textile craft—technologized craft, to use a somewhat oxymoronic term—where political critique is generally missing

from the community-shared work, work that is, after all, paving the road toward vali-dating engineering knowledge as craft. A lack of semantic depth and irony character-izes much of the production on the community sites, and Buechley and Hill's goal to show "that it is possible to build complex, innovative technological artifacts that are colorful, soft, and beautiful" hints at enclosing female techno-crafters in nostalgic but preposterous stereotypes. Moreover, the new user-friendly Arduinos, especially LilyPad, are often prominently displayed on the pieces uploaded to the site, so that they func-tion as their own brand logos (figure 5.13). Of course, not all the shared LilyPad projects involve textiles or sewing, though textile-based projects appear to be in the majority (as would be expected). Of these, only a percentage involve actual garments, while the rest verge on infantilizing their constituents with wired-up handbags or hats, or stuffed animals to which functionality of some kind has been added.

DIY e-textile design opposes the rampant commoditization of fashion as design industry but involves a contradiction, since it is based on the rhetoric of open-source technologies and code that surrounds what are still proprietary technological concepts based on traditional avenues of research (e.g., Arduinos). This relates to Galloway and Thacker's concept of open-source "freedom rhetoric," wherein the term "open" sup-plies a false or at least confusing rallying point: "We find it self-evident that informatic (or material) control is equally powerful as, if not more so than, social control."[68] Moreover, the "refusal of mastery" approach to garment design, which dominates these sites, barely participates in the cultural discourses of dress and any contextualiza-tion of design. Many works, like Buechley's Turn Signal Biking Jacket, with LED direc-tional signals in the back, are simply schemes for wiring up industrially produced sportswear. The proliferation of rudimentary abilities to wire and program simple microcontrollers expands the population of users more than it does programmers, and, as Galloway and Thacker state, "'User' is a modern synonym for 'consumer.'"[69]

Few designs to be found in the online production of Arduino community crafters or DIY e-textile-sharing sites represent a confrontation between the aesthetic of pure functionality and the larger context of dress in contemporary culture. One example, Diffus Design's Climate Dress (Michel Guglielmi and Hanne-Louise Johannesen, 2009), uses conductive thread embroidery, a LilyPad Arduino, a CO_2 sensor, and LEDs to produce illumination in accordance with CO_2 concentrations in the air. Climate Dress uses dress as a platform for environmental awareness and (in a sense) pits beauty against health. The work is shared on the LilyPad Flickr site, but here the participant is a design company, not a grassroots crafter.

Wearing and Sharing

As we advance through the early twenty-first century, adding interactive or user-designed components to wearable designs has become the most consistent trend in

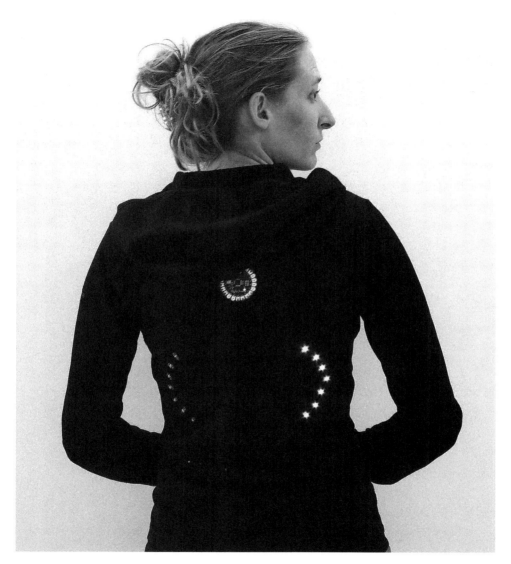

Figure 5.14
Leah Buechley, Turn Signal Biking Jacket, 2008. Courtesy of the designer.

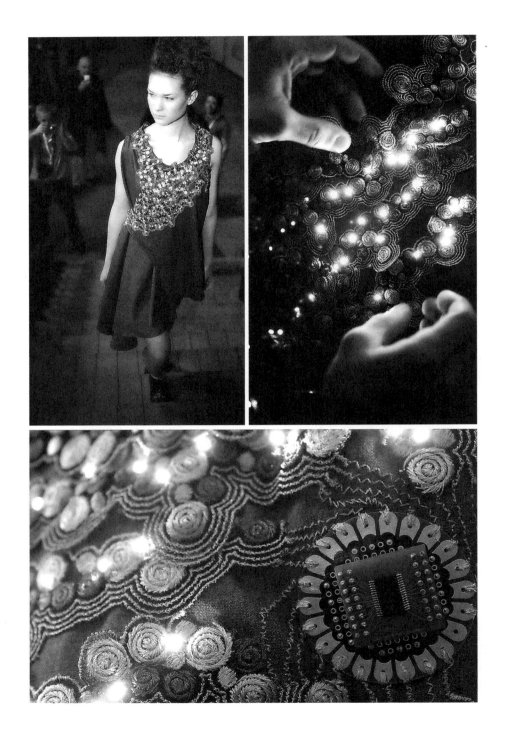

WT. In 2007 Norene Leddy's Aphrodite Project, mentioned above, initiated workshops teaching women how to equip their purses and platform shoes with protective technology, and has placed instructions online.[70] Mika Satomi and Hannah Perner-Wilson, working together as KOBAKANT, have maintained a blog since 2007, *How to Get What You Want*, that serves as a clearinghouse for shared technical information.[71] The site documents the range of wearable technology and soft-circuit solutions, showing, for example, how to use nitinol wire, how to modify commercial Arduinos and other microcontroller modules, and how to make various kinds of flexible circuits, with designs shared as open-source hardware. Satomi and Perner-Wilson share their own work on the site according to the definition of "free cultural works" (freedomdefined. org). But there have also been hard-copy books, technical primers like Syuzi Pakhchyan's *Fashioning Technology: A DIY Intro to Smart Crafting* (2008) and Diana Eng's *Fashion Geek: Clothing, Accessories, Tech* (2009).

In a paper delivered at ISEA in 2011, Valérie Lamontagne described her own "collective," 3lectromode, which takes a slightly different approach to user participation in the design process.[72] She embraces the DIY aesthetic without relinquishing her role as designer, taking her cue from utopian discussions of design like *Open Design Now: Why Design Cannot Remain Exclusive* (2011), and *FAB: The Coming Revolution on Your Desktop—from Personal Computing to Personal Fabrication* (2005) by Neil Gershenfeld.[73] Gershenfeld is the head of MIT's Center for Bits and Atoms who popularized the idea of Fab Labs in a course entitled How To Make (almost) Anything. In this class students often made garments or jewelry, many of which had entirely personal and expressive aims, like Kelly Dobson's Screambody (2004), a portable bladderlike sound muffler that allows the wearer the psychological release of screaming silently in public but also records the sounds for later use, creating a menu of favorite screams. (Dobson's conceptualization of wearable machines as external body organs harks back to Ernst Kapp's Victorian theories about technology's origins as organ projection.) Slightly more sophisticated sartorially, though ideologically similar, is the work of another Gershenfeld student, Meejin Yoon, who designed a protective garment based on the natural defenses of blowfish: enlarging and growing spikes. Meejin's Defensible Dress (2001) has a skirt trimmed with pointed rods that rise up when proximity sensors are triggered by someone encroaching on the wearer's personal space, especially from behind.[74] Gershenfeld says he is interested not in marketing the technologies but rather in advancing the idea of personal production, as if this is something we have forgotten how to do. This is despite announcements by news sources since the mid-2000s that sales of home sewing machines have been steadily rising.[75]

Figure 5.15
Diffus Design (Hanne-Louise Johannesen and Michel Guglielmi), Climate Dress, 2009. Photography by Anni Norddahl. Courtesy Diffus Design.

Rather than offering a technology kit online, Valérie Lamontagne seeks to provide open-source fashions themselves as DIY kits, a series of customizable designs featuring a selection of patterns, fabric preprinted with Lamontagne's graphics, interactive components (LEDs, kinetics), sensors, preprogrammed electronic components (with LilyPads and conductive silver thread), and detailed instructions. The user is buying Lamontagne's design but assembling it herself in a way that allows for user modification.

Despite Lamontagne's attempts to draw emphasis away from the technological devices and toward the combination of patterns, fabrics, and effects—that is, toward the dresses themselves—her methodology can be interpreted as a compromised version of e-textile DIY. And it is a version that is difficult to maintain: to supply new designs that must stand or fail based, in the end, on their style and popularity (just like commercial fashion design). But 3lectromode helps throw some of these issues into relief. Ultimately the culture of sharing, and social platforms for design that include technology, might someday shape our discourses of dress in thoughtful ways, but they will have to aim beyond niche markets near the tip of the long tail.

Diana Eng, a WT designer who emerged in the popular media when she became a competitor on the TV series *Project Runway*, promotes interaction design and dissemination of the technology, boiled down to fundamentals, in her book *Fashion Geek*, which is geared for teenagers and young adults. Unlike other instruction manuals, Eng's book provides information about sewing and pattern-cutting as well as soldering and simple circuits—some not requiring Arduinos or programming—so that two divergent fields of activity, tangible computing and fashion design, are merged.

In 2010 Eng completed a residency at Eyebeam Art + Technology Center in New York (which, like V2 in Rotterdam, emphasizes WT as a category of media art). Her project Fairytale Fashion was aimed especially at young girls, attempting, like Buechley's LilyPad project, to encourage science, technology, and math studies in this demographic. Eng worked with specific schools in New York and Florida, creating a twelve-week interactive distance-learning curriculum. Each week Eng produced a video dramatizing a specific problem, such as how to make inflatable or illuminated garments, for example, or nontechnological garments with mathematically based structures, like miura-ori folding patterns. In some videos Eng worked with guests like Hilary Mason, cofounder of hackNY, to explain in simple terms technical procedures like data mining for responsive garments. Other videos deal with aspects of fashion besides production. There is even a video visit with Leah Buechley at the MIT Media Lab. In video #10, "Trends and Statistics," Eng shows students how to think about predicting fashion trends using mathematical formulas, and asks students to submit their own predictions, supporting them with pictures, weblinks, and calculations. Each video solicited comments that imagined garments incorporating the techniques in some way. Eng developed her own sewable microprocessor, Twinkle Pad, a board made

specifically for LEDs, to create an illuminated dress inspired by one student's love of "Edward in *Twilight*"—a reference to the vampire character in Stephanie Meyer's book series and the *Twilight Saga* films (2008–2012), whose body sparkles in sunlight.[76] Such participation clearly opened the project to mass and commoditized culture. But the students' input was interpreted by Eng and informed the design of clothes that were ultimately constructed and appeared in a final fashion show video, so the project was more about WT in the context of distance learning than about advancing particular technology tools.

Eng says she used the idea of fairy tales not only to attract her young audience but also to bypass the science fiction associations that are so often evoked by WT. I interviewed Eng a few years after the Eyebeam project, when she was heading WT workshops at the Museum of Modern Art (art museums have begun to explore this area as they have many other DIY practices). The workshops are aimed not just at personal instruction but at the integration of garment-based devices in society. She says of WT: "I want people to actually own things, to wear them and get used to them."[77] Eng points to the fact that WT is already being assimilated throughout the fashion industry, not just in sports clothes but also on runways.

Danielle Wilde would concur. She is a performance artist working with WT who writes about a "new performativity" based on creative garments that heighten experience but are embedded in everyday life. As an example, she points to a very simple 2005 design by Grace Kim, Twirl Skirt, that enhances apperception of dress and of the body in an interconnected way. The skirt has an accelerometer in the waist that sends data to a circuit board sewn into its lining, which in turn triggers three luminescent panels embroidered in a column along the seams. As the wearer spins more vigorously, more panels light up. Wilde writes that the effect of the skirt triggers the wearer's imagination: "Forty-year-old women put the skirt on and spin like they haven't done since they were eight."[78] The experience is infectious. In this case WT expands the inherent properties of dress to communicate meaning on emotional and social levels.

The reality is that dress is motivated. Motivations vary, but they are routinely bound up with capitalism. Dress is dominated by the fashion industry and thus commerce, and injecting technology involves discourses that trace back to proprietary designs (foregrounding brand logos) and professional models, which tend to replace or eradicate the language of dress and appropriate its discourse. This is even true of efforts to reinterpret dress within the aesthetics of makers and social media. An example is Ping (2010), a garment by Seattle-based designer Jennifer Darmour at Electricfoxy. Ping automatically connects the wearer to her Facebook page and enables her to "ping" friends by manipulating the garment itself: for example, sensors in the hood enable the gesture of pulling it on and off to send status updates (using a Lilypad XBee). Communication entirely through Facebook bypasses even the need to carry a phone,

Figure 5.16
Electricfoxy, Ping, 2010.

and the wearer can stay "in touch" by touching her garment, without actually being in touch in a larger sense. The sleek prototype design, with stripes, textural stitch-circuitry, and colorfully lined hood, alludes to the design aesthetics of major-brand sports clothes and athletic shoes. The hood in this case provides an ironic emblem of noncommunication, as social media bypasses linguistic behavior. Proprietary social media is collapsed with proprietary fashion: such working-wearing is the very essence of immaterial labor. Ping can be contrasted with Rambler (figures 4.26 and 4.27), the former appropriating the signature of serious fashion design and the latter appearing comic, flaunting its playful associations with sports shoes and social media (in Rambler's case, Twitter) without committing to either.

If the experience of dress as a socially shared and negotiated behavior is related to what Agamben calls the experience of language as such, then dress, as an ongoing technology—and especially WT, which is the experimental edge of dress in our time—should be capable of advancing that experience.[79] Much of WT, like Kim's Twirl Skirt or O'Nascimento's Rambler, retains an aspect of play (language as pure self-reference). At its best it participates in what Mary Flanagan calls "playculture," after Homi Bhabha's "thirdspace" (between production and consumption)—a space of subversion, hybridity, and blasphemy.[80] Agamben likens the player to Lévi-Strauss's bricoleur, who reworks not just artifacts but historical meanings. Playing is a "relationship with objects and human behaviour that draws from them a pure historical-temporal aspect."[81] Accordingly, critical dress like Rambler or the open-source Aphrodite Project has the potential to create a third space for exploring WT in a hybridized and participatory manner: a space for play that privileges the awareness of dressing and empowers wearers to manipulate their cultural codes, but still a politicized space that can shine a light on how technology might produce dress.

6 Augmented Dress

How do new technologies enter the discourses of dress? Not without difficulty. If advances in textiles have created challenges in the past, the active technologies for use in everyday life that are now on the horizon present more extreme trials for our behaviors of dress. To become broadly based in culture, the new WT will need to take a sizable leap. For one thing, beyond the economic challenges of design and production (and the latter are considerable), the prospects for WT have been typically framed by a prevailing futurism involving lingering images from science fiction and belief in benign technology. The implication always is that this future is on our doorstep, and perhaps it is. This has meant that, for two decades, the formulation of active digital technologies in wearable or garment form has proceeded largely within discourses of science rather than of dress. Genevieve Bell and Paul Dourish point out that this "collective envisionment" of a technological future, always almost here, is endemic to the language of ubiquitous computing and testifies to its persistence. Moreover, they write, "Homogeneity and an erasure of differentiation is a common feature of future envisionments; the practice is inevitably considerably messier, and perhaps dealing with the messiness of everyday life should be a central element of ubicomp's research agenda."[1] This suggestion recalls De Landa's preferred pattern of innovation based on "combinatorial richness"—the heterogeneous combinations of ideas mentioned in chapter 1. Dourish suggests that, as opposed to seamless visions, "messiness" characterizes our technological realities; first, because the goals and ideologies surrounding new technologies are always contested; and second, because the technologies play out differently across various user groups in "divergent places, contexts, and circuits."[2] But critique and divergence of use are not conditions for which technologies are often prepared.

On the other hand, messiness is built into the relationships between fashion and dress—industry and street—that we experience in contemporary life. Gilles Lipovetsky describes how fashion, as a model for modern democracy, is riddled with paradoxes. For him, dress is the "characteristic emblem" of fashion as a larger force, one too entrenched to shrug off. He says: "The problems of the future will obviously not be settled by fashion logic; however, nothing lasting will be accomplished without that

logic, either. Let us not fool ourselves: no exit from the system of the ephemeral and of seduction is thinkable or even desirable."[3] As forms of pervasive computing like touchpads and apps continue to develop, we can only speculate how these will help spawn cultural changes yet to come. With WT, the messiness of dress must be reconciled with the systematic programming of digital devices that seek affective returns. The hybridization of dress/device must become a transversal practice that also folds in multiple associations, contexts, physiological repercussions (the nagging health concerns of batteries and EMFs, for example), and participatory modifications based on transitory desires. From the beginning, the digital dream of merging dress and device has forced technological research in wearables to enter the world of fashion on runways, and, as we have seen, it has spawned a range of counterpractices, aesthetic approaches, and critical dressing.

WT as transversal practice must confront the problem of what we might call homogeneous or formalist thinking—designers thinking inside the boxes of professional disciplines. Certainly professional formalism is not limited to technology labs but dominates the fashion academy as well, which also separates technological advancements from ideas about dress. But while technology looks forward, fashion so often looks back, as it has in recent years. In 2012 the progressive V2 Lab in Rotterdam held a discussion with lab manager Piem Wirtz, students from ArtEZ Institute of the Arts in Enschede, and participants on Skype from the Swedish School of Textiles and San Francisco Fashion+Tech, a fashion and technology promotional group. The title of the discussion was "Is Wearable Tech Just Bad Fashion?" Clearly the participants understood the popularity of WT as commercial product and viewed it in the abstract, with few specific, executed, "successful" pieces discussed at any length.[4] Judging from a report on the event, their impression was not positive. Students and professionals who were present specifically mentioned Chalayan's now famous S/S2007 collection, One Hundred and Eleven, calling it a "pitfall"—as if the animatronics are not comprehensible, or perhaps not desirable or not strategic enough for these practical-minded designers, who have little interest in technology-enabled applications (one attendee's comment was: "I don't need something that can DO something. . . . There are already too many computers around me"). According to the report, the trends that were discussed, such as the proliferation of flexible solar panels on bags and garments (popular in the 2000s), were considered awkward and off the radar for fashion design. The discussion uncovered a lot of concern about technologies that malfunction, fail to operate, or just create hassles for designers. Overall the response is a marked contrast to that of students from the Créapole and other fashion institutes back in the mid-1990s who participated in "Beauty and the Bits" and were eager to work with MIT computing and engineering students to create imaginative, if unmakeable, garment designs (see figures 2.10–2.13).

We have seen that, in the past, fashion has been occasionally receptive and even enthusiastic toward futurism and has adopted its images. Certainly this was true in the early twentieth century, in the 1960s, and in the 1980s. At other times, like the years around the economic recession that began in 2008, dress reflected a retreat into images of the past, even though technology was still advancing. Fashion is, as Elizabeth Wilson writes, "a cycle rather than an arrow pointing through time in one direction."[5] But there may be multiple cycles. Questions remain: Are we intuitively ambivalent toward technological functionality in behavior that is as personal and publicly revealing as dress? When it comes to technology, how will our intellectual inclinations toward perfectibility interact with our complicated, sometimes quirky, habits of personal display? Or will those habits be overruled by technology's increasing reliance on data patterns? As Ana Viseu writes, "There is a danger . . . that wearable computers will favor the known—the routine, or that which is pre-programmed—while filtering out the unknown, the new."[6] This chapter looks at some emerging design initiatives from the standpoints of both technology and dress, and considers how, after the naturalization of smart devices and the expansion of social media models, WT is adapting to advancing regimes of augmented reality.

Post-Smart Phone WT

The appearance of smart phones in the late 2000s changed the landscape of mobile devices. It advanced what Lev Manovich calls the "aestheticization of technology" that began in the late 1990s, which I discussed in chapter 4 as the application of interaction design to wearables.[7] But when is a phone a wearable? Manuel Castells notes that the mobile phone became the "symbol of youth and identity in many countries."[8] Despite the fact that we stare down in isolation at these devices with their personal-sized screens, Castells finds that, for the youth demographic, phones have also become personalized display: "A mobile phone . . . can be compared with, and treated as, a piece of clothing, linked to temporary collections because it is a product of limited life that is always attached to the body." Based on his own research in his 2007 book *Mobile Communication and Society*, Castells suggests the mobile phone is like a contemporary wristwatch: on the one hand, placing us in the flow of space and time; on the other, contributing to personalization and self-conscious display, and locating the wearer in a hierarchy of brand values.

But the phone-as-wristwatch association is a difficult sell for some WT designers, who see the effects of smart phones on dress as more complicated. Margaret Orth believes that smart-phone-based systems are game changing for industrial WT, and that clothing designs now must be configured through these mobile devices:

Given the way the iPhone is developing, popular wearable technology will not happen without a space program. For example, most video camera innovation in the consumer market will be designed to fit inside your iPhone. Now, that video camera—is that designed to be in your clothing? In fact it's moving away from that. If anything, it is becoming smaller, it needs more protection, it needs to be in a brick. For things to move into your clothing they need to spread out. They need to become more robust. They need to be re-engineered. That requires money.[9]

Orth also refers to the need for clothes to be resilient and cleanable—to adapt to normal life wear. She implies that advancements in WT will require a different socio-economic environment than existed in 2011, when she made that statement: a society willing to invest in futuristic projects on many fronts, one that would naturally have an ambitious space program with federal, commercial, and cultural support, one that initiates and inspires leaps in integrating active technologies into clothing design.

But some of the requisite social changes have already taken place, driven in part from the ground up, though not based on prospective missions to Mars. According to Castells, studies in the 1990s already demonstrated that young, especially female, users of mobile phones in Japan tended toward extreme personalization. Dressing them up and otherwise modifying their phones with raucous colors and icons, and wearing them around their necks, was bound up with ruptures in roles and status—"technosocial changes"—that were taking place in Japan's teen street culture.[10] This bottom-up behavior of dressing with technology to proclaim social emancipation appeared earlier in artworks, with Atsuko Tanaka's *Electric Dress* in 1956 and again in 2003 with Noriko Yamaguchi's *Keitai Girl* (figures 1.1 and 1.2). Castells points out that connections between mobile phones and personal display vary across cultures and local attitudes, but in the 1990s the use of mobile phones as social signaling (if not dress per se) became a global phenomenon.

It was a development with some ominous implications at that time. But now, besides participating in local forces of social change, the accelerating simplification and miniaturization of electronic components suggests that deployment of mobile-phone technology to advance broad corporate agendas is evolving and may not include overt personalized display. This is already true in areas like medical WT, where devices like blood and heart rate monitors support increasingly mobile lifestyles for individuals with health impairments. These products have begun to transform the medical subject (Foucault's disciplinary subject) into a broader subject of capitalism. For example, a product called Vitaband (2007), developed as a digital bracelet that contains legal ID, medical history, and emergency contacts, also features Visa account access for making card-free purchases wherever the wearer happens to be. Vitaband's medical-capitalist subject is free of diagnostic tethers but also free of pockets, bags, and most other dress-based accoutrements—essentially a consumer version of Agamben's *homo sacer*. In more recent years there has been no shortage of initiatives involving

mobile phone apps as personal credit systems, such as automatic identification and capture systems and apps for reading barcodes.

Beyond the medical-industrial markets, a flood of other body-based devices has appeared in the press. In 2008 (one year after the iPhone appeared) Gopinath Prasana released designs for an Apple iBangle, literally a bracelet with the functions of an iPod, projected as having the potential to take over all iPhone capabilities, including phone calls, GPS, and Internet.[11] The iBangle prototype (with no announced connection to Apple) was designed with a futuristic appearance—the sleek, minimalist profile and brushed aluminum finishing of Apple products. The bracelet device appeared about the same time that silicone "awareness" wristbands gained ground, based on the popularity of the yellow Livestrong bracelet (launched in 2004 as a fundraising icon for the Lance Armstrong Foundation and developed by Nike), and bracelets of various colors for other international causes followed. But colored wristbands go back to the jelly bracelets worn by teenagers in the 1980s, whose different colors were associated with specific sex acts.[12] The iBangle made no such references, of course, but its association with hip youth culture and (later) global awareness was part of the subtext by which wearers might be cataloged.

Bracelets as wrist-borne information and communication devices literally marry the smart phone with the far older and more fashion-entrenched wristwatch, which has reemerged as an alternative communications platform. The tiny touchscreen Apple iPod Nano appeared as a wrist-based device with a range of wrist-strap holders beginning in 2010. In 2012 Apple launched its Accelerator program, pairing with companies to develop products like the Nike+ FuelBand. This has a functionality similar to the iBangle but is geared to sports, tracking a range of movements and workout results, and, when coupled with the NikeConnect program on a phone or laptop, becoming a virtual trainer and workout community. It has all the functionality of the jackets envisioned fifteen years earlier by Philips—without the jackets. In appearance the Nike+ FuelBand resembles the iBangle (though it is black instead of silver). And while it doesn't yet operate as a phone, the band could serve as a platform for further development, just as the iPod evolved into the iPhone.

Eric Migicovsky's Pebble Technology Corporation designed a customizable smart watch with a multifunction, variable e-paper display and, after raising initial backing, turned to crowdfunding—capitalizing the business through multiple contributors online. After launching its project on Kickstarter.com in April 2012, it raised more than one million dollars in twenty-eight hours from people willing to pay up front to preorder the Pebble. The *Wall Street Journal* called it the "poster child of crowdfunding," since the record backing was followed closely by federal legislation encouraging Internet start-up funding, passed the same month in the U.S. Congress as the JOBS Act.[13] But the Pebble is a peripheral; it links with a bearable, a phone—Android or iPhone—which the wearer must also carry. Data and messages are transmitted to the

Figure 6.1
Pebble, 2008–2013.

Pebble. But the wrist-worn peripheral makes the smart phone experience colorful and changeable, a more aesthetic and interactive visual presence, since the crisp, graphic display can be customized to show a classic watch dial with numbers and hands, or a contemporary readout with digital numerals, or words ("twelve thirty"), and other configurations. It can also display incoming messages and connect with apps to track the wearer's sports activity (it contains an accelerometer) or access GPS, calendar, and music. Crowdfunding and customizable displays enhance the participatory profile of the Pebble and function as a market strategy.

The Pebble is a big watch/wearable, but it is smaller and lighter than other smart-phone-linked watches, such as the Wimm One (2011), a wrist-strap computer running a modified Android system. In the end they are all less like jewelry and more like black boxes with screens mounted on the wearer's arm. Today's wrist-based computers have evolved from the early multifunction digital watches by Seiko and Casio in the 1970s and 1980s, but one might also trace their lineage to early wearable computers' keypads like the Twiddler, which appeared in the 1990s. In 2000, IBM developed a "Linux Watch" or WatchPad that could connect, and was projected to have voice command capabilities, with any PC running Linux. It was never marketed. With the advent of better displays and networking technologies like apps, more recent multifunction watch prototypes have proliferated and will inevitably include advanced touchscreen versions.

For now, since most multifunction wrist-borne wearables are peripherals, they make the smart phone experience more display-oriented but do not challenge the primacy of handheld phones. Despite the equivalence Castells sees between mobile phones and watches, bands and bracelets still only marginally qualify as dress, if dress can be defined as an assemblage of garment parts that coexist, change often, and have multiple places of contact with the body. The new devices do not aspire to visual complication or unconventional semantics beyond what their "customizable" interfaces allow. Indeed, customization in digital devices is often a lie about personal modification (control) when choices are actually predetermined—although the devices might be hacked by individual users making unscripted changes. A dark specter of posthuman subjectivity hovers in this landscape of new and sometimes inventively financed devices for heightened consumerism and branding.

Cyborgs Revisited

Google Glass or Project Glass, an actual wearable computer, is in beta testing as I write this. The Glass is a metal eyeglass frame—not actual glasses at all in the prototype version—mounted with a front-facing camera.[14] It features a transparent LCD or active-matrix organic LED display for one eye and runs on an Android system.[15] The glasses are projected to have embedded applications that can access maps, send texts through voice transcription, keep calendars, make live video calls, take photos and videos, and post to social media sites. They have the heft of a major multinational Internet conglomerate behind them, one with a platform to organize the user's entire social life and identity, the proprietary Google+ networking service.

These sleek, functional, lifestyle glasses are distant relatives of the post-World War II military HUDs and the wearable projects developed by the Borgs at the MIT Media Lab in the 1990s (compare figure 6.2 with figures 2.7 and 2.8). Google Glass appears on the heels of other futuristic-looking headgear, like Silicon Micro Display's sleek ST1080 HD head-mounted display, introduced in November 2011. The appearance of the ST1080 mimics Geordi La Forge's VISOR from episodes of *Star Trek: The Next Generation* so closely that it actually suggests the character's blindness. But the ST1080 is a personal home entertainment system, not something context-aware to be worn throughout the day.[16]

In contrast, Google Glass is streetwear. With it, Google's corporate reach will extend past the realm of phone and computer platforms right to (or right back to) the modernist figure of pure communication. As American comedian Jon Stewart quipped, the glasses respond to a failing of both desktop and handheld devices: "The problem with Google is that it is too far away from your face."[17] This back-to-the-future approach, though entirely nongestural (in the bodily sense) and antiperformative (in Danielle Wilde's sense of dress as interactive and gestural), nevertheless suggests a new

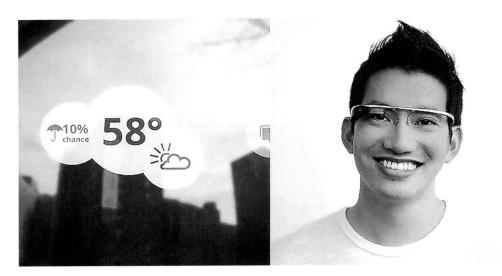

Figure 6.2
Google Glass, prototype on model and sample display, 2012. Google Photo.

awareness of what Nancy Troy calls "the dialectical workings of the logic of fashion, which require a carefully calibrated oscillation not only between novelty and tradition but also between distinction and conformity, correlating the quest for visibility with the determination not to be seen."[18] In other words, our dress acts negotiate the complicated social and self-expressive impulses both to distinguish and identify ourselves and to fit within specific social parameters, both to stand out and to avoid doing so in any garish or awkward way.

Google Glass aspires to occupy this very phenomenological position of personal display. Its look is reminiscent of cyborg outfits from decades ago, only revived in a sleek, appealing, and geekishly retro manner, with the promise of enhancements so desirable that the glasses assume the aura of fetish. In so doing they expand the discourse of dress to include the "revival" of augmented reality (AR) computing. In the 1990s technology researchers at MIT discovered that, when it came to devices worn on the body, they needed to leverage advances in personal augmentation by appealing to fashion. Twenty years later, as the technology has advanced through miniaturization and intuitive design, the same principle holds: without the appeal to style, WT is limited to computer scientists and industry specialists. Thad Starner, one of the original MIT Borgs and also a technical lead on Project Glass, puts it this way: "The big thing about heads-up displays today, or any kind of wearable computing, is to make it fashionable enough that people will put it on. If people won't put it on, it doesn't matter what it does."[19] To this end Sergey Brin, cofounder of Google

Figure 6.3
Model wearing Google Glass, Diane von Fürstenberg S/S 2013 Runway, Mercedes-Benz Fashion Week. Photograph by Frazer Harrison. Getty Images.

and the Glass project, collaborated with fashion designer Diane von Fürstenberg to create colorful versions of Glass that coordinated with the outfits in her collection at New York Fashion Week in September 2012. (It was an evolved replay of designer Stephen Sprouse's show in 1999, when his models walked the runway wearing Xybernaut's Mobile Assistant IV.) Von Fürstenberg even created a video for social media, positioning the Glass squarely in a fashion and celebrity context and merging her DVF brand slogan with the glasses' technological vision: "Things that we thought would be science fiction exist. When you can reach everything at every time, anytime, and it goes so fast! But fashion, technology, it's all about life. And it's all about being the woman you want to be."[20] Google Glass next appeared in fashion print media, as the centerpiece of a spread in the September 2013 *Vogue* in which male and female models wear ultramodern coats while walking amid the futuristic houses in Ransom Canyon, Texas, at sunset.[21] Glass has made a calculated effort to infiltrate fashion spectacle as produced by media. But does Glass really infuse technology with the discourse of dress? Is it different historically from other radical fashion changes, for example Paul Poiret's at first outlandish-looking lampshade tunics and harem trousers, when they took America by storm in the 1910s? Is Glass a similar "look" that we will acclimate to?

Of course it is different. Augmentation based on online networks and wearable data screens projects us into a hybridized reality, where seeing and being seen are starkly altered and contained by the corporate system. Moreover, if the seamlessness of "invisible" computing is a kind of mask that connects it with dress, then wearable human enhancements, like the superpowers of comic book heroes of yore (still endlessly popular), are full-blown masquerade. Donning the technology is not so much a false front as a costume of superpowers suitably redesigned for the twenty-first century.

Simply because it is sleekly designed and comes in colors, is Google Glass more brand than look? Consider that the foundation of fashion, and of dress in contemporary culture, is embodiment. Dress is activated through temporality and change, and is bound up with dumb matter: our biological mass on the one hand, and the sensation and mobilization of attached fabrics and additional materials on the other.[22] These things fly in the face of branding priorities that nevertheless exist and impose their own restrictions. DVF, a highly branded fashion line, is based on the seasonal rotation of real clothes, clothes that fearlessly perform masquerade (Semper's "haze of the carnival candles"). Each season the line projects diversity and takes risks; individual garment items are either hits or misses, and either way they are replaced within a few months. By contrast, Apple's brand display is consistently folded into product appearance. Ever since Apple's iPods first appeared on the market, they have maintained a minimalist consistency as sleekly designed supports for the centralized Apple logo—the schematic apple with the perky leaf and bite mark—and that design-as-logo concept, shared with the company's computers and laptops, has changed very little through

the subsequent generations of phones, computers, pads, and their many variations. The user selects Apple, the brand and the look. The overall device gets sleeker and lighter, but the look doesn't substantially change. Personal choice is offered through color variation of the housing (we can purchase a coral or cerulean blue iPhone) and through the selection of apps. But in the sense of personal modification, one does not actually wear one's apps—not yet, anyway.

In fact, with Google Glass personal display is a reluctant afterthought—the device is all about enhancement from the inside, the improvement over smart phones. As one *New York Times* reviewer noted about the phones, staring at them "is like Narcissus at the edge of a pond," with the inference that eventually Narcissus died from isolation.[23] Context-aware devices like Google Glass, descended from early AR wearable computers, position wearers upright, as active in the world. The new devices add layers of information, in fact very high levels of continually updated data. Thad Starner remarks: "It is a much better experience than a cell phone. That's why, back in 1993, I put on the wearable computer as part of my daily life . . . and the reason it stuck was that, in that first month of wearing one, it showed me a different lifestyle, a more powerful lifestyle, a lifestyle in which you are more in control and things are more calm and independent. That lifestyle is something I fell in love with."[24]

Starner revives Mark Weiser's prediction that transparent information technology would "calm us down" like a mechanical pharmaceutical.[25] Once again we hear the echo of the modernist dream of pure control, pure information, and pure communication. We hear the longing for ontologically perfect embodiment, articulated by Giorgio Agamben as any form of dress that substitutes for the lost dress of paradise, that dress of light, "of tight-fitting glory," though technological dress performs this longing best.[26] But in the end, the view through the Glass resembles the one through the eyes of the *Terminator* cyborg. Product initiatives like Glass aspire to be a universal dress, or antidress, a single product that rules the market, a must-have like the iPhone, a fashionable fetish that changes the game and outwits fashion altogether by being visible and invisible at once. In a promotional video launched in February 2013, Google project director Steve Lee says how the Glass "gets technology out of the way." He explains, "We don't want this to be a niche thing; we think this can help every human being. So we look forward to this being used by millions and millions of people."[27] And Google is not alone. Apple has also filed patents for headgear and optical devices to work with iPhones and iPods, and more devices will undoubtedly be unveiled as this book goes to print.[28]

Like Starner, philosopher Andy Clark sees a permeable boundary between ourselves and our tools, the multifunction wearable devices that extend our sensory and cognitive capabilities. Clark, too, revives the cyborg model of the continually evolving, hybrid self, the "soft self," as "a constantly negotiable collection of resources easily able to straddle and criss-cross boundaries between biology and artifact."[29] But while

Clark supports a dynamic and optimistic view of our constantly renegotiated embodi-
ment in the world, he cautions that hybridity is not without risks: "Uncritical talk of
'enhancement' thus threatens to beg philosophically, culturally, and politically impor-
tant questions. How do we distinguish genuine enhancement from pernicious
encroachment and new horizons from new impositions?"[30]

 What are these new impositions? One might be that technological hybridization
through WT like Google Glass proposes not just our merging with technology, but our
absorption by lifestyles dictated by the tech industry. Reviews have appeared criticizing
Project Glass on privacy issues, since we can use it to take pictures of what we see,
hands-free and undetectably, on an ongoing basis. In essence, if you talk to a Glass
wearer, they might be tracking you, or Google might be. Critic Andrew Keen pointed
out in *CNNTech* that "the terabytes of data sucked up every five seconds by its omni-
scient glasses will, of course, flow to Google. That's the whole business model, the very
raison d'être of Google Glass. Those pics every 5 seconds will be used to aggregate data
and then to generate billions of dollars of revenue by selling advertising around it."[31]
In addition to seeing text messages or the time in our robot view, will we also see ads
and commercial videos? As cyborg subjects, will we be surplus-value labor within a
fabric Virno describes as "activity without an end product," the operaists' immaterial
labor or "reduction of life to work"?[32] On the other hand, Clark does not recognize
that our "tools"—the objects and devices that we use to interface with the world—are
not always solely functional. When it comes to dress, the interface between skin and
culture does not reduce to function, even the function of arousing desire. As dress, our
evolving devices will have to be embodied in complicated ways. They will have to be
changeable and involve "useless" and ephemeral applications: garment items with
quirky emotional or mnemonic qualities, enhancements that acknowledge masquer-
ade, and pieces experimentally combined through rapidly adaptive vernaculars—dress
acts that are leaps of speech. These also are part of the way we negotiate in the world,
and part of our body-based interactions with each other.

AR is the New Black

With the flurry of media surrounding Google Glass and related devices, in 2014 the
potential for WT that many foresaw a decade ago seems imaginable once again. In
particular, the appearance of AR devices like glasses have encouraged related design
projects, like Google's projected smart gloves, called Seeing with Your Hand. According
to the developers, these would be wireless gloves that connect to networks, access data,
and use cameras to "see," "as if the user's eyes were located on the user's hand or
finger, or on the other area [*sic*] of the user's body."[33] Furthermore, they might be
paired with Google Glass to call up a virtual keyboard to enhance wearers' ability to
interact online with both the world of the Internet and the real world they are seeing

Figure 6.4
Normals, Apparel VO.9A, garment prototype, 2012. Courtesy of Aurélien Michon and Cedric Flazinski.

and navigating. In fact, despite the customary association between gloves and touch, Google Glass as a base for peripherals enshrines the role of vision in processing reality. Such developments reach beyond AR to a mixed reality, and to life along what was once proposed as the "reality-virtuality continuum."[34]

Consider the implications of what might be called augmented reality fashion. Normals, a design collective from France, has developed a prototype for garments called Apparel, with embedded digital information that can be infinitely redesigned through a computer program. One might say it is a version of the fable about the emperor's new clothes: the designs are only viewable through the technology's optics. But from the designer's point of view, those optics have taken center stage in an augmented-reality-infused society. Normals designers Aurélien Michon and Cedric Flazinski describe Apparel this way:

Figure 6.5
Normals, Apparel VO.9A, garment design program, 2012. Courtesy of Aurélien Michon and Cedric Flazinski.

How can augmented reality be more fitting to the current cultural context? Meaning, once you have the capacity to display any color, you could also think of animations, or contextual changes. Since we live in a world of information, and especially since online profiles are becoming such a prominent part of one's expression of individuality, personal data was for us an important cultural factor to investigate. And so we made Apparel not to be just a random canvas. . . . [It] reacts to the wearer's footprint. The 3D model is connected to a person's online information and changes in form depending on how he or she behaves.[35]

Apparel is built on the parameters of a real-world garment, a basic black tunic that, through its quantifiable pattern of faceting, serves as platform for virtual fantasy clothes.[36] Perhaps it was inspired by the "virtual dressing rooms" installed in many stores, like Macy's, beginning in 2010, where mirrors are replaced by screens that project images of the merchandise as worn by customers, who then do not need to try them on.[37] We are also familiar with virtual closets, programs and apps that allow us to organize our wardrobes or wish lists. These are ways that we, in a digital culture, are beginning to experience dressing—at least partly—online. But Apparel expands the range of clothing beyond any sartorial possibility, virtually outfitting the body with a changeable, continuously reelaborated exterior display that (in the prospectus at least) reacts in real time to its "wearer's" biometrics and social media profiles. The realities of textiles and construction are no longer constraints. Cut and drape are replaced by graphics and animation. Apparel eclipses the line between augmented reality and dress

in a way geared not to the designer but to the user, and as customizable (or more so) as apps or social media profiles, because (according to this logic) we are a society that aspires to be permanently connected to the Internet, and our new-world objects, including our dress, must reflect our changed human condition.[38]

However, rather than being augmentation that reflects reality, Apparel seems to cross the line that Mark Weiser emphasized in his definitive conceptualization of ubiquitous computing:

Perhaps most diametrically opposed to our vision is the notion of "virtual reality," which attempts to make a world inside the computer. Users don special goggles that project an artificial scene on their eyes; they wear gloves or even body suits that sense their motions and gestures so that they can move about and manipulate virtual objects. . . . Virtual reality focuses an enormous apparatus on simulating the world rather than on invisibly enhancing the world that already exists.[39]

But now the experience has shed its "enormous apparatus" and relies on the simple screen. And not just the screen: the Apparel program is projected to run on a minimally invasive, heads-up display like Google Glass or some other sleek, future augmented-reality system, where the notion of dress would be all but transferred to a virtual realm. In 1999 Elise Co's fantastical backpack featuring a changing visual display, her Chimerical Garment, was designed to project "imaginary clothing into the physical world." Nearly fifteen years later, with Apparel, the fantasy is complete, but it is a dream of ourselves as viewed, as looked at. The "wearer" will neither physically support nor directly experience her garments at all. Instead, properly equipped admirers in her vicinity will see them on her, and if she wears the program's headset, she will see imaginary clothes on others who do so also.

In such a scenario the distinction between AR and VR is certainly not as clear as Weiser and ubicomp practitioners once suggested. Like so many things in the realm of WT, we can trace the idea of AR back to futuristic fiction: in this case a novel by L. Frank Baum called *The Master Key*, written in 1901. The story was subtitled *An Electrical Fairy Tale, Founded upon the Mysteries and the Optimism of Its Devotees*. As the subtitle indicates, it is an affirmation of the modernist faith in technology. In the story a young boy, a turn-of-the-century electronics enthusiast who wires his family's home with lights and telephone cables, crosses some connections and unintentionally releases a being called the Demon of Electricity. A variant of the legendary genie in the bottle, the Demon offers the reward of nine wishes, but since the boy does not know what to wish for, the Demon selects electronic wonders, and three of them are WT. The first is a wristwatch transportation device that allows the boy to fly around the world at high speeds, but it is fragile and ultimately breaks. The Demon also gives the boy a "garment of protection," which, like battle armor, protects the boy from physical attacks. But the most spectacular gift is called a "character marker"—glasses that allow their wearer to "see" the character of everyone around by showing a virtual letter above

their heads: for example, E for evil, K for kind, or F for foolish. The story provides a short inventory of letter symbols. "Thus you will determine by one look the natures of all those you encounter," says the Demon, and the entire human drama is inventoried by letters of the alphabet.

Since the interest in "smart glasses" stimulated by the Google Glass project, Baum's story is claimed by some to be an early harbinger of AR.[40] But the story makes even more clear the confusion between AR and VR, the distinction so important to Weiser but blurred by contemporary projects like Google Glass and their progeny. VR submerges us in a simulated world, while AR aids us in dealing with the perceptually real one in which we are situated. But when the interface itself becomes so sophisticated, so wearable, its data so manipulable, it enables us to live in two worlds at once, one of embodiment and one of representation. In his essay "Trying to Be Calm: Ubiquity, Cognitivism, and Embodiment," Simon Penny writes that the discourses of technological virtuality characterized the 1990s because of the relatively crude state of interface tools at that time as contrasted with the grand vision behind the concept.[41] But today the newer "miniaturized but intensified interface, attention-demanding and insistent, is foregrounded," as is the "discontinuity between the dataworld and the physical world." This situation, Penny affirms, is anything but calm. Moreover, the superimposition of data upon perceptual reality thins out experience, due to the "preoccupation with problem-solving on the symbolic plane and the ensuing elision of the situated, embodied action."[42] The physical world is reduced to optical experience (or the optical representation of sensation, like readouts that tell us the ambient temperature, something our bodies already feel). Such fragmentation of experience, or mixed reality—between optics, cognition, and sensation—does not enhance our embodied experience of the world, in which, cognition researchers like George Lakoff and Mark Johnson have realized, we often "think" or "see" with our bodies.[43] WT's existence within our intensified information society takes on new meaning because, as N. Katherine Hayles writes, "information should be understood in the context of the embodied receiver."[44]

The ultimate problem, as Google Glass or potential peripherals products that extend communication or fabricate virtual garments show, is that WT as human knowledge and evolutionary process has been imbricated with new social relations of commerce, including new behaviors that take place online. Our wearable devices are still in the experimental stage, but they are deployed to carve out new real estate within what Penny calls the "imperializing project of computer culture."[45]

WT and the Lost Body of Technology

At a time when industrial conglomerates rush to divine the future of augmented-reality—or augmented-virtual, mixed-reality—devices, new designs explore the

Figure 6.6
CuteCircuit, Twitter Dress for Everything Everywhere, Battersea Power Station, London, 2012.

insertion of technological activity into the multiple interfaces of dress. Despite the seeming conservatism endemic to contemporary fashion producers, change is likely to come. In 2012, EE (Everything Everywhere), Britain's enterprising 4G mobile network, created a media event for its launch party in London's Battersea Power Station by commissioning a red-carpet gown from CuteCircuit (Francesca Rosella and Ryan Genz), which was worn by Nicole Scherzinger, formerly of the rock group Pussycat Dolls. Unlike the 2010 Twitter Dress designed by Moritz Waldemeyer and worn by Imogene Heap (discussed in chapter 4), CuteCircuit's 2012 creation, also called Twitter Dress, seamlessly integrated texts generated by social media into the fabric of the gown itself. It was made of layers of French chiffon with LEDs enhanced by crystals and connected to a Twitter account with the hashtag #tweetthedress. During the EE party the gown's bodice radiated spots and waves of light, but on registers of the gauzy, floor-length skirt real-time tweets were displayed in a manner reminiscent of actual LED signage, only softened by the layers of black silk that acted as a translucent veil.[46] There, and at an additional showing of the dress at London's Science Museum (where it was worn by a model), the dress was connected wirelessly to Twitter running on a nearby laptop. Rosella and Genz are also designing a line of similar dresses capable of displaying tweets by the dresses' owners and connected to mobile phones running customized apps. That way a wearer can monitor the tweets that get displayed on her own dress and even answer them and display her answers on the spot. This is a far cry from the social media dress by Electricfoxy (figure 5.17), which made its wearer seem isolated, working her social media sites in private. Rosella and Genz believe that externalizing social media as fashion, as their Twitter Dress does, is inevitable, because it affords a heightened experience of display and communication between the wearer and an audience or passersby.

CuteCircuit's Twitter Dress symbolizes an almost transcendent multiplication of interfaces built on the substrate of dress and fashion: the spectacular interface, the computational interface, and the virtual social interface. In addition, it posits the insertion of the self within, or more precisely at the center of, the dynamics of online identity in real time. Twitter's global voice materializes, literally. It allows one to wear speech. It might even be called an illocutionary dress, since the speech acts it performs—both digital texts and light projections—accomplish the action of tweeting, which goes beyond merely exclaiming or describing, because tweets are actually counted within a system that tries to grant social value through quantification and ranks the popularity of tweeters.

As spectacular display, the 2012 Twitter Dress also "disappears," reminding us of the ghostly quality of technology that wants to be invisible, even when design is center stage. Manovich calls this kind of aesthetics of disappearance "supermodernism," when he discusses its initial arrival in the 2000s with Apple's brushed aluminum PowerBooks and "white" products, and in certain postmodern architecture such as Diller

Figure 6.7
Anouk Wipprecht, Smokedress, 2012. Photo by Jean-Sébastien Senécal. Courtesy of the designer.

and Scofidio's atmospheric Blur Building (2002).[47] This recalls Dourish's comments above about the seamlessness and erasures of ubicomp. Normals, the designers of the Apparel project, also write about the tendency toward disappearance, using mobile phones as their example. Noting the color and variety of early phones, they point out that recent smart phones have more and more become uniform black rectangles, despite their brand: "Where did the crazy different shapes go? Well, they just shifted into cyberspace [and] the smartphone became a non-object: a semantic information display platform."[48] In an oddly similar way, the Twitter Dress's nearly transparent black chiffon layers, over a minimal, short underdress, form a shadowy background or screen for the illuminated "content"—the dress's light show and scrolling text. Aside from the colored lights and high-tech branding, the social media dress reminds one of nothing so much as Walter Dorwin Teague's Nearly Nude Evening Dress in the 1939 *Vogue* (figure 1.4), except the recent interactive version embodies ideologies of digital rather than genetic perfectibility. The Twitter Dress dissolves within its own virtual environment, and the body dissolves with it. Anouk Wipprecht comments on this archetype of WT's diaphanous disappearance in many of her designs, including Intimacy Black (mentioned in chapter 3), and specifically in her Smokedress (2011–2013,

accomplished with technology by Aduen Darriba). The Smokedress, which is a critical rather than commercial design, literally produces a smokescreen, obscuring itself in proximity to others, becoming the very figure of the confrontation between technology and dress.[49]

Google Glass and the Twitter Dress illustrate the still bifurcated experimentation that is taking place in the arenas of consumer products and celebrity spectacle: device versus dress, though in fact they both involve problems of invisibility, subjectification, and control. However, we are still a long way from any widespread and proficient employment of dress technologies, because they are too expensive and their larger implications for social and cognitive structures will take time to resolve. At the moment, industrial sources account for much of the proliferation of WT prototypes. Fashion, music, and media spectacles are the arenas where ideas about WT are currently circulated, a situation that upholds Certeau's top-down schema. In his 2006 discussion of augmented space, or "cellspace"—physical space that is "filled" with data—Manovich finds that developments are dictated by high-tech and media industries and tested in places like high-profile urban architecture, music performances, and retail spaces; he particularly points to the technology-infused atmosphere of Rem Koolhaas's Prada flagship store in New York. As augmented space more and more takes over our ambient realities, Manovich asks whether or not cultural institutions like museums or academic centers can play a role "as laboratories where alternative futures are tested."[50] Experimental WT like Apparel and the Twitter Dress remind us that the future will involve inhabiting this augmented space, and its evolution will require the kind of modification, critique, and diversity that the street provided for dress in the past. In this book I have noted the tendency for examples of critical WT to cluster at academic conferences and publicly funded technology centers in Europe, Canada, and elsewhere (generally less often in the United States). But as testing grounds for speculations about augmented dress, are these venues up to the task? It will be interesting to see how, or even if, alternative discourses for WT unfold, because in matters of dress everything is in play, and we are perpetually fascinated with the uncontrived and emergent.

In its focus on WT as grounded in dress as a behavior, this book has largely steered a course around the normative scholarship on dress as an expression of identity, and "skirted" knotty issues of selfhood and personal expression. I concur with Hayles when she suggests that a new framework is needed for interpreting human agency and its interaction with information and technological objects:

Such a framework would allow us to shed the misconception that humans alone are capable of cognition. . . . The way forward . . . should not be a retreat to traditional liberal humanism but rather to rethink the ways in which human cognition is like RFID technologies: multilayered, context aware, and capable of generating novel meanings and interpretations. Nevertheless, human cognition remains distinct from thinghood because it arises from embodied contexts that

have a biological specificity capable of generating consciousness as an emergent phenomenon, something no mechanical system can do.[51]

As I have tried to show, the body that wears technology is still a body dominated by ideological meaning and augmentation that too easily relinquishes agency. But unlike the seeming sameness of smart phones, which visually recede from the real world, dress is tethered to both the material and the digital worlds—the realm of body and dress and the shifting sands of processes and images (street *and* screen). This is what connects Agamben's theological paradigm of the light-clad body to bodies augmented by information or illuminated by LEDs—in this case, garments of paradise where paradise is mistaken for a technological event horizon. Brian Massumi points out one way to think about today's conflicts between ideology and the body, which are manifold but I think include the behavior of dress. Dress is ideological, but it can also represent the action of time and change, and the continuity of movement, and it can capture moments between ideologies. This is what Massumi calls "another order of reality": a reality that cannot be pinned down to a single subject position but is always multiple and in process, incorporating movement and distance as well as past, present, and future.[52] In his emphasis on the "primacy of process" to leverage possibility, Massumi's emergent corporeality can be compared to Agamben's "whatever body." As to the future, it will remain important to challenge the notion that technology has lost its body, and to experiment with dress as corporeal and social speech that is mutable and ongoing. That is the hopeful promise of WT.[53]

Notes

Introduction: Wearing Technologies

1. Kaja Silverman, "Fragments of a Fashionable Discourse," in *Studies in Entertainment: Critical Approaches to Mass Culture*, ed. Tania Modleski (Bloomington: Indiana University Press, 1986), 145; Silverman quotes from Eugénie Lemoine-Luccioni, *La Robe: Essai psychanalytique sur le vêtement* (Paris: Éditions du Seuil, 1983), 147.

2. Gilles Lipovetsky, *The Empire of Fashion: Dressing Modern Democracy*, trans. Catherine Porter (Princeton: Princeton University Press, 1994), 24, 243.

3. Ibid., 3–12.

4. Ibid., 10.

5. See a variety of market reports such as, for example, Roland Piquepaille, "Smart Fabrics and Interactive Technologies," in Chris Jablonski, "Emerging Tech," *ZD Net*, U.S. edition (October 15, 2008), which reported a market value in excess of €300M and an annual growth rate of 20 percent, http://www.zdnet.com/blog/emergingtech/smart-fabrics-and-interactive-textiles/1065, accessed October 10, 2011. Another 2008 report entitled "Smart Fabrics and Interactive Textiles" cited growth that year of over US$640M worldwide, http://www.businesswire.com/news/home/20081028005930/en/Examine-Global-Markets-Smart-Fabrics-Interactive-Textiles, accessed September 13, 2013.

6. "Developments in Material Science to Shape the Market for Smart Fabrics and Interactive Textiles," press release for Global Industry Analysts, "Smart Fabrics and Interactive Textiles—A Global Strategic Business Report," *PR Web*, April 23, 2012, http://www.prweb.com/releases/smart_fabrics_market/interactive_textiles/prweb9431379.htm, accessed April 26, 2012.

7. For example, David Amerland, "Wearable Tech Is Going to Change Marketing," *David Amerland helpmyseo.com* blog, April 4, 2012, http://helpmyseo.com/seo-blog/718-google-project-glass-impacts-seo-and-solomo.html, accessed October 20, 2012.

8. Bradley Quinn, *Techno Fashion* (Oxford: Berg, 2002).

9. Andrew Bolton, *The Supermodern Wardrobe* (London: V&A Publications, 2002).

10. Suzanne Lee, *Fashioning the Future: Tomorrow's Wardrobe* (London: Thames and Hudson, 2005); Sabine Seymour, *Fashioning Technology: The Intersection of Design, Fashion, Science, and Technology* (Vienna: Springer-Verlag, 2008); Sabine Seymour, *Functional Aesthetics: Visions in Fashionable Technology* (Vienna: Springer-Verlag, 2010); Bradley Quinn, *Fashion Futures* (London: Merrell, 2012).

11. *Smart Clothes and Wearable Technology*, ed. Jane McCann and David Bryson (Oxford: Woodhead Publishing with the Textile Institute, 2009).

12. Sarah E. Braddock and Marie O'Mahony, *Techno Textiles: Revolutionary Textiles for Fashion and Design* (London: Thames and Hudson, 1998); and Sarah E. Braddock Clarke and Marie O'Mahony, *Techno Textiles 2: Revolutionary Textiles for Fashion and Design* (New York: Thames and Hudson, 2005).

13. Bradley Quinn, *Textile Futures: Fashion, Design and Technology* (Oxford: Berg, 2010).

14. Marie O'Mahony and Sarah E. Braddock, *Sportstech: Revolutionary Fabrics, Fashion and Design* (New York: Thames and Hudson, 2002).

15. Larry Hardesty, "Fibers That Can Hear and Sing," *MIT News*, July 12, 2010, http://web.mit.edu/newsoffice/2010/acoustic-fibers-0712.html, accessed August 1, 2011.

16. Simon Penny, "Consumer Culture and the Technological Imperative: The Artist in Dataspace" (1993), in *Critical Issues in Electronic Media*, ed. Simon Penny (Buffalo: SUNY Press, 1995).

17. Margot Lovejoy, Christiane Paul, and Victoria Vesna, "Introduction," in *Context Providers: Conditions of Meaning in Media Arts*, ed. Margot Lovejoy, Christiane Paul, and Victoria Vesna (Bristol, U.K.: Intellect, 2011).

18. Johannes Birringer and Michèle Danjoux, "The Telematic Dress: Evolving Garments and Distributed Proprioception in Streaming Media and Fashion Performance," 2005, http://www.ephemeral-efforts.com/TheTelematicDress.pdf, accessed August 1, 2011.

19. David Bryson, "Designing Smart Clothing for the Body," in McCann and Bryson, *Smart Clothes and Wearable Technology*, 103.

20. Di Mainstone, "Serendiptichord," in Seymour, *Functional Aesthetics*, 64.

21. Umberto Eco, "Lumbar Thought," in *Travels in Hyperreality* (Orlando, FL: Harcourt, Brace, Jovanovich, 1986), 192–194.

22. Roland Barthes, "History and Sociology of Clothing," trans. Andy Stafford, in *The Language of Fashion: Roland Barthes*, ed. Andy Stafford and Michael Carter (Oxford: Berg, 2006), 4; originally published in *Annales* 3 (July–September 1957), 430–441.

23. Roland Barthes, *The Fashion System*, trans. Matthew Ward and Richard Howard (London: Jonathan Cape, 1985), 5 and n. 4.

24. Valentin Volosinov, *Marxism and the Philosophy of Language*, trans. Ladislav Matejka and I. R. Titunik (Cambridge, Mass.: Harvard University Press, 1986); quoted in Therese Grisham, "Linguistics as Indiscipline: Deleuze and Guattari's Pragmatics," *SubStance #66*, 20, no. 3 (1991): 39.

25. The term "illocutionary force" is somewhat ambiguous in Austin and Searle but generally means the impact or affective force of an utterance. See John R. Searle, *Speech Acts: An Essay in the Philosophy of Language* (Cambridge: Cambridge University Press, 1969), 30.

26. Grisham, "Linguistics as Indiscipline," 45.

27. Gilles Deleuze and Félix Guattari, *A Thousand Plateaus: Capitalism and Schizophrenia*, trans. Brian Massumi (Minneapolis: University of Minnesota Press, 1987), 75–110. Originally published in French in 1980. Manuel De Landa describes these ideas of Deleuze and Guattari's in an entertaining lecture at the European Graduate School (2009), http://www.egs.edu/faculty/manuel-de-landa/videos/theory-of-language/, accessed May 12, 2012. De Landa's account stresses the material aspects of language ("acoustic matter" and its basis in the body, the glottis, etc.), and a parallel could be drawn with the bodily basis of dress as a linguistic or communicative phenomenon.

28. Gilles Deleuze, "Postscript on Societies of Control," *October* 59 (1992): 3–7.

29. Danielle Wilde, "A New Performativity: Wearables and Body-Devices," paper presented at Re:live: Third International Conference on the Histories of Media Art, Science, and Technology, Melbourne, Australia, November 28, 2009, http://www.daniellewilde.com/dw/publications_files/wilde_a%20New%20Performativity_wearables+body%20devices.pdf, accessed April 3, 2012.

30. Paolo Virno, *A Grammar of the Multitude*, trans. Isabella Bertoletti, James Cascaito, and Andrea Casson (Los Angeles: Semiotext(e), 2004), 56.

31. Deleuze and Guattari, *A Thousand Plateaus*, 116.

32. I use the figure of dark matter/energy in the spirit of Gregory Sholette: see his *Dark Matter: Art and Politics in the Age of Enterprise Culture* (London: Pluto Books, 2011). On Agamben's singularity as light, he writes of the "potentiality that comes only after the act, of matter that does not remain beneath form, but surrounds it with a halo"; Giorgio Agamben, *The Coming Community*, trans. Michael Hardt (Minneapolis: University of Minnesota Press, 1993), 56. Agamben reinterprets Benjamin's concept of "aura."

33. Vernor Vinge, "What Is the Singularity," paper delivered at the VISION-21 Symposium sponsored by NASA Lewis Research Center and the Ohio Aerospace Institute, March 30–31, 1993; online at http://mindstalk.net/vinge/vinge-sing.html, accessed September 13, 2013.

34. Agamben, *The Coming Community*, 1–2.

35. Ibid., 73. See also Jessica Whyte, "'A New Use of the Self': Giorgio Agamben on the Coming Community," *Theory and Event* 13, no. 1 (2010).

36. See Stuart J. Murray, "Thanatopolitics: Reading in Agamben a Rejoinder to Biopolitical Life," *Communication and Critical/Cultural Studies* 5, no. 2 (June 2008): 204; Murray's focus is on Agamben's *Homo Sacer* and *State of Exception*.

37. Agamben, *The Coming Community*, 47.

38. Ibid., 50.

1 Disparate Histories

1. The bulbs were actually hand painted, making an ironic connection with the traditional art forms Gutai had abandoned. In one exhibition, Tanaka had three models wearing different electric clothes walking around a stage, moving their arms up and down, and swinging the clothes. Much of Tanaka's work centered on fabric, and there were other garment pieces, such as *Stage Clothes* (1956), essentially a performance in which she put on and took off several self-fashioned, painted garments, ending with one covered in electric lights. *Electric Dress* was created shortly afterward and first shown at the 2nd Gutai Art Exhibition, 1956. See Mizuho Kato, "Searching for a Boundary," trans. Simon Scanes and Keiko Shiraha, in *Atsuko Tanaka: Search for an Unknown Aesthetic, 1954–2000*, ed. Mizuho Kato and Ming Tiampo (Ashiya: Ashiya City Museum of Art and History; Shizuoka: Shizuoka Prefectural Museum of Art, 2001), 15–25.

2. Jiro Yoshihara, "Regarding the Second Gutai Outdoor Exhibition," *Gutai Journal* 5 (October 1956), quoted in Kato, "Searching for a Boundary," 18.

3. Quoted in Ming Tiampo, "Electrifying Painting," in *Electrifying Art: Atsuko Tanaka 1954–1968*, ed. Mizuho Kato and Ming Tiampo (New York: Grey Art Gallery, 2004), 72.

4. Ibid. See also Namiko Kunimoto, "Tanaka Atsuko and the Circuits of Subjectivity," *Art Bulletin* 45, no. 2 (September 2013).

5. "Vogue Point of View," *Vogue*, March 2012, 217.

6. Mark Stevens, "Everything Is Illuminated," *New York*, May 21, 2005, http://nymag.com/nymetro/arts/art/reviews/9937/, accessed August 15, 2011; or the retrospective of Tanaka's work at the Espai d'art contemporani de Castelló, 2011, which featured the reconstruction of the "Electric Dress," or, again, the reconstructed work's appearance at Documenta 12 in Kassel, where it was a central exhibit, occasioning many viewers to document it themselves on YouTube.

7. For example, Jean M. Ippolito, "From the Avant-Garde: Re-Conceptualizing Cultural Origins in the Digital Media Art of Japan," *Leonardo: Journal of the International Society for the Arts, Sciences, and Technology* 40 (2007): 144.

8. Noriko Yamaguchi, "Keitai Girl," *Imagining Ourselves: A Global Generation of Women*, http://imaginingourselves.imow.org/pb/Story.aspx?G=1&C=0&id=1330&lang=1, accessed April 28, 2012.

9. "I Just Wanna Be Touched—Keitai Girl Story," literature accompanying exhibition of *Keitai Girl* at the 2006 SIGGRAPH conference.

10. For example, "The Fibres and Fabrics of Antiquity," in Robert James Forbes, *Studies in Ancient Technology*, vol. 3 (Leiden: Brill Archive, 1964); and John W. Humphries, *Ancient Technology* (Westport, Conn.: Greenwood Press, 2006), 19–34.

11. E. J. W. Barber, *Prehistoric Textiles: The Development of Cloth in the Neolithic and Bronze Ages with Special Reference to the Aegean* (Princeton: Princeton University Press, 1991), 83, 91.

12. Ibid., 287.

13. Carl Mitcham, *Thinking Through Technology: The Path Between Engineering and Philosophy* (Chicago: University of Chicago Press, 1994).

14. From Ernst Kapp, *Philosophie der Technik: Zur Entstehungsgeschichte der Cultur aus neuen Gesichtspunkten* [Fundamentals of a Philosophy of Technology: The Genesis of Culture from a New Perspective] (Braunschweig: Westermann, 1877), 44–45, cited and translated by Mitcham in *Thinking Through Technology*, 24.

15. Kapp, *Philosophie der Technik*, 266. Kapp's pre-Freudian understanding of the unconscious came from Karl Robert Eduard von Hartmann's *Philosophie des Unbewussten*.

16. Steve Mann with Hal Niedzviecki, *Cyborg: Digital Destiny and Human Possibility in the Age of the Wearable Computer* (Toronto: Doubleday Canada, 2001), 55.

17. See discussions of Veblen's *Theory of the Leisure Class* (1957), Barthes's *Système de la mode* (1967), Baudrillard's *For a Critique of the Political Economy of the Sign* (1981), as well as earlier commentary on fashion, like Thomas Carlyle's *Sartor Resartus* (1831), in Elizabeth Wilson, *Adorned in Dreams: Fashion and Modernity* (New Brunswick: Rutgers University Press, 2003), 47–66.

18. Gilles Lipovetsky, *The Empire of Fashion: Dressing Modern Democracy*, trans. Catherine Porter (Princeton: Princeton University Press, 1994), 21.

19. Wilson, *Adorned in Dreams*, 48.

20. Gottfried Semper, *Style in the Technical and Tectonic Arts; or, Practical Aesthetics*, trans. Harry Francis Mallgrave and Michael Robinson (Los Angeles: Getty Publications, 2004), 247. Italics in original.

21. Mark Wigley, *White Walls, Designer Dresses: The Fashioning of Modern Architecture* (Cambridge, Mass.: MIT Press), 12.

22. Ibid., 438–439, n. 85.

23. Semper, *Style in the Technical and Tectonic Arts*, 439, n. 85.

24. Wigley, *White Walls, Designer Dresses*, 64.

25. Ulrich Lehmann, *Tigersprung: Fashion in Modernity* (Cambridge, Mass.: MIT Press, 2000), 201.

26. Ibid., 200.

27. Walter Benjamin, "Paris, the Capital of the Nineteenth Century" (1935), in *The Arcades Project*, trans. Howard Eiland and Kevin McLaughlin (Cambridge, Mass.: Harvard University Press, 1999), 15.

28. According to Rolf Tiedemann, editor of the German edition of *The Arcades Project*, the quote was actually written by Ernst Renan in *Essais de morale et de critique* (Paris: Calmann Lévy, 1889); Benjamin, "Paris," 19 and 956 n. 11.

29. Susan Buck-Morss, *The Dialectics of Seeing: Walter Benjamin and the Arcades Project* (Cambridge, Mass.: MIT Press, 1989), 33–34. Buck-Morss is quoting from Benjamin's article "Der Surrealismus: Die letzte Aufnahme der europäischen Intelligenz" (1929), in the *Gesammelte Schriften*, vol. 2, ed. Rolf Tiedemann and Hermann Schweppenhäuser, with the collaboration of Theodor W. Adorno and Gershom Scholem (Frankfurt am Main: Suhrkamp Verlag, 1972–1989), 304.

30. Benjamin, *The Arcades Project*, 63 and 881.

31. Ibid., 79.

32. Buck-Morss, *The Dialectics of Seeing*, 22–23.

33. Andrew Bolton, *The Supermodern Wardrobe* (London: V&A Publications, 2002), 6–7.

34. Ibid., 7. Bolton is referencing Marc Augé's *Non-Places: Introduction to an Anthropology of Supermodernity* (London: Verso, 1995), which argues that "non-places" like hotels, highways, and supermarkets are the real spaces of globalization.

35. Radu Stern, *Against Fashion: Clothing as Art, 1850–1930* (Cambridge, Mass.: MIT Press, 2004), 2.

36. Lipovetsky, *The Empire of Fashion*, 3.

37. Theodor Adorno, *Ästhetische Theorie* (Frankfurt: Suhrkamp, 1973), 265–266; trans. C. Lenhardt as *Aesthetic Theory* (London: Routledge, 1984), 255, translation slightly altered by Lehmann, from which this quote is taken (see Lehmann, *Tigersprung*, 453, n. 5).

38. Joanne Entwistle, *The Fashioned Body: Fashion, Dress, and Modern Social Theory* (Cambridge, U.K.: Polity, 2000), 3.

39. Michel Foucault, *Discipline and Punish: The Birth of the Prison*, trans. Alan Sheridan (London: Penguin, 1977), originally published as *Surveiller et punir: Naissance de la prison* in 1975.

40. Michel Foucault, "The Meshes of Power," trans. Gerald Moore, in *Space, Knowledge and Power: Foucault and Geography*, ed. Jeremy W. Crampton and Stuart Elden (Aldershot, U.K.: Ashgate, 2007), 161. In the original, Foucault used the French term *dressable* (trainable, not "dressage," as Moore and Hurley translate it). See Foucault, "Les Mailles du pouvoir," in *Dits et écrits*, vol. 5 (Paris: Gallimard, 1976–1981), 182–201 and 896. The essay was originally delivered as a lecture in 1976.

41. Michel Foucault, *The History of Sexuality: An Introduction*, vol. 1, trans. Robert Hurley (New York: Vintage, 1990), 147.

42. Joanne Entwistle, "The Dressed Body," in *Body Dressing*, ed. Joanne Entwistle and Elizabeth Wilson (Oxford: Berg, 2001), 39.

43. Judith Butler, *Gender Trouble: Feminism and the Subversion of Identity* (New York: Routledge, 1990), 142. Joan Entwistle points to earlier writings that treat dress and body style as performance, for example, Joan Riviere's essay "Womanliness as Masquerade," written in 1929; see Entwistle, *The Fashioned Body*, 178–179.

44. Butler, *Gender Trouble*, 136. Italics in original.

45. See, for example, John E. Brozek, "The History and Evolution of the Wristwatch," *International Watch Magazine*, January 2004, 11–14. Jaquet-Droz was also known for creating impressive automata in the form of human figures and birds—at least one example with rudimentary programmable memory—to help promote his watch business in the 1770s.

46. Charlotte Gere and Judy Rudoe, *Jewelry in the Age of Queen Victoria: A Mirror to the World* (London: British Museum Press, 2010), 209–210.

47. Giacomo Balla, "Male Futurist Dress, A Manifesto," 1914, in Stern, *Against Fashion*, 155–156.

48. Stern, *Against Fashion*, 32. The manifesto is "The Futurist Reconstruction of the Universe," signed by Balla and Fortunato Depero in 1915.

49. Ibid., 32 and 156.

50. Ibid., 37.

51. Volt, "Futurist Manifesto of Women's Fashion," published in Italian in *Roma Futurista* 3, no. 72 (February 29, 1920); in Stern, *Against Fashion*, 160–161.

52. Judith Clark, "Looking Forward: Historical Futurism," in *Radical Fashion*, ed. Claire Wilcox (London: V&A Publications, 2001), 15–17.

53. Cited in Cinzia Saratini Blum, "The Futurist Re-Fashioning of the Universe," *South Central Review* 13, no. 2–3 (Summer-Fall 1996): 83 and 101 n. 4.

54. Ibid., 88.

55. Ibid., 84 and n. 6, quoting from Norbert Elias, *The Civilizing Process*, trans. Edmund Jephcott (New York: Urizen Books, 1978).

56. Gilles Deleuze and Félix Guattari, *Anti-Oedipus: Capitalism and Schizophrenia*, trans. Robert Hurley, Mark Seem, and Helen R. Lane (Minneapolis: University of Minnesota Press, 1983), 260.

57. Everette S. Lagarde and Peter A. Angenend Jr., Illuminated Vest or Coat Buttons, Specification of Letters. U.S. Patent 1,030,516, filed April 13, 1911, and issued June 25, 1912. This item and the next were brought to my attention by Ryan Genz of CuteCircuit.

58. The brooch and cravat pins shown at the 1867 Paris exhibition were similarly arranged with concealed switches and batteries. See Gere and Rudoe, *Jewelry in the Age of Queen Victoria*, 209–210.

59. Walter D. Graham and Charles M. Uhlig, Electrically-Heated Garment, U.S. Patent 1,691,472, filed June 25, 1925, and issued November 13, 1928.

60. Mary O'Mahony and Sarah E. Braddock, *Sportstech: Revolutionary Fabrics, Fashion, and Design* (New York: Thames and Hudson, 2002), 14.

61. Larry Zim, Mel Lerner, and Herbert Rolfes, *The World of Tomorrow: The 1939 New York World's Fair* (New York: Harper and Row, 1988), 94.

62. Susannah Handley, *Nylon: The Story of a Fashion Revolution* (Baltimore: Johns Hopkins University Press, 1999), 43.

63. Wilson Kaiser, "Partial Affinities: Fascism and the Politics of Representation in Interwar America" (PhD diss., University of North Carolina at Chapel Hill, 2011), 73–74.

64. "Vogue Presents Fashions of the Future," *Vogue*, February 1, 1939, 71.

65. "To-Morrow's Daughter," *Vogue*, February 1, 1939, 61.

66. Harry Hamilton Laughlin, *Eugenical Sterilization in the United States* (Chicago: Psychopathic Laboratory of the Municipal Court of Chicago, 1922).

67. Elizabeth Wilson, "These New Components of the Spectacle: Fashion and Postmodernism," in *Postmodernism and Society*, ed. Roy Boyne and Ali Rattansi (London: Macmillan, 1990), 219. See also J. C. Flügel, *The Psychology of Clothes* (London: Hogarth Press, 1930).

68. Susan Currell, "Introduction," in *Popular Eugenics: National Efficiency and American Mass Culture in the 1930s*, ed. Susan Currell and Christina Cogdell (Athens: Ohio University Press, 2006), 3.

69. Numerous designers, like Norman Bel Geddes, Egmont Arens, and Henry Dreyfuss, were interested in digestive efficiency as well, and considered "smooth flow" a sister concept to streamlining. See Christina Cogdell, "Smooth Flow," in Currell and Cogdell, *Popular Eugenics*, 217–248.

70. George Sakier, "No Mechanistic Clothes for Future Women Predicts George Sakier," *Vogue*, February 1, 1939, 144.

71. Walter Dorwin Teague, "Nearly Nude Evening Dress Designed by Walter Dorwin Teague," *Vogue*, February 1, 1939, 143.

72. *Vogue*, February 1, 1939, 138.

73. Ibid., 146.

74. "Woven Glass Fibre Costume for a Future Bride Designed by Egmont Arens," ibid., 142.

75. D. N. Jarrett, *Cockpit Engineering* (Aldershot, U.K.: Ashgate, 2005), 189–190.

76. Manuel De Landa, *War in the Age of Intelligent Machines* (New York: Zone, 1991), 43.

77. *Amazing Stories*, August 1928. In the late 1950s, Robert A. Heinlein wrote *Starship Troopers* (first published in 1959 as "Starship Soldier" in *The Magazine of Fantasy and Science Fiction*), which featured elaborate powered-armor exoskeletons that reflected actual military research. The story's fictional armor could enhance soldiers' strength and stride as well as their ability to withstand physical assaults and could even display information and dispense medication.

78. Rob Arndt, "Himmelstürmer Flightpack (1944–1945)," http://discaircraft.greyfalcon.us/HIMMELSTURMER.htm, accessed September 2, 2011.

79. Friedrich Weltzien, "Masque-*ulinities*: Changing Dress as a Display of Masculinity in the Superhuman Genre," *Fashion Theory* 9 (June 2005): 231.

80. See Joshua Derman, "Max Weber and Charisma: A Transatlantic Affair," *New German Critique* 113, vol. 38, no. 2 (Summer 2011): 51–88.

81. George Hersey, *The Evolution of Allure* (Cambridge, Mass.: MIT Press, 1996), 159; Kerry Soper, "Classical Bodies versus the Criminal Carnival," in Currell and Cogdell, *Popular Eugenics*, 269–307.

82. See, for example, Les Daniels, *Superman, the Complete History: The Life and Times of the Man of Steel (*New York: DC Comics, 1998), 18–19. Daniels points out that an additional influence may have come from Alex Raymond's sci-fi-oriented *Flash Gordon* comic strip, which appeared in 1934, competing with Buck Rogers, in which the protagonist was dressed in a circus strong-man–inspired shirt and trunks rather than the unitard and briefs that Superman and others made indispensable. Philip Wylie's 1930 science fiction novel *Gladiator*, about a scientifically enhanced man who does not perform heroic acts but dies questioning his place in the universe, is well accepted as a precedent for Superman.

83. "Jules Léotard," *V&A*, http://www.vam.ac.uk/content/articles/j/jules-leotard, accessed September 2, 2011.

84. Hersey, *The Evolution of Allure*, 167.

85. *Health and Strength* was a UK magazine and *Strength and Health* its American counterpart; both were popular in the 1940s and 1950s along with generations of imitations.

86. Gillian Freeman, *The Undergrowth of Literature* (London: Panther, 1969), 200–201.

87. Giammanco's argument is contained within Eco's article "The Myth of Superman," trans. Natalie Chilton, *Diacritics* 2, no. 1 (Spring 1972): 18 and 21–22; also Fredric Wertham, *Seduction of the Innocent* (New York: Rinehart, 1954). The theme of homosexuality comes up most prominently in considerations of the Batman and Robin narratives; see Mark Best, "Domesticity, Homosociality, and Male Power in Superhero Comics of the 1950s," *Iowa Journal of Cultural Studies* 6 (Spring 2005): 80–99.

88. The wrist radio was conceived by *Dick Tracy* creator Chester Gould, adding a technological edge to this popular character, who had been in print since 1931 and in a radio show from 1934. The wrist radio, worn by the detective and members of the police, is sometimes considered the progenitor of later cellular phones and certainly prefigures the smart watches of today. The radio was the first of several futurist devices that appeared in *Dick Tracy* episodes in the 1960s, such as the "Space Coupe," a personal spacecraft with magnetic propulsion system.

89. Bill Moggridge, "The Radio Watch," in Moggridge, *Designing Interactions* (Cambridge, Mass.: MIT Press, 2007), 3.

90. Vannevar Bush, "As We May Think," *Atlantic*, July 1945.

91. Ibid.

92. E. O. Thorp, "A Favorable Strategy for Twenty-One," *Proceedings of the National Academy of Sciences* 47, no. 1 (1961): 110–112, written with Claude R. Shannon; see Edward O. Thorp, "The

Invention of the First Wearable Computer," *ISWC'98: Proceedings of the 2nd IEEE International Symposium on Wearable Computers* (Washington, DC: IEEE Computer Society, 1998): 4.

93. Thorp, "A Favorable Strategy for Twenty-One," 4.

94. Ibid., 4.

95. Hubert Upton, "Wearable Eyeglass Speechreading Aid," *American Annals of the Deaf* 113 (March 2, 1968): 222–229. See also Bradley Rhodes, "A Brief History of Wearable Computing" (1997), http://www.media.mit.edu/wearables/lizzy/timeline.html, accessed September 9, 2011.

96. Roland Barthes, "Plastic," in *Mythologies*, trans. Annette Lavers (New York: Farrar, Straus and Giroux, 1957), 97–99.

97. Meriel McCooey, "Plastic Bombs," *Sunday Times Color Supplement* (August 15, 1965), 21, quoted in Penny Sparke, "Plastics and Pop Culture," in *The Plastics Age: From Bakelite to Beanbags and Beyond*, ed. Penny Sparke (Woodstock, NY: Overlook Press, 1993), 98–99.

98. Lydia Kamitsis, *Paco Rabanne* (London: Thames and Hudson, 1999), 9.

99. *Marie Claire*, 1967, quoted in ibid., 11.

100. Quoted in Steven Watson, *Factory-Made: Warhol and the Sixties* (New York: Pantheon, 2003), 280.

101. Wilson, *Adorned in Dreams*, 215.

102. On Goodman and Multiples Gallery, see Susan Elizabeth Ryan, *Robert Indiana: Figures of Speech* (New Haven: Yale University Press, 2000), 211; and Constance W. Glenn, *The Great American Pop Art Store: Multiples of the Sixties* (Long Beach: California State University Art Museum; Santa Monica, Smart Art, 1997).

103. Amy Larocca, "The House of Mod," *New York*, Spring Fashion Issue (2003), http://nymag.com/nymetro/shopping/fashion/spring03/n_8337/, accessed September 5, 2011.

104. Joel Lobenthal, *Radical Rags: Fashions of the Sixties* (New York: Abbeville, 1990), 83.

105. Larocca, "The House of Mod."

106. "The 1960s Paper Dress," Wisconsin Historical Society, http://www.wisconsinhistory.org/museum/artifacts/archives/003291.asp, accessed September 8, 2011.

107. Article on Andy Warhol's Banana Dress in the *New York Times*, November 8, 1966, cited in Mark Francis and Margery King, *The Warhol Look: Glamour, Style, Fashion* (Pittsburgh: Andy Warhol Museum; Boston: Little, Brown, 1997), 162.

108. Alvin Toffler, *Future Shock* (New York: Random House, 1970), 48.

109. Lobenthal, *Radical Rags*, 101.

110. Deanna Littell, telephone interview with the author, October 12, 2011.

111. Gerald Jones, "Aglow," *New Yorker*, January 28, 1967, 26–28. This article contains the most extensive biographical information in print on this designer, who disappeared from sight after Paraphernalia closed.

112. Lobenthal, *Radical Rags*, 101.

113. "Fashion: Turn On, Turn Off," *Time*, January 20, 1967, http://www.time.com/time/maga zine/article/0,9171,843346,00.html, accessed September 7, 2011.

114. "Science and Society Picture Library," *Manchester Daily Express*, February 2, 1968, http://www.scienceandsociety.co.uk/results.asp?image=10450947&screenwidth=1396, accessed October 18, 2011.

115. Amelia Jones, *Body Art: Performing the Subject* (Minneapolis: University of Minnesota Press, 1998), 278, n. 118.

116. Marshall McLuhan, *Understanding Media: The Extensions of Man* (Cambridge, Mass.: MIT Press, 1994), 120–121; first published in 1964.

117. Gilles Deleuze and Félix Guattari, *A Thousand Plateaus: Capitalism and Schizophrenia* (Minneapolis: University of Minnesota Press, 1987), 406.

118. Manuel De Landa, "The Machinic Phylum," in *Technomorphica* (Rotterdam: V2, 1997).

2 Wearable Computing

1. William J. Mitchell, *Me++: The Cyborg Self and the Networked City* (Cambridge, Mass.: MIT Press, 2003), 62. See also Mark C. Taylor, *The Moment of Complexity: Emerging Network Culture* (Chicago: University of Chicago Press), 2002; and Brian Massumi, *Parables for the Virtual* (Durham: Duke University Press, 2002), 128.

2. Manuel De Landa, *War in the Age of Intelligent Machines* (New York: Zone Books, 1991), 155, 175.

3. Ibid., 159.

4. This story is apocryphal, though it is repeated on numerous websites; however, no actual watch is on view in the final, edited version of the movie.

5. Pavel's concept involved hi-fi units inserted in pockets, with connected headphones, patented in 1977. In Paul Du Gay, Stuart Hall, Linda Janes, Hugh Mackay, and Keith Negus, *Doing Cultural Studies: The Story of the Sony Walkman* (London: Sage, 1997), 42.

6. Ibid., 33–35.

7. Steve Mann was working on wearable and portable devices in the late 1970s, and Thomas A. Bass records a number of tinkerers working on miniature computer projects. See Thomas A. Bass, *Eudaemonic Pie* (Lincoln: iUniverse.com, 1985).

8. Almost all the members of the group had read or were familiar with Thorp's book, *Beat the Dealer* (1966), and several were aware of Thorp and Shannon's experiments with roulette. See Bass, *Eudaemonic Pie*, 43.

9. N. Katherine Hayles, *How We Became Posthuman: Virtual Bodies in Cybernetics, Literature, and Informatics* (Chicago: University of Chicago Press, 1999), xi–xii. She is referring to Alan Turing, "Computing Machinery and Intelligence," *Mind* 59, no. 236 (1950): 433–460; Norbert Wiener, *The Human Use of Human Beings: Cybernetics and Society* (Garden City, N.Y.: Doubleday, 1950), 103–104; and Hans Moravec, *The Mind Children: The Future of Robot and Human Intelligence* (Cambridge, Mass.: Harvard University Press, 1988), 109–110.

10. For the lineage of the body as machine, see the discussion in Bernadette Wegenstein, *Getting under the Skin: The Body and Media Theory* (Cambridge, Mass.: MIT Press, 2006), 12–13.

11. John Mullarkey, "Deleuze and Materialism One," *South Atlantic Quarterly* 96, no. 3 (Summer 1997), http://www.scribd.com/doc/23287359/Deleuze-and-Materialism-One, accessed October 29, 2011.

12. Gilles Deleuze and Félix Guattari, *A Thousand Plateaus: Capitalism and Schizophrenia*, trans. Brian Massumi (Minneapolis: University of Minnesota Press, 1987), 16.

13. Erkki Huhtamo, "Cyborg Is a Topos," in *Evolution Haute Couture: Art and Science in the Post-Biological Age*, ed. Dmitry Bulatov, vol. 2 (Kaliningrad: National Center for Contemporary Art, 2013), 253.

14. Chris Hables Gray, Steven Mentor, and Heidi J. Figueroa-Sarriera, "Cyborgology: Constructing the Knowledge of Cybernetic Organisms," in *The Cyborg Handbook*, ed. Chris Hables Gray (London: Routledge, 1995), 5.

15. For more on the notion of the cyborg in the Weimar Republic, see Matthew Biro, *The Dada Cyborg: Visions of the New Human in Weimar Berlin* (Minneapolis: University of Minnesota Press, 2009).

16. Sigmund Freud, "The Uncanny," in *The Standard Edition of the Complete Psychological Works of Sigmund Freud*, ed. and trans. James Strachey, vol. 17 (London: Hogarth Press, 1953), 219–252.

17. Istvan Csicsery-Ronay, Jr., *The Seven Beauties of Science Fiction* (Middletown, Conn.: Wesleyan University Press, 2008), 198–199. Gundam is a reference to Yoshiyuki Tomino's *Mobile Suit Gundam* (a combination of the English words "gun" and "freedom"), a Japanese anime TV series beginning in 1979. Actually, the Gundams are not exactly cyborgs but mobile-suited robots with cockpits for their human operators.

18. Manfred E. Clynes and Nathan S. Kline, "Cyborgs and Space," *Astronautics* (September 1960), 26–27, 74–76. See also the influence of cybernetics in Nicholas de Monchaux, *Spacesuit: Fashioning Apollo* (Cambridge, Mass.: MIT Press, 2011), 68–76.

19. On the Macy conferences, see Hayles, *How We Became Posthuman*, 50–83.

20. Wiener, *The Human Use of Human Beings*, 174. See also Norbert Wiener, "Sound Communication with the Deaf," in *Norbert Wiener: Collected Works with Commentaries*, ed. Pesi Masani, vol. 4 (Cambridge, Mass.: MIT Press), 1985, 409–411.

21. Wiener, *The Human Use of Human Beings*, 185. Italics in original.

22. N. Katherine Hayles, "Liberal Subjectivity Imperiled: Norbert Wiener and Cybernetic Anxiety," n.d., http://www.english.ucla.edu/faculty/hayles/Wiener.htm, accessed November 3, 2011.

23. Robert W. Driscoll, "Engineering Man for Space: The Cyborg Study," Report NASw-512, in Gray, *The Cyborg Handbook*, 75–81. (Report originally published by United Aircraft Corporate Systems Center in 1963.)

24. Edwin G. Johnsen and William R. Corliss, "Teleoperators and Human Augmentation," AEC-Casa Technology Survey, NASA SP-5047, 1967, excerpted in Gray, *The Cyborg Handbook*, 83–92.

25. See Ronald Kline, "Where are the Cyborgs in Cybernetics?," *Social Studies of Science* 39 (2009): 331–362.

26. Ted Polhemus, *Street Style: From Sidewalk to Catwalk* (New York: Thames and Hudson, 1994), 127.

27. Simon Reynolds, *Generation Ecstasy: Into the World of Techno and Rave Culture* (Boston: Little, Brown, 1998), 53–55.

28. Polhemus, *Street Style*, 124–127.

29. Laura Frost, "Circuits of Desire: Techno Fetishism and Millennial Technologies of Gender," *Artbyte* (February-March 1999), 27.

30. On Click + Drag, see Brian Farnam, "Glam Nerds and Cyber Sluts, Fetishists and Goths," *New York*, December 8, 1997, 41–43.

31. Csicsery-Ronay, *The Seven Beauties of Science Fiction*, 198.

32. Donna Haraway, "A Manifesto for Cyborgs: Science, Technology and Socialist Feminism in the 1980s," *Socialist Review* 80 (1985): 65–108. Expanded and revised as "A Cyborg Manifesto: Science, Technology, and Socialist-Feminism in the Late Twentieth Century" in Haraway, *Simians, Cyborgs and Women: The Reinvention of Nature* (New York: Routledge, 1991).

33. See the discussion in Zoë Sofoulis, "CYBERQUAKE: Haraway's Manifesto," in *The Cybercultures Reader*, 2nd ed., ed. David Bell and Barbara M. Kennedy (London: Routledge, 2000), 365–385.

34. Ibid., 371.

35. Haraway, *Simians, Cyborgs, and Women*, 149–181.

36. The term "flesh-eating" is from Arthur and Louise Kroker's *Hacking the Future: Stories for the Flesh-Eating 90s* (New York: St. Martin's Press, 1996).

37. Laura Mulvey, "Visual Pleasure and Narrative Cinema," *Screen* 16, no. 3 (Autumn 1975): 6–18.

38. See illustration in Suzanne Lee, *Fashioning the Future: Tomorrow's Wardrobe* (London: Thames and Hudson, 2005), 53.

39. The communicator and tricorder were designed by Chinese-American special effects designer Wah Chang, who also created costumes for some of the alien races in the original *Star Trek*.

40. "The Measure of a Man," written by Melinda M. Snodgrass and directed by Robert Scheerer, a *Star Trek: The Next Generation* episode that first aired February 13, 1989.

41. Marc Weiser, "The Computer in the 21st Century," *Scientific American*, September 1991, 94. The original 1988 presentation, where the term first appeared, is frequently cited but undocumented.

42. Ibid., 100.

43. Paul Dourish and Genevieve Bell, "'Resistance is Futile': Reading Science Fiction Alongside Ubiquitous Computing," written for *Personal and Ubiquitous Computing*, 2010, http://www .dourish.com/publications.html, accessed October 26, 2011.

44. Ibid.

45. Allen Becker, "High Resolution Virtual Displays," paper for Virtual Reality Society of Japan— International Conference on Artificial Reality and Telexistence, 1991, http://www.ic-at.org/ papers/92027.pdf, accessed November 15, 2011.

46. Such as the "Put-that-there" project at MIT; see David J. Sturman and David Zeltzer, "A Survey of Glove-Based Input," *Computer Graphics and Applications, IEEE* 14, no. 1 (January 1994): 30–39.

47. See Carnegie Mellon's Computer Science Department Mobile and Pervasive Research page: http://www.csd.cs.cmu.edu/research/areas/mopercomp/.

48. Thad Starner, telephone interview with author, November 14, 2011. Data glove technology dates back to the late 1970s but became popular technology with the Power Glove and Data Glove developed by Thomas G. Zimmerman in 1989.

49. Thad Starner, "The Cyborgs Are Coming; Or, the Real Personal Computers," unpublished manuscript distributed via the Media Lab in 1993 and 1994; see http://hd.media.mit.edu/tech-reports/TR-318-ABSTRACT.html.

50. These systems are further described in various sources, including Bradley Rhodes's "A Brief History of Wearable Computing" at http://www.media.mit.edu/wearables/lizzy/timeline .html#1966b, accessed July 30, 2011.

51. Starner, telephone interview, November 14, 2011. Later on, Wearable Computing became a project area under the Human Dynamics working group under Alex "Sandy" Pentland.

52. Anne Cranny-Francis, "From Extension to Engagement: Mapping the Imaginary of Wearable Technology," *Visual Communication* 7, no. 3 (August 2008): 267.

53. Figure 2.8 shows, left to right, Steve Mann, Lee Campbell, Rob Gruhl, Baback Moghaddam, Jim Davis, and Thad Starner.

54. Starner, "The Cyborgs Are Coming."

55. De Landa, *War in the Age of Intelligent Machines*, 7.

56. For example, Bradley Rhodes, "The Wearable Remembrance Agent: A System for Augmented Reality," *Personal Technologies* 1 (1997): 218–224; and Thad Starner, "Human-Powered Wearable Computing," *IBM Systems Journal* 35, nos. 3–4 (1996).

57. David Mizell, email message to Thad Starner, March 22, 1996. The Boeing workshop, held the following August, was attended by about two hundred people and organized by Mizell, Tom Claudell (University of New Mexico), Zary Segall (University of Oregon), Dan Siewiorek (Carnegie Mellon University), and Thad Starner (MIT).

58. "Boeing Wearable Computer Workshop Breakout Session Summary," http://www.cs.cmu .edu/~wearable/boeing/index.html, accessed November 16, 2011.

59. Starner, telephone interview, November 14, 2011. The fabric was actually one of his mother's old silk saris with metallic embroidery, and Post was exploring its conductive capabilities; Rehmi Post, telephone interview with author, December 5, 2011.

60. Mikko Malmivaara, "The Emergence of Wearable Computing," in *Smart Clothes and Wearable Technology*, ed. Jane McCann and David Bryson (Oxford: Woodhead Publishing with the Textile Institute, 2009), 9.

61. For example, C. Thompson, J. J. Ockerman, L. J. Najjar, and E. Rogers, "Factory Automation Support Technology (FAST): A New Paradigm of Continuous Learning and Support Using a Wearable," paper presented at the First International Symposium for Wearable Computing, Cambridge, Mass., October 13–14, 1997, in *IEEE Computer Society, Digest of Papers* (Los Alamitos, Calif.: IEEE Computer Society, 1997), 31–38.

62. However, in 2011 (San Francisco) and 2012 (Newcastle, U.K.) it was absorbed by the conference on Pervasive Computing.

63. Steve Mann with Hal Niedzviecki, *Cyborg: Digital Destiny and Human Possibility in the Age of the Wearable Computer* (Toronto: Doubleday Canada, 2001), 83–84.

64. Steve Mann, "An Historical Account of the 'WearComp' and 'WearCam' Inventions Developed for Applications in 'Personal Imaging,'" paper presented at the First International Symposium for Wearable Computing, Cambridge, Mass., October 13–14, 1997, in *IEEE Computer Society, Digest of Papers*, 66–73.

65. Ibid., 69.

66. Ibid.

67. Mann, *Cyborg*, 87–88.

68. Judith Gaines, "Cyberclothes," *Boston Globe*, September 23, 1997, cited in Mann, *Cyborg*, 89. While the article focuses on Mann, Thad Starner's continuous wearing of an actual computer predates Mann's continuous wearing of the Webcam.

69. Mann, *Cyborg*, 96.

70. Nicholas Negroponte and Neil Gershenfeld, "Wearable Computing," *Wired*, December 1995.

71. Alex Pentland and Créapole École de Création, "Collection 'Smart Wear,' Prototypes de vêtements et d'outils informatiques portables," 1997. The tape of the show was provided to the author by Alex Pentland, but the name and exact date of the show were not recorded.

72. Alex Pentland, telephone interview with author, November 17, 2011.

73. "Wearables: Beauty and the Bits," event brochure, MIT Media Lab, 1997.

74. Sarah H. Wright, "'Wearables' Combine Fashion, High-Tech," *MIT News*, October 22, 1997, http://web.mit.edu/newsoffice/1997/wearables-1022.html, accessed February 5, 2013.

75. Maria Redin Poor, telephone interview with author, January 21, 2013. See also Karen Freeman, "A Chance to Wear Your Heart on Your Sleeve—or Bosom," *New York Times*, March 26, 1998.

76. She was drawn to early feminist artists like Charlotte Moorman, who experimented with technology in her performances with Nam June Paik. Orth, "Adventures in Electronic-Textiles," 2011, unpublished manuscript provided to author.

77. Maggie Orth, telephone interview with author, November 28, 2011.

78. Ibid. It was constructed with Emily Cooper. Also see E. Rehmi Post and Margaret Orth, "Smart Fabric, or 'Wearable Clothing,'" *Proceedings of the First International Symposium on Wearable Computers* (1997), 167–168.

79. An outgrowth of the Hyperinstrument Group, which Machover began at the Media Lab in 1986.

80. Margaret Orth, telephone interview, November 28, 2011.

81. Orth, "Adventures in Electronic Textiles," 25.

82. Brochure for "Tech-U-Wear: The World of Wearable Computing," held October 30–31, 2001, organized by First Conferences Ltd., London, and sponsored by Nokia, Charmed Technology, Xybernaut, and others.

83. Ginger Greff Duggan, "The Greatest Show on Earth: A Look at Contemporary Fashion Shows and Their Relationship to Performance Art," *Fashion Theory* 4, no. 3 (2001): 243–270; also Carolyn Evans, *Fashion at the Edge: Spectacle, Modernity and Deathliness* (New Haven: Yale University Press, 2003), 67–85.

84. Entitled "Zenith," it was Mugler's autumn-winter 1984–1985 show; ibid., 69–71.

85. Duggan, "The Greatest Show on Earth," 244.

86. Evans, *Fashion at the Edge*, 74; Evans also cites Daniel Bell, "The Third Technological Revolution and Its Possible Socio-Economic Consequences," University of Salford, Faculty of Social Sciences Annual Lecture, 1988.

87. "Computer Couture," *Vogue*, February 1998, 126–130; "Haute-Tech Couture," *New York Times*, October 26, 1997. The *60 Minutes* spot was broadcast in October or November 1997.

88. "Xybernaut(R) Wearable PC Debuts at Fashion Week," *PR Newswire*, March 25, 1999, http://www.thefreelibrary.com/Xybernaut(R)+Wearable+PC+Debuts+at+Fashion+Week.-a054201948, accessed November 11, 2011. See also Tara Kieffner, "Wearable Computers: A General Overview" (1999), http://misnt.indstate.edu/harper/Wearable_Computers.html, accessed November 11, 2011.

89. Alex Lightman with William Rojas, *Brave New Unwired World: The Digital Big Bang and the Infinite Internet* (New York: John Wiley and Sons, 2002), 62–63.

90. Greg Priest Dorman, "Charmit Developer's Kit from 2000," http://www.cs.vassar.edu/~priestdo/charmit/, accessed December 4, 2011. See also "Wearable Technology Fashion Shows" (1999–2001), *Jarrell Pair* blog, http://www.jarrellpair.com/wearable-technology-fashion-shows/, accessed May 7, 2013.

91. John Gartner, "The Spy Who Geeked Me," *Wired*, October 2000.

92. As in Bradley Quinn, *Techno Fashion* (New York: Berg, 2002), 71–75.

93. Isa Gordon, SIGGRAPH Cyberfashion Show script, unpublished manuscript, 2002. Interestingly, according to Gordon, Steve Mann was to be a featured guest of the show but pulled out at the last minute.

94. Isa Gordon, *Psymbiote* website, http://www.psymbiote.org, accessed December 2, 2011.

95. Isa Gordon and W. Thomas Wall, "SIGGRAPH 2005 CyberFashion Show Report" (2005), unpublished manuscript, 65–70.

96. For example, the exhibitions "Safe: Design Takes on Risks" at the Museum of Modern Art in New York (curator, Paola Antonelli) and "Pattern Language: Clothing as Communicator" at Tufts University (curator, Judith Hoos Fox) both had wearable technology components, as did "Sartorial Flux," at Columbia College Chicago (curator, Valérie Lamontagne) the following year.

97. Knouf and Liu produced the "Seamless" shows in 2005 and 2006; the final "Seamless" in 2007 was produced by Liu, Lisa Monrose, and Amanda Parkes.

98. In Sarah H. Wright, "Students Showcase 'Seamless' Pairing of Fashion, Technology," *MIT News*, January 26, 2006, http://web.mit.edu/newsoffice/2006/seamless.html, accessed December 7, 2011.

99. See Susan Elizabeth Ryan, "Social Fabrics: Wearables + Media + Interconnectivity," *Leonardo* 42, no. 2 (2009): 114–116.

100. Scott Patterson, post to Empyre: Soft-Skinned-Space, August 29, 2005; see http://lists.cofa.unsw.edu.au/pipermail/empyre, accessed December 20, 2011.

101. Giorgio Agamben, "What Is the Contemporary," in *Nudities*, trans. David Kishik and Stefan Pedatella (Stanford: Stanford University Press, 2011).

3 The Invisible Interface

1. See for example Bradley Rhodes's "Brief History of Wearable Computing," c. 1999, written as a part of the Wearable Computing activity under Alex Pentland's Human Dynamics Group at the MIT Media Lab (http://www.media.mit.edu/wearables/lizzy/timeline.html). For wearables as tech talk, see Isabel Pederson, "Dehumanization, Rhetoric, and the Design of Wearable Augmented Reality Interfaces," in *Small Tech: The Culture of Digital Tools*, ed. Byron Hawk et al. (Minneapolis: University of Minnesota Press, 2008), 166.

2. The term written as WearComp is attributed to Steve Mann, who claims to have used it since the 1970s. See Steve Mann with Hal Niedzviecki, *Cyborg: Digital Destiny and Human Possibility in the Age of the Wearable Computer* (Toronto: Doubleday Canada, 2001), 3. The term (without capitalization) has gained wider use.

3. William Gibson, *Neuromancer: Remembering Tomorrow* (New York: Ace Books, 2000), 66–67.

4. For further discussion of this theme, see Susan Elizabeth Ryan, "Re-Visioning the Interface: Technological Fashion as Critical Media," *Leonardo: Journal of the Arts, Sciences and Technology* 42, no. 4 (2009): 300–306.

5. Alex Pentland and Créapole École de Création, "Collection 'Smart Wear,' Prototypes de vêtements et d'outils informatiques portables," 1997, DVD, collection of Alex Pentland.

6. Seymour taught a course called Fashionable Technology as early as 2002. Sabine Seymour, *Fashionable Technology: The Intersection of Design, Fashion, Science, and Technology* (Vienna: Springer, 2008), 12.

7. Woodrow Barfield et al., "Computational Clothing and Accessories," in *Fundamentals of Wearable Computers and Augmented Reality*, ed. Woodrow Barfield and Thomas Caudell (Mahwah, N.J.: Lawrence Erlbaum Associates, 2001), 472.

8. The term "art" here is used not to locate the work within a system of aesthetic valuation and merchandizing, but only to distinguish it from affective design and, I hope, to underscore its creative content—embracing at once conceptual, cultural, and material components.

9. Mark Weiser, "Building Invisible Interfaces," talk delivered at the Computer Science Lab, Xerox Park, November 2, 1994. But see also Weiser's legendary essay "The Computer in the Twenty-First Century," *Scientific American,* September 1991, 94–100.

10. Mark Weiser and John Seely Brown, "Designing Calm Technology," December 21, 1995, Xerox PARC, http://www.ubiq.com/hypertext/weiser/calmtech/calmtech.htm, accessed January 4, 2012.

11. Rosalind Picard, *Affective Computing* (Cambridge, Mass.: MIT Press, 1997), 3.

12. Rosalind Picard and Jennifer Healy, "Affective Wearables," *Personal Technologies* 1 (1997): 231–240.

13. Ibid., 233.

14. Picard, *Affective Computing*, 113.

15. Ibid., 117.

16. Ibid., 123–124.

17. Ibid., 228–229.

18. Thad Starner, Steve Mann, Bradley Rhodes, Jeffrey Levine, Jennifer Healey, Dana Kirsch, Roz Picard, and Alex Pentland, "Augmented Reality through Wearable Computing," *Presence* 6, no. 4 (Winter 1997).

19. Antonio Damasio, *Descartes' Error* (New York: Penguin, 1994), 87.

20. Antonio Damasio, *The Feeling of What Happens* (New York: Harcourt Brace, 1999), 54.

21. Ibid., 42.

22. Ibid., 43.

23. Ibid., 284.

24. Anna Munster, *Materializing New Media: Embodiment in Information Aesthetics* (Lebanon, N.H.: Dartmouth University Press, 2006), 142.

25. Riitta Ikonen, email message to the author, June 16, 2009.

26. Munster, *Materializing New Media*, 15.

27. Marcel Mauss, "Techniques of the Body," *Economy and Society* 2, no. 1 (1973): 70–89; Michel Foucault, *Discipline and Punish* (Harmondsworth: Penguin, 1977).

28. Joanne Entwistle, "The Dressed Body," in *Body Dressing*, ed. Joanne Entwistle and Elizabeth Wilson (Oxford: Berg, 2001), 55.

29. N. Katherine Hayles, *How We Became Posthuman: Virtual Bodies in Cybernetics, Literature, and Informatics* (Chicago: University of Chicago Press, 1999), 195, quoting from Elizabeth Grosz, *Volatile Bodies: Toward a Corporeal Feminism* (Bloomington: Indiana University Press, 1994). The exception of course is phenomenology.

30. Mark Hansen, *New Philosophy for New Media* (Cambridge, Mass.: MIT Press, 2004), 269.

31. Bernadette Wegenstein, *Getting under the Skin: The Body and Media Theory* (Cambridge, Mass.: MIT Press, 2006), 161.

32. Lev Manovich, "Visual Technologies as Cognitive Prostheses: A Short History of the Externalization of the Mind," in *The Prosthetic Impulse: From a Posthuman Present to a Biocultural Future*, ed. Marquard Smith and Joanne Morra (Cambridge, Mass.: MIT Press, 2006), 209–210.

33. Paul Virilio, *The Aesthetics of Disappearance*, trans. Philip Beitchman (Los Angeles: Semiotext(e), 2009), 62.

34. Ibid., 113–114.

35. Manuel De Landa, *War in the Age of Intelligent Machines* (New York: Zone Books, 1991), 175–177.

36. The social media data is different in kind, since it is not biological but rather tries to index our psychologies.

37. Giorgio Agamben, "Identity without the Person," in *Nudities*, trans. David Kishik and Stefan Pedatella (Stanford: Stanford University Press, 2011), 51–52.

38. Ibid., 54.

39. Exemplified by recent emphasis on implantation, body modification, and virtual skin metaphors; see *Re:Skin*, ed. Mary Flanagan and Austin Booth (Cambridge, Mass.: MIT Press, 2006).

40. Radu Stern, *Against Fashion: Clothing as Art, 1850–1930* (Cambridge, Mass.: MIT Press, 2004), 48–49.

41. Gibson, *Neuromancer*, 66–67. More recent invisibility fabrics for military usage have been on the drawing boards of a number of researchers, as in, for example, J. C. Soric et al., "Demonstration of an Ultralow Profile Cloak for Scattering Suppression of a Finite-Length Rod in Free Space," *New Journal of Physics* 15 (March 2013), online journal, http://iopscience.iop.org/1367-2630/15/3/033037/article, accessed January 11, 2012.

42. H. G. Wells, *The Invisible Man* (London: C. Arthur Pearson, 1897). Hans Christian Andersen, "The Emperor's New Clothes," in *Fairy Tales for Children* (Copenhagen: C. A. Reitzel, 1837). The Andersen story tells that the ruler is led to believe that the clothes are only invisible to corrupt or stupid individuals. The ruler cannot see the clothes himself, of course, as they are a hoax, but he hides his inability to see. Within our context, the story seems like a prescient critique of technologically empowering wearables.

43. Roy R. Behrens, "Art and Camouflage: An Annotated Bibliography," *Leonardo On-Line*, http://www.leonardo.info/isast/spec.projects/camouflagebib.html, accessed January 19, 2012.

44. Bradley Quinn, *Textile Futures: Fashion, Design, and Technology* (Oxford: Berg, 2010), 66–68.

45. Giorgio Agamben, "Nudity," in *Nudities*, 57.

46. Agamben mentions Saint Nilus, Theodoret of Cyrus, and Jerome as sources, and the Septuagint's *chitonai dermatinoi*, related to the Vulgate *tunicae pelliceae* and Italian *pelliccia*, fur coat, but a word that carries the sense of "unnecessary luxury" or "indulgence." Ibid., 62.

47. Quinn, *Textile Futures*, 67. The *Tarnkappe*—cloak of invisibility and superhuman strength—was also worn by Siegfried in the *Nibelungenlied* and is adapted (as *Tarnhelm*, a magic helmet) in Wagner's *Ring* cycle. Of course, the idea is perpetuated, for example, in Harry Potter's magic invisibility cloak in J. K. Rowling's *Harry Potter and the Deathly Hallows* (New York: Arthur A. Levine Books, 2009) and the subsequent two-part film adaptation (2010 and 2011, Warner Bros.).

48. Lone Koeford Hansen, "The Interface at the Skin," in *Interface Criticism: Aesthetics beyond Buttons*, ed. Christian Ulrik Andersen and Søren Bro Pold (Aarhus: Aarhus University Press, 2011), 70–71.

49. Ibid., 71. Hansen cites Pamela Thurschwell's *Literature, Technology, and Magical Thinking, 1880–1920* (Cambridge: Cambridge University Press, 2001) as a source for further information on late nineteenth-century investigation of invisible properties of the world.

50. Eric Kluitenberg, "The Network of Waves: Living and Acting in a Hybrid Space," *Open 11: Hybrid Space* (2006), 13.

51. The project should not be confused with the much later I Wear app for mobile phones by Jan Mazurczak.

52. "The i-Wear Project," website archived at http://web.archive.org/web/20010712203912/www.starlab.org/bits/intell_clothing/project.html, accessed December 12, 2011. This was a blue-sky initiative that went bankrupt suddenly, in 2001, just as i-Wear was being launched.

53. This was before wide use of phone-based GPS. Ana Viseu, "Simulation and Augmentation: Issues of Wearable Computers," *Ethics and Information Technology* 5 (2003): 20. See also Bradley Quinn, *Techno Fashion* (New York: Berg, 2002), 101–106.

54. Ana Viseu, "Augmented Bodies: The Visions and Realities of Wearable Computers" (PhD diss., University of Toronto, 2005), 141.

55. Ibid., 155, 159.

56. Bruno Latour, *Reassembling the Social: An Introduction to Actor-Network Theory* (Oxford: Oxford University Press, 2005).

57. Cited in Viseu, "Augmented Bodies," 110.

58. Ibid., 193.

59. Munster, *Materializing New Media*, 138.

60. Gilles Deleuze and Félix Guattari, *A Thousand Plateaus: Capitalism and Schizophrenia*, trans. Brian Massumi (Minneapolis: University of Minnesota Press, 1987), 181.

61. Viseu, "Augmented Bodies," 23.

62. Robert Lambourne, Khodi Feiz, and Bertrand Rigot, Philips Corporate Design, "Social Trends and Product Opportunities: Philips' Vision of the Future Project," 1997, CHI 97 Electronic Publications (ACM Special Interest Group on Human Computer Interaction), http://www.sigchi.org/chi97/proceedings/briefing/rl.htm#U4, accessed December 27, 2011.

63. Stefabi Marzano, "The Quest for Power, Comfort and Freedom: Exploring Wearable Electronics 1999," Philips News Center, posted November 11, 2008, http://www.newscenter.philips.com/main/design/about/design/speakers/speeches/questforpower.wpd. The author's first name is printed as Stefabi, but presumably in error, as the author is Stefano Marzano.

64. Marzano, "The Quest for Power."

65. Mikko Malmivaara, "The Emergence of Wearable Computing," in *Smart Clothes and Wearable Technology*, ed. Jane McCann and David Bryson (Oxford: Woodhead Publishing with the Textile Institute, 2009), 11.

66. *New Nomads: An Exploration of Wearable Electronics by Philips* (Rotterdam: 010 Publishers, 2000), 21.

67. Ibid., 16.

68. Ibid., 19.

69. Ibid., 55. Heart monitoring technology for athletes was first launched by Polar Electro in 1982 (Malmivaara, "The Emergence of Wearable Computing," 12).

70. See Andrew Bolton, *Bravehearts: Men in Skirts* (London: V&A Museum, 2003).

71. Clive van Heerden, email to author, January 31, 2012.

72. The original IDC jacket, made from water-repellant, metallic-coated nylon, came with a body-area network with remote control, earphones, a Philips GSM mobile phone, and a Philips Ruch Digital MP3 player. See Quinn, *Techno Fashion*, 99.

73. At the ISWC conference in 2003 MIT premiered MIThril, a body-worn computation, sensing, and networking system with its own software platform, integrated into a double-layer jacket or vest, accompanied by micro-optical display sunglasses. Though the name appears to be a conjunction of MIT and "thrill," it is actually named after a magical garment, the mithril coat, in J. R. R. Tolkien's *Lord of the Rings* trilogy (see http://www.media.mit.edu/wearables/mithril/). In opposition to Philips's positioning of *New Nomads* and Probes as spectacle, MIThril was oriented to an academic and tech-related context.

74. Malmivaara, "The Emergence of Wearable Computing," 13–14.

75. Invented by Josh Reynolds and Maris Ambats, versions of the ring, made of liquid crystal and quartz, first sold at Bonwit Teller in New York but rapidly became a nationwide (if short-lived) fad. See for example "Ring Buyers Warm Up to Quartz Jewelry That Is Said to Reflect Their Emotions," *Wall Street Journal*, October 14, 1975, 16.

76. Lisa Stead, Peter Goulev, Caroline Evans, and Ebrahim Mandani, "The Emotional Wardrobe," *Personal and Ubiquitous Computing* 8, no. 304 (July 2004): 284.

77. Robert Plutchik, *The Emotions: Facts, Theories, and a New Model* (New York: Random House, 1962).

78. "Biography: Clive van Heerden," http://www.design.philips.com/philips/shared/assets/design_assets/downloads/speakers/bio_2011/ClivevanHeerdenApr11.pdf, accessed January 2, 2012.

79. Regine Debatty, "Lucy McRae's Talk at NEXT," *We Make Money Not Art* (December 4, 2006), http://we-make-money-not-art.com/archives/2006/12/lucy-mcraes-tal.php, accessed June 12, 2010. On the media emphasis of Philips dress probes, see Hansen, "The Interface at the Skin," 83.

80. Hansen, "The Interface at the Skin," 81. The Philips quote is also cited here.

81. Munster, *Materializing New Media*, 122–123.

82. "Fractal 'Living Jewelry,' New Provocation of the Design Probe Team," press release, August 2008, accessed January 2, 2012.

83. Hans Driessen, "Phillips Emotions Jacket—A New Level in Immersive Cinematic Experience" (October 2009). See http://www.research.philips.com/technologies/projects/emotionsjacket/index.html, accessed January 31, 2012.

84. Gilles Lipovetsky, *The Empire of Fashion: Dressing Modern Democracy*, trans. Catherine Porter (Princeton: Princeton University Press, 1994), 126.

85. Ibid., 192.

86. Gilles Deleuze, "Postscript on Societies of Control," in *The Cybercities Reader*, ed. Stephen Graham (London: Routledge, 2004), 75.

87. Jenny Tillotson, "A Science Fashion Story," *TedxTalks*, February 15, 2004, Central Saint Martins, http://www.youtube.com/watch?v=OEQiuWrCRss, accessed February 12, 2012.

88. Ben Hughes and Jenny Tillotson, "Design as a Means of Exploring the Emotional Component of Scent" (paper presented at the 5th Conference on Design and Emotion, Gothenburg, Sweden, 2006), http://ualresearchonline.arts.ac.uk/1137/), accessed January 10, 2012.

89. "Smart Second Skin Dress: Description," Smart Second Skin Research by Jenny Tillotson, http://www.smartsecondskin.com/main/description.htm, accessed January 3, 2012.

90. "Smart Second Skin Dress," http://www.smartsecondskin.com/main/smartsecondskindress.htm, accessed January 3, 2012.

91. Paul Brokenshire, Azmina Karimi, and April Pierce, "Heart on the Sleeve: Visualizing Human Touch and Emotion through Wearable Technology" (2010), http://www.paul.brokenshire.ca/heartSleeve.php, accessed January 3, 2012.

92. Mark Weiser, "Some Computer Science Issues in Ubiquitous Computing," *Communications of the ACM* 36 (1993): 75–84, quoted in Rachel Zuanon and Geraldo Lima, "NeuroBodyGame: The Design of a Wearable Computer For Playing Games through Brain Signals" (paper presented at ISEA 2011, Istanbul, Turkey); see http://isea2011.sabanciuniv.edu/paper/neurobodygame-design-wearable-computer-playing-games-through-brain-signals, accessed January 31, 2012.

93. Zuanon and Lima, "NeuroBodyGame."

94. Picard, *Affective Computing*, 123.

95. Ibid., 124.

96. As discussed in Alexander R. Galloway and Eugene Thacker, *The Exploit: A Theory of Networks* (Minneapolis: University of Minnesota Press, 2007), 70.

97. Giorgio Agamben, *Homo Sacer: Sovereign Power and Bare Life*, trans. Daniel Heller-Roazen (Stanford: Stanford University Press, 1998).

98. *Intimacy* is really a series of projects created by Studio Roosegaarde at the V2_Lab (Institute for Unstable Media in Rotterdam) (Daan Roosegaarde, fashion designers Maartje Dijkstra and Anouk Wipprecht, with technicians Simon de Bakker, Stan Wannet, Piem Wirtz, and assistants Peter de Man and João Carneiro). Information on the construction of the dresses was obtained from Anouk Wipprecht in Skype interview with author, January 16, 2012.

99. "Intimacy White," V2, http://v2.nl/archive/works/intimacy-white, and Studio Roosegaarde, "Intimacy," http://www.studioroosegaarde.net/project/intimacy/info/, both accessed January 7, 2012.

100. Bruce Sterling, "Intimacy Lotus and Intimacy Black," *Beyond the Beyond* (March 31, 1910), *Wired*, http://www.wired.com/beyond_the_beyond/2010/03/intimacy-lotus-and-intimacy-black.

4 The Material Interface

1. See, for example, Jay David Bolter and Diane Gromala, *Windows and Mirrors: Interaction Design, Digital Art, and the Myth of Transparency* (Cambridge, Mass.: MIT Press, 2003).

2. Christian Ulrik Anderson and Søren Bro Pold, "Interface Criticism," in *Interface Criticism: Aesthetics beyond Buttons* (Aarhus: Aarhus University Press, 2011), 8.

3. Maria Chatzichristodoulou (aka Maria X) and Rachel Zerihan, introduction to *Interfaces of Performance* (Farnham, U.K.: Ashgate, 2009), 1.

4. Peter Weibel, foreword to *The Art and Science of Interface and Interaction Design*, vol. 1, ed. Christa Sommerer, Lakhmi C. Jain, and Laurent Mignonneau (Berlin: Springer-Verlag, 2008), v.

5. Lev Manovich, *The Language of New Media* (Cambridge, Mass.: MIT Press, 2001), 88–91.

6. Barbara Wegenstein, *Getting under the Skin: The Body and Media Theory* (Cambridge, Mass.: MIT Press, 2006), 97–99.

7. Sylvie Parent and Angus Leech, "Reflection: Sub-rosa," in *HorizonZero*, no. 16, *Wear: Smart Clothes, Wearable Technologies*, Banff New Media Institute (July/August 2004), n.p.

8. Kaja Silverman, "Fragments of a Fashionable Discourse," in *Studies in Entertainment: Critical Approaches to Mass Culture*, ed. Tania Modleski (Bloomington: Indiana University Press, 1986), 147.

9. David Bryson, "Designing Smart Clothing for the Body," in *Smart Clothes and Wearable Technology*, ed. Jane McCann and David Bryson (Oxford: Woodhead Publishing with the Textile Institute, 2009), 103.

10. Giorgio Agamben, "Nudities," in Agamben, *Nudities*, trans. David Kishik and Stefan Pedatella (Stanford: Stanford University Press, 2011), 57. John Carl Flügel, *The Psychology of Clothes* (London: Hogarth Press and the Institute of Psychoanalysis, 1930).

11. Alexander R. Galloway and Eugene Thacker, *The Exploit: A Theory of Networks* (Minneapolis: University of Minnesota Press, 2007), 123–124.

12. Bill Moggridge, *Designing Interactions* (Cambridge, Mass.: MIT Press, 2007), 14.

13. Brygg Ulmer, interview with author, August 9, 2011.

14. Anthony Dunne, "Hertzian Tales: An Investigation into the Critical and Aesthetic Potential of the Electronic Product as a Post-Optimal Object" (PhD diss., Department of Computer Related Design, Royal College of Art, 1997), 1. The dissertation was published in 1999 by the Royal College of Art, and a slightly different version was published in 2005 as *Hertzian Tales: Electronic Products, Aesthetic Experience, and Critical Design* (Cambridge, Mass.: MIT Press, 2005). The 2005 version has less emphasis on the idea of design as critical response.

15. Dunne, "Hertzian Tales," 2.

16. Anthony Dunne and Fiona Raby, *Design Noir: The Secret Life of Electronic Objects* (London: August Media; Basel: Birkhäuser, 2001), 46.

17. Ibid., 21.

18. Bill Verplank, "Interaction Design Paradigms," in Moggridge, *Designing Interactions*, 128–129.

19. Ryan Genz, email to author, February 18, 2012.

20. Anne Hollander, *Seeing through Clothes* (New York: Viking Press, 1975).

21. Alison Lurie, *The Language of Clothes* (1981; New York: Vintage, 1983), 3.

22. Ibid.

23. Elizabeth Wilson, *Adorned in Dreams: Fashion and Modernity* (New Brunswick: Rutgers University Press, 2003), 57.

24. Joanne Entwistle, *The Fashioned Body: Fashion, Dress, and Modern Social Theory* (Cambridge: Polity Press, 2000), 68.

25. Fred Davis, *Fashion, Culture, and Identity* (Chicago: University of Chicago Press, 1992), 5.

26. Umberto Eco, "Social Life as a Sign System" (1973), in *Fashion: Critical Concepts in Media and Cultural Studies*, ed. Malcolm Barnard (London: Routledge, 2012), vol. 2, 101–102.

27. Mikhail Bakhtin, *Rabelais and His World*, trans. Helene Iswolsky (Bloomington: Indiana University Press, 1984).

28. Mikhail Bakhtin, *Speech Genres and Other Late Essays*, trans. Vern W. McGee (Austin: University of Texas Press, 1986), 91.

29. The term "illocutionary force" is somewhat ambiguous in Austin and Searle but generally means the inherent impact or effect of an utterance. See John R. Searle, *Speech Acts: An Essay in the Philosophy of Language* (Cambridge: Cambridge University Press, 1969), 30.

30. "Indirect Speech Acts," in John R. Searle, *Expression and Meaning: Studies in the Theory of Speech Acts* (Cambridge: Cambridge University Press, 1979), 30–57.

31. J. L. Austin, *How to Do Things with Words* (Cambridge, Mass.: Harvard University Press, 1962), 76.

32. Terry Winograd, "A Language/Action Perspective on the Design of Cooperative Work," *Human-Computer Interaction* 3, no. 1 (1987–1988): 3–30.

33. Terry Winograd and Fernando Flores, *Understanding Computers and Cognition: A New Foundation for Design* (Norwood, N.J.: Ablex Publishing, 1987).

34. Lucy Suchman, *Human-Machine Reconfigurations: Plans and Situated Actions*, 2nd ed. (Cambridge: Cambridge University Press), 61–62.

35. Jan Ljungberg and Peter Holm, "Speech Acts on Trial," *Scandinavian Journal of Information Systems* 8, no. 1 (1996): 29–52.

36. Valentin Volosinov, *Marxism and the Philosophy of Language*, trans. Ladislav Matejka and I. R. Titunik (Cambridge, Mass.: Harvard University Press, 1986); quoted in Therese Grisham, "Linguistics as Indiscipline: Deleuze and Guattari's Pragmatics," *SubStance* 20, no. 3 (1991): 39.

37. Gilles Deleuze and Félix Guattari, "November 20, 1923: Postulates of Linguistics," in *A Thousand Plateaus: Capitalism and Schizophrenia*, trans. Brian Massumi (Minneapolis: University of Minnesota Press, 1987), 75–110.

38. Giorgio Agamben, *Infancy and History*, trans. Liz Heron (London: Verso, 1993), 5–6; first published in 1978 as *Infanzia e storia*.

39. Judith Butler, *Excitable Speech: A Politics of the Performative* (New York: Routledge, 1997), 3; citing Austin, *How to Do Things with Words*, 52.

40. Butler, *Excitable Speech*, 10; italics in original.

41. Ibid.; Butler cites Shoshana Felman, *The Literary Speech Act: Don Juan with J. L. Austin, or Seduction in Two Languages*, trans. Catherine Porter (Ithaca: Cornell University Press, 1983).

42. Laura Beloff also discusses conceptual clothing in "The Hybronaut and the Umwelt: Wearable Technology as Artistic Strategy" (PhD diss., University of Plymouth, 2012).

43. Blogs can be found at www.fashioningtech.com and http://www.talk2myshirt.com/blog/; *By-Wire: Design and Research in Fashion Technology* can be found at http://by-wire.net/. This is not an exhaustive list.

44. Elise Dee Co, "Computation and Technology as Expressive Elements of Fashion" (MS thesis, Media Arts and Science, MIT, 2000), 12.

45. Ibid., 35–40.

46. Although fashion theorists like Ted Polhemus, Malcolm Barnard, and Elizabeth Wilson argue that traditional dress has also always incorporated targeted messaging. Co, "Computation and Technology," 37.

47. Ibid., 12.

48. Antonio Damasio, *The Feeling of What Happens* (New York: Harcourt Brace, 1999), 303.

49. Co, "Computation and Technology," 77.

50. Ibid., 57. This piece was done before avatars became fleshed out in online animation programs, and three to four years before the virtual environment Second Life was launched.

51. Ibid., 52.

52. Puddlejumper at *Minty Monkey*, accessed January 17, 2012. *Minty Monkey*, one of Co's previous websites, is no longer online.

53. The Day for Night Solar Dress was partially completed during a residency at First Andros International (FAI), organized by Nice and Fit Gallery, Berlin.

54. Quoted in Bradley Quinn, "Hussein Chalayan, Fashion and Technology," *Fashion Theory* 6, no. 4 (December 2002): 361.

55. Emily King, "Rituals Renewed," in *Hussein Chalayan*, ed. Robert Violette (New York: Rizzoli, 2011), 11.

56. "The Tangent Flows" and Sarah Mower, "Looking Back on Hussein Chalayan," both in Violette, *Hussein Chalayan*, 29 and 36.

57. Carolyn Evans, "No Man's Land," in *Hussein Chalayan*, exh. cat. (Rotterdam: NAI Publishers and Groninger Museum, 2005), 15.

58. Gilles Deleuze, "What Is a *dispositif?*," in *Michel Foucault, Philosopher*, trans. Timothy J. Armstrong (New York: Routledge, 1992), 163–164.

59. Giorgio Agamben, "What Is an Apparatus?," in Agamben, *What Is an Apparatus? and Other Essays*, trans. David Kishik and Stefan Pedatella (Stanford: Stanford University Press, 2009), 6.

60. Ibid., 14.

61. Ibid., 20.

62. Joanna Berzowska, telephone conversation with author, January 31, 2012.

63. Skorpions, by Joanna Berzowska and Di Mainstone, XS Labs, Montreal (with Marguerite Bromley, Marcelo Coelho, David Gauthier, Francis Raymond, and Valérie Boxer). See http://www.xslabs.net/skorpions/. See also Joanna Berzowska, *XS Labs: Seven Years of Design Research and Experimentation in Electronic Textiles and Reactive Garments* (Montreal: XS Labs, 2010).

64. Leeches were created by Berzowska with Gaïa Orain and Marc Beaulieu. See Berzowska, *XS Labs*, 41.

65. Joanna Berzowska, telephone conversation with author, January 31, 2012.

66. Joanna Berzowska, "Sticky," http://www.captain-electric.net/site/sticky.php#6, accessed February 1, 2012.

67. Co, "Computation and Technology," 64.

68. Katherine Moriwaki and Jonah Brucker-Cohen, "Coincidence and Intersection: Networks and the Crowd," in *UbiComp in the Urban Frontier*, workshop proceedings, Nottingham, 2004, http://www.urban-atmospheres.net/Ubicomp2004/Papers/Urban%20Computing%20Workshop%20Proceedings.pdf#page=41.

69. "Magnetic Appeal: Katherine Moriwaki is Making Wearable Art that Actually Works, *Samsung DigitAll Magazine*, Fall 2004, http://www.samsung.com/Features/BrandMagazine/magazinedigitall/2004_fall/heroes_02.htm, accessed February 3, 2012.

70. Marsh Vdovin, "An Interview with Valérie Lamontagne," July 13, 2010, http://cycling74.com/2010/07/13/an-interview-with-valerie-lamontagne/, accessed February 10, 2012. The dresses were produced with Patrice Coulombe, David Beaulieu, and Lynn van Gastel.

71. Susan Elizabeth Ryan, "Social Fabrics: Wearables + Media + Interconnectivity," *Leonardo* 42, no. 2 (2009): 114–116 (text provided by Sarah Kettley and Frank Greig, Speckled Computing Consortium, Scotland).

72. Sarah Kettley, "Framing the Ambiguous Wearable" (2003), in "Crafting the Wearable Computer: Design Process and User Experience," vol. 2 (PhD diss., Napier University, 2007).

73. M. Chalmers, I. MacColl, and M. Bell, "Seamful Design: Showing Seams in Wearable Computing," *Proceedings of IEE Eurowearable* (London: IEE, 2003): 11–17, referenced in Kettley, "Framing the Ambiguous," 1.

74. Laura Beloff, "Wearable Artifacts as Research Vehicles," *Technoetic Arts: A Journal of Speculative Research* 8, no. 1 (2010): 49.

75. Ibid.

76. Laura Beloff, "Wearable Worlds; Reality in a Pocket," paper presented at the 11th Consciousness Reframed Conference/Making Reality Real, Trondheim Electronic Arts Centre, Norway, November 4–6, 2010; Beloff cites Adriana de Souza e Silva, "From Cyber to Hybrid: Mobile Technologies as Interfaces of Hybrid Spaces," *Space and Culture* 9, no. 3 (August 2006): 261–278.

77. Andraž Petrovčič, "Reconfiguring Socialities: The Personal Networks of ICT Users and Social Cohesion," *tripleC* 6, no. 2 (2008): 163.

78. Sherry Turkle, *Alone Together: Why We Expect More from Technology and Less from Each Other* (New York: Basic Books, 2011), 160–161.

79. Ibid., 152–154.

80. For example, Minerva Terrades and Yann Bona, "Mobile Phone-Mediated Interaction: Technoaffectivity, Mobile Subject, and Urban Space," in *Mobile Media 2007: Proceedings of an International Conference on Social and Cultural Aspects of Mobile Phones, Convergent Media, and Wireless Technologies*, ed. Gerard Goggin and Larissa Hjorth (Sydney: University of Sydney Press, 2007), 151–160.

81. In 2000, IBM's Pervasive Computing Division showcased a prototype jewelry cell phone (matching silver earrings, necklace, watch, and ring) coordinated in a BAN. "Instead of hearing

your cell phone squeal when you get a call, a tiny light starts blinking on your ring. The phone number of the person calling is displayed on the watch. You answer the phone by pressing a button on your watch. Next, you hear the call through your earring, which has a tiny speaker embedded in it. You then speak to the necklace, which has a tiny microphone inside and acts as a mouthpiece." The jewelry phone was never marketed because the required tiny rechargeable batteries for the earrings did not exist at the time, and, as with most WT, the marketing concept was unclear. Tom Spring, "IBM Gets Fashionable with Wearable Cell Phone," *PC World*, November 3, 2000.

82. Isabel Pedersen, "'No Apple iPhone? You Must Be Canadian: Mobile Technologies, Participatory Culture and Rhetorical Transformation," *Canadian Journal of Communication* 33 (2008): 492.

83. Ibid., 502.

84. Steve Mann has used the term "Bearable Computing," in his 2012 encyclopedia entry on Wearable Computing, to include not only smart phones but implanted technology. See Mann, "Wearable Computing," in *The Encyclopedia of Human-Computer Interaction*, 2nd ed., ed. Mads Soegaard and Rikke Friis Dam (Aarhus, Denmark: Interaction Design Foundation, 2012), http://www.interaction-design.org/encyclopedia/wearable_computing.html, March 15, 2012.

85. Francesca Rosella and Ryan Genz, "CuteCircuit: Wearable Technology," digital presentation, 2008. The Hug Shirt was named one of the "Best Inventions of 2006" by *Time* magazine (November 20, 2006).

86. The original women's Taiknam Hat was developed by O'Nascimento with Ebru Kurbak and Fabiana Shizue. The artists' statement can be found on their website, http://www.popkalab.com/th.html.

87. Ricardo O'Nascimento, telephone interview with author, February 9, 2012.

88. Ricardo O'Nascimento, "Rambler," 2010: see http://www.popkalab.com/ramblershoes.html, February 9, 2012.

89. Carolyn Evans, *Fashion at the Edge: Spectacle, Modernity, and Deathliness* (New Haven: Yale University Press, 2003), 114.

90. Ibid., 47 and 50, quoting from Derrida, *Specters of Marx: The State of Debt, the World of Mourning, and the New International*, trans. Peggy Kamuf (New York: Routledge, 1994), 11.

91. Walter Benjamin, "Theses on the Philosophy of History," in *Illuminations*, trans. Harry Zohn (London: Fontana/Collins, 1973), 259–260; quoted in Evans, *Fashion at the Edge*, 62.

92. Douglas Kellner, *Media Spectacle* (London: Routledge, 2003), 7–8.

93. Evans, *Fashion at the Edge*, 74.

94. Syuzi Pakhchyan, "Interview with Vin Burnham: Designer of Lady Gaga's 'Living Dress,'" *FashioningTech*, April 21, 2010, http://www.fashioningtech.com/profiles/blogs/interview-with-vin-burnham, February 12, 2012.

95. Francesca Rosella, interview with author, October 3, 2010.

96. Pamela Church Gibson, *Fashion and Celebrity Culture* (New York: Berg, 2012). Gibson refers to the "uncoupling of celebrity from talent" (from Diane Negra and Su Holmes, "Going Cheap? Female Celebrity in the Reality, Tabloid, and Scandal Genres," *Genders* 48 [2008]).

97. Guy Debord, *Society of the Spectacle*, trans. Donald Nicholson Smith (New York: Zone Books, 1995), 22.

98. Henry Jenkins, *Convergence Culture: Where Old and New Media Collide* (New York: NYU Press, 2006).

99. Claire Bishop, *Artificial Hells: Participatory Art and the Politics of Spectatorship* (London: Verso, 2012), 190; and Boris Groys, "Comrades of Time," *e-flux journal*, December 11, 2009, http://www.e-flux.com/journal/comrades-of-time/, March 11, 2012.

100. Vilém Flusser, *Toward a Philosophy of Photography* (London: Reaktion Books, 2000). In a performance in 2009, Bono asked the audience to hold up their phones, to expand the lighting of the spectacle onstage.

101. Anna Munster, *Materializing New Media: Embodiment in Information Aesthetics* (Hanover: Dartmouth College Press, 2006), 180.

102. Syuzi Pakhchyan, "Twitter Dress at Grammys," *FashioningTech*, February 1, 2010, http://www.fashioningtech.com/profiles/blogs/twitter-dress-at-grammys, March 1, 2012.

103. Debord, *The Society of the Spectacle*, 24; Giorgio Agamben, "Shekinah," in Agamben, *The Coming Community*, trans. Michael Hardt (Minneapolis: University of Minnesota Press, 1993), 79.

104. Agamben, "Shekinah," 82.

105. Ying Gao showed with robotics designer Simon Laroche, assistant Isabelle Campeau, and videographer Marcio Lana Lopez.

106. Ying Gao, telephone interview with author, February 2, 2012.

107. Collaborating as Modern Nomads (MoNo). See http://v2.nl/archive/works/daredroid.

108. The coats were created with Alma Weiser. Tesia Kosmalski, "Echo Coats Series," University of Illinois College of Art and Design Grad Gallery, 2011, http://adweb.aa.uic.edu/web/gallery/project_view.php?pid=735.

109. Genevieve Bell and Paul Dourish, "Yesterday's Tomorrows: Notes on Ubiquitous Computing's Dominant Vision," *Personal Ubiquitous Computing* 11, no. 2 (2007): 133.

110. Byron Hawk and David M. Rieder, "On Small Tech and Complex Ecologies," in *Small Tech: The Culture of Digital Tools* (Minneapolis: University of Minnesota Press, 2008), ix.

111. Sponsored by the UK joint research council's "New Dynamics of Aging" program, "Design for Aging Well." See *Newsletter for New Markets in Wearable Technology*, no. 3 (Winter/Spring 2011); also Jane McCann, "Smart Clothes for Ageing Population," in McCann and Bryson, *Smart Clothes and Wearable Technology*, 346–370.

5 The Critical Interface

1. Rita Raley, *Tactical Media* (Minneapolis: University of Minnesota Press, 2009), 30.

2. Paolo Virno, *A Grammar of the Multitude*, trans. Isabella Bertoletti, James Cascaito, and Andrea Casson (Los Angeles, Semiotext(e), 2004), 90.

3. Oskar Negt and Alexander Kluge, *Public Sphere and Experience: Toward an Analysis of the Bourgeois and the Proletarian Public Sphere*, trans. Peter Labanyi, Jamie Owen Daniel, and Assenka Oksiloff (Minneapolis: University of Minnesota Press, 1993), 34.

4. Carl DiSalvo, *Adversarial Design* (Cambridge, Mass.: MIT Press, 2012), 5, 9, 121.

5. For example, Harmony Hammond's *Presence* series of dresses inspired by Native American craftswomen, 1972; also see Elissa Auther, *String, Felt, Thread: The Hierarchy of Art and Craft in American Art* (Minneapolis: University of Minnesota Press, 2010), 136.

6. Otto von Busch, "Fashion-able: Hacktivism and Engaged Fashion Design" (PhD diss., University of Gothenburg, 2008), 36.

7. See "Hacking Couture," *UnRavel*, pamphlet for the SIGGRAPH 2007 Fashion Event (San Diego: SIGGRAPH, 2007); also "Hacking-Couture" at http://hacking-couture.com/.

8. Michel de Certeau, *The Practice of Everyday Life*, trans. Steven Rendall (Berkeley: University of California Press, 1984), xiii–xiv. Certeau draws his characteristics of the speech act from Émile Benveniste, *Problèmes de linguistique générale*, vol. 1 (Paris: Gallimard, 1966), 251–266.

9. Certeau, "Walking in the City," in *The Practice of Everyday Life*, 100; he is quoting from A. J. Greimas, "Linguistique statistique et linguistique structurale," *Le Français moderne* (October 1962): 245; and referencing E. S. Klima, "The Linguistic Symbol with and without Sound," in *The Role of Speech in Language*, ed. James F. Kavanagh and James E. Cutting (Cambridge, Mass.: MIT Press, 1975), and an unpublished paper by Klima and U. Bellugi, "Poetry and Song in a Language without Sound"; see Certeau, *The Practice of Everyday Life*, 219n21.

10. Fashion shows, like art exhibitions, are considered public displays even though they are sometimes (or even often) exclusive in their admissions.

11. Ted Polhemus, *Street Style* (New York: Thames and Hudson, 1994); Dick Hebdige, *Subculture: The Meaning of Style* (London: Methuen, 1979); Dick Hebdige, *Hiding in the Light: On Images and Things* (London: Routledge, 1988).

12. Certeau, "'Making Do': Uses and Tactics," in *The Practice of Everyday Life*, 37.

13. Certeau, "Reading as Poaching," in *The Practice of Everyday Life*, 165.

14. Alexander R. Galloway and Eugene Thacker, *The Exploit* (Minneapolis: University of Minnesota Press, 2007), 73.

15. Temporary Services, *Temporary Conversations: Peggy Diggs* (Chicago: Temporary Services, 2010), 26.

16. Nicolas Bourriaud, "Interview," in *Lucy Orta*, ed. Roberto Pinto, Nicolas Bourriaud, and Maia Damianovic (London: Phaidon Press, 2006), 8.

17. Gregory Sholette, "Las Agencias, Dark Matter, and the Aesthetics of Tactical Embarrassment," *Radical Art Caucus Newsletter*, no. 2 (February 2004): 3–5.

18. Jess Ramrez Cuevas, "Body as a Weapon for Civil Disobedience," *Archives of Global Protests* (2000); available at http://www.nadir.org/nadir/initiativ/agp/s26/praga/bianche.htm, accessed March 26, 2012.

19. IMF stands for International Monetary Fund.

20. Jeffrey S. Juris, *Networking Futures* (Durham: Duke University Press, 2008), 123–124.

21. Ibid., 145.

22. Sholette, "Las Agencias," 3.

23. Outlast Technologies, Inc., founded in Boulder, Colorado, in 1990, specializes in researching and producing phase-change materials, called Thermocules, embedded in fibers, which absorb, store, and release excess heat.

24. Ralph Borland, "Suited for Subversion" (MA thesis, New York University, 2002).

25. "Egyptian Protester's Helmets," *Sad and Useless*, February 4, 2011; available at http://www.sadanduseless.com/2011/02/egyptian-helmets/, accessed March 28, 2012.

26. "What to Wear to a Protest," *New York Times*, October 6, 2011; "Man of the Week: Occupy Wall Street Protester A-," *Women's Wear Daily*, October 20, 2011. Before the film, directed by James McTeigue, was made, *V for Vendetta* was a British comic book series by Alan Moore and David Lloyd, featuring an anarchist revolutionary in a futuristic dystopia, wearing a Guy Fawkes mask. The stylized mask became the signature for members of the hacker group Anonymous, but it was not limited to that group.

27. Mikhail Bakhtin, *Rabelais and His World*, trans. Helene Isowolsky (Cambridge, Mass.: MIT Press, 1968), 317.

28. Hank Hardy Unruh, "Globalization of Textile Trade," presentation, Tampere, Finland, 2001; http://theyesmen.org/finland/photos.html, accessed March 20, 2013.

29. Bakhtin, *Rabelais and His World*, 370.

30. Gilles Deleuze and Félix Guattari, *A Thousand Plateaus: Capitalism and Schizophrenia*, trans. Brian Massumi (Minneapolis: University of Minnesota Press, 1987), 493.

31. Karl Marx, "Economic and Philosophic Manuscripts of 1844," in Karl Marx and Frederick Engels, *Economic and Philosophical Manuscripts of 1844 and the Communist Manifesto*, trans. Martin Milligan (New York: Prometheus Books, 1988), 100. On Benjamin, see Beatrice Hanssen, *Walter Benjamin and the Arcades Project* (London: Continuum, 2006), 97–99.

32. Rosalind Picard, *Affective Computing* (Cambridge, Mass.: MIT Press, 1997), 15.

33. Steve Mann with Hal Niedzviecki, *Cyborg: Digital Destiny and Human Possibility in the Age of the Wearable Computer* (Toronto: Doubleday Canada, 2001), 104.

34. Mann says the connection to situationism was suggested to him by Krzysztof Wodiczko, former director of the Center for Advanced Visual Studies at MIT. See Steve Mann, "'Reflectionism' and 'Diffusionism': New Tactics for Deconstructing the Video Surveillance Superhighway," *Leonardo* 3, no. 2 (1998): 93–102.

35. Mann, *Cyborg*, 51. Critical Art Ensemble, *The Flesh Machine*: *Cyborgs, Designer Babies, and New Eugenic Consciousness* (Brooklyn: Autonomedia, 1998); available at http://www.critical-art.net/books/flesh/.

36. For specific references, see Mann, *Cyborg*, 270.

37. Ibid., 105–110. See also Steve Mann, "Existential Technology: Wearable Computing Is Not the Real Issue!," *Leonardo* 36, no. 1 (2003): 19–25; and Mann, "'Reflectionism' and 'Diffusionism'."

38. Steve Mann, "Sousveillance: Inventing and Using Wearable Computing Devices for Data Collection in Surveillance Environments," with Jason Nolan and Barry Wellman, *Surveillance and Society* 1, no. 3 (2003): 332.

39. Ibid., 333.

40. Sarah Kettley, "Visualising Social Space with Networked Jewellery," in "Crafting the Wearable Computer: Design Process and User Experience" (PhD diss., Napier University, Edinburgh, 2007), n.p.

41. Ulrich Lehmann, *Tigersprung: Fashion in Modernity* (Cambridge, Mass.: MIT Press, 2000), 179.

42. Kettley, "Visualising Social Space," n.p.

43. Sarah Kettley, "Crafts Praxis as a Design Resource," paper presented at the Engineering and Product Design Education Conference, Edinburgh, UK, September 15–16, 2005; printed in Kettley, "Crafting the Wearable Computer," n.p.

44. See, for example, the popular "Maker Faires" held annually in Silicon Valley, New York, and elsewhere around the world; "More Than Just Digital Quilting," *Economist Technology Quarterly* (December 3, 2011), available online at http://www.economist.com/node/21540392/, accessed March 13, 2012. One of the movement's proselytizers is science fiction author Cory Doctorow with his novel *Makers* (2009).

45. Dennis Stevens, "Validity Is in the Eye of the Beholder: Mapping Craft Communities of Practice," in *Extra/Ordinary: Craft and Contemporary Art*, ed. Maria Elena Buszek (Durham: Duke University Press, 2011), 52.

46. Jack Bratich, "The Digital Touch: Craft-Work as Immaterial Labour and Ontological Accumulation," *Ephemera: Theory and Politics in Organization* 10, no. 3/4 (2010): 303.

47. Ibid., 309.

48. Casey Reas, quoted in Daniel Shiffman, "Interview with Casey Reas and Ben Fry," *Rhizome*, September 23, 2009, http://rhizome.org/editorial/2009/sep/23/interview-with-casey-reas-and-ben-fry/, accessed March 13, 2012.

49. Leah Buechley, "A Construction Kit for Electronic Textiles," *Proceedings of the 10th IEEE International Symposium on Wearable Computers* (2006), 83. See also *Dispatches from the World of E-Textiles and Education*, ed. Leah Buechley (New York: Peter Lang, 2013).

50. Leah Buechley and Benjamin Mako Hill, "LilyPad in the Wild: How Hardware's Long Tail Is Supporting New Engineering and Design Communities," proceedings of the Designing Interactive Systems (DIS) conference, Aarhus, Denmark, August 16–20, 2010, 201. The second version of the LilyPad was sold by SparkFun electronics, another "long tail" retailer for electronics hardware.

51. "High-Low Tech," MIT Media Lab website, http://hlt.media.mit.edu/, accessed March 18, 2012.

52. Chris Anderson, "The Long Tail," *Wired* 12.10 (October 2004); see also Chris Anderson, *The Long Tail: Why the Future of Business Is Selling Less of More* (New York: Hyperion, 2006).

53. Buechley and Hill, "LilyPad in the Wild," 203.

54. Instructables was sold to Autodesk, Inc., in 2011.

55. Erich Zainziger quoted in Deborah Hustic, "Interview with Erich Zainziger a.k.a. talk2myShirt, Part 1: Hooked Up to Wearable Electronics," *Body Pixel* (March 29, 2011), http://www.body-pixel.com/2011/03/29/interview-with-erich-zainziger-a-k-a-talk2myshirt-part-1-hooked-up-to-wearable-electronics/, accessed March 20, 2012.

56. Buechley and Hill, "LilyPad in the Wild," 200.

57. Leah Buechley and Michael Eisenberg, "The LilyPad Arduino: Toward Wearable Engineering for Everyone," *IEEE Pervasive Computing* 2, no. 2 (April-June 2008): 15.

58. Buechley and Hill, "LilyPad in the Wild," 206.

59. See Leah Buechley, "Crafting Technology: Reimagining the Processes, Materials, and Cultures of Electronics," *ACM Transactions on Computer-Human Interaction* 19, no. 3, article 21 (October 2012). On criticism of Mechanical Turk, see Xtine Burrough, "Mechanical Olympics," in *Net Works: Case Studies in Web Art and Design*, ed. Burrough (New York: Routledge, 2012): 55–64.

60. Maurizio Lazzarato, "Immaterial Labor," in *Radical Thought in Italy: A Potential Politics*, ed. Paolo Virno and Michael Hardt (Minneapolis: University of Minnesota Press, 1996), 132.

61. Michael Hardt, "Affective Labor," *Boundary* 2, 26, no. 2 (1999): 89–100.

62. Bratich, "The Digital Touch," 303–318.

63. Ibid., 309. See also, for example, MicroRevolt's mission statement at http://microrevolt.org/mission.htm. 1990s sweatshop scandals include the National Labor Committee's 1996 human rights report that TV host Kathie Lee Gifford's clothing line was produced in a Honduras sweatshop; other similar reports followed.

64. Bratich, "The Digital Touch," 315. See also Sara Mosle, "Etsy.com Peddles False Feminist Fantasy," *DoubleX* blog, posted June 10, 2009, now found at http://web.archive.org/web/2012 0424145141/http://www.doublex.com/section/work/etsycom-peddles-false-feminist-fantasy, accessed September, 28, 2013. The original article became the subject of extensive anti-Etsy discussion on the Internet.

65. Bratich, "The Digital Touch," 315.

66. Stevens, "Validity Is in the Eye of the Beholder," 45.

67. Ibid., 42.

68. Galloway and Thacker, *The Exploit*, 126.

69. Ibid., 143.

70. See, for example, Norene Leddy and Ed Bringas, "Shoe Shine: Make Cinderella Jealous," *Make* 12 (2007): 148–151.

71. *How to Get What You Want*, at http://www.kobakant.at/DIY/?page_id=318, accessed January 12, 2013. Satomi is a researcher at the Smart Textile Design Lab at Textilehögskolan in Borås, Sweden, and Perner-Wilson is a former student of Leah Buechley at MIT.

72. Valérie Lamontagne, "Open Design Practices + Wearables + 3lectromode," paper delivered at ISEA 2011, Istanbul.

73. Neil Gershenfeld, *Fab: The Coming Revolution on Your Desktop—From Personal Computers to Personal Fabrication* (New York: Basic Books, 2005); Bas van Abel et al., *Open Design Now: Why Design Cannot Remain Exclusive* (Premsela, Netherlands: BIS Publishers with Netherlands Institute for Design and Fashion, and the Waag Society under a Creative Commons License, 2011).

74. Projects described in Gershenfeld, *Fab*, 19–22. Of course, not all the Fab Lab student projects were wearables, but many were, suggesting a broad-based interest in technological dress.

75. Gershenfeld, *Fab*, 16. On the popularity of sewing machines in the 2000s see, for example, Rosa Silverman, "Sewing Machines Make a Comeback," *Independent* (April 21, 2008).

76. Diana Eng, interview with the author, April 2, 2012.

77. Ibid.

78. Danielle Wilde, "A New Performativity: Wearables and Body-Devices," paper delivered at Re:Live: Third International Conference on the Histories of Media Art, Melbourne, Australia, November 26–29, 2009.

79. See chapter 4. Giorgio Agamben, *Infancy and History*, trans. Liz Heron (London: Verso, 1993), 5–6.

80. Mary Flanagan, *Critical Play: Radical Game Design* (Cambridge, Mass.: MIT Press, 2009), 253. Flanagan references Homi K. Bhabha, *The Location of Culture* (London: Routledge, 1994).

81. Agamben, *Infancy and History*, 72.

6 Augmented Dress

1. Genevieve Bell and Paul Dourish, "Yesterday's Tomorrows: Notes on Ubiquitous Computing's Dominant Vision," *Personal Ubiquitous Computing* 11 (January 2007): 134.

2. Paul Dourish, *Divining a Digital Future: Mess and Myth in Ubiquitous Computing* (Cambridge, Mass.: MIT Press, 2011), 4.

3. Gilles Lipovetsky, *The Empire of Fashion: Dressing Modern Democracy*, trans. Catherine Porter (Princeton: Princeton University Press, 1994), 244 and 251.

4. "Is Wearable Tech Just Bad Fashion?," *V2_*, Institute for Unstable Media blog entry, March 2012, http:/v2.nl/lab/blog/is-wearable-tech-just-bad-fashion, accessed March 30, 2012.

5. Elizabeth Wilson, "Ethics and the Future of Fashion," in *The Fashion History Reader: Global Perspectives*, ed. Giorgio Riello and Peter McNeil (London: Routledge, 2010), 532.

6. Ana Viseu, "Wearcomps and the Informed Informational Body," in *Evolution Haute Couture: Art and Science in the Post-Biological Age*, 2 vols., ed. Dmitry Bulatov (Kaliningrad: National Center for Contemporary Arts, 2014), 2:133.

7. Lev Manovich, "Interaction as a Designed Experience," in *Throughout: Art and Culture Emerging with Ubiquitous Computing*, ed. Ulrik Ekman (Cambridge, Mass.: MIT Press, 2012), 313–314.

8. Manuel Castells, Jack Linchuan Qui, Mireia Fernández-Ardèvol, and Araba Sey, *Mobile Communication and Society: A Global Perspective* (Cambridge, Mass.: MIT Press, 2007), 160.

9. Margaret Orth, interview with author, November 28, 2011.

10. Castells et al., *Mobile Communication and Society*, 161–162. Castells draws upon a number of Japanese studies, for example by Mizuko Ito and Daisuke Okabe, "Mobile Phones, Japanese Youth, and the Re-Placement of Social Contact," paper presented at the conference Front Stage-Back Stage: Mobile Communication and the Renegotiation of the Public Sphere, Grimstad, Norway, June 22–24, 2003.

11. See http://www.yankodesign.com/2008/10/21/this-ipod-is-full-of-air/, accessed March 21, 2012.

12. Related in some ways to the gay subculture's use of colored bandanas or handkerchiefs in the 1970s. Jelly bracelets were supposedly popularized by Madonna and Cyndi Lauper in the 1980s. See also "Sex Bracelets," November 2003, archived at http://www.snopes.com/risque/school/bracelet.asp, accessed March 21, 2012.

13. Paui-Wing Tam, "Pebble Technology Becomes Kickstarter Test Case," *Wall Street Journal Technology Online*, July 2, 2012. The JOBS (Jumpstart Our Business Startups) Act improved financial requirements for new small businesses, including allowing Internet funding portals.

14. The protype frames are glassless, but the project is intended to also produce prescription or sunglass versions or adapt to a wearer's own spectacles.

15. See Steven Levy's interview with Google Glass project leader Babak Parviz and Google Project Manager Steve Lee: Levy, "Google Glass Team: 'Wearable Technology Will Be the Norm,'" *Wired*, Digital Access, June 29, 2012.

16. Ben Lang, "St1080 and ST1080 DDK Head Mounted Display Pricing Announced," *Road to Virtual Reality*, December 7, 2011, http://www.roadtovr.wordpress.com/2011/12/07/st1080-and-st1080-ddk-head-mounted-display-pricing-announced, accessed April 11, 2012.

17. Jon Stewart on the *Daily Show*, April 11, 2012.

18. Nancy Troy, "Poiret's Modernism and the Logic of Fashion," in Riello and McNeil, *The Fashion History Reader*, 458.

19. Thad Starner, telephone interview with author, August 7, 2012.

20. Diane von Fürstenberg, "DVF [through Glass]," September 13, 2012, YouTube, http://www.youtube.com/watch?v=30Pjl31cyDY, accessed April 30, 2012.

21. "The Final Frontier," *Vogue*, September 2013, 779–789.

22. The term "dumb matter" is drawn from Brian Massumi's discussion of embodiment in *Parables for the Virtual: Movement, Affect, Sensation* (Durham: Duke University Press, 2002).

23. Nick Bilton, "Disruptions: Wearing Your Computer on Your Sleeve," *New York Times*, Technology, December 8, 2011.

24. Starner, telephone interview with author, August 7, 2012.

25. Mark Weiser and John Seely Brown, "Designing Calm Technology," December 21, 1995, Xerox PARC, published in *PowerGrid Journal* 101 (July 1996).

26. Giorgio Agamben, "The Lost Dress of Paradise: A Theology of Nakedness," trans. Christian Nilsson, European Graduate School faculty site, http://www.egs.edu/faculty/giorgio-agamben/articles/the-lost-dress-of-paradise/, accessed April 30, 2012.

27. Joshua Topolsky, "I Used Google Glass," *YouTube*, http://www.youtube.com/watch?v=V6Tsrg_EQMw, accessed April 30, 2012.

28. For example, Edward Craig Hyatt, for Apple, Inc., "Display Resolution Increase with Mechanical Actuation," U.S. Patent 20120188245 A1, filed January 20, 2011, and issued July 26, 2012.

29. Andy Clark, "Embodiment, Sensing, and Mind," *Journal of Medicine and Philosophy* 32 (2007): 278. On balance, Clark takes an optimistic view of the risks.

30. Ibid.

31. Andrew Keen, "Why Life through Google Glass Should Be for Our Eyes Only," *CNN Tech*, http://www.cnn.com/2013/02/25/tech/innovation/google-glass-privacy-andrew-keen/index.html, accessed February 26, 2013.

32. Paolo Virno, *A Grammar of the Multitude*, trans. Isabella Bertoletti, James Cascaito, and Andrea Casson (Los Angeles: Semiotext(e), 2004), 7 and 56.

33. Liang-Yu Chi, Robert Allen Ryskamp, Louis Ricardo Prada Gomez, Harvey He, and Sergey Brin, "Seeing with Your Hand," U.S. Patent 8,009,141 B1, filed March 14, 2011, and issued August 30, 2011. The notion of virtual keypads projected onto the body was already proposed by MIT's Patty Maes and Pranav Mistry in 2009; see their "SixthSense: A Wearable Gestural Interface," *SIGGRAPH Asia 2009 Sketches* (December 2009).

34. See, for example, Paul Milgram et al., "Augmented Reality: A Class of Displays on the Reality-Virtuality Continuum," *Telemanipulator and Telepresence Technologies, Proceedings of SPIE* 2351 (1994): 282–292.

35. Cedric Flazinski, email message to author, January 5, 2013.

36. Normals, "Apparel VO.9A," online at http://www.normalfutu.re/, accessed January 15, 2013.

37. See, for example, Doug Gross, "Macy's 'Magic Mirror' Lets Shoppers Don Virtual Clothes," *CNN International*, October 14, 2010, http://edition.cnn.com/2010/TECH/innovation/10/14/macys.virtual.mirror/index.html, accessed March 3, 2013.

38. Aurélien Michon and Cedric Flazinski, "On the Separation between the Esthetic and the Functional and How the Digital Realm Will Steal Form," *Normals* 1 (2013), published in Paris by the authors, n.p.

39. Mark Weiser, "The Computer for the 21st Century," *Scientific American* (September 1991): 94.

40. Joel Johnson, "'The Master Key': Frank Baum Envisions Augmented Reality Glasses in 1901," *Mote and Beam*, blog entry, September 10, 2012.

41. Simon Penny, "Trying to Be Calm: Ubiquity, Cognitivism, and Embodiment," in Ekman, *Throughout*, 263.

42. Ibid., 266–267.

43. Ibid., 272–273. See, for example, Johnson and Lakoff, *Philosophy in the Flesh* (New York: Basic Books, 1999). The position is similar to that of Maurice Merleau-Ponty in several publications.

44. N. Katherine Hayles, "Radio-Frequency Identification: Human Agency and Meaning in Information-Intensive Environments," in Ekman, *Throughout*, 523.

45. Penny, "Trying to Be Calm," 271.

46. "CuteCircuit Twitter Dress," last modified December 19, 2012, http://cutecircuit.com/cutecircuit-twitter-dress/.

47. Manovich, "Interaction as a Designed Experience," 316–319.

48. Michon and Flazinski, "On the Separation between the Esthetic and the Functional."

49. Operated by a custom, battery-powered microcontroller on the back of the garment, calculating and sampling the wearer's proximal space and sending data to a smoke generator between the shoulders.

50. Lev Manovich, "The Poetics of Augmented Space," *Visual Communication* 5 (2006): 236.

51. Hayles, "Radio-Frequency Identification," 522.

52. Massumi, *Parables for the Virtual*, 6.

53. Ibid., 14.

Bibliography

Adilkno. "The Laughing Body: Wetware." In *The Media Archive*, trans. Laura Martz and Sakhara-l'Assal. Amsterdam: Autonomedia, 1998. Available online at http://thing.desk.nl/bilwet/adilkno/TheMediaArchive/content.html.

Adorno, Theodor. *Aesthetic Theory*. Trans. C. Lenhardt. London: Routledge, 1984.

Agamben, Giorgio. *The Coming Community*. Trans. Michael Hardt. Minneapolis: University of Minnesota Press, 1993.

Agamben, Giorgio. *Homo Sacer: Sovereign Power and Bare Life*. Trans. Daniel Heller-Roazen. Stanford: Stanford University Press, 1998.

Agamben, Giorgio. "The Lost Dress of Paradise. A Theology of Nakedness: Vanessa Beecroft's Performance in Berlin." Trans. Christian Nilsson. The European Graduate School Faculty Page. Available online at http://www.egs.edu/faculty/giorgio-agamben/articles/the-lost-dress-of-paradise/.

Agamben, Giorgio. *Nudities*. Trans. David Kishik and Stefan Pedatella. Stanford: Stanford University Press, 2011.

Agamben, Giorgio. "What Is an Apparatus." In *What Is an Apparatus? and Other Essays*, trans. David Kishik and Stefan Pedatella, 1–24. Stanford: Stanford University Press, 2009.

Anderson, Christian Ulrik, and Søren Bro Pold. "Interface Criticism." In *Interface Criticism: Aesthetics beyond Buttons*, ed. Christian Ulrik Anderson and Søren Bro Pold, 7–18. Aarhus: Aarhus University Press, 2011.

Arndt, Rob. "Himmelstürmer Flightpack (1944–1945)." Available at http://discaircraft.greyfalcon.us/HIMMELSTURMER.htm.

Augé, Marc. *Non-Places: Introduction to an Anthropology of Supermodernity*. London: Verso, 1995.

Auslander, Philip. "Reactivation: Performance, Mediatization and the Present Moment." In *Interfaces of Performance*, ed. Maria Chatzichristodoulou, Janis Jefferies, and Rachel Zerihan, 81–94. Farnham, U.K.: Ashgate, 2009.

Austin, J. L. *How to Do Things with Words*. Cambridge, Mass.: Harvard University Press, 1962.

Auther, Elissa. *String, Felt, Thread: The Hierarchy of Art and Culture in American Art*. Minneapolis: University of Minnesota Press, 2010.

Badmington, Neil. *Alien Chic: Posthumanism and the Other Within*. New York: Routledge, 2004.

Bakhtin, Mikhail. *Rabelais and His World*. Trans. Helene Iswolsky. Bloomington: Indiana University Press, 1984.

Bakhtin, Mikhail. *Speech Genres and Other Late Essays*. Trans. Vern W. McGee. Austin: University of Texas Press, 1986.

Barfield, Woodrow, and Thomas Caudell, eds. *Fundamentals of Wearable Computers and Augmented Reality*. Mahwah, N.J.: Lawrence Erlbaum, 2001.

Barthes, Roland. "Plastics." In *Mythologies*, trans. Annette Lavers. New York: Farrar, Straus and Giroux, 1957.

Barthes, Roland. *Système de la mode*. Paris: Éditions du Seuil, 1967.

Bass, Thomas A. *Eudaemonic Pie*. Lincoln: iUniverse.com, 1985.

Baudrillard, Jean. *For a Critique of the Political Economy of the Sign*. St. Louis: Telos Press, 1981.

Becker, Allen. "High Resolution Virtual Displays." Paper presented at the Virtual Reality Society of Japan—International Conference on Artificial Reality and Telexistence, Tokyo, Japan, 1991. http://www.vrsj.org/ic-at/papers/92027.pdf.

Behrens, Roy R. "Art and Camouflage: An Annotated Bibliography." *Leonardo On-Line*. http://www.leonardo.info/isast/spec.projects/camouflagebib.html.

Bell, Daniel. *The Third Technological Revolution and Its Possible Socio-Economic Consequences*. Stanford, Calif.: Stanford University, Faculty of Social Sciences Annual Lecture, 1988.

Bell, Genevieve, and Paul Dourish. "Yesterday's Tomorrows: Notes on Ubiquitous Computing's Dominant Vision." *Personal and Ubiquitous Computing* 11 (2) (2007): 133–143.

Beloff, Laura. "The Body in Posse: Viewpoints on Wearable Technology." In *Evolution Haute Couture: Art and Science in the Post-Biological Age*, 2 vols., ed. Dmitry Bulatov, 2:154–169. Kaliningrad: National Center for Contemporary Arts, 2013.

Beloff, Laura. "Wearable Artefacts as Research Vehicles." *Technoetic Arts: A Journal of Speculative Research* 8 (1) (2010): 47–53.

Beloff, Laura. "Wearable Worlds; Reality in a Pocket." Paper presented at the 11th Consciousness Reframed Conference/Making Reality Real, Trondheim Electronic Arts Centre, Norway, November 4–6, 2010.

Benjamin, Walter. *The Arcades Project*. Trans. Howard Eiland and Kevin McLaughlin. Cambridge, Mass.: Harvard University Press, 1999.

Benjamin, Walter. "The Work of Art in the Age of Mechanical Reproduction." In *Illuminations*, trans. Harry Zohn, 217–251. New York: Schocken, 1968.

Berzowska, Joanna. "Electronic Textiles: Wearable Computers, Reactive Fashion, and Soft Computation." *Textile* 3 (1) (2005): 58–75.

Berzowska, Joanna. "Outside/Inside." *Euphoria and Dystopia: The Banff New Media Institute Dialogues*, ed. Sarah Cook and Sara Diamond, 163–169. Banff: Banff Center Press, Riverside Architectural Press, 2011. Paper originally delivered August 4, 2004.

Berzowska, Joanna. *XS Labs: Seven Years of Design Research and Experimentation in Electronic Textiles and Reactive Garments*. Montreal: XS Labs, 2010.

"Biography: Clive van Heerden." http://www.design.philips.com/shared/assets/design_assets/downloads/speakers/ClivevanHeerdenMar08.pdf.

Biro, Matthew. *The Dada Cyborg: Visions of the New Human in Weimar Berlin*. Minneapolis: University of Minnesota Press, 2009.

Birringer, Johannes, and Michèle Danjoux. "The Telematic Dress: Evolving Garments and Distributed Proprioception in Streaming Media and Fashion Performance." 2005. http://www/ephemeral-efforts.com/TheTelematicDress.pdf.

Bolter, Jay David, and Diane Gromala. *Windows and Mirrors: Interaction Design, Digital Art, and the Myth of Transparency*. Cambridge, Mass.: MIT Press, 2003.

Bolton, Andrew. *The Supermodern Wardrobe*. London: V&A Publishing, 2002.

Braddock, Sarah E., and Marie O'Mahony. *Techno Textiles: Revolutionary Textiles for Fashion and Design*. London: Thames and Hudson, 1999.

Braddock Clarke, Sarah E., and Marie O'Mahony. *Techno Textiles 2: Revolutionary Textiles for Fashion and Design*. New York: Thames and Hudson, 2005.

Bratich, Jack. "The Digital Touch: Craft-Work as Immaterial Labour and Ontological Accumulation." *ephemera: theory and politics in organization* 10 (3/4) (2010): 303–318.

Bryson, David. "Designing Smart Clothing for the Body." In *Smart Clothes and Wearable Technology*, ed. Jane McCann and David Bryson, 95–107. Oxford: Woodhead Publishing with the Textile Institute, 2009.

Buck-Morss, Susan. *The Dialectics of Seeing: Walter Benjamin and the Arcades Project*. Cambridge, Mass.: MIT Press, 1989.

Buechley, Leah, and Benjamin Mako Hill. "LilyPad in the Wild: How Hardware's Long Tail Is Supporting New Engineering and Design Communities." *Proceedings of the 8th ACM Conference on Designing Interactive Systems*, Aarhus, Denmark, August 2010.

Buechley, Leah, Kylie Peppler, Mike Eisenberg, and Yasim Kafai, eds. *Textile Messages: Dispatches from the World of E-Textiles and Education*. New York: Peter Lang, 2013.

Bulatov, Dmitry, ed. *Evolution Haute Couture: Art and Science in the Post-Biological Age*. 2 vols. Kaliningrad: National Center for Contemporary Arts, 2013.

Busch, Otto von. "Fashion-able: Hacktivism and Engaged Fashion Design." PhD diss., University of Gothenberg, 2008.

Bush, Vannevar. "As We May Think." *Atlantic Monthly* 176 (1) (July 1945): 101–108.

Butler, Judith. *Excitable Speech: A Politics of the Performative*. New York: Routledge, 1997.

Butler, Judith. *Gender Trouble: Feminism and the Subversion of Identity*. New York: Routledge, 1990.

Carnegie Mellon Computer Science Department. "Mobile and Pervasive Computing Research in the Computer Science Department at Carnegie Mellon." http://www.csd.cs.cmu.edu/research/areas/mopercomp.

Castells, Manuel, Mireia Fernández-Ardèvol, Jack Linchuan Qiu, and Araba Sey. *Mobile Communication and Society: A Global Perspective*. Cambridge, Mass.: MIT Press, 2007.

Certeau, Michel de. *The Practice of Everyday Life*. Trans. Steven Randall. Berkeley: University of California Press, 1984.

Chalmers, M., I. MacColl, and M. Bell. "Seamful Design: Showing Seams in Wearable Computing." *Proceedings of IEE Eurowearable*. London: IEE, 2003.

Chatzichristodoulou, Maria, Janis Jefferies, and Rachel Zerihan, eds. *Interfaces of Performance*. Farnham, U.K.: Ashgate, 2009.

Clark, Andy. "Re-Inventing Ourselves: The Plasticity of Embodiment, Sensing, and the Mind." *Journal of Medicine and Philosophy* 32 (2007): 263–282.

Clark, Judith. "Looking Forward: Historical Futurism." In *Radical Fashion*, ed. Claire Wilcox, 8–17. London: V&A Publications, 2001.

Clynes, Manfred E., and Nathan S. Kline. "Cyborgs and Space." *Astronautics* 26–27 (September 1960): 74–76.

Co, Elise Dee. "Computation and Technology as Expressive Elements of Fashion." Master's thesis, Media Arts and Science, MIT, 2000.

Codgell, Christina. "Smooth Flow: Biological Efficiency and Streamline Design." In *Popular Eugenics: National Efficiency and American Mass Culture in the 1930s*, ed. Susan Currell and Christina Cogdell, 217–248. Athens: Ohio University Press, 2006.

Cook, Sarah, and Sara Diamond, eds. *Euphoria and Dystopia: The Banff New Media Institute Dialogues*. Banff: Banff Centre Press and Riverside Architectural Press, 2011.

Cranny-Francis, Anne. "From Extension to Engagement: Mapping the Imaginary of Wearable Technology." *Visual Communication* 7 (3) (August 2008): 363–382.

Csicsery-Ronay, Istvan, Jr. *The Seven Beauties of Science Fiction*. Middletown: Wesleyan University Press, 2008.

Currell, Susan. Introduction. In *Popular Eugenics: National Efficiency and American Mass Culture in the 1930s*, ed. Susan Currell and Christina Cogdell, 1–15. Athens: Ohio University Press, 2006.

Damasio, Antonio. *Descartes' Error*. New York: Penguin, 1994.

Damasio, Antonio. *The Feeling of What Happens*. New York: Harcourt Brace, 1999.

Daniels, Les. *Superman, the Complete History: The Life and Times of the Man of Steel*. New York: DC Comics, 1998.

Davis, Fred. *Fashion, Culture, and Identity*. Chicago: University of Chicago Press, 1992.

Debatty, Regine. "Lucy McRae's Talk At NEXT." *We Make Money Not Art*. Last Modified December 4, 2006. http://we-make-money-not-art.com/archives/2006/12/lucy-mcraes-tal.php.

Debord, Guy. *The Society of the Spectacle*. Trans. Donald Nicholson-Smith. New York: Zone Books, 1995.

De Landa, Manuel. *War in the Age of Intelligent Machines*. New York: Zone Books, 1991.

Deleuze, Gilles. "Postscript on Societies of Control." In *The Cybercities Reader*, ed. Stephen Graham, 73–77. London: Routledge, 2004.

Deleuze, Gilles. "Postscript on Societies of Control." *October* 59 (Winter 1992): 3–7.

Deleuze, Gilles. "What Is a Dispositive?" In *Michel Foucault: Philosopher*, trans. Timothy J. Armstrong, 159–168. New York: Routledge, 1992.

Deleuze, Gilles, and Félix Guattari. *Anti-Oedipus: Capitalism and Schizophrenia*. Trans. Robert Hurley, Mark Seem, and Helen R. Lane. Minneapolis: University of Minnesota Press, 1983.

Deleuze, Gilles, and Félix Guattari. *A Thousand Plateaus: Capitalism and Schizophrenia*. Trans. Brian Massumi. Minneapolis: University of Minnesota Press, 1987.

De Monchaux, Nicholas. *Spacesuit: Fashioning Apollo*. Cambridge, Mass.: MIT Press, 2011.

De Souza e Silva, Adriana. "From Cyber to Hybrid: Mobile Technologies as Interfaces of Hybrid Spaces." *Space and Culture* 9 (3) (August 2006): 261–278.

Dickenson, Colby. *Agamben and Theology*. London: Continuum, 2011.

DiSalvo, Carl. *Adversarial Design*. Cambridge, Mass.: MIT Press, 2012.

Dourish, Paul. *Divining a Digital Future: Mess and Mythology in Ubiquitous Computing*. Cambridge, Mass.: MIT Press, 2011.

Dourish, Paul. *Where the Action Is: The Foundations of Embodied Interaction*. Cambridge, Mass.: MIT Press, 2001.

Dourish, Paul, and Genevieve Bell. "'Resistance Is Futile': Reading Science Fiction Alongside Ubiquitous Computing." Accessed October 26, 2011. http://www.dourish.com/publications.html.

Driessen, Hans. "Philips Emotions Jacket—A New Level in Immersive Cinematic Experience." Accessed October 30, 2011. http://www.research.philips.com/technologies/projects/emotions jacket/index.html.

Driscoll, Robert W. "Engineering Man for Space: The Cyborg Study Final Report NASw-512." In *The Cyborg Handbook*, ed. Chris Hables Gray, 75–81. London: Routledge, 1995. (Originally published by United Aircraft Corporate Systems Center in 1963.)

Du Gay, Paul, Stuart Hall, Linda Janes, Hugh Mackay, and Keith Negus. *Doing Cultural Studies: The Story of the Sony Walkman*. London: Sage, 1997.

Dunne, Anthony. "Hertzian Tales: An Investigation into the Critical and Aesthetic Potential of the Electronic Product as a Post-Optimal Object." PhD diss., Royal College of Art, 1997.

Dunne, Anthony. *Hertzian Tales: Electronic Products, Aesthetics Experience, and Critical Design*. Cambridge, Mass.: MIT Press, 2005.

Dunne, Anthony, and Fiona Raby. *Design Noir: The Secret Life of Electronic Objects*. London: August Media; Basel: Birkhäuser, 2001.

Eco, Umberto. "Lumbar Thought." In *Travels in Hyperreality*, 191–196. Orlando: Harcourt Brace Jovanovich, 1986.

Eco, Umberto. "Social Life as a Sign System." In *Fashion: A Critical Concepts in Media and Cultural Studies*, vol. 2, ed. Malcolm Barnard, 101–106. London: Routledge, 2012.

Ekman, Ulrik, ed. *Throughout: Art and Culture Emerging with Ubiquitous Computing*. Cambridge, Mass.: MIT Press, 2013.

Eng, Diana. *Fashion Geek: Clothing, Accessories, Tech*. Cincinnati: North Light Books, 2009.

Entwistle, Joanne. "The Dressed Body." In *Body Dressing*, ed. Joanne Entwistle and Elizabeth Wilson, 33–58. Oxford: Berg, 2001.

Entwistle, Joanne. *The Fashioned Body: Fashion, Dress, and Modern Social Theory*. Cambridge, U.K.: Polity, 2000.

Evans, Caroline. *Fashion at the Edge: Spectacle, Modernity and Deathliness*. New Haven: Yale University Press, 2003.

Evans, Caroline. "No Man's Land." In *Hussein Chalayan*. Exh. cat. Rotterdam: NAI Publishers and Groninger Museum, 2005.

Farman, Jason. *Mobile Interface Theory: Embodied Space and Locative Media*. New York: Routledge, 2012.

Farren, Anne, and Andrew Hutchison. "Cyborgs, New Technology, and the Body: The Changing Nature of Garments." *Fashion Theory* 8 (4) (2004): 461–476.

"Fashion: Turn On, Turn Off." *Time,* January 20, 1967. http://www.time.com/time/magazine/article/0,9171,843346,00.html.

Felman, Shoshana. *The Literary Speech Act: Don Juan with J. L. Austin, or Seduction in Two Languages*. Trans. Catherine Porter. Ithaca: Cornell University Press, 1983.

Flanagan, Mary, and Austin Booth, eds. *Re: Skin*. Cambridge, Mass.: MIT Press, 2006.

Flügel, John Carl. *The Psychology of Clothes*. London: Hogarth Press and the Institute of Psychoanalysis, 1930.

Flusser, Vilém. *The Shape of Things: A Philosophy of Design*. London: Reaktion Books, 1999.

Flusser, Vilém. *Towards a Philosophy of Photography*. London: Reaktion Books, 2000.

Forbes, Robert James. *Studies in Ancient Technology*. Vol. 4, *The Fibres and Fabrics of Antiquity*. Leiden: Brill Archive, 1964.

Foucault, Michel. *Discipline and Punishment: The Birth of a Prison*. Harmondsworth: Penguin, 1977.

Foucault, Michel. *The History of Sexuality: An Introduction*. Vol. 1. Trans. Robert Hurley. New York: Vintage, 1990.

Foucault, Michel. "Les mailles du pouvoir." In vol. 4 of *Dits et écrits*, ed. Daniel Defert, 182–201. Paris: Gallimard, 1994.

Foucault, Michel. "The Meshes of Power." Trans. Gerald Moore. In *Space, Knowledge and Power: Foucault and Geography*, ed. Jeremy W. Crampton and Stuart Elden, 153–162. Aldershot, U.K.: Ashgate, 2007.

"Fractal 'Living Jewelry,' New Provocation of the Design Probe Team." Last modified August, 2008. http://www.newscenter.philips.com/main/design/about/design/designnews/pressreleases/pressbackgrounders/fractal_living_jewelry.wpd.

Frances, Mark, and Margery King. *The Warhol Look: Glamour, Style, Fashion*. Pittsburgh: Andy Warhol Museum; Boston: Little, Brown, 1997.

Freeman, Gillian. *The Undergrowth of Literature*. London: Panther, 1969.

Frost, Laura. "Circuits of Desire: Techno Fetishism and Millenial Technologies of Gender." *Artbyte* 3 (February-March 1999): 22–28.

Galloway, Alexander R. *The Interface Effect*. Malden, Mass.: Polity Press, 2012.

Galloway, Alexander R., and Eugene Thacker. *The Exploit: A Theory of Networks*. Minneapolis: University of Minnesota Press, 2007.

Gartner, John. "The Spy Who Geeked Me." *Wired*, October 25, 2000.

Gere, Charlotte, and Judy Rudoe. *Jewellery in the Age of Queen Victoria: A Mirror to the World*. London: British Museum Press, 2010.

Gibson, Pamela Church. *Fashion and Celebrity Culture*. New York: Berg, 2012.

Gibson, William. *Neuromancer*. New York: Ace Books, 1984.

Glenn, Constance W. *The Great American Pop Art Store: Multiples of the Sixties*. Long Beach: California State University Art Museum; Santa Monica: Smart Art, 1997.

Gordon, Isa. "Psymbiote." Accessed November 27, 2011. http://www.psymbiote.org.

Gordon, Isa. "SIGGRAPH CyberFashion Show Script." Unpublished manuscript, last modified 2002.

Gordon, Isa, and W. Thomas Wall. "SIGGRAPH 2005 CyberFashion Show Report." Unpublished manuscript, last modified 2005.

Gray, Chris Hables, Steven Mentor, and Heidi J. Figueroa-Sarriera. "Cyborgology: Constructing the Knowledge of Cybernetic Organisms." In *The Cyborg Handbook*, ed. Chris Hables Gray, 1–14. London: Routledge, 1995.

Greff Duggan, Ginger. "The Greatest Show on Earth: A Look at Contemporary Fashion Shows and Their Relationship to Performance Art." *Fashion Theory* 4 (3) (2001): 247–270.

Grisham, Therese. "Linguistics as Indiscipline: Deleuze and Guattari's Pragmatics." *SubStance* 20 (3) (1991): 36–54.

Grosz, Elizabeth. *Volatile Bodies: Toward a Corporeal Feminism*. Bloomington: Indiana University Press, 1994.

Guattari, Félix. "On Machines." Trans. Vivian Constantinopoulos. *Complexity: Journal of Philosophy and the Visual Arts* 6 (1995): 8–12.

Handley, Susannah. *Nylon: The Story of a Fashion Revolution*. Baltimore: Johns Hopkins University Press, 1999.

Hansen, Lone Koeford. "The Interface at the Skin." In *Interface Criticism: Aesthetics beyond Buttons*, ed. Christian Ulrik Anderson and Søren Bro Pold, 63–90. Aarhus, Denmark: Aarhus University Press, 2011.

Hansen, Mark. *New Philosophy for New Media*. Cambridge, Mass.: MIT Press, 2004.

Haraway, Donna. "A Cyborg Manifesto: Science, Technology, and Socialist-Feminism in the Late Twentieth Century." In *Simians, Cyborgs and Women: The Reinvention of Nature*. New York: Routledge, 1991.

Haraway, Donna. "A Manifesto for Cyborgs: Science, Technology, and Socialist Feminism in the 1980s." *Socialist Review* 80 (1985): 65–108.

Hardesty, Larry. "Fibers That Can Hear and Sing." *MIT News,* July 12, 2010. http://web.mit.edu/newsoffice/2010/acoustic-fibers-0712.html.

Hardt, Michael. "Affective Labour." *Boundary 2* 26 (2) (1999): 89–100.

Hawk, Byron, and David M. Rieder, eds. *Small Tech: The Culture of Digital Tools*. Minneapolis: University of Minnesota Press, 2008.

Hayles, N. Katherine. *How We Became Posthuman: Virtual Bodies in Cybernetics, Literature, and Informatics*. Chicago: University of Chicago Press, 1999.

Hayles, N. Katherine. "Liberal Subjectivity Imperiled: Norbert Wiener and Cybernetic Anxiety." http://www.english.ucla.edu/faculty/hayles/Wiener.htm.

Hayles, N. Katherine. "Radio-Frequency Identification: Human Agency and Meaning in Information-Intensive Environments." In *Throughout: Art and Culture Emerging with Ubiquitous Computing*, ed. Ulrik Ekman, 503–528. Cambridge, Mass.: MIT Press, 2013.

Hersey, George. *The Evolution of Allure*. Cambridge, Mass.: MIT Press, 1996.

Hollander, Anne. *Seeing through Clothes*. New York: Viking Press, 1975.

Hughes, Ben, and Jenny Tillotson. "Design as a Means of Exploring the Emotional Component of Scent." Paper presented at the 5th Conference on Design and Emotion, Gothenburg, Sweden, 2006.

Huhtamo, Erkki. "Cyborg Is a Topos." In *Evolution Haute Couture: Art and Science in the Post-Biological Age*, 2 vols., ed. Dmitry Bulatov, 2:259–269. Kaliningrad: National Center for Contemporary Arts, 2013.

Ihde, Don. *Bodies in Technology*. Minneapolis: University of Minnesota Press, 2002.

Ippolito, Jean M. "From the Avant-Garde: Re-Conceptualizing Cultural Origins in the Digital Media Art of Japan." *Leonardo: Journal of the International Society for the Arts, Sciences, and Technology* 40 (2) (2007): 142–151.

Ishii, Hiroshi, and Brygg Ullmer. "Tangible Bits: Towards Seamless Interfaces Between People, Bits and Atoms." *CHI '97: Proceedings of the ACM SIGCHI Conference on Human Factors in Computing Systems* (March 1997), 234–241.

"i-Wear Project, The." Last modified February 16, 2002. http://web.archive.org/web/20010712203912/www.starlab.org/bits/intell_clothing/projects.html.

Jarrett, D. N. *Cockpit Engineering*. Aldershot, U.K.: Ashgate, 2005.

Jefferies, Janis. "Laboured Cloth: Translations of Hybridity in Contemporary Art." In *The Object of Labor: Art, Cloth, and Cultural Production*, ed. Joan Livington and John Ploof, 283–294. Chicago: School of the Art Institute of Chicago; Cambridge, Mass.: MIT Press, 2007.

Jenkins, Henry. *Convergence Culture: Where Old and New Media Collide*. New York: New York University Press, 2006.

Johnsen, Edwin G., and William R. Corliss. "Teleoperators and Human Augmentation." AEC-Casa Technology Survey, NASA SP-5047, 1967. Excerpted in *The Cyborg Handbook*, ed. Chris Hables Gray, 83–92. London: Routledge, 1995.

Jones, Amelia. *Body Art: Performing the Subject*. Minneapolis: University of Minnesota Press, 1998.

Kaiser, Wilson. "Partial Affinities: Fascism and the Politics of Representation in Interwar America." PhD diss., University of North Carolina at Chapel Hill, 2011.

Kamitsis, Lydia. *Paco Rabanne*. London: Thames and Hudson, 1999.

Karimi, Azmina. "Heart on the Sleeve: Visualizing Human Touch and Emotion through Wearable Technology." http://azmina-iat320.blogspot.com/.

Kato, Mizuho. "Searching for Boundary." Trans. Simon Scanes and Keiko Shiraha. In *Atsuko Tanaka: Search for an Unknown Aesthetic, 1945–2000,* ed. Mizuho Kato and Ming Tiampo, 15–25. Ashiya: Ashiya City, Museum of Art and History; Shizuoka: Shizuoka Prefectural Museum of Art, 2001.

Katz, J. E., and S. Sugiyama. "Mobile Phones as Fashion Statements: The Co-Creation of Mobile Communication's Public Meeting." In *Mobile Communications: Re-Negotiation of the Social Sphere,* ed. Rich Ling and Per E. Pederson, 63–81. London: Springer-Verlag, 2005.

"Keitai Girl." *Unravel: Siggraph 2006 Fashion Show*. July 31, 2006. http://old.siggraph.org/s2006/unravel/Projects/3/. Accessed April 3, 2012.

Kellner, Douglas. *Media Spectacle*. London: Routledge, 2003.

Kettley, Sarah. "Crafting the Wearable Computer: Design Process and User Experience." PhD diss., Napier University, Edinburgh, 2007.

Kieffner, Tara. "Wearable Computers: A General Overview." 1999. http://misnt.indstate.edu/harper/Wearable_Computers.html. Accessed February 18, 2012.

Kline, Ronald. "Where are the Cyborgs in Cybernetics?" *Social Studies of Science* 39 (2009): 331–362.

Kluitenberg, Eric. "The Network of Waves: Living and Acting in a Hybrid Space." *Open 11: Hybrid Space* (2006): 6–16.

Kozel, Susan. *Closer: Performance, Technologies, Phenomenology*. Cambridge, Mass.: MIT Press, 2007.

Kroker, Arthur, and Louise Kroker. *Hacking the Future: Stories for the Flesh-Eating 90s*. New York: St. Martin's Press, 1996.

Kunimoto, Namiko. "Tanaka Atsuko and the Circuits of Subjectivity." *Art Bulletin* 45 (2) (September 2013).

Lambourne, Robert, Khodi Feiz, and Bertrand Rigot. "Social Trends and Product Opportunities: Philips' Vision of the Future Project." *CHI 97 Electronic Publications* (1997). http://www.sigchi.org/chi97/proceedings/briefing/rl.htm#U4. Accessed February 11, 2012.

Larocca, Amy. "The House of Mod." *New York* (2003). http://nymag.com/nymetro/shopping/fashion/spring03/n_8337/. Accessed October 23, 2011.

Latour, Bruno. *Reassembling the Social: An Introduction to Actor-Network Theory*. Oxford: Oxford University Press, 2005.

Laughlin, Harry Hamilton. *Eugenical Sterilization in the United States*. Chicago: Psychopathic Laboratory of the Municipal Court of Chicago, 1922.

Lazzarato, Maurizio. "Immaterial Labour." In Paolo Virno and Michael Hardt, eds. *Radical Thought in Italy: A Potential Politics*, 132–146. Minneapolis: University of Minnesota Press, 1996.

Lee, Suzanne. *Fashioning the Future: Tomorrow's Wardrobe*. London: Thames and Hudson, 2005.

Lehmann, Ulrich. *Tigersprung: Fashion in Modernity*. Cambridge, Mass.: MIT Press, 2000.

Lightman, Alex, and William Rojas. *Brave New Unwired World: The Digital Big Bang and the Infinite Internet*. New York: John Wiley and Son, 2002.

Lipovetsky, Gilles. *The Empire of Fashion: Dressing Modern Democracy*. Trans. Catherine Porter. Princeton: Princeton University Press, 1994.

Lobenthal, Joel. *Radical Rags: Fashion of the Sixties*. New York: Abbeville, 1990.

Lungberg, Jan, and Peter Holm. "Speech Acts on Trial." *Scandinavian Journal of Information Systems* 8 (1) (1996): 29–52.

Lurie, Alison. *The Language of Clothes*. 2nd ed. New York: Random House, 1983.

Mainstone, Di. "Serendiptichord." In *Functional Aesthetics: Visions in Fashionable Technology,* ed. Sabine Seymour, 64. New York, Vienna: Springer: 2010.

Malmivaara, Mikko. "The Emergence of Wearable Computing." In *Smart Clothes and Wearable Technology*, ed. J. McCann and D. Bryon. Oxford: Woodhead Publishing, 2009.

Mann, Steve. "An Historical Account of the 'WearComp' and 'WearCam' Inventions Developed for Applications in 'Personal Imaging.'" ISWC '97 Proceedings of the 1st IEEE International Symposium on Wearable Computers (1997), 66.

Mann, Steve. "Wearable Computing." In *The Encyclopedia of Human-Computer Interaction*, 2nd ed., ed. Mads Soegaard and Rikke Friis Dam. Aarhus, Denmark: Interaction Design Foundation, 2012.

Mann, Steve, with Hal Niedzviecki. *Cyborg: Digital Destiny and Human Possibility in the Age of the Wearable Computer*. Toronto: Doubleday Canada, 2001.

Manovich, Lev. *Fashion Sites*. http://www.manovich.net/DOCS/art_fashion.html. Last modified March 2001.

Manovich, Lev. "Interaction as a Designed Experience." In *Throughout: Art and Culture Emerging with Ubiquitous Computing*, ed. Ulrik Ekman, 311–336. Cambridge, Mass.: MIT Press, 2013.

Manovich, Lev. *The Language of New Media*. Cambridge, Mass.: MIT Press, 2001.

Manovich, Lev. "The Poetics of Augmented Space." *Visual Communication* 5 (2006): 219–240.

Manovich, Lev. "Visual Technologies as Cognitive Prostheses: A Short History of the Externalization of the Mind." In *The Prosethetic Impulse: From a Posthuman Present to a Biocultural Future*, ed. Marquard Smith and Joanne Morra, 203–220. Cambridge, Mass.: MIT Press, 2006.

Marzano, Stefabi. "The Quest for Power, Comfort and Freedom: Exploring Wearable Electronics." *Philips News Center*. http://www.newscenter.philips.com/main/design/about/design/speakers/speeches/questforpower.wpd. Last modified November 11, 2008.

Marzano, Stefano, Josephine Green, C. van Heerden, and J. Marma. *New Nomads: An Exploration of Wearable Electronics by Philips*. Rotterdam: Koninklijke Philips Electronics N.V. and 010 Publishers, 2000.

Massumi, Brian. *Parables for the Virtual*. Durham: Duke University Press, 2002.

Mauss, Marcel. "Techniques of the Body." *Economy and Society* 2 (1) (1973): 70–88.

McCann, Jane, and David Bryson, eds. *Smart Clothes and Wearable Technology*. Cambridge, U.K.: Woodhead Publishing in association with the Textile Institute, 2009.

McCooney, Meriel. "Plastic Bombs." *Sunday Times Colour Supplement*, August 15, 1965.

McLuhan, Marshall. *Understanding Media: The Extensions of Man.* 1964; Cambridge, Mass.: MIT Press, 1994.

"The Measure of a Man." Television episode in *Star Trek: The Next Generation.* Written by Melinda M. Snodgrass. Directed by Robert Scheerer. 1989.

Mitchell, William J. *Me++: The Cyborg Self and the Networked City.* Cambridge, Mass.: MIT Press, 2003.

MIT Media Lab. *Wearables: Beauty and the Bits.* 1997.

Moggridge, Bill. *Designing Interactions.* Cambridge, Mass.: MIT Press, 2007.

Moravec, Hans. *The Mind Children: The Future of Robot and Human Intelligence.* Cambridge, Mass.: Harvard University Press, 1988.

Moriwaki, Katherine. "Outside/Inside." In *Euphoria and Dystopia: The Banff New Media Institute Dialogues,* ed. Sarah Cook and Sara Diamond, 268–273. Banff: Banff Center Press, Riverside Architectural Press, 2011. Paper originally delivered August 4, 2004.

Moriwaki, Katherine, and Jonah Brucker-Cohen. "Coincidence and Intersection: Networks and the Crowd." In *UbiComp in the Urban Frontier,* workshop proceedings, Nottingham, 2004.

Mullarkey, John. "Deleuze and Materialism One." *South Atlantic Quarterly* 96 (3) (Summer 1997): 439–463.

Mulvey, Laura. "Visual Pleasure and Narrative Cinema." *Screen* 16 (3) (Autumn 1975): 6–18.

Munster, Anna. *Materializing New Media: Embodiment in Information Aesthetics.* Hanover, N.H.: Dartmouth College Press, 2006.

Negroponte, Nicholas. "Wearable Computing." *Wired* 3 (12) (December 1995): 256.

Negt, Oskar, and Alexander Kluge. *Public Sphere and Experience: Toward an Analysis of the Bourgeois and the Proletarian Public Sphere.* Trans. Peter Labanyi, Jamie Owen Daniel, and Assenka Oksiloff. Minneapolis: University of Minnesota Press, 1993.

"The 1960s Paper Dress." *Wisconsin Historical Society.* Accessed October 10, 2011. http://www.wisconsinhistory.org/museum/artifacts/archives/003291.asp.

O'Mahony, Mary, and Sarah E. Braddock. *Sportstech: Revolutionary Fabrics, Fashion, and Design.* New York: Thames and Hudson, 2002.

O'Nascimento, Ricardo. "Rambler." *Popkalab.* 2010. http://www.popkalab.com/ramblershoes.html. Accessed July 14, 2012.

Pakhchyan, Syuzi. *Fashioning Technology: A DIY Intro to a Smart Crafting.* Sebastopol, Calif.: O'Reilly Media, 2008.

Parent, Sylvie, and Angus Leech. "Reflection: Sub-rose." In *HorizonZero Issue 16: Wear, Smart Clothes, Wearable Technologies,* ed. Angus Leech. Banff: Banff New Media Institute, July/August 2004.

Pederson, Isabel. "Dehumanization, Rhetoric, and the Design of Wearable Augmented Reality Interfaces." In *Small Tech: The Culture of Digital Tools*, ed. Byron Hawk, David M. Reider, and Ollie Oviedo, 166–178. Minneapolis: University of Minnesota Press, 2008.

Penny, Simon. "Trying to Be Calm: Ubiquity, Cognitivism, and Embodiment." In *Throughout: Art and Culture Emerging with Ubiquitous Computing*, ed. Ulrik Ekman, 263–278. Cambridge, Mass.: MIT Press, 2013.

Picard, Rosalind. *Affective Computing*. Cambridge, Mass.: MIT Press, 1997.

Picard, Rosalind, and Jennifer Healy. "Affective Wearables." *Personal Technologies* 1 (4) (1997): 231–240.

Pinto, Roberto, Nicolas Bourriaud, and Maia Damainovic, eds. *Lucy Orta*. London: Phaidon Press, 2003.

Plutchik, Robert. *The Emotions: Facts, Theories, and a New Model*. New York: Random House, 1962.

Polhemus, Ted. *Street Style: From Sidewalk to Catwalk*. New York: Thames and Hudson, 1994.

Priest-Dorman, Greg. "Charmit Developer's Kit from 2000." http://www.cs.vassar.edu/~priestdo/charmit/. Last modified March 7, 2004.

Quinn, Bradley. *Fashion Futures*. London: Merrell, 2012.

Quinn, Bradley. *The Fashion of Architecture*. New York: Berg, 2003.

Quinn, Bradley. "A Note: Hussein Chalayan, Fashion and Technology." *Fashion Theory* 6 (4) (December 2002): 359–368.

Quinn, Bradley. *Techno Fashion*. Oxford, New York: Berg, 2002.

Quinn, Bradley. *Textile Futures: Fashion, Design, and Technology*. Oxford, New York: Berg, 2010.

Rehmi Post, E., and Margaret Orth. "Smart Fabric, or 'Wearable Clothing.'" *Proceedings of the First International Symposium on Wearable Computers*, 167–168. Cambridge, Mass., IEEE, 1997.

Reynolds, Simon. *Generation Ecstasy: Into the World of Techno and Rave Culture*. Boston: Little, Brown, 1998.

Rhodes, Bradley. "A Brief History of Wearable Computing." 1997. http://www.media.mit.edu/wearables/lizzy/timeline.html.

Rhodes, Bradley. "The Wearable Remembrance Agent: A System for Augmented Reality." *Personal Technologies* 1 (1997): 218–224.

Ryan, Susan Elizabeth. "Dress for Stress: Wearable Technology and the Social Body." *Intelligent Agent* 8 (1) (February 2008): 1–6.

Ryan, Susan Elizabeth. "Encompassing the Body: Wearable Technology vs. the Avatar." *Proceedings of ISEA 2008: The 14th International Symposium on Electronic Art*. Singapore: ISEA, 2008.

Ryan, Susan Elizabeth. "Emotional Exchange: Wearable Technology as Embodied Practice." In *Evolution Haute Couture: Art and Science in the Post-Biological Age*, 2 vols., ed. Dmitry Bulatov, 2:136–153. Kaliningrad: National Center for Contemporary Arts, 2013.

Ryan, Susan Elizabeth. "Re-Visioning the Interface: Technological Fashion as Critical Media." *Leonardo* 43 (4) (2009): 300–306.

Ryan, Susan Elizabeth. *Robert Indiana: Figures of Speech*. New Haven: Yale University Press, 2000.

Ryan, Susan Elizabeth. "Social Fabrics: Wearable + Media + Interconnectivity." *Leonardo* 42 (2) (2009): 114–116.

Ryan, Susan Elizabeth. "What Is Wearable Technology Art?" *Intelligent Agent* 8 (1) (February 2008): 1–6.

Sakier, George. "No Mechanistic Clothes for Future Women Predicts George Sakier." *Vogue* 93 (2) (February 1, 1939): 144.

San Martin, Macarena. *Future Fashion / El futuro de la moda*. Barcelona: Promopress, 2010.

"Science and Society Picture Library." *Manchester Daily Express,* February 2, 1968. http://www.scienceandsociety.co.uk/results.asp?image=10450947&screenwidth=1396.

Searle, John R. *Speech Acts: An Essay in the Philosophy of Language*. Cambridge: Cambridge University Press, 1969.

Semper, Gottfried. *Style in the Technical and Tectonic Arts; or, Practical Aesthetics*. Trans. Harry Francis Mallgrave and Michael Robinson. Los Angeles: Getty Publications, 2004.

Seymour, Sabine. *Fashionable Technology: The Intersection of Design, Fashion, Science, and Technology*. New York, Vienna: Springer, 2008.

Seymour, Sabine. *Functional Aesthetics: Visions in Fashionable Technology*. New York, Vienna: Springer, 2010.

Seymour, Sabine. "The Garment as Interface." In *The Handbook of Research on User Interface Design and Evaluation for Mobile Technology*, vol. 1, ed. Joanna Lumsden, 176–186. Hershey, N.Y.: Information Science Reference, 2008.

Siewiorek, Dan. "Hardware Breakout Session." Boeing Wearable Computer Workshop Breakout Session Summary. http://cs.cmu.edu/~wearable/boeing/index.html.

Silverman, Kaja. "Fragments of a Fashionable Discourse." In *Studies in Entertainment: Critical Approaches to Mass Culture*, ed. Tania Modleski, 139–152. Bloomington: Indiana University Press, 1986.

Smith, Courtenay, and Sean Topham. *Xtreme Fashion*. New York: Prestel, 2005.

Sofoulis, Zoë. "Cyberquake: Haraway's Manifesto." In *The Cybercultures Reader*, 2nd ed., ed. David Bell and Barbara M. Kennedy. London: Routledge, 2000.

Sommerer, Christa, Lakhmi C. Jain, and Laurent Mignonneau, eds. *The Art and Science of Interface and Interaction Design*. Vol. 1. Berlin: Springer-Verlag, 2008.

Sparke, Penny. "Plastics and Pop Culture." In *The Plastics Age: From Bakelite to Beanbags and Beyond*, ed. Penny Sparke, 92–103. Woodstock: Overlook Press, 1993.

Starner, Thad. "The Cyborgs Are Coming; Or, the Real Personal Computers." Unpublished manuscript, last modified June 1995. http://hd.media.mit.edu/tech-reports/TR-318-ABSTRACT.html.

Starner, Thad. "Human-Powered Wearable Computing." *IBM Systems Journal* 35 (3–4) (1996): 618–629.

Starner, Thad, Steve Mann, Bradley Rhodes, Jeffrey Levine, Jennifer Healy, Dana Kirsch, Roz Picard, and Alex Pentland. "Augmented Reality through Wearable Computing." *Presence* 6 (4) (Winter 1997): 386–398.

Stead, Lisa, Peter Goulev, Caroline Evans, and Ebrahim Mandani. "The Emotional Wardrobe." *Personal and Ubiquitous Computing* 8 (304) (July 2004): 282–290.

Sterling, Bruce. "Intimacy Lotus and Intimacy Black." *Beyond the Beyond*. *Wired*, March 31, 2010. http://www.wired.com/beyond_the_beyond/2010/03/intimacy-lotus-and-intimacy-black.

Stern, Radu. *Against Fashion: Clothing as Art, 1850–1930*. Cambridge, Mass.: MIT Press, 2004.

Stevens, Denis. "Validity Is in the Eye of the Beholder: Mapping Craft Communities of Practice." In *Extra/Ordinary: Craft and Contemporary Art*, ed. Maria Elena Buszek, 43–58. Durham: Duke University Press, 2011.

Stevens, Mark. "Everything Is Illuminated." *New York*, May 21, 2005. http://nymag.com/nymetro/arts/art/reviews/9937/. Accessed July 15, 2012.

Studio Roosegaarde. "Intimacy." Last modified May 27, 2005. http://www.studioroosegaarde.net/project/intimacy/info/.

Studio subTela. *The Narrative Cloth: Textiles, Translations and Transmissions*. Toronto: Hexagram and Concordia University in collaboration with the Social Sciences and Research Council of Canada, 2011.

Sturman, David J., and David Zeltzer. "A Survey of Glove-based Input." *Computer Graphics and Applications, IEEE* 14 (1) (January 1994): 30–39.

Suchman, Lucy. *Human-Machine Reconfiguration: Plans and Situated Actions*. 2nd ed. Cambridge: Cambridge University Press, 2006.

Sutherland, Ivan E. "A Head-Mounted Three-Dimensional Display." *Proceedings of AFIPS* 68 (1968): 757–764.

Taylor, Mark C. *The Monument of Complexity: Emerging Network Culture*. Chicago: University of Chicago Press, 2002.

Teague, Walter Dorwin. "Nearly Nude Evening Dress Designed by Walter Dorwin Teague." *Vogue* 93 (2) (February 1, 1939): 143.

Temporary Services. *Temporary Conversations: Peggy Diggs*. Chicago: Temporary Services, 2010.

Terrades, Minerva, and Yann Bona. "Mobile Phone-Mediated Interaction: Technoaffectivity, Mobile Subject, and Urban Space." In *Mobile Media 2007: Proceedings of an International Conference on Social and Cultural Aspects of Mobile Phones, Convergent Media, and Wireless Technologies,* ed. Gerard Goggin and Larissa Hjorth, 151–160. Sydney: University of Sydney, 2007.

Thacker, Eugene. "The Science Fiction of Technoscience: The Politics of Simulation and a Challenge for New Media Art." *Leonardo* 34 (2) (2001): 155–158.

Thorp, Edward O. "A Favorable Strategy for Twenty-One." *Proceedings of the National Academy of Sciences of the United States of America* 47 (1) (1961): 110–112.

Thorp, Edward O. "The Invention of the First Wearable Computer." *ISWC '98: Proceedings of the 2nd IEEE International Symposium on Wearable Computers.* Washington, DC: IEEE Computer Society, 1998.

Thrasher, Elizabeth. "Computer Couture." *Vogue* 188 (2) (February 1998): 124, 126, 130.

Thurschwell, Pamela. *Literature, Technology, and Magical Thinking, 1880–1920.* Cambridge: Cambridge University Press, 2001.

Tiampo, Ming. "Electrifying Painting." In *Electrifying Art: Atsuko Tanaka 1954–1968,* ed. Mizuho Kato and Ming Tiampo, 63–77. New York: Grey Art Gallery, 2004.

Tillotson, Jenny. "Smart Second Skin Dress." Last modified 2003. http://www.smartsecondskin .com/main/home.htm.

Toffler, Alvin. *Future Shock.* New York: Random House, 1970.

"To-Morrow's Daughter." *Vogue* 93 (2) (February 1, 1939): 61.

Turing, Alan. "Computing Machinery and Intelligence." *Mind* 59 (236) (1950): 433–460.

UnRavel. SIGGRAPH 2007 Fashion Event. 2007. San Diego: SIGGRAPH.

Upton, Hubert. "Wearable Eyeglass Speechreading Aid." *American Annals of the Deaf* 113 (2) (March 2, 1968): 222–229.

Van Abel, Bas, Lucas Evers, Rael Klaassen, and Peter Traxler. *Open Design Now: Why Design Cannot Remain Exclusive.* Premsela, the Netherlands: BIS Publishers with Netherlands Institute for Design and Fashion, and the Waag Society under a Creative Commons License, 2011.

Veblen, Thorstein, and Stuart Chase. *Theory of the Leisure Class.* New York: Modern Library, 1934.

Victoria and Albert Museum. "Jules Léotard." http://www.vam.ac.uk/content/articles/j/jules-leo tard/. Accessed December 21, 2011.

Violette, Robert, Judith Clark, Susannah Frankel, and Pamela Golbin. In *Hussein Chalayan.* Ed. Robert Violette. New York: Rizzoli, 2011.

Virilio, Paul. *The Aesthetics of Disappearance.* Trans. Philip Beitchman. Los Angeles: Semiotext(e), 2009.

Virno, Paolo. *A Grammar of the Multitude*. Trans. Isabella Bertoletti, James Cascaito, and Andrea Casson. Los Angeles: Semiotext(e), 2004.

Viseu, Ana. "Augmented Bodies: The Visions and Realities of Wearable Computers." PhD diss., University of Toronto, 2005.

Viseu, Ana. "Simulation and Augmentation: Issues of Wearable Computers." *Ethics and Information Technology* 5 (1) (2003): 17–26.

Viseu, Ana. "Wearcomps and the Informed Informational Body." In *Evolution Haute Couture: Art and Science in the Post-Biological Age*, 2 vols., ed. Dmitry Bulatov, 2:122–135. Kaliningrad: National Center for Contemporary Arts, 2013.

"Vogue Presents Fashions of the Future." *Vogue* 93 (2) (February 1, 1939): 1–9, 70–81, 137–146.

Volosinov, Valentin. *Marxism and the Philosophy of Language*. Trans. Ladislav Matejka and I. R. Titunik. Cambridge, Mass.: Harvard University Press, 1986.

Volt (Vincenzo Fani). "Futurist Manifesto of Women's Fashion." *Roma Futurista* 3 (72) (February 29, 1920).

Watson, Steven. *Factory-Made: Warhol and the Sixties*. New York: Pantheon, 2003.

"Wear: Smart Clothes, Fashionable Technologies." *Horizon 0* 16 (2004). http://www.horizonzero .ca/index.php?pp=28&lang=0#.

Wegenstein, Bernadette. *Getting under the Skin: The Body and Media Theory*. Cambridge, Mass.: MIT Press, 2006.

Weibel, Peter. "Foreword." In *The Art and Science of Interface and Interaction Design*, ed. Christa Sommerer, Lakhmi C. Jain, and Laurent Mignonneau, vol. 1, v–x. Berlin: Springer-Verlag, 2008.

Weiser, Mark. "Building Invisible Interfaces." Last modified November 2, 1994. http://www.ubiq .com/hypertext/weiser/UIST94_4up.ps.

Weiser, Mark. "The Computer in the 21st Century." *Scientific American* 265 (3) (September 1991): 94–110.

Weiser, Mark. "Some Computer Science Issues in Ubiquitous Computing." *Communications of the ACM* 36 (7) (1993): 75–84.

Weiser, Mark, and John Seely Brown. "Designing Calm Technology." Xerox PARC. Last modified December 25, 1995. http://www.ubiq.com/hypertext/weiser/calmtech/calmtech.htm.

Weltzein, Friedrich. "Masque-*ulinities*: Changing Dress as a Display of Masculinity in the Superhuman Genre." *Fashion Theory* 9 (2) (June 2005): 229–250.

Wiener, Norbert. *The Human Use of Human Beings: Cybernetics and Society*. Garden City, N.Y.: Doubleday, 1950.

Wiener, Norbert. "Sound Communication with the Deaf." In Wiener, *Collected Works with Commentaries*, vol. 4, ed. Pesi Masani, 409–411. Cambridge, Mass.: MIT Press, 1985.

Wigley, Mark. *White Walls, Designer Dresses: The Fashioning of Modern Architecture*. Cambridge, Mass.: MIT Press, 1995.

Wilcox, Claire. *Radical Fashion*. London: V&A Publications, 2001.

Wilde, Danielle. "A New Performativity: Wearables and Body-Devices." Paper presented at Re:Live Third International Conference on the Histories of Media Art, Melbourne, November 26–29, 2009.

Wilson, Elizabeth. *Adorned in Dreams: Fashion and Modernity*. 2nd ed. New Brunswick: Rutgers University Press, 2003.

Wilson, Elizabeth. "Ethics and the Future of Fashion." In *The Fashion History Reader: Global Perspectives*, ed. Giorgio Riello and Peter McNeil, 531–532. London: Routledge, 2010.

Wilson, Elizabeth. "These New Components of the Spectacle: Fashion and Postmodern." In *Postmodernism and Society*, ed. Roy Boyne and Ali Rattansi, 209–236. London: Macmillan, 1990.

Winograd, Terry. "A Language/Action Perspective on the Design of Cooperative Work." *Human-Computer Interaction* 3 (1) (1987–1988): 3–30.

Wright, Sarah H. "Students Showcase 'Seamless' Pairing of Fashion, Technology." *MIT News*, January 26, 2006.

Ying Gao: Art, Mode et Technologie. Musée National des Beaux-Arts du Québec, 2011. Exhibition catalog.

Yoshihara, Jiro. "Regarding the Second Gutai Outdoor Exhibition." *Gutai Journal* 5 (October 1956).

Zim, Larry, Mel Lerner, and Herbert Rolfes. *The World of Tomorrow: The 1939 New York World's Fair*. New York: Harper and Row, 1988.

Zuanon, Rachel, and Geraldo Lima. "NeuroBodyGame: The Design of a Wearable Computer for Playing Games through Brain Signals." Paper presented at ISEA 2011, Istanbul, September 2011.

Index

Page numbers in italics indicate illustrations.